Pictorial Guide to pond invertebrates (excluding Protozoa, Gastrotricha and Tardigrada)

Freshwater sponge
Shape irregular. Supporting spicules visible. Small inhalent, large exhalent, pores. Colour grey, yellowish, or green. p 94.

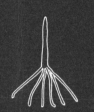

Hydra
Tubular body column ends in circle of tentacles surrounding single opening. Buds forming new hydras arise from column. Hydra very contractile. p 95.

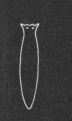

Planarian flatworm
Body soft, elongate, very flattened. Often short tentacles on head. Eyespots. Cilia cover body. Mouth ventral. Gut of large species has 3 branches. p 96.

Roundworm
Long, thin, colourless body not segmented. Pointed at both ends. Movement in S-shaped curves characteristic. Usually among roots and in mud. p 99.

Hairworm
Resembles long hair. Very long and thin ranging in length from 10 to 70 cm. Grey, black or brown. Usually found as tangled mass of one or more individuals. p 100.

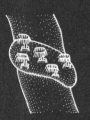

Moss animal
Occurs as colonies of connected individuals embedded in protective matrix. When the crown bearing tentacles is expanded, it resembles a minute flower. p 104.

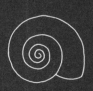

Ram's horn or trumpet snail
Shell coiled in flat spiral. Thin tapering tentacles. Foot small and rounded at each end. Blood contains haemoglobin and is red in colour. p 107.

Pond snail
Thin, brown, conical shell with pointed spine. Tentacles not rectractile. Takes air into lungs at surface. p 108.

Lake limpet
Hood-shaped shell with no whorls and apex turned to left. Shell is thin and breaks easily. Usually found on leaves of aquatic plants. p 108.

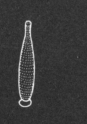

Freshwater mussel
Two equal valves hinged together by an elastic ligament. Valves normally slightly open to show two siphons and muscular foot. No head, eyes, or tentacles. p 109.

Tubifex worm
Thin red worms living head downwards in tubes on muddy bottom waving tail to augment oxygen supply. Blood contains haemoglobin. p 114.

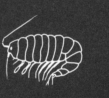

Leech
Elongate, flattened, segmented, with sucker around mouth. Larger sucker at caudal end. Body very muscular and contractile. Progress by looping or swimming. p 116.

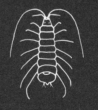

Water spider
Body in two parts with narrow waist between. Eight legs and eyes. Spinnerets at end of abdomen spin shelter filled with air in which spider lives. p 122.

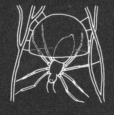

Watermite
Globular unsegmented body, often bright red. Four pairs of legs. Two pigmented eyes. Swims by flailing legs. Usually found near bottom of pond. p 124.

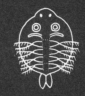

Fish louse
Greatly flattened dorsoventrally. Large protective shield. Two large suckers. Piercing proboscis. Four pairs of swimming legs. Parasitic on fishes. p 126.

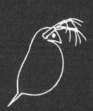

Waterflea
Body enclosed by folded 'shell' usually with posterior spine. Compact head and large fringed antennae for movement. Large compound eyes. Colour may be pinkish. p 128.

Seed shrimp
Body covered by two shells joined dorsally by ligament. Shells gape for extrusion of locomotory appendages. p 128.

Cyclops
Cylindrical tapering body clearly segmented. Single eye and large antennae. Two egg sacs carried by female in summer. p 130.

Freshwater shrimp
Body laterally compressed and curved. Usually swims on side. Long antennae; compound eyes. Numerous limbs. Female carries eggs and young under thorax. p 132.

Waterlouse
Flattened body with legs of all same type. Second pair of antennae long. Five pairs of gills on abdomen. In spring female carries eggs beneath her body. p 132.

Adult insect (dragonfly)
Body in three parts: head, thorax, abdomen. Three pairs legs. Two pairs wings. Large eyes. p 136 ff.

THE POND

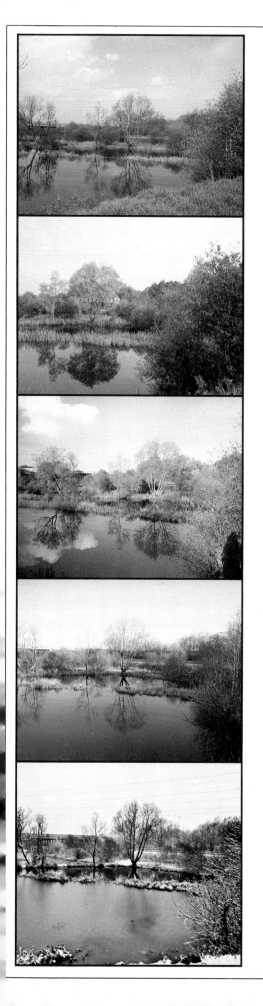

OXFORD SCIENTIFIC FILMS

The pond

DISCARD

TEXT BY
Gerald Thompson OBE
Jennifer Coldrey

PRINCIPAL PHOTOGRAPHER
George Bernard

LINE ILLUSTRATIONS BY
Gerald Thompson

The MIT Press
Cambridge, Massachusetts

In memory of Wilfred Kings, 1889–1980,
a great teacher and a wonderful friend.

First MIT Press edition, 1984

First published 1984
© Oxford Scientific Films Ltd 1984

Printed in Hong Kong by South China Printing Co.

Library of Congress Cataloging in Publication Data

Thompson, Gerald.
 The pond.

 (Oxford scientific films)
 Bibliography: p.
 Includes index.
 1. Pond ecology. 2. Pond fauna—Identification.
3. Pond flora—Identification. I. Coldrey, Jennifer.
II. Bernard, George, 1949– . III. Title.
IV. Series.
QH541.5.P63T48 1984 574.5′26322 83–17574
ISBN 0–262–20049–X

FOREWORD

A freshwater pond is a self-contained world full of fascination for anyone who spares the time to stop and gaze through the limpid surface to see what lurks below. Children who collect frogspawn or sticklebacks in spring find other creatures in their nets – a hint of the profound variety and complexity of life that abounds in the water. Visible pond plants and animals are often weird and wonderful and always interesting, but the pond contains another world that cannot be seen even with a hand lens. This is a world of minute animals and plants that can be revealed only through the eyepiece of a microscope. In the hope that some readers will be able to enter this hidden world, examples of microscopic animals and plants are included in this book.

The Pond is an illustrated guide to the main types of animals and plants found in ponds throughout the world. The book is written for everyone who would just like to be able to identify the different kinds of pond life in broad terms but it also outlines the part that organisms play in the life of a pond. Ponds throughout the world conform to a basic ground-plan so that, although the genera and species of plants and animals may differ from place to place, the same types are found everywhere.

For convenience, most of the animals and plants described and illustrated here were taken from a British pond with a few additions from elsewhere. But a pond from North America, the West Indies, or Australia could equally well have been used. The group of insects known as Hemiptera (*see* page 150) – the true 'bugs' of the entomologist – shows how well this worldwide approach works. To the untrained eye the predatory needle bug of Europe, *Ranatra linearis*, looks identical to *R. dispar* from Australia. Both species are aquatic predators with similar life histories. Another European bug, the Water Scorpion, *Nepa cinerea*, has as its equivalent *Laccotrephes tristis* in Australia, a member of another genus, but instantly recognizable as a water scorpion. Both species are known to be predators of small fishes, insects, tadpoles, and so on. European, North American, West Indian, and Australian ponds all contain water measurers, water crickets, and pond skaters on the surface and needle bugs, water scorpions, backswimmers, water boatmen, and saucer bugs beneath the surface. Except in Europe, giant water bugs are also present, so this type is included in the book.

Descriptive keys devised by botanists and zoologists for identification purposes are difficult to use without much tedious explanation, and photographs are much

more helpful for the non-biologist. All groups of invertebrate animals with pond representatives are included in the book but, among the vertebrates, we have included mainly the newts, frogs, and toads. Much has already been written elsewhere about fishes, reptiles, birds, and mammals so we have only included a few examples of each group. Fishes do not lend themselves so easily to our world-ranging approach, and the other vertebrate groups contain few permanent members of the pond fauna.

Most of the plants included in *The Pond* are those typical of mineral-rich, lowland, freshwater ponds, mainly of temperate climates, although some tropical species are also included. There are representatives from most of the major groups in the plant kingdom, including algae, fungi, mosses, liverworts, ferns, and a large number of Angiosperms or flowering plants.

Our selection is not comprehensive, nor is every family of plants containing aquatic species represented. There is an enormous range and diversity of pond plants to be found throughout the world, but we have illustrated and described a representative selection of the types commonly found growing in and around the water.

A simple guide to the classification of the animal and plant kingdoms, including those categories represented in the book, is given on page 12 and there is a more complete classification at the end of the book. This lists the major groups and within these the subdivision into families, from which our species are selected.

The plants that grow in and around a pond are grouped into distinct zones, so it is convenient to consider plants under the zones in which they are found although within each zone the plants are arranged in systematic order beginning with the most primitive forms.

The algae, fungi, and bacteria are dealt with separately at the end of the plant section, because most of them are generally found throughout the pond environment and are not restricted to any one zone. These simple and often microscopically small plants are less familiar to most people than the larger and more highly developed plants. Nevertheless, they usually occur in abundance and play an extremely important part in the life of a pond. Most animals move about and are less suited to a zonal treatment so we have described them in systematic order beginning with the single-celled protozoans and progressing through the multicelled invertebrates of increasing complexity to end with the vertebrates.

We hope that *The Pond* will not only help you to understand better the living pond, but also convince you of the need to conserve the ever-dwindling number of ponds in urban areas and on farms. Perhaps you may wish to help further by building your own garden pond and you will then have on your doorstep a never-failing source of interest and pleasure.

The photographs within these preliminary pages show the following ponds –

Title page, the four seasons at Kennington pond, near Oxford, England: spring; summer; autumn; winter (frost); winter (snow). 1, a 'natural' garden pond excavated by bulldozer and lined with puddled clay. It is visited by wild duck in winter. 2, a raised stone garden pond lined with concrete, coated with non-toxic plastic paint. Five years after construction and planting, when this photograph was taken, the pond contained more than forty species of microscopic plants and animals. 3, part of a pond fenced off for watering *cattle. The effect on the marginal vegetation of trampling by hooves can be seen. 4, an excellent example of human despoliation of the environment. Luckily no toxic chemicals are present and many aquatic animals flourish amid the rubbish. 5, John Cooke sampling a pond on St Catherine's Island, Georgia, USA, unaware that there is a resident alligator. 6, a pond at Maarssen, Holland. Although Holland has few ponds there are many canals which contain similar animals and plants.*

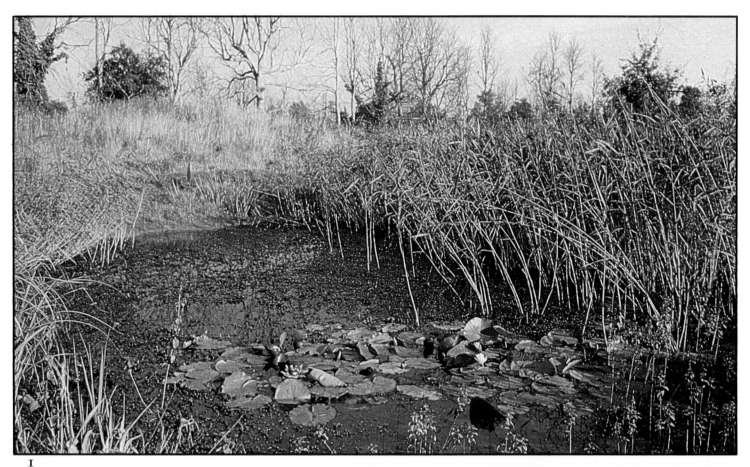

I

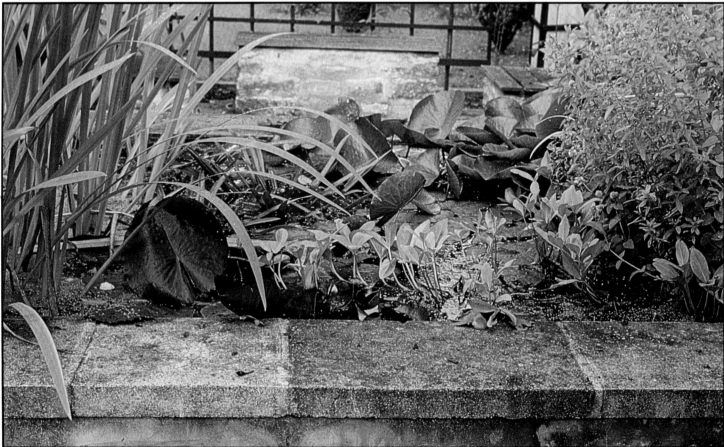

2

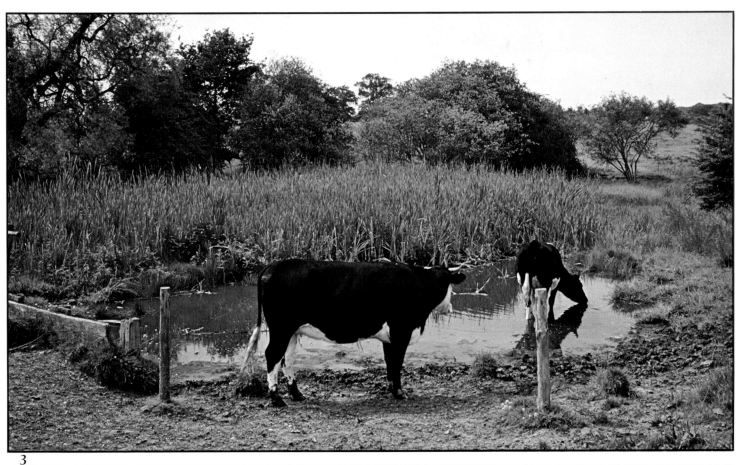

3

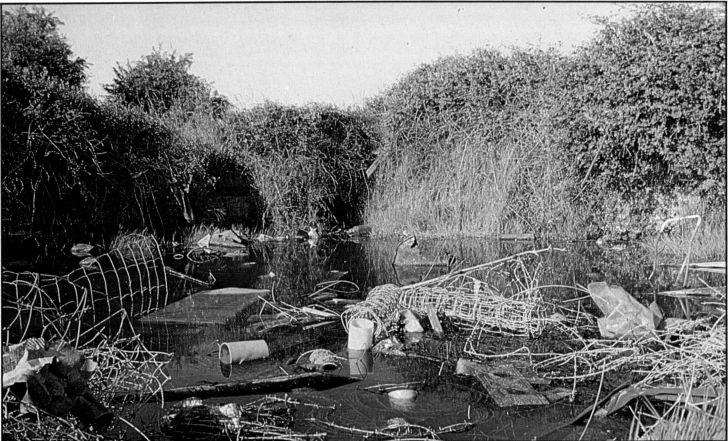

4

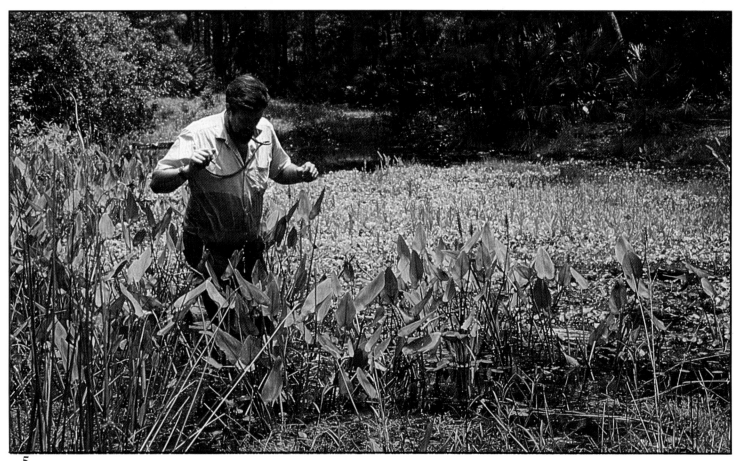

5

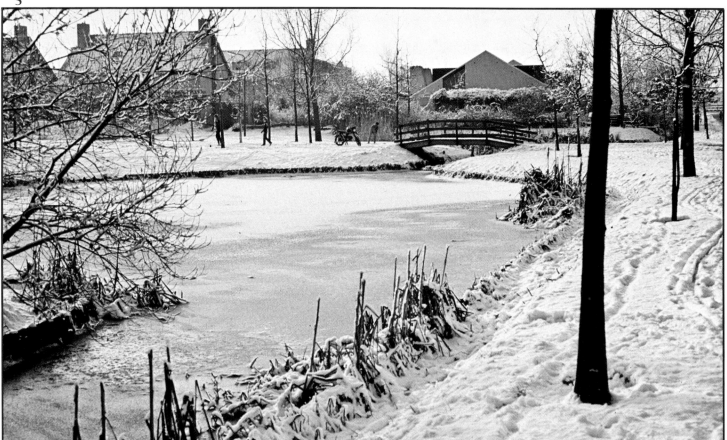

6

Authors' acknowledgements

It gives us great pleasure to thank our colleague, George Bernard, for his magnificent contribution to The Pond. *The 250 photographs under his name represent nearly a whole year's work. Two other colleagues have made invaluable contributions: Peter Parks photographed most of the very small organisms, using the equipment he has designed for this type of work, and Stephen Dalton, who has a worldwide reputation for high-speed photography, took the eye-catching jacket photographs specially for us.*

We also wish to extend our grateful thanks to the following, who have helped most generously with advice or by collecting material: Dr Robert Angus, Jill Bailey, Dr Laurie Barnes, Dr Humphrey Bowen, John Clegg, Dr Anthony Eve, Jacquie Fynn, Dick Manuel, Nigel May, Dr Chris McCready, Joan Merrifield, John Parry, Pat Thompson, Professor George Varley, Dr Stanley Woodell.

All the British animals have been named according to A Coded Checklist of Animals Occurring in Fresh Water in the British Isles *prepared by the Institute of Terrestrial Ecology. This checklist does, however, exclude the phylum Protozoa. Scientific plant names are largely according to the* Excursion Flora of the British Isles *by Clapham, A R, Tutin, T G, and Warburg, E F, 1981. Common plant names have been taken from* English Names of Wild Flowers, *by Dory, J G, Perring, F, and Rob, C M, 1974.*

We are greatly indebted to our designer, Bridget Morley, and our editor, Neil Curtis, who have shared our enthusiasm and with whom it has been a joy to work. Lastly, we thank Robert MacDonald of Collins for the continuous interest he has shown in this project.

Jennifer Coldrey

Gerald Thompson

Oxford 1982

CONTENTS

Naming and classifying animals and plants

In 1745, the Swedish naturalist, Carolus Linnaeus, devised a system to name living things using two words usually derived from Latin or Greek. This scientific way of naming animals and plants is known as the binomial system and is still used today.

English-speaking entomologists will know what is meant when someone refers to the predatory water bug called a Water Scorpion. But the common English name is likely to be meaningless to entomologists from other parts of the world, and it also has the disadvantage that it is used for several similar, but slightly different, insects. There is, however, only one European Water Scorpion and it has been given the scientific names *Nepa* (Latin for scorpion) and *cinerea* (Latin for ashy grey). So entomologists from all over the world refer to *Nepa cinerea* and the proper or scientific name constitutes an international language which enables everyone to refer to one particular kind of animal or plant without the risk of being misunderstood. Similarly, even within one country, a particular animal or plant may be known by a variety of common names but it will still have only one scientific name.

The second word in the scientific name, *cinerea* in our example, is known as the specific or trivial name and it always begins with a lower-case letter, not with a capital. A number of closely related species form the larger group or genus. In this case, *Nepa* is the genus and the generic name always begins with a capital letter. Examples of different kinds of water scorpion are: *Nepa cinerea* (Europe), *Nepa apiculata* (North America), *Nepa hoffmanni* (Japan). Notice that the genus and species are printed in italics.

The genus *Nepa* belongs to a larger group, the family Nepidae, which contains several genera of water scorpions, including *Nepa, Austronepa, Laccotrephes, Ranatra*. There are many different families of bugs, both aquatic and terrestrial, such as Cicadidae (cicadas), Cercopidae (spittle bugs), Aphididae (greenfly), Cimicidae (bed bugs), Corixidae (water boatmen), and many others. The families form a natural group, an order, in this case the Hemiptera, which includes all those insects with a particular kind of piercing and sucking mouthparts. The ordinal name Hemiptera is derived from two Greek words for 'half' and 'wings' and refers to the partly thickened and partly membranous forewings found in all the species in the order.

The Hemiptera is one of twenty-nine orders making up the class Insecta, the insects. The insects, and other classes of animals with jointed legs, like the Arachnida (spiders and mites) and Crustacea (waterfleas, waterlice, shrimps) make up the phylum Arthropoda (from the Greek for 'jointed foot'). The phylum is the highest division in the Animal Kingdom.

Plants are classified in a similar way to animals. Individual species and genera are grouped into families, orders, classes, and phyla, and arranged according to the currently accepted scientific opinion of how they have evolved, from the simplest, most primitive forms to the most advanced and highly developed types.

Formerly the algae, fungi, and bacteria were grouped together in one phylum, the Thallophyta, but now they are classified separately. Many biologists regard bacteria as being intermediate between animals and plants, in a kingdom of their own, but we have included them as a separate phylum at the beginning of the Plant Kingdom. Similarly, we have placed the fungi as a separate phylum in the Plant Kingdom, although many botanists do not consider them to be true plants. The various algal groups, once classified closely together, are now usually considered as separate phyla, the Cyanophyta or blue-greens being the most primitive.

There are twenty-four plant and animal phyla with representatives included in this book.

Bacteriophyta	bacteria
Cyanophyta	blue-green algae
Chrysophyta	yellow-green algae, including diatoms
Chlorophyta	green algae
Rhodophyta	red algae
Charophyta	stoneworts
Fungi	fungi
Bryophyta	mosses and liverworts
Pteridophyta	ferns and horsetails
Spermatophyta	seed plants
Angio-spermae	flowering plants

Protozoa	single-celled animals
Porifera	sponges
Coelenterata	hydra
Platyhelminthes	flatworms, tapeworms
Nematoda	roundworms
Nematomorpha	hairworms
Rotifera	wheel animals
Gastrotricha	hairy-backs
Ectoprocta	moss animals
Mollusca	snails, mussels
Tardigrada	water bears
Annelida	worms
Arthropoda	insects, crustaceans, spiders, mites
Chordata	fishes, amphibians, reptiles, birds, mammals

The world of the pond

What is a pond?

There is no single feature that can be used to distinguish a pond from a lake or from any other body of freshwater. The best we can do is to use a combination of characters, and define a pond as *a rather small, shallow body of freshwater in which there is little difference in temperature between the surface and the bottom*. Most of us are satisfied that we can recognize a pond when we see one but no two ponds contain exactly the same animals and plants; every pond is different from every other pond and this makes them even more interesting to explore. Ponds that are rich in nutrients – the kind considered in this book – contain a variety and concentration of life exceeding most other aquatic environments. Each pond may be small but the total area of ponds in countries such as Britain and the United States is very large so that they rank as important wildlife habitats.

Origins of ponds

Natural ponds are formed in various ways. They may be hollows resulting from glaciation, ox-bows cut off from rivers in flat, level valleys, streams blocked by landslides, pools formed behind barrier dunes, depressions left when a soluble rock such as limestone dissolves away, and, in countries where the beaver constructs its dams there are, of course, beaver ponds.

In some countries man has made more ponds than nature has provided. In eastern Holland, for example, there are virtually no natural ponds, but there are many man-made canals which, for practical purposes, are elongated ponds. Village ponds are a delightful adjunct to the British scene, although, for the most part, they are no longer used for watering stock as they were originally intended. Similarly, farm ponds and dew ponds are disappearing in Britain as piped water is taken to the fields, although in some countries ponds still play an important part in good farming practice. Ponds are made for a great variety of reasons: to supply water for fire fighting; for raising fish; as a product of mining, gravel extraction, or clay digging for bricks; for the attraction of waterfowl or for recreation. And last, but not least, there are garden ponds, which may have been conceived purely as ornaments but are just as capable of supporting a variety of animals and plants.

Characteristics of water

The universal solvent Water is called the 'universal solvent' because it will dissolve more substances than any other liquid. Carbon dioxide, oxygen, and nitrogen, all essential to life, are absorbed into water from the atmosphere and elsewhere.

Most plants and all animals respire by absorbing oxygen to break down carbohydrates into carbon dioxide and water. This oxidation process is accompanied by the release of energy and it goes on day and night for as long as the supply of oxygen is adequate. Sometimes, when a large amount of dead organic matter is being decomposed by fungi and bacteria whose respiration uses up the gas, the oxygen in a pond may decline to a low level at which animals cannot survive. The leaves from overhanging trees may accumulate on the bottom of the pond with the same evil-smelling consequences. Only a few animals are able to survive in these conditions. Warm water holds less oxygen than cold and, because animals differ in their needs, the faunas of different ponds are different.

The oxygen required for respiration by aquatic animals and plants comes from two sources. Firstly, 20 per cent of a given volume of air consists of oxygen and some of it dissolves into the water where the atmosphere is in contact with the surface. Unlike air, a given volume of water contains only about 0·8 per cent oxygen. Secondly, oxygen is produced by green plants during the process known as photosynthesis (*see* page 26) in which the green pigment, chlorophyll, traps the energy of the sun and uses it to convert the simple inorganic compounds, carbon dioxide and water, into complex organic substances, the sugars, which are the building blocks of life. During the synthesis of carbon dioxide and water into sugar, the gas, oxygen, is released to augment the amount available for respiration. But this happens only in the presence of light. In a weed-filled pond on a sunny day constant streams of bubbles can be seen rising to the surface of the water as copious amounts of oxygen are released. During the hours of darkness there is no photosynthesis and, because respiration continues unabated, by morning the supply of oxygen may be quite low. Respiration and photosynthesis are exact opposites and each process uses the products of the other. But because only green plants can synthesize organic compounds from inorganic ones, all animals ultimately depend on them.

Nitrogen is an essential constituent of proteins – hence of protoplasm. Water can dissolve a small amount of the gas but few organisms can use it in this form. Most plants and animals obtain nitrogen from the products of bacterial decomposition of dead bodies in the pond.

Various minerals are present in water and some are essential to life. Particularly important are the salts of calcium and silicon. The amount of calcium determines whether the water is soft or hard (less than 7 milligrams per litre – soft water, 7 to 24 mg/l – intermediate, more than 24 mg/l – hard). Some plants require calcium while others grow better without it. Some animals, such as snails and crustaceans, require calcium for their shells and skeletons. The microscopic single-celled plants called diatoms, which are the main diet of many small aquatic animals, extract silicon from the water to construct their cell walls. After oxygen, silicon is the most abundant element on Earth.

Surface tension The molecules of which water is composed are strongly attracted to one another and, at the water's surface, this results in an apparently elastic skin which is of great importance to many pond inhabitants. Surface tension supports the weight of many plants and small animals, and larval and adult insects that take in air at the surface are able to do so because the tension prevents water from entering the openings to their breathing systems.

Density The density of water is greatest at $4\,°C$ ($39·2\,°F$). As water becomes warmer its density decreases so that in summer small creatures are less buoyant than they are in winter. Waterfleas develop extensions to the body in the warmer part of the year, perhaps to compensate for the reduction in buoyancy.

The density of water is similar to that of protoplasm, so the smallest animals float in the pond with little or no effort. Larger animals are relieved of having to support all or most of their body weight in water. On the other hand, water offers a resistance to movement which is why many pond animals are streamlined. Delicate animals, such as tubifex worms, hydra, and moss animals are able to extend their bodies in a manner that would be impossible in air. Water plants have no need for strengthening tissue and they bend and sway to the movement of the water with little risk of being broken.

At $0\,°C$, the freezing point of water, its density falls to $0·917$ so that ice floats to the surface. Ice is a poor conductor and the loss of heat from the unfrozen water below the ice is reduced so that only very shallow ponds are likely to freeze solid. Usually plants and animals can survive the winter in the unfrozen water below the ice.

Temperature Water absorbs and releases heat much more slowly than air does, and life in ponds is subjected to smaller changes in temperature than the organisms living in the surrounding air. Invertebrates do not control their body temperature and those living in ponds take their temperature from that of the surrounding water.

Transparency In clear water enough light penetrates to the bottom of a pond to allow plants to photosynthesize and, therefore, to live anywhere in the pond. If nutrients are abundant the high density of microscopic plants and animals may make the water so turbid that the bottom of the pond becomes too dark for the plants to live. The absence of plants and consequent reduction in photosynthesis may lead to a deficiency of oxygen at lower levels. Some animals, such as tubifex worms, have haemoglobin in their blood and can live in places where the amount of oxygen is below average. Large areas of the muddy pond bottom may be thick with the tubes and waving tails of these worms.

Pond habitats

In a pond there are several distinct habitats or zones, that is, places which have their own special features. The different zones are characterized by their own species of plants which we shall look at in more detail on pages 33–66. The animals in a pond are influenced by the presence of different kinds of plants so it is worth looking briefly now at the different zones they occupy.

Swamp plant zone The swamp plant zone is closest to the shore and is dominated by plants that are rooted in very shallow water although, in hot weather, the water may retreat to leave the plants high and dry. Numerous stems and leaves rise above the surface of the water, and grasses, sedges, and rushes are typical of this zone the world over. Many kinds of amphibians, birds, and mammals find food and shelter among the emergent stems, and beneath the surface, a variety of aquatic creatures can be found depending upon the depth of the water.

Floating-leaf and emergent zone This habitat occurs in slightly deeper water and, because it does not dry out, the plants are truly aquatic and will not survive out of water. They are rooted in mud with leaves either floating at the surface or projecting into the air. The water-lily is commonly found in this zone. Many different kinds of animals live on the slimy

undersurfaces of water-lily leaves including snails and their egg masses, eggs of the beetles *Donacia* and *Gyrinus*, flatworms, hydras, rotifers, protozoans such as *Vorticella*, watermites and their eggs, caddisfly eggs and larvae, and moss animals. Sponges, too, may encircle the stems. On the upper surfaces of the leaves aphids may occur in thousands. Among the underwater stems, shoals of fish fry surge backwards and forwards, and the nymphs of damselflies, dragonflies, and mayflies abound. Many kinds of algae live in this zone.

Submerged plant zone

The zone of vegetation furthest from the shore includes plants that grow completely submerged except when they flower. Pondweeds and milfoils, rooted in the mud, are typical here. Many turtles, fishes, and ducks feed on waterweed, and Muskrats will dive to collect it. The Swan uses its long neck to reach down to pull up weed in this habitat. Many water bugs and beetles as well as damselflies, lay their eggs on or in the stems, and carnivorous insects lie in wait or actively search for prey among the branching fronds.

Free-floating plant zone

Of the various floating plants that are not rooted in the mud, the duckweeds are by far the most numerous; indeed, a pond surface may be completely covered in a carpet of green so that it looks like solid ground, and many terrestrial insects and spiders run around on the surface of the leaves. The undersides of the leaves and the roots are home to a large number of small aquatic organisms that are protected and shaded yet have plenty of diffused light and oxygen. Rotifers, hydras, algae, desmids, assorted protozoans, and small, predatory insect larvae are all to be found in abundance.

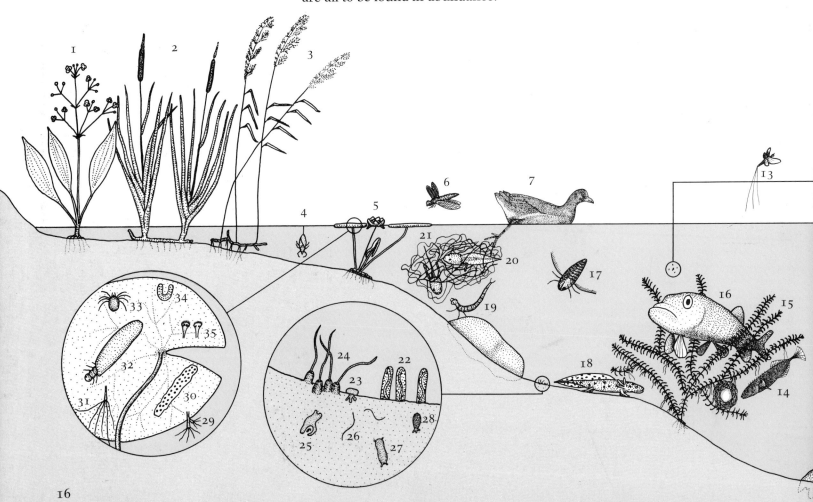

Summer in the pond

The drawing shows a section through a pond in summer with many of the animals and plants in their typical habitats.

1 Water Plantain *Alisma plantago-aquatica*
2 Bulrush *Typha latifolia*
3 Common Reed *Phragmites australis*
4 water scorpion *Nepa cinerea*
5 White Water-lily *Nymphaea alba*
6 darter dragonfly *Libellula* sp
7 Moorhen *Gallinula chloropus*
8 slipper animal *Paramecium* sp
9 cyclops *Cyclops* sp
10 waterflea *Daphnia* sp
11 euglena *Euglena* sp
12 seed shrimp Cyprididae
13 mayfly Ephemeroptera
14 Ten-spined Stickleback at nest *Pungitius pungitius*
15 Canadian Waterweed *Elodea canadensis*
16 Pike *Esox lucius*
17 backswimmer *Notonecta* sp
18 newtpole of Great Crested Newt *Triturus cristatus*
19 Great Diving Beetle larva *Dytiscus marginalis*
20 tadpole of Common Frog *Rana temporaria*
21 green alga *Spirogyra* sp
22 bloodworm larvae of midge *Chironomus* sp
23 testate amoeba *Arcella* sp
24 tubifex worms *Tubifex* sp
25 amoeba *Amoeba* sp
26 roundworm Nematoda
27 hairy-back Gastrotricha
28 testate amoeba *Difflugia* sp
29 green hydra *Chlorohydra viridissima*
30 Giant Pond Snail eggs *Lymnaea stagnalis*
31 brown hydra *Hydra oligactis*
32 caterpillar of Brown China-mark Moth *Nymphula nymphaeata*
33 Watermite Hydracarina
34 egg mass of midge *Chironomus* sp
35 stentor *Stentor* sp

36 Water-soldier *Stratiotes aloides*
37 mosquito pupa (tumbler) culicine
38 duckweed *Lemna* sp
39 bell animal *Vorticella* sp
40 wheel animal *Rotaria* sp
41 mosquito egg raft culicine
42 mosquito larva (wriggler) culicine
43 Great Diving Beetle *Dytiscus marginalis*
44 Yellow Water-lily *Nuphar lutea*
45 Arrowhead *Sagittaria sagittifolia*
46 Water Mint *Mentha aquatica*
47 rush *Juncus* sp
48 Water Shrew *Neomys fodiens*
49 Yellow Flag *Iris pseudacorus*
50 reed beetle larva *Donacia* sp
51 Great Pond Snail *Lymnaea stagnalis*
52 moss animal Ectoprocta
53 freshwater sponge *Ephydatia fluviatilis*
54 reed beetle cocoon *Donacia* sp
55 water bear Tardigrada
56 caddisfly larva *Limnephilus* sp
57 Fish Leech *Piscicola geometra*
58 bell of Water Spider *Argyroneta aquatica*
59 alderfly larva *Sialis* sp
60 nymph of darter dragonfly *Libellula* sp
61 cranefly larva Tipulidae
62 hairworm Nematomorpha
63 planarian *Dendrocoelum lacteum*
64 Freshwater Swan Mussel *Anodonta cygnaea*
65 Horse Leech *Haemopsis sanguisuga*
66 phantom larva *Chaoborus* sp
67 Three-spined Stickleback at nest *Gasterosteus aculeatus*
68 Perch *Perca fluviatilis*

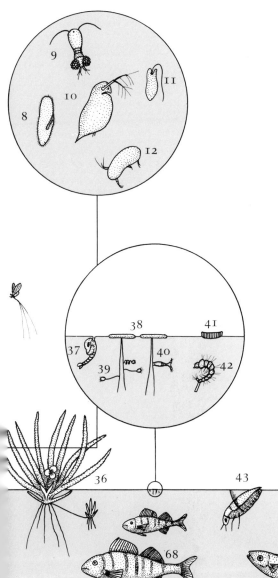

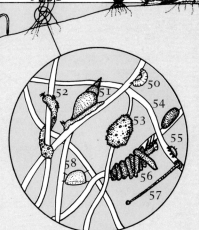

Winter in the pond

A section through a typical pond in winter showing the effects that the conditions have on some of the animals and plants.

1 Water Plantain *Alisma plantago-aquatica*
2 Bulrush *Typha latifolia*
3 Common Reed *Phragmites australis*
4 water scorpion *Nepa cinerea*
5 Moorhen *Gallinula chloropus*
6 slipper animal *Paramecium* sp
7 cyclops *Cyclops* sp
8 waterflea *Daphnia* sp
9 chlamydomonas *Chlamydomonas* sp
10 euglena *Euglena* sp
11 seed shrimp Cyprididae
12 Canadian Waterweed *Elodea canadensis*
13 Ten-spined Stickleback *Pungitius pungitius*
14 Three-spined Stickleback *Gasterosteus aculeatus*
15 Pike *Esox lucius*
16 Common Frog *Rana temporaria*
17 testate amoeba *Arcella* sp
18 tubifex worms *Tubifex* sp
19 diatoms Bacillariophyceae
20 amoeba *Amoeba* sp
21 roundworms Nematoda
22 hairy-back Gastrotricha
23 testate amoeba *Difflugia* sp
24 green hydra *Chlorohydra viridissima*
25 Watermite Hydracarina
26 Lake Limpet *Acroluxus lacustris*
27 brown hydra *Hydra oligactis*
28 caterpillar of Brown China-mark moth *Nymphula nymphaeata*
29 rotifer Rotifera
30 stentor *Stentor* sp
31 bell animal *Vorticella* sp
32 green alga *Spirogyra* sp
33 White Water-lily *Nymphaea alba*
34 winter eggs of rotifers Rotifera
35 duckweed *Lemna* sp

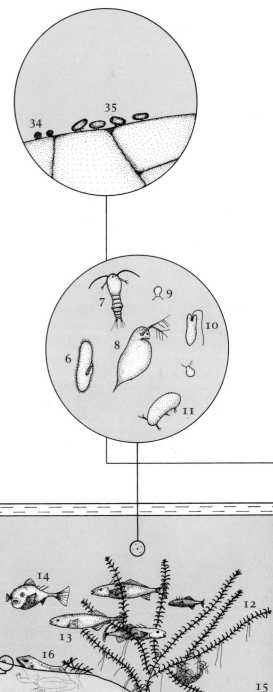

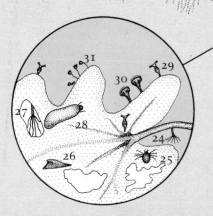

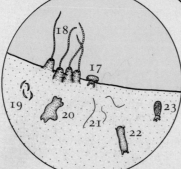

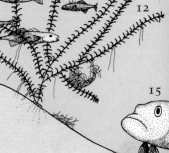

The bottom habitat

In stagnant freshwater ponds, that is, in ponds where there is no through current, the bottom is usually covered with mud or silt containing a lot of organic debris. Many animals that burrow through the mud extracting the organic matter are eaten in their turn by small predators. Nematodes, segmented worms, mussels, snails, and certain fly larvae predominate in the ooze. Crawling over the surface are waterlice, flatworms, certain mayfly, dragonfly, and damselfly nymphs, and crayfish (North America). Carp, among other fishes, are provided with sensitive fleshy organs that hang down like whiskers around the mouth and enable them to search out particles of food on the muddy bottom.

Most of the activity in the bottom mud goes on unseen. Hidden from sight, fungi and bacteria are ceaselessly at work converting the organic matter that falls down from above into simple nutrients that once more become available to the living. Many algae also live on the stones and mud at the bottom of ponds.

36 Water-soldier *Stratiotes aloides*
37 Arrowhead *Sagittaria sagittifolia*
38 Water Mint *Mentha aquatica*
39 rush *Juncus* sp
40 Yellow Flag *Iris pseudacorus*
41 Water Shrew *Neomys fodiens*
42 statoblasts of moss animal Ectoprocta
43 empty cocoon of reed beetle *Donacia* sp
44 decaying freshwater sponge *Ephydatia fluviatilis*
45 water bear Tardigrada
46 caddisfly larva *Limnephilus* sp
47 Fish Leech *Piscicola geometra*
48 Great Pond Snail *Lymnaea stagnalis*
49 Water Spider in bubble *Argyroneta aquatica*

50 gemmules of freshwater sponge *Ephydatia fluviatilis*
51 live cocoon of reed beetle *Donacia* sp
52 Great Diving Beetle *Dytiscus marginalis*
53 alderfly larva *Sialis* sp
54 nymph of darter dragonfly *Libellula* sp
55 planarian *Dendrocoelum lacteum*
56 hairworm Nematomorpha
57 cranefly larva Tipulidae
58 Yellow Water-lily *Nuphar lutea*
59 Freshwater Swan Mussel *Anodonta cygnaea*
60 backswimmer *Notonecta* sp
61 phantom larvae *Chaoborus* sp
62 Perch *Perca fluviatilis*
63 Horse Leech *Haemopsis sanguisuga*

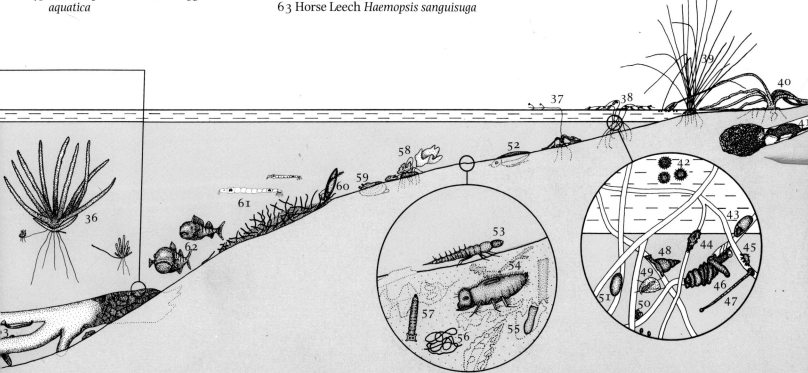

Water surface habitat

The surface film of a pond appears to be fluid, yet to small animals it is a firm, elastic platform on which they can move about freely on the upper surface or undersurface, or from which they can hang down. Water measurers walk sedately over the surface with the ends of their legs covered in dense, fine hairs which are unwettable. Pond skaters move rapidly; their legs end in a pad of bristles which stops the legs from breaking through the surface film. As an added precaution the claw which is normally at the end of an insect's leg, has become moved up the leg a short distance. *Dolomedes*, the fisher spider, is able to run across the pond's surface to retrieve struggling insects trapped by the surface tension. Large colonies of *Podura aquatica*, the water collembolan, feed, crawl, moult, and leap about on the surface film. The whirligig beetle lives in both air and water at the same time as it swims in furious circles half immersed. The beetle's back repels water while its lower surface does not and so it floats at the midline. Each eye is separated into distinct upper and lower portions so that one part looks upwards into the air and the other looks down into the water. Various fly eggs, including those of *Culex* mosquitoes, float on the surface.

Certain animals crawl about beneath the surface film or hang down and may be carried by currents caused by the wind. Hydra can hang from the ceiling, as it were, and snails and flatworms glide smoothly across the undersurface of the film.

Although the surface film is a living place for many forms of pond life, it is death to others. Small organisms that are caught up in a splash may find themselves the wrong side of the film and, if they cannot break through into their true watery medium they will soon fall prey to a surface hunter like the pond skater, or a water spider or backswimmer rising up from the depths.

The surface film of a pond

The forces attracting the water molecules together at the interface with the air make the surface behave as though it had an elastic skin stretched over it.

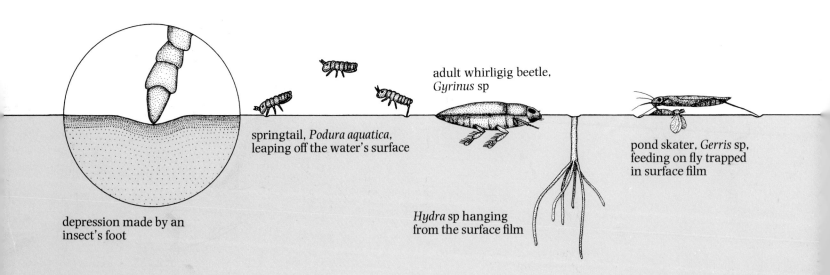

depression made by an insect's foot

springtail, *Podura aquatica*, leaping off the water's surface

adult whirligig beetle, *Gyrinus* sp

Hydra sp hanging from the surface film

pond skater, *Gerris* sp, feeding on fly trapped in surface film

The sun is the source of life

All life on this planet depends ultimately on energy derived from the sun. When sunlight strikes green plants growing on land or in water, photosynthesis takes place whereby some of the sun's energy becomes locked up in a complex molecule made from carbon dioxide and water which pond plants have around them in abundance. The molecule is a sugar which forms the basic substance for growth and for the other activities of life of both plants and animals. Oxygen is released as a byproduct of photosynthesis and, as we have seen already, its importance to the life of a pond is incalculable.

Apart from the inflow of energy from the sun, a pond contains or produces everything necessary for the survival of the plants and animals that live in it or beside it. Ponds are small and well defined so that they are excellent places in which to study the relationships which plants and animals have with each other and with their environment.

Plants are called *primary producers* because they alone can manufacture living substances from the raw materials, carbon dioxide and water. All animals are dependent, either directly or indirectly, upon the ability of plants to do this. Herbivores feed directly on plants and are known as *first-order consumers*. To these belong the minute protozoans that feed on diatoms, waterfleas that filter off algae as food, or a swan that pulls up waterweed from below the surface. *Second-order consumers* eat first-order consumers; for example, waterfleas are eaten by sticklebacks

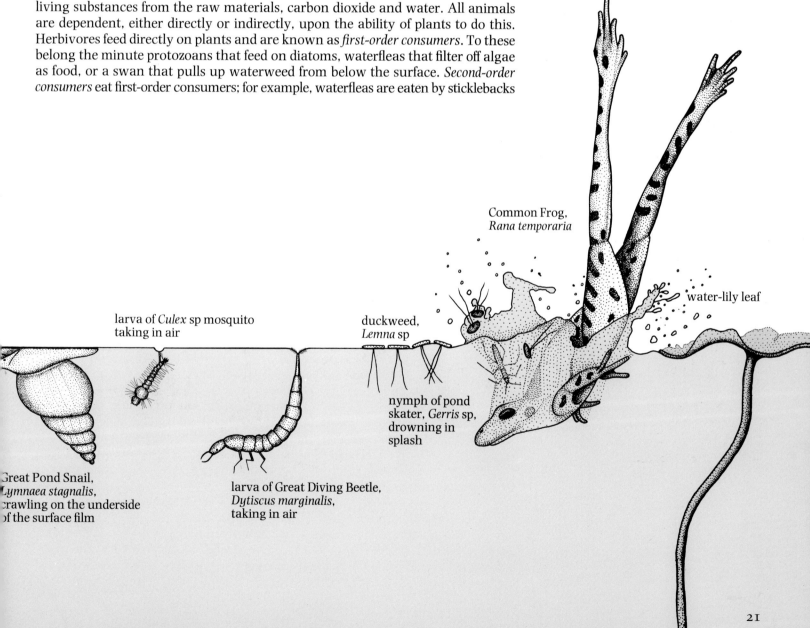

Common Frog,
Rana temporaria

water-lily leaf

larva of *Culex* sp mosquito
taking in air

duckweed,
Lemna sp

nymph of pond
skater, *Gerris* sp,
drowning in
splash

Great Pond Snail,
Lymnaea stagnalis,
crawling on the underside
of the surface film

larva of Great Diving Beetle,
Dytiscus marginalis,
taking in air

which in turn are eaten by perch, *third-order consumers*, which may be speared by a heron, in this case a *fourth-order consumer*. Extremely important are the *decomposers*, bacteria and fungi, that break down dead plants and animal corpses to release their components into the water and air where they again become available to plants. If it were not for the decomposers all nutrients would eventually become locked up in dead bodies and no new life could begin.

The transfer of food energy from plants through a series of animals is known as a *food chain*. Most animals eat more than one kind of food and in their turn are eaten by more than one kind of animal, so that food chains connect up to form an extremely complicated *food web*. The number of links in any food chain is relatively few, three to five as a rule, because of the way in which energy behaves. Only a finite amount of energy is present in the Universe so that, although it may be changed from one type to another, it cannot be created or destroyed. The energy that reaches the Earth as light is balanced by the energy that leaves the Earth's surface as invisible heat radiation. During the transformation of energy a large proportion is converted to heat.

On average, 90 per cent of the energy contained in a food source is converted to heat when an animal eats it. Suppose the food chain starts with algae and runs through waterfleas, sticklebacks, and perch to end with a heron, the climax predator in a British pond with no enemy except man. If we started with 10000 kilograms of algae in a pond, this would convert to 1000 kilograms of waterfleas which would produce 100 kilograms of sticklebacks, and 10 kilograms of Perch. This weight of Perch would add 1 kilogram to the growth of a young Heron. The loss of energy as heat explains why a pond may support untold millions of waterfleas but only one Heron, and why the number of links in food chains cannot be large.

Pond succession

Nature is not static; gradual and progressive change is the rule, and ponds are no exception. It is possible for the birth, development, and death of a pond to take place during the lifetime of a man; or it may take hundreds of years for the succession to be completed. The succession is the sequence of plant communities that replace one another as a pond matures and finally disappears. In the beginning a new pond is colonized by pioneer plants that only need low levels of nutrient and can grow in the absence of sediments. As the pioneer plants die and decay they release organic nutrients that enable more demanding plants to become established.

The process of enrichment continues and sediments accumulate on the bottom so that other plants can become established. If a pond is left undisturbed by man, it will gradually silt up and change into dry land, as swamp and marsh take over. The vegetation slowly encroaches from the sides into the centre until there is not enough water for the true aquatic plants to survive, and a patch of marshy ground finally replaces the original pond. The stages of this natural process of plant succession can be seen in the zonation of plants around a pond, particularly in a shallow, gently sloping pond where the transition from aquatic to terrestrial conditions is more gradual.

As the plants and conditions change so do the associated animal populations and the relative importance of different animal species. A pond is a dynamic entity and surprising changes in the kinds and sizes of animal populations can be seen from one year to another. There is much to be studied and explained, and anyone can add to the knowledge of ponds by observing keenly and recording their findings accurately.

Pond ecology

The plants that grow in any particular pond obviously reflect the geological foundation and nature of the soil beneath. The abundance of the vegetation is largely dependent upon the availability of nutrients in the water, although other factors, including the immediate climate of the pond, will have their effect. Generally speaking, plant life is richer in neutral or alkaline waters, where the essential minerals, such as calcium and magnesium bicarbonates, promote good plant growth. Thus, a pond containing water that drains off calcareous rock or soil will contain many nutrient salts and will support a variety of plant species which prefer neutral or slightly alkaline waters. There is usually abundant growth under these conditions, and, if the pond is shallow, light will be able to penetrate through the water, encouraging the formation of dense underwater vegetation which provides food and cover for many animals.

On the other hand, a boggy pool on moorland with acid, peaty water, will support fewer plants with quite different requirements. Such pools are usually poor in mineral salts, although there is an abundance of dissolved organic matter (humus), and this supports a very limited flora, mainly consisting of Bog Moss (*Sphagnum* sp) and various sedges (*Carex* spp).

Some mountain tarns or pools, where the water drains off hard, insoluble rocks, are lacking both in mineral nutrients and humus. They are often steep sided, with sandy or gravelly bottoms and, although their vegetation is sparse, their restricted flora is often highly characteristic and includes plants such as Quillwort (*Isoetes lacustris*), Water Lobelia (*Lobelia dortmanni*), and Pillwort (*Pilularia globulifera*), all of which can tolerate acid conditions. The marginal vegetation of these moorland pools usually merges into bog rather than into marshland such as occurs around lowland ponds.

Ponds with acidic, nutrient-deficient waters are unfavourable to plant and animal life. Even bacteria are unable to survive in these conditions and such ponds and pools are incapable of supporting the wealth of life to be found in mineral-rich waters.

Shallow ponds favour plant growth but ponds which are steep sided tend to have a more limited flora, mainly confined to the marginal areas, with very little underwater or bottom vegetation, because in deeper water there is not enough light to support plant growth. Some woodland ponds also have a limited flora because of the shading by surrounding trees. One or two trees around a pond can, however, be an advantage. Trees provide shelter from the wind, which can whip across the surface of exposed ponds and tear up floating vegetation. In such ponds the floating and emergent vegetation may be very much restricted to the sheltered margins.

Alder trees and various species of willow are commonly found growing around ponds. Their leaves cast shade over the water in summer and this prevents excessive growth of algae and duckweed, both of which thrive in warm, sunny conditions. The trunks and branches of trees provide convenient resting places for the adults and emerging nymphal stages of many aquatic insects while, underwater, their tangle of rootlets offers a refuge for many small pond creatures.

Different species of plant have evolved to live in different parts of the pond. In deeper water there occur plants that can only survive when completely submerged; others float on the surface with their roots hanging freely. The tall marginal plants are not true aquatics but are adapted to living in waterlogged soil.

Pros and cons of aquatic life

Plants add a great deal to the beauty and richness of life in a pond as well as providing a fascinating study in themselves. Many ponds are characterized by a wealth and variety of plant life both in and around the water. A wide range of flowering plants is usually represented, together with many non-flowering plants such as ferns, mosses, and algae. The vegetation is often very luxuriant, indicating that the water and its surrounding environment offer distinct advantages to plants living there. Because water is plentiful, the plants are in much less danger of dying from drought than are many terrestrial plants. There is often an abundant supply of readily available nutrients dissolved in the water, while the plants which are totally submerged do not suffer such extreme temperature changes as occur on land.

There are, however, certain disadvantages to living in an aquatic environment. Oxygen may be hard to come by, especially for submerged plants with no access to atmospheric air. Light may be inadequate in deep or turbid water, and flowering and seed production can be difficult especially when conditions fluctuate to cause flooding or drought.

The life processes of plants

Transpiration

Water is essential to all life and the proportion of water in plants may exceed 90 per cent. In the water there are salts, obtained through the roots, and sugars, manufactured by the plant to fuel its life processes. Water enters the roots by a process called osmosis. The plant cells in the roots contain a more concentrated solution of salts and sugars than does the soil or pond water on the outside of the cell membranes, and water passes through the membranes from the weaker to the stronger solutions in an attempt to equalize the difference in concentration. Water entering the plant in this way passes from cell to cell and then into conducting tubes up to the leaves where much of it evaporates through small pores (stomata), normally on the lower leaf surface except in certain aquatic plants. This process, called transpiration, creates the pull or suction needed to raise water up the stem. A plant takes in water by osmosis until the cells are fully stretched and can take no more. As long as the water supply is adequate the leaves and soft stems are held rigid by water pressure or turgor. If there is not enough water the plant wilts.

Photosynthesis

Like animals, plants need food to provide the raw materials for building new tissues and the energy to power the complex chemistry involved in vital processes. Proteins, carbohydrates, and fats are all needed but, whereas animals get their requirements by eating plants, or other animals which themselves eat plants, green plants have the unique ability to make food from non-living things – from water, air, and chemicals in their environment. Only green plants can do this so that all life ultimately depends on them.

Photosynthesis is the name given to the process by which green plants use the energy of light to make sugar from carbon dioxide and water. The process depends on the green pigment, chlorophyll, found mainly in the cells of the leaves. Chlorophyll absorbs light energy from the sun and the energy is used to combine water, from the roots, and carbon dioxide, from the air, to make the sugar, glucose. During this chemical reaction, which can only take place in daylight, oxygen is released into the air.

Respiration

Plants respire or breathe throughout the day and night, just like animals. The process is the opposite of photosynthesis; oxygen from the air is combined with

glucose to release energy and the gas, carbon dioxide, which returns to the air. The energy is used in various ways: to change sugar into carbohydrates and fats; to build up amino-acids from glucose and nitrogen (amino-acids are the chemical building blocks from which different types of plant cells are made); to convert amino-acids into protein, of which all living tissue is made.

To summarize. During day and night plants take in water through the roots and release water vapour into the atmosphere. At the same time they respire, taking in oxygen from the air and releasing carbon dioxide. During daylight they photosynthesize, removing carbon dioxide from the air and releasing oxygen. More oxygen is released during daylight than is used in respiration and an excess of the gas builds up. During the night oxygen is gradually used up as the plant respires until by morning it may be in short supply. In terrestrial plants, the gases in these life processes are taken in from, or released into, the atmosphere through the stomata on the leaves.

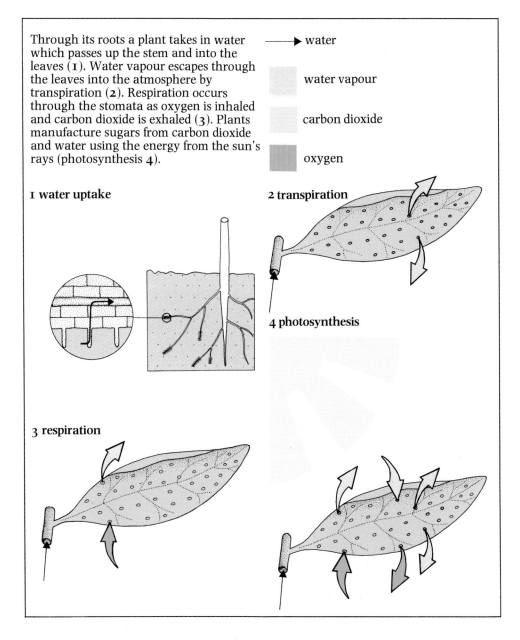

Through its roots a plant takes in water which passes up the stem and into the leaves (1). Water vapour escapes through the leaves into the atmosphere by transpiration (2). Respiration occurs through the stomata as oxygen is inhaled and carbon dioxide is exhaled (3). Plants manufacture sugars from carbon dioxide and water using the energy from the sun's rays (photosynthesis 4).

→ water

water vapour

carbon dioxide

oxygen

1 water uptake

2 transpiration

3 respiration

4 photosynthesis

Cross-section through the stem of a terrestrial plant. The tissue is dense and there are no large air spaces.

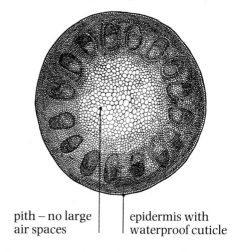

pith – no large air spaces

epidermis with waterproof cuticle

Cross-section through the stem of an aquatic plant to show the large air spaces within the plant tissue for buoyancy.

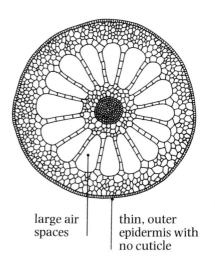

large air spaces

thin, outer epidermis with no cuticle

Buoyancy, water flow, and respiration

Aquatic plants are distinguished from terrestrial plants by certain characteristics which enable them to survive in their aquatic environment. Most of the plants described in this book are adapted to a greater or lesser extent for life in the water. Plants living in the marsh and swampy areas at the edge of the water are only semiaquatic and have many of the features which are usually associated with terrestrial plants.

Those plants which show the greatest modifications live in deeper water – the floating plants and those partially or entirely submerged throughout their lives. These plants cannot survive out of water and are the true aquatics or hydrophytes. Water gives submerged plants all-round support so that they have no need of firm, strengthening tissue. They tend to have flimsy, delicate stems, branches, and leaves which are pliable and resistant to breaking in deep or turbulent water.

The buoyancy which keeps the plants upright or floating in the water is often achieved by the presence of large air spaces within the plant tissue called aerenchyma. These air spaces, between the cells, occur within the stems, leaves, or roots, and frequently link up to form a continuous passage for the circulation of oxygen to all parts of the plant. Oxygen is needed for respiration and, because it is often in short supply in the water, or even totally absent in the waterlogged mud at the bottom of the pond, many aquatic plants survive by storing it in their aerenchyma tissue.

In terrestrial plants and those semiaquatics with their vegetation above water, transpiration occurs through the stomata on the undersides of the leaves. These are capable of opening and closing under different conditions to regulate the amount of water loss, and prevent the plant from drying up. The stomata also serve as pores through which gaseous exchange with the atmosphere can occur during respiration and photosynthesis. Terrestrial plants also have a thick waterproof and protective outer skin called the cuticle which covers the surface layer of cells (the epidermis) and prevents water loss. Submerged aquatic plants have no waterproof cuticle, but only a thin outer layer of cells (the epidermis) which allows absorption of water, dissolved gases, and other nutrients to take place over the entire surface of the plant. Since these plants are surrounded by water, the conservation of this vital commodity is not so important. Stomata are not usually present on underwater plants and are found only on the upper surfaces of floating-leaved plants, such as the water-lilies. These flat, floating leaves have an extra tough waxy coating on their upper surfaces which repels water and enables gaseous exchange with the air above to occur unimpeded. Other semiaquatic and terrestrial plants subjected to flooding often have their surfaces densely covered in hairs which help to prevent waterlogging.

Submerged aquatic plants, living as they do in an excess of water, may be liable to supersaturation. The stems and leaves of many of these plants are often covered with a layer of slime or mucilage, which is especially evident on young plants, and may help to prevent waterlogging.

Root systems are poorly developed and, indeed, sometimes absent altogether in aquatic plants. Water containing dissolved nutrients is absorbed all over the plant surface so there is obviously no need for roots to specialize in this nor is there any need for a highly developed water transport system to operate within, such as occurs in terrestrial plants. Evidence suggests, however, that water does pass in a steady upward stream through these plants and it has been shown that the roots of submerged aquatics do absorb some mineral salts from their surroundings as well as serving as an anchor.

Photosynthesis in aquatic plants

Photosynthesis in terrestrial plants is carried out mainly by the leaves, which are usually flattened in shape to give a large surface area for absorbing sunlight. The chlorophyll in the cells is contained in special bodies called chloroplasts. Many submerged water plants have additional chloroplasts present in the outer layer of cells of their leaves and stems. Light penetration is poor under water, so that submerged plants need to make maximum use of whatever light is available. In terrestrial plants chloroplasts are not usually present in the outer layers of cells, because strong sunlight actually destroys chlorophyll.

In submerged aquatics the oxygen released as the end product of photosynthesis, instead of escaping into the environment, may be used up immediately for respiration, or surplus supplies stored in the aerenchyma tissue for use overnight when photosynthesis stops.

In aquatic plants the carbon dioxide needed for photosynthesis is usually absorbed in solution from the water, whereas terrestrial plants absorb atmospheric carbon dioxide through their stomata. A further source of carbon dioxide for some submerged aquatics is calcium bicarbonate, which is often present in solution in hard or alkaline waters. Carbon dioxide is absorbed by these plants, leaving a residue of calcium carbonate, which is deposited on the stems and leaves as a white, chalky crust. This can be seen on the stoneworts and on the Water Soldier, *Stratiotes aloides*.

Surviving winter and drought

Many water plants are perennial, surviving year after year by vegetative means rather than relying on seed production. They manage to stay alive in winter in many ingenious ways. Plants such as water-lilies and pondweeds have thick underground stems, called rhizomes, which accumulate and store reserve food material (mainly starch) before the winter. These food reserves are used up in spring when new young shoots start to sprout. Most of the marginal plants also survive the winter by means of underground stems, even though the vegetation above dies back and perishes in the cold.

Submerged aquatic plants are protected from the more severe cold experienced by plants on land. Some plants, like the starworts, *Callitriche* spp, and Water Soldier, remain relatively unchanged, but sink to the warmer waters at the bottom of the pond until springtime. Members of the floating community, such as the duckweeds, also sink down from the surface, where frost can attack the plants in winter.

Other plants, including Frogbit, *Hydrocharis morsus-ranae*, and the water milfoils, *Myriophyllum* spp, produce special short shoots or 'winter buds', which contain an embryo plant and are densely packed with food reserves. These develop in the autumn, become detached from the parent plant, and sink to the bottom of the pond where they remain until spring, when each one develops into a new plant. As the young plant develops it uses up the starch, becomes lighter, and floats to the surface again.

Some of these remarkable methods of survival may be used by aquatic plants when other adverse conditions, such as drought, occur. Ponds do occasionally dry up and, although some plants die, many are able to survive, by means of underground stems, 'winter buds', or even as seeds, all capable of sprouting into new plants on the return of favourable conditions. A semiaquatic plant like Amphibious Bistort, *Polygonum amphibium*, is highly adaptable in such conditions, because it is just as much at home on dry land as it is in water.

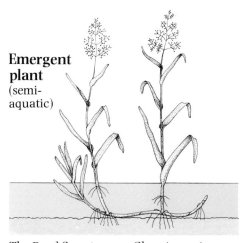

Emergent plant (semi-aquatic)

The Reed Sweet-grass, *Glyceria maxima*, has a strong, erect stem with broad leaves, and a horizontal underwater stem which is firmly rooted and allows vegetative reproduction.

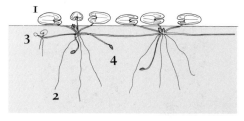

Free-floating plant (a true aquatic)

The Frogbit, *Hydrocharis morsus-ranae*, has flat, circular leaves (**1**) which enable it to float, and unbranched aquatic roots (**2**). It reproduces vegetatively by means of underwater stems which form shoots at their tips (**3**), and also by winter buds (**4**).

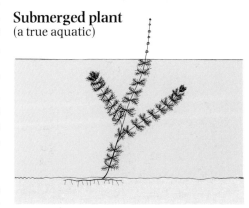

Submerged plant (a true aquatic)

The water milfoil, *Myriophyllum* sp, has thin, weak stems which are supported by the water and contain many air spaces to increase buoyancy. The leaves are finely divided and feathery to avoid damage in turbulent water.

Reproduction

The majority of water plants, even those with totally submerged vegetative parts, produce their flowers above the surface of the water. Flowers are the means by which plants reproduce sexually, and, to succeed, pollen from the male flower parts or stamens must reach the stigma of the female part to bring about fertilization and the setting of seeds. Although male and female flowers may be separate, in many plants they occur together in the same flower, in which case the flowers may be able to fertilize themselves. Cross-pollination from different flowers is usually necessary for successful fertilization, however, and plants have evolved various ways of achieving this.

Many water plants are pollinated by wind, while others are visited by insects such as flies and beetles, which transfer the pollen from flower to flower. Some plants, such as Canadian Waterweed, *Elodea canadensis*, use water as the medium for carrying pollen to the female stigma, while the hornwort, *Ceratophyllum* sp, has flowers which are specially adapted for pollination underwater. One or two species are adaptable and able to form their flowers either above or below water, according to conditions.

Some water plants apparently use both wind and water for their pollination, but both these methods are unreliable. Unfavourable conditions often deny water plants the chance even to form flowers, let alone become fertile and produce seeds. They make up for this by reproducing asexually, by vegetative means. Many survive and multiply extremely successfully by means of underground stems, roots, runners, and offsets, or by simple fragmentation of parts of the plant. Some water plants, such as Canadian Waterweed and the duckweeds, *Lemna* spp, proliferate by producing simple offshoots which are capable of living separately. This enables the species to spread rapidly and successfully over vast areas. Unlike terrestrial plants, these newly formed individuals do not need to become rooted in the mud before becoming detached from the parent plant; they can survive alone immediately, absorbing all the nutrients they need directly from the water.

Pollination and fruit development underwater in an aquatic plant, Rigid Hornwort, *Ceratophyllum demersum.* The stamens from male flowers detach and float to the surface. There the stamens split open and release pollen which sinks. Those female flowers that receive pollen produce underwater fruits. *See* page 62.

1 stigma
2 style
3 ovary

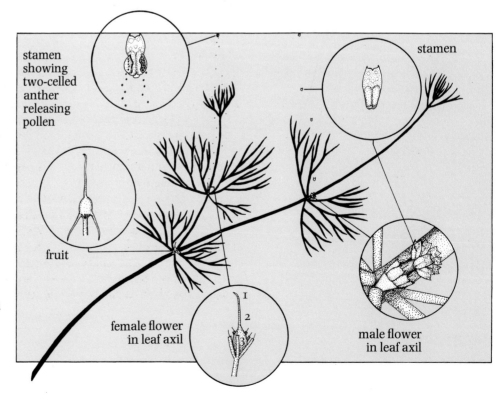

stamen showing two-celled anther releasing pollen

stamen

fruit

female flower in leaf axil

male flower in leaf axil

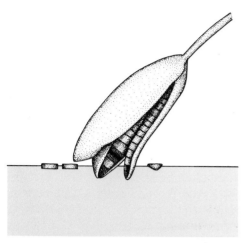

Seed dispersal in a typical swamp zone plant, Yellow Flag, *Iris pseudacorus*. The fruit splits open to release air-filled buoyant seeds which float away.

Seed dispersal

Seed dispersal is important for the spread and multiplication of a species, and many plants have evolved complex mechanisms for ensuring its success. Water plants are no exception and they are fortunate in having an ideal medium to transport their seeds and fruits to places suitable for germination.

The fruits and seeds of many water plants are well adapted for floating. Some are extremely lightweight, or possess special features such as an inflated coat, long appendages, or a slimy covering. Others may be adapted for different methods of dispersal. Sticky or rough fruits and seeds, like those of bur-reeds, *Sparganium* spp, can become attached to the fur of mammals or to the plumage of waterbirds. Others may be eaten by birds and carried long distances before passing through the digestive system and colonizing a new environment. Amphibians, small mammals, and even insects that travel from one pond to another, may occasionally carry small pieces of pond plant with them.

The 'winter buds' can also assist seed dispersal by floating away or by being carried off in the mud on the feet of waterbirds. It is fascinating to observe that many species of aquatic plants are very widely distributed geographically. Some, such as Hornwort, *Ceratophyllum demersum*, some duckweed species, the Reed, *Phragmites australis*, bulrushes, *Typha* spp, and various species of pondweed, *Potamogeton* spp, occur throughout the world. This would seem to indicate that their methods of dispersal are highly effective.

Value of plants to life in a pond

Plants are as important to life in an aquatic environment as they are on land. They are able to manufacture organic materials from inorganic substances by photosynthesis, and pond animals feed on them, either directly or indirectly, through various food chains.

Decaying plant material is also an important food source for small, scavenging animals, and the accumulation of detritus and humus which it produces on the bottom is rapidly decomposed by bacteria in warm, shallow water, producing ammonium salts, phosphates, and other nutrients which are released into the water for the metabolism of other organisms.

The oxygen produced by plants during photosynthesis helps to supplement the often depleted supplies available in stagnant water. Both animals and plants need oxygen for respiration and, while there is often enough available during the day when plants are photosynthesizing, the levels can drop drastically during the night, so that aquatic animals may barely have enough to survive.

The stems and leaves of water plants provide mechanical support for aquatic animals, as well as protection from predators and shade from excessive sunlight. Many pond creatures lay their eggs on or in various parts of aquatic plants, and some insects, such as the Bulrush Moth, *Nonagria typhae*, pass their early stages actually living within the plant tissues.

The complicated interrelationship which exists between the plants and animals in a pond is dependent on other factors such as climate, temperature, availability of light, acidity or alkalinity of the water, abundances of dissolved nutrient salts, and so on. These can fluctuate frequently or even drastically, causing continual disturbances to the delicate balance of the environment.

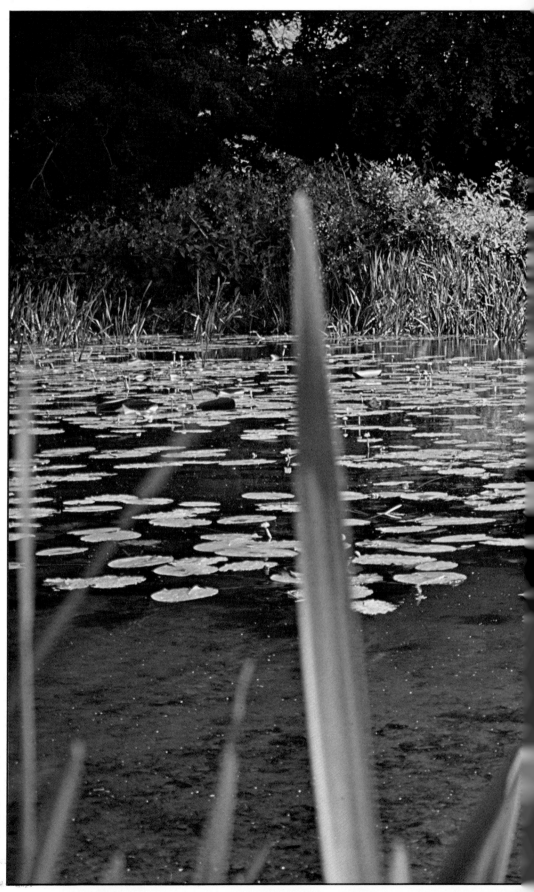

This pond shows clearcut zones of vegetation. Tall swamp plants, dominated by Reed Sweetgrass (Glyceria maxima), form the margin, while in deeper water the floating leaves of the Yellow Water-lily, (Nuphar lutea), cover much of the surface. Behind the swamp zone an area of marshland plants rapidly gives way to deciduous woodland.

Pond plants and plant communities

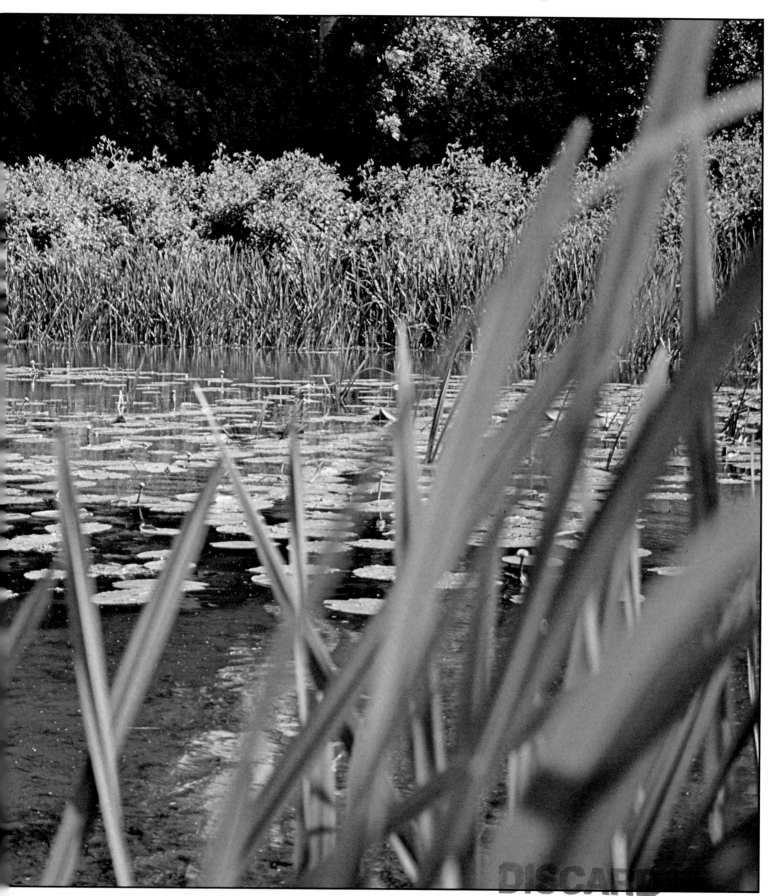

In a well-established pond it is often easy to see that the vegetation in and around the water forms definite zones. These zones are roughly related to the depth of water and to how much waterlogging occurs. We can usually recognize certain characteristic communities of plants even though some species may overlap into neighbouring zones.

Moving from the land towards the open water we find there is usually a marshy area, often dominated by rushes and sedges, where plants grow in waterlogged soil but are not usually subjected to flooding. Inside this there is a swamp zone, characterized by tall, upright plants such as the Common Reed, *Phragmites australis*, and the Bulrush, *Typha latifolia*, which habitually live in standing water near to the edge of the pond. The swamp zone gives way to a zone of plants rooted in the mud in the shallow water at the margins of the pond, their leaves either floating or emerging above the water. Out in deeper water live plants which are rooted in the bottom mud with their vegetation totally submerged. Finally, there is the community of free-floating plants which live either at the surface or just below it, with no roots attaching them to the bottom.

These zones (in reverse order) represent the stages in the process of plant succession that leads, by encroachment of the vegetation, from open water to reed-swamp and marshland and, eventually, to the complete drying up of the pond. This zonation is typical of many well-established, biologically productive ponds in a lowland, temperate environment but it is not always complete. Depending on conditions such as altitude, and depth and acidity of the water, the vegetation can vary from a thin fringe around the edge to complete cover over the whole pond.

Pond plants are described in more detail below, and attention is drawn to the special features and structural adaptations that fit them for the zone in which they are found.

Some plants have been more difficult than others to place in one particular zone. Species such as Water Mint, *Mentha aquatica*, and Marsh-marigold, *Caltha palustris*, adapt to different conditions and can be found thriving in several zones. The dividing lines between the marsh, swamp, and emergent marginal vegetation at the edges of the pond are particularly difficult to define, because the water-level can fluctuate considerably in these areas, and several plant species can overlap the zonal boundaries. In general, we have tried to place each plant in the zone where it most often grows, and we have indicated those species which also grow in other communities.

Plants growing in marshy ground are not truly aquatic although they are adapted to living in a habitat which is nearly always moist, with a waterlogged soil rich in mineral salts. The vegetation is often lush, containing many tall, beautiful plants such as Great Willow Herb, *Epilobium hirsutum*. There is no need for these plants to economize on their water supplies, so that transpiration can occur freely and their leaves are often large. The waterlogged soil, which has water instead of air occupying the spaces between the soil particles, is often deficient in oxygen, and many marsh plants have spongy stems and leaves plentifully supplied with aerating tissue for storing and transmitting air.

Strictly, the marshland habitat is outside the confines of the pond, and we shall not consider it here as a separate vegetational zone. Many marshland plants are often present in the swamp zone, however, because marshland merges into the swamp zone almost imperceptibly at the edges of many ponds. Thus, common marshland plants such as Marsh-marigold, Great Willowherb, Purple Loosestrife, *Lythrum salicaria*, Yellow Iris or Flag, *Iris pseudacorus*, Water Dock, *Rumex hydrolapathum*, and various species of rush, *Juncus* spp, and sedge, *Carex* spp, may often be found in the swamp zone and are included there in this book.

Swamp zone

The swamp zone differs from marshland in that the ground is covered with water at all but the driest times of the year. It is characterized by tall, upright plants such as the Common Reed, Reed Sweet-grass *Glyceria maxima*, and the Bulrush which all have few or no branches, and long, narrow leaves. These features ensure that the plants offer little resistance to high water and are less likely to be damaged by floods. The hollow stems and tough, fibrous nature of these plants help them to withstand high water and buffeting winds. Their height ensures that changes in the water-level will not seriously interfere with flowering or photosynthesis because the flowers and the upper parts of the leaves are normally well above water.

Long, creeping rhizomes penetrate the mud in all directions and hold the plants upright. Many of the more dominant species, such as the Common Reed, the Bulrush, and the Common Club-rush, *Scirpus lacustris*, produce abundant buds on the rhizomes, each of which may give rise to a new plant, so that in quite a short time a dense community of one species builds up and effectively crowds out all other plants. These dense beds of vegetation often extend into open water and quite large areas can be converted into swamp.

The lower parts of these swamp plants limit water movement and encourage the accumulation of silt. After their death in autumn, the fibrous leaves decompose very slowly, adding to the accumulation of debris, and gradually raising the level of the substrate. Other plants found growing in the reed swamp community include bur-reeds, *Sparganium* spp, Water Dock, the Yellow Flag, Sweet Flag, *Acorus calamus* and Flowering-rush, *Butomus umbellatus*. The Bog bean, *Menyanthes trifoliata*, often occurs towards the pond side of the swamp zone, where its floating rhizomes grow out from the edge into the water and its trifoliate leaves and pink spring flowers merge with the other marginal plants, including Water-plantain, *Alisma plantago-aquatica*, and Arrowhead, *Sagittaria sagittifolia*.

Horsetails EQUISETACEAE

The horsetails are spore-bearing plants (cryptogams) and are more closely related to ferns than to flowering plants. They are of ancient origin, having been on the Earth for many millions of years. In Carboniferous times some species were as tall as trees. Horsetails are fairly widespread throughout the world, but they are commoner in the northern hemisphere, and absent from Australia and New Zealand.

Several *Equisetum* species may be found growing in the vicinity of a pond, especially the Marsh Horsetail, *Equisetum palustre*, which usually occurs on swampy soil, and the Water Horsetail, *E. fluviatile*, which is normally found in shallow water up to 1 metre (3 feet) deep at the edges of lakes, ponds, and ditches, and may become dominant, forming extensive stands.

The horsetails have perennial, creeping rhizomes giving rise to erect hollow stems (usually green in aquatic species) which are grooved and jointed with irregular whorls of upright branches at the joints. At each joint a ring of small leaves is joined into a toothed sheath around the stem.

The Pteridophyta (ferns and horsetails) have a complicated life cycle with an alternation of sexual and asexual stages, each of which is represented by a totally different form of plant. The leafy fern or horsetail plant, as we know it, is the asexual or sporophyte generation, and its spores give rise to a tiny, flattened, frond-like structure (the prothallus) which looks rather like a liverwort. This is the sexual generation or gametophyte, which bears male and female sex organs and, after fertilization, gives rise to the new sporophyte generation.

In the horsetails, reproductive sporophyte shoots bear cones of spore-producing bodies, called sporangiophores, at their tips. The sporangiophores are mushroom shaped and closely arranged at right angles to the stem, in whorls, with several spore capsules, called sporangia, on the underside. Many thousands of spores are released from each sporangium to be dispersed by the wind.

Horsetails tend to accumulate silica which gives them a rough, abrasive quality. They were once called 'scouring rushes' and were used for cleaning pots and pans.

Marsh Horsetail
Equisetum palustre
This horsetail may grow to as much as 60 centimetres (2 feet) tall. The stems are green and rather rough, with four to eight deep grooves on the surface and a very narrow central cavity within. The encircling leaf sheaths are green and loosely fitting with four to eight lance-shaped teeth which have broad, white, papery margins. Short, simple, erect branches usually grow from around the joints.

The fertile stems are similar in appearance to the vegetative stems, apart from the cones of sporangiophores from 1 to 3 centimetres (0·4 to 1·2 inches) long which are produced at their tips in early summer.

Marsh-marigold or Kingcup
Caltha palustris

The Marsh-marigold is commonly found in swampy, wet ground near the edges of ponds and streams where its golden flowers brighten the scene in early spring.

It belongs to the same family as buttercups, *Ranunculus* spp, and its large, heart-shaped leaves look very like those of another member of this family, the Lesser Celandine, *Ranunculus ficaria*. The plant grows from a stout, underground, perennial rootstock which thrives in waterlogged soil or mud and sends up erect, hollow shoots every spring. The lower parts of the plant are often underwater, but the long-stalked basal leaves are carried high above water-level, as are the upper leaves and flowers. The upper leaves are more-or-less stalkless, but they have a similar kidney or heart shape to the basal leaves with notched margins. All the leaves are dark green and glossy.

The flowers consist of five golden-yellow sepals (there are no true petals) which are greenish underneath. There are numerous stamens and five to thirteen carpels at the centre. The flowers appear in March to May (sometimes later) and are visited by a variety of insects which come to feed on the abundant pollen as well as on the sweet nectar which is produced deep in the centre of the flower.

The plant is very variable in form, depending on altitude and other environmental factors. The several varieties and subspecies differ in size, habit of growth, leaf-form, and the size and arrangement of the perianth segments.

The Marsh-marigold has many other names, including Mayflower, Mare-blobs, May-blobs, or Molly-blobs, the 'blobs' apparently referring to the tight buds it produces in spring.

The Marsh-marigold is found in cold and temperate regions of the world, mainly in the northern hemisphere.

Celery-leaved Buttercup
Ranunculus sceleratus

This plant is not an aquatic but it is found growing in muddy soil at the margins of ponds. It is an annual or overwintering herb with a fibrous root system and a stout, erect, hollow stem, 20 to 60 centimetres (8 to 24 inches) tall.

The leaves, which are rather celery-like in appearance, have wavy edges and are deeply divided into several lobes. The lower leaves have long stalks and are shiny and broader in outline than the upper leaves which are short stalked or sessile (stalkless) with the leaf blade very deeply divided into narrow segments.

The stem is ridged and branches out above to bear many small, buttercup-like yellow flowers. Each flower is about 5 to 10 millimetres (0·2 to 0·4 inch) across, and has five pale-yellow petals, below which the five green, reflexed sepals show clearly. The long, green, dome-shaped female part (called the receptacle) stands out in the centre of the flower. This later enlarges as the fruit ripens to form a dense cone, 6 to 10 millimetres (0·2 to 0·4 inch) long and consisting of seventy to 100 tiny roundish green fruits. The petals have nectaries at their bases which are attractive to insects, and the flowers are usually pollinated by flies.

Celery-leaved Buttercup is found throughout most of Britain and Europe. It likes mineral-rich water with a muddy bottom.

Marsh St John's-wort
Hypericum elodes

This is a small, creeping, perennial plant of marshy, wet ground beside ponds and streams on acid soil.

Its soft, smooth stems either float or creep along the muddy ground rooting at the nodes. The whole plant is covered in a soft down which gives it a silvery-grey, woolly appearance. These hairs prevent the plant from becoming waterlogged when submerged. The opposite pairs of rounded, rather heart-shaped leaves clasp the stem at their base.

A few resinous, scented flowers are produced at the top of the stem. Each flower, about 1·5 centimetres ($\frac{1}{2}$ inch) across, has five erect, yellow petals, surrounded by five, elliptical sepals covered with fine, red or purplish, glandular teeth. The flower stalks are tinged with red. Each flower has many stamens and a central ovary with three stigmas. The plant is pollinated by a variety of insects, and the fruit (a capsule) eventually splits to release large numbers of seeds.

Marsh St John's-wort is found throughout Britain (commoner in the west) as well as in western Europe and the Azores. Many other species of *Hypericum* are found in bogs and marshes and can tolerate temporary flooding, although *H. elodes* is perhaps the only species habitually found in water.

Purple Loosestrife
Lythrum salicaria

The tall, brightly coloured flowering spikes of Purple Loosestrife are frequently seen in midsummer among the marshland plants, although the plant may often extend its range into the swamp zone.

This plant is a sturdy perennial which grows up to a metre (3 feet) or more in height. The stem is usually four angled, simply branched, often reddish in colour, and slightly downy. The stalkless, lance-shaped leaves, from 4 to 7 centimetres (1·5 to 2·75 inches) long, with broad, heart-shaped bases, are borne in opposite pairs, sometimes alternate or in whorls of three.

Each inflorescence consists of a mass of reddish-purple flowers, densely packed together in a terminal spike, up to 30 centimetres (12 inches) long. The flowers are arranged in whorls in the axils of leaf-like bracts, and each consists of six (sometimes five) elliptical, bluntly tapering petals, surrounded by six sepals fused into a cylindrical, ribbed tube with prominent teeth at the top. There are twelve stamens and a two-celled ovary.

Each flower is approximately 10 to 15 millimetres (0·4 to 0·6 inch) in diameter.

This plant is of interest in that three forms of flower are found on different plants. In one the style is short and the stamens are of two lengths, long and medium; in the second the style is of medium length and the stamens are long and short; in the third type the style is long and the stamens short and medium. Three sizes of pollen grain are produced in the three different types of stamen, and these are only fertile on one type of stigma, which corresponds in position with that of the related stamens. As in members of the primrose family, Primulaceae, (which have two forms of flower) this complicated arrangement ensures that cross-pollination will occur, and that pollen picked up by a visiting insect can be transferred and deposited in exactly the right position for fertilization on the appropriate type of stigma. None of the flowers can be fertilized by its own pollen.

Purple Loosestrife is found in many localities throughout temperate regions of the northern hemisphere.

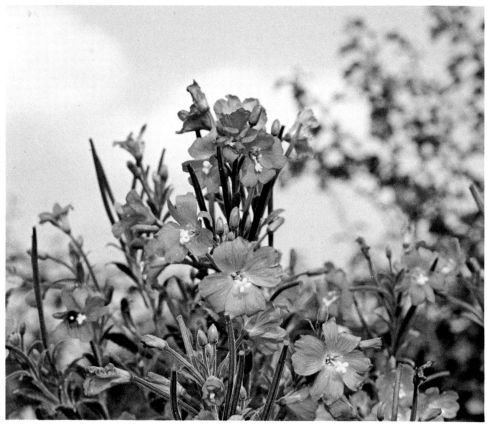

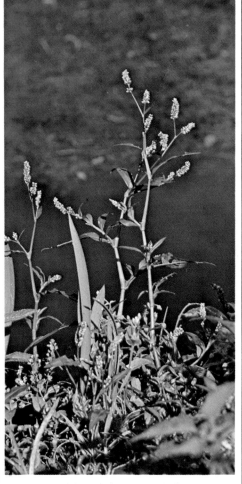

Great Willow Herb or Codlins-and-cream

Epilobium hirsutum

This tall, colourful herb with its cheerful, rose-coloured flowers, is often seen growing in the marshy area around ponds.

With erect, branching stems 80 to 150 centimetres (2·5 to 5 feet) tall, this perennial plant produces white, fleshy, underground stolons in summer which enable it to spread and reproduce by vegetative means. The stems are covered with many soft, spreading hairs and the leaves, too, are hairy on both sides, especially on the veins. The leaves are lance-shaped, long, unstalked, and mostly opposite, the upper ones smaller and half-clasping the stem. Their margins are hairy with small, saw-like teeth.

The deep-pink flowers, 15 to 23 millimetres (0·6 to 0·9 inch) across, are borne in loose terminal clusters. They are erect in bud, and later open to reveal broad ovate, purplish-pink petals, each petal notched on the outer margin. There are eight stamens, the outer ones twice as long as the inner, and a four-lobed, whitish stigma which projects beyond the stamens. The flowers are visited by insects such as bees and hoverflies which carry out pollination. The fruit, a long, thin, four-sided, downy pod, develops below the petals. It reaches 5 to 8 centimetres (2 to 3 inches) in length and splits when ripe to release the tiny, brownish-red seeds. These have long, silky hairs attached to them and blow away readily in the wind.

The name, Codlins-and-cream, probably derives from the old name 'Codded Willow Herbe' (that is, with flowers on a codd or stem). This name, together with the rosy petals and creamy white stigmas, may have suggested codlins-and-cream. There is also a suggestion that the bruised leaves smell something like codlins (apples). It is probably given the name Willow Herb because the leaves are similar to those of willow among which it often grows.

It is common throughout Britain and Europe (except the extreme north) as well as temperate Asia, North Africa, and the Cape. It has been introduced in North America.

Common Persicaria or Redshank

Polygonum persicaria

This is a common plant of damp ground, and it is often found beside ponds in temperate regions of the northern hemisphere.

Its branched, erect stem is purplish red and swollen above the nodes. The nodes are the points at which the leaves branch out from the stem, and here it can be seen that the leaves have a sheathing base which forms a fringe-like tube around the base of each leaf stalk. The spear-shaped leaves, 5 to 10 centimetres (2 to 4 inches) long, are slightly hairy and sometimes woolly beneath, and are often dark blotched in the centre.

The flowers are pink and are borne in tightly packed inflorescences. Each flower is tiny and usually has five perianth segments surrounding the four to eight stamens, and a female ovary with two styles. Blunt, triangular-shaped fruits about 3 millimetres (0·1 inch) long with shining concave surfaces, are formed in autumn.

Water Dock
Rumex hydrolapathum

The Water Dock is a large conspicuous plant of wet, swampy ground and is commonly found around the margins of ponds in temperate climates.

It is a sturdy, branching perennial, up to 2 metres (6 feet) tall and bears very large, broadly lance-shaped, lower leaves that are from 40 to 100 centimetres (15 to 40 inches) long, stalked, and with a slightly wavy margin.

The small, reddish-green flowers are borne in pendulous whorls on branching stems in the axils of smaller linear upper leaves. The flowers are usually hermaphrodite and are pollinated by wind. Six petal-like structures surround the stamens and ovary and, as the seeds ripen, the inner three petal segments swell and harden to form a triangular-shaped casing to the fruit. Each segment develops an elliptical, corky, swollen tubercle down the mid-rib. These tiny, triangular, purse-like fruits, no more than 4 millimetres (0·16 inch) long, are presumably light and buoyant enough to float on water and thus be dispersed.

There are many hollow cavities in the stems of the Water Dock where air is stored – a useful adaptation in plants growing in waterlogged soil where a regular supply of oxygen is rare.

The plant is common in many temperate regions of the world, mainly in the northern hemisphere.

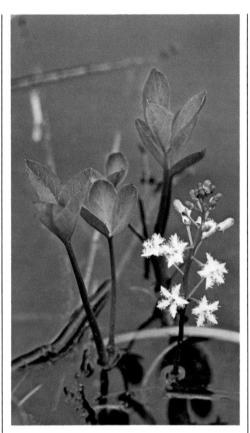

Bogbean
Menyanthes trifoliata

The Bogbean is often found growing at the edges of ponds, in swamps and in shallow water.

It is a perennial with a long, creeping rhizome rooting on the ground or in the mud. The long-stalked leaves, borne alternately on the stem, rise above the surface of the water and clasp the rhizome with a long sheath below. The leaves are in three parts (trifoliate), clover-like, and are reminiscent of the young leaves of the Broad Bean, hence the name 'Bogbean'.

The pretty pink-and-white flowers appear from early May to June, in rather dense, hyacinth-like spikes on flower stalks from 25 to 40 centimetres (10 to 15 inches) high, well above the surface of the water. Each flower, about 15 millimetres (0·6 inch) across has five petals which are white inside and pink outside, with finely fringed margins. The flowers are attractive to insects and are pollinated by them. By August the round, green, capsular fruits are evident.

The Bogbean may be found at altitudes of up to 900 metres (3000 feet) throughout much of the northern hemisphere.

Brooklime
Veronica beccabunga

This attractive, blue-flowered herb is commonly found in calcareous streams and ditches (hence the name 'Brooklime'), but it can also occur at the swampy or marshy edges of calcareous ponds.

It is a perennial, often growing half-submerged, with a creeping rhizome rooting in the mud. It has a stout, ascending, hollow stem which is somewhat fleshy and bears opposite pairs of elliptical, blunt-ended, rather thick, fleshy leaves that are short stalked and very slightly saw edged.

The tiny blue flowers are borne on branching inflorescences in the axils of the upper leaves. Each flower has four sepals and four tiny azure-blue petals, the whole being no more than 7 to 8 millimetres (0·3 inch) across. There are two stamens and a two-celled ovary with one style and stigma. Pollination is carried out by various insects, and the ripe fruit (a capsule) is somewhat heart shaped and splits open to release seeds.

Brooklime should not be confused with the Water-speedwell, *Veronica anagallis–aquatica*, which is found in similar situations. Water-speedwell has longer, thinner, lance-shaped leaves, which are more obviously saw edged and have no stalks but almost clasp the stem at their bases. The flowers are a slightly paler blue and in taller inflorescences than in Brooklime.

Brooklime is found throughout temperate regions of the world.

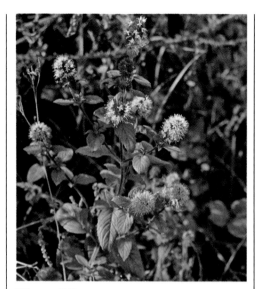

Water Mint
Mentha aquatica

Together with other mints, *Mentha* spp, this plant has a pungent smell which can easily be detected by crushing a leaf between the fingers. It is commonly found, often in large quantities, among the emergent vegetation and marshy ground at the edge of a pond.

The mints are all perennial herbs with creeping rootstocks, on or just below the surface of the ground, which send off runners freely. They have four-angled stems, opposite or whorled leaves, and flowers in dense whorls. Water Mint has opposite pairs of oval, hairy, stalked leaves with toothed margins.

The tiny, lilac-coloured flowers are borne in whorls and are compressed into a terminal, globular head about 2 centimetres (0·8 inch) across, with a few smaller whorls below in the leaf axils. The flowers, which appear in late summer, are sweet smelling, nectar producing, and very attractive to the insects which visit them and bring about their pollination. Four purple stamens protrude from each small flower, giving the inflorescence a peppered appearance. Later in the autumn four small, ovoid nutlets are formed from the ovary at the base of each flower.

Non-flowering, submerged forms of Water Mint may be found growing in water up to 2 metres (6 feet) deep.

M. aquatica is common throughout Britain and Europe, western Asia, North and South Africa, and Madeira. Many other species of mint occur throughout temperate regions of the world. Some of these hybridize freely and are difficult to classify.

Flowering-rush
Butomus umbellatus

This lovely plant may grow in the swamp zone, its rhizome rooting in the mud.

Long, twisted leaves, which are triangular in cross-section and taper to an abrupt point at the tip, develop in a rosette from sheathing bases. The leaves are about 1 centimetre (0·4 inch) broad and can be over a metre (3 feet) tall.

The smooth, rounded flowering stalks are equally tall or even taller. They are totally leafless apart from the ring of brownish bracts below the terminal, umbrella-like inflorescence. The pretty pink flowers are up to 3 centimetres (1·2 inches) in diameter and are borne on the ends of stalks of unequal length. Each consists of six perianth segments (no distinction into sepals and petals), nine dark-red stamens, and an ovary of six dark-red carpels joined at the base. The perianth segments are arranged in two whorls of three, the outer somewhat smaller and narrower than the inner.

This plant is not a true rush but belongs to a small family, the Butomaceae, which has few genera and less than ten species. They occur in temperate and tropical regions of the world, except Africa south of the equator. *Butomus umbellatus* is found throughout Europe and temperate Asia. It has become naturalized in North America.

Rushes JUNCACEAE

Like sedges, rushes are common plants of damp, marshy ground. They are perennials with a tough, often woody rootstock, which in some species spreads to form an extensive network of loose turf, while in others it gives rise to tussock formation.

The rushes comprise a comparatively small family, the main genus being *Juncus*, the true rushes. Their leaves and stalks are smooth, hairless, and round in cross-section, and are often filled with pith. The leaves are surrounded by brownish scales at the base and usually taper to a fine, sharp point at the tip.

The inflorescence is produced near the tip of the leaf-like stem, usually to one side. It is branched, and the clusters of tiny flowers may be loose and widely spreading (*J. effusus*) or tightly compacted into a ball (*J. conglomeratus*). Each flower is hermaphrodite and consists of an ovary of three compartments with three feathery stigmas. There are three or six stamens which hang out of the flower when ripe, ready to catch the wind which disperses the pollen. Unlike grasses and sedges, rushes may be said to have complete flowers, because a six-leaved brownish perianth surrounds the male and female parts. The fruits are brownish, three-sided, and vary in shape from species to species. Inside each capsule there are many seeds.

Rushes are useful for animal bedding because they are highly absorbent. Loose stands in shallow water provide cover for aquatic animals including fishes which like to spawn among them.

Rushes may be found worldwide but especially in cold and temperate climates.

Hard Rush

Juncus inflexus (**1**)

Large, dense tufts of Hard Rush grow from an underground horizontal rhizome. The plant is easy to identify with its stiffly erect, slender stems which are strongly ridged and of a dull grey-green colour. A longitudinal section through the stem will show the pith inside to be interrupted, with many air spaces, rather than solid and compact throughout.

The inflorescence (**2**) is loose and spreading, the flowers on long, branched, upright stalks. In the photograph the plant is in fruit, the dark, glossy, chestnut-brown capsules, 3 to 4 millimetres (0·12 to 0·16 inches) long having an ovoid shape with a short, narrow point at the tip. (Rushes are often easier to identify when in fruit.)

Conglomerate Rush

Juncus conglomeratus (**3**)

This is a familiar rush of boggy, acid soils, sometimes occurring in marshy areas around ponds. It grows in smaller tufts than *J. inflexus*, and has brightish-green but dull stems, with numerous fine ridges or striations which are most noticeable just beneath the inflorescence. The pith inside the stems is densely compacted and continuous, unlike that of *J. inflexus*.

The inflorescence (**4**) forms a tight, compact, ball-like cluster to one side of the stem. The capsular fruits are very tiny, 1 to 2 millimetres, yellowish to chestnut brown, and broadly ovoid with a blunt tip which is slightly indented.

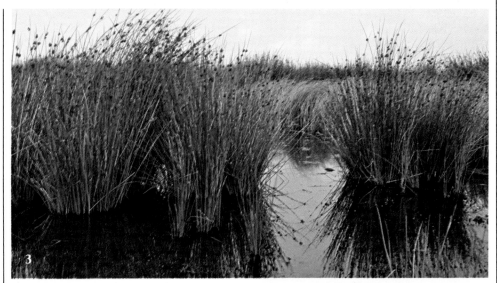

Yellow Flag or Yellow Iris
Iris pseudacorus

The brilliant yellow flowers of the Yellow Flag or Iris are commonly seen in summer among the community of plants in marshes and swampy ground around the edges of ponds. This plant is a perennial, with a thick, branched, horizontal rhizome which bears two ranks of sword-shaped leaves from 50 to 100 centimetres (20 to 40 inches) tall.

The smooth, green stems, of similar height, each bears two or three flowers which may vary from pale yellow to almost orange. As in all members of the iris family, the flowering parts are arranged in threes. The three large outer 'sepals' or 'falls' are curved outwards and bear a dark-brownish patch near the base, while inside these are three smaller upright 'petals', called 'standards', and three long stamens attached to the bottom of the sepals. At the base of the flower is a three-chambered ovary with three yellow arching styles which spread out like petals over the stamens. The strongly veined, dark patches at the base of the outer sepals function as honey guides to attract insects to the flower. These broad, reflexed outer sepals form convenient landing platforms for insects like the heavy humble bee, which probes deep into the flower for the nectar that is secreted at the base of the flower tube. After pollination the ovary ripens into a conspicuous green, three-celled capsule which eventually splits open to reveal the shiny brown, disc-like seeds. The flower stalks often bend down, allowing the seeds, with their air-filled coats, to fall into the water and float away.

Iris pseudacorus is found throughout Britain and Europe, North Africa, the Caucasus, and temperate western Asia. It has also been introduced to North America and New Zealand. There are many other species of *Iris* to be found throughout the world, of which about ten species are aquatic, while many others occur in wet places.

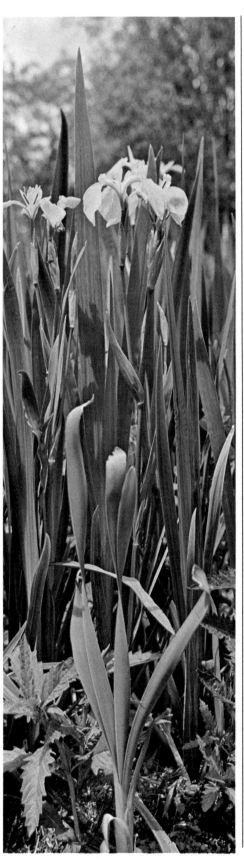

Bog Arum
Calla palustris

The Bog Arum is found in swampy wet ground at the margins of ponds where it spreads by means of its stout, creeping, underground rhizome.

The rhizome is green, jointed and scaly, and gives rise to several leathery, long-stalked leaves which are roundish and heart shaped with a pointed tip. The base of each leaf stalk is expanded into a long sheath.

The cone-shaped inflorescence, called a spadix, is borne on the end of a long stalk, and beneath it is an oval, heart-shaped leaf, green outside and white inside, which surrounds the flower head and is called the spathe. Unlike the Wild Arum or Cuckoo-pint, *Arum maculatum*, this spathe is flat and does not enclose the inflorescence. The spadix is covered with inconspicuous, greenish-white, hermaphrodite flowers and later produces bright scarlet berries which are poisonous.

The Bog Arum occurs throughout temperate regions of the northern hemisphere. It was first introduced to Britain (Surrey) in 1861.

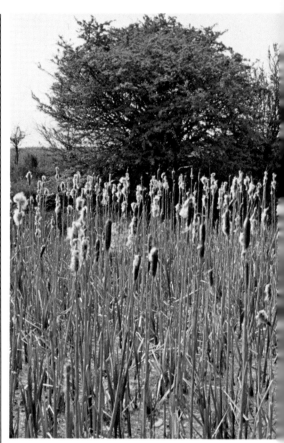

Branched Bur-reed
Sparganium erectum

The Branched Bur-reed is found in the marginal swamp zone of lakes and ponds where it frequently forms large clumps. It prefers muddy ground and is often found in association with the Bulrush and the Common Reed.

A rosette of erect, linear leaves, each about 10 to 15 millimetres (0·4 to 0·6 inch) wide and 30 to 60 centimetres (1 to 2 feet) tall, grows from a tuberous underground rhizome. The leaves, sheathing at the base, are triangular in cross-section and taper bluntly at the tip.

The flowering shoot is much shorter than these basal leaves and is branched with conspicuous leaves at the base of each flowering branch. Each branch has two to four female flower heads near the bottom with ten to twenty male ones above them. The flower heads consist of many tiny flowers packed together in a round ball. The male flowers have three small petals and three stamens and, when the pollen ripens, the whole flower head becomes a bright-yellow pom-pom. The female flowers each consists of three wedge-shaped petals and one ovary with a short, projecting style and stigma. As the fruits ripen the flower head takes on the appearance of a spiky ball which resembles a rolled-up hedgehog. It is obvious that this plant gets its name from these bur-like fruits.

Wildfowl like to nest, roost, and feed in stands of *Sparganium*, and the fruits form an important part of their diet in late autumn and winter.

Bur-reeds, *Sparganium* spp, are widely distributed throughout temperate and subarctic regions of the northern hemisphere. One or two species also occur in Malaysia and southern Australasia. Some floating species may be found in deeper water.

Bulrush
Typha latifolia

The familiar Bulrush, also called the Reed-mace, is a tall, impressive member of the plant community growing at the margins of ponds and lakes. Like the Common Reed it is one of the plants which contributes most to the process of silting. Its hard, large leaves decompose only very slowly and the creeping rhizomes can spread and extend into a dense network so that it becomes difficult to eradicate.

The rhizomes, which can grow up to 2·5 centimetres (1 inch) in diameter are soft, rich in starch, and edible. The long, stiff, narrow leaves, just over 1 centimetre (0·4 inch) wide, can grow up to 2 metres (6 feet) tall. They are arranged in two ranks up the stem and have long, sheath-like bases. A layer of mucilage is secreted by each leaf sheath and this prevents water seeping in around the stem.

The flowers which form during the summer are crowded together tightly at the top of the stem, well above water level, to form the easily recognized, brown, cigar-shaped spikes. The upper spike is paler in colour and consists only of male flowers, while the lower, dark-

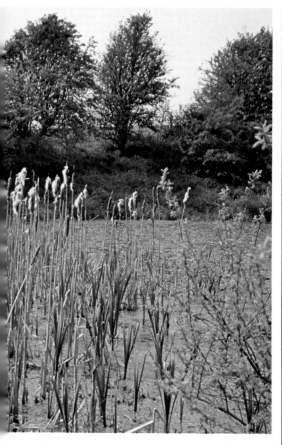

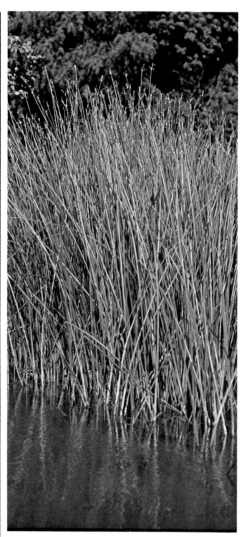

brown spike is female. Each male flower consists of three stamens, with anthers that have a crown of hairs projecting from the base of the stalk. The anthers produce clouds of pollen which are carried by the wind to fertilize the female flowers, each of which has one ovary and a long style. When it is ripe the brown female inflorescence splits and thousands of fluffy seeds are released to be dispersed by the wind. Reproduction is also carried out by vegetative propagation of shoots arising from the rhizome.

The leaves of the Bulrush are tough and fibrous and are used for plaiting and for woven goods as well as in the manufacture of cardboard. The leaf fibres are brittle but they can also be used for ropes and textiles.

Typha angustifolia, the Lesser Bulrush, is usually found in deeper parts of the pond and is smaller and less common than *T. latifolia*. It has narrower leaves and a well-defined gap between the male and female flower spikes.

Various species of bulrush, *Typha* spp, occur throughout the world, from the Arctic Circle to 30° South. *T. latifolia* is native to countries of the northern hemisphere and introduced elsewhere.

Common Club-rush
Scirpus lacustris

The Common Club-rush looks like a rush, but it is actually a member of the sedge family, Cyperaceae. It is another tall, impressive member of the reed swamp community and usually occurs at the inner edge of the fringing zone of a pond or lake, in deeper water than the Common Reed or Bulrush. Its strong creeping rhizomes penetrate the mud and help support the plant, as well as causing extensive silting.

The tall, dark-green, smooth, cylindrical stems are bare and leafless except for a few leaf sheaths at the base. They can be up to 3 metres (10 feet) tall and are filled with pith which makes them light and buoyant.

The inflorescences are borne near the tip of the tapering stems, as small, dense clusters of unequally stalked, reddish-brown flowers. Each tiny flower has six bristle-like 'petals', three stamens, and an ovary with a long style and three awl-shaped stigmas. The Club-rush flowers in summer and produces brown triangular fruits, nearly 3 millimetres (0·1 inch) long, in the autumn.

This plant causes severe silting in a pond and, once it is established in the swamp community, it is persistent and difficult to eradicate. Its bare, erect stems provide little cover for small creatures living at the edge of the pond. It is an attractive plant to see growing among the reeds, however, and it is useful to man for plaiting into woven goods, for the seating of rush-bottomed chairs, and sometimes for thatching. The light, pithy stems can also be used for eel bobs and floats.

There are many species of *Scirpus* found throughout the world, particularly in North America, where one or two species are floating and aquatic.

Sedges CYPERACEAE

All sedges belong to the family Cyperaceae which is a widespread group with many different species, the majority belonging to the genus *Carex*. They are perennial, grass-like plants, often forming dense tussocks of vegetation, which grow from an underground, often creeping, rhizome. Sedges are commonly to be found in the marshy areas of land around a pond where, together with rushes, they can often dominate the vegetation. They are marsh plants, rather than aquatics, although some species thrive in shallow water and may occasionally be found near the edge of a pond.

Their leaves are long, narrow, and often have a prominent mid-rib forming a keel, as well as sharp cutting edges caused by minute serrations. Unlike grasses, the leaves grow in ranks of three, and the flowering stalk is triangular in cross-section and usually solid or pithy instead of being hollow and rounded with swollen joints.

The flowers are borne in cylindrical, brownish spikes, either singly or in groups. Male and female flowers are either together in one spike, or are separate in different spikes, according to the species. Male flowers consist of three stamens borne in the axil of a scale-like leaflet, called a glume. When ripe, the anthers hang out freely and their pollen is dispersed by the wind. The female flowers, which also have glumes, have the ovary enclosed in a flask-shaped, loose case, called the perigynium, with the two- or three-lobed stigma protruding from the top. This perigynium persists to protect the fruit which is a tiny, brown, leathery nut.

Some of the larger sedges, such as the Tufted Sedge, *Carex elata*, form distinct zones of their own which are usually as wet as reed swamp in winter although they are often dry during the summer.

Sedges are widespread throughout the world but they are especially abundant in cool, temperate regions of the north.

Great Pond Sedge

Carex riparia

This tall, upright sedge is commonly found at the edges of ponds. The rough, sharply angled, triangular stems can be from 1 to 1·6 metres (3 to 5 feet) tall. The coarse leaves, from 6 to 15 millimetres (0·24 to 0·6 inch) wide, are sharply keeled and are a bluish-green colour which distinguishes this plant from the closely related Lesser Pond Sedge, *Carex acutiformis*.

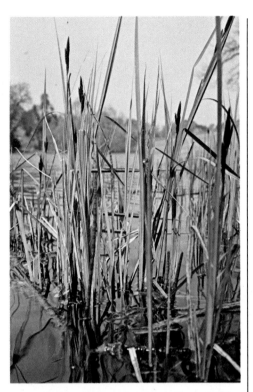

Several male flower spikes are borne above the female spikes. The female spikes, from one to five in number, are fairly widely separated. The upper ones are erect with no or very little stalk while the lower ones are on long stalks and hang down from the plant. The fruits which form in the female flowers are brown, ovoid, slightly three-cornered nuts, 2·5 to 3 millimetres (0·1 inch) long, with a short stalk, and a double-toothed beak or tip.

Common Reed

Phragmites australis

This handsome grass is commonly found growing in the swamp zone of ponds, lakes, and marshes, where it may dominate and form extensive stands in water up to 1·5 metres (5 feet) deep. Depending on the richness of the substrate, it may be low growing, or tall and luxuriant, with shoots anything from 1 to 4 metres (3 to 13 feet) high. It is a true grass, a perennial, and spreads vigorously by means of a much-branched, creeping, underground rhizome.

The tough, fibrous stem has great bending strength and can withstand strong winds, as can most grasses. The long green leaves are also wind resistant – they are attached to the stem by a loose sheath and they all point in the same direction when the wind blows. At the base of each leaf a ring of fine hairs prevents water entering between the stem and the leaf sheath. The leaves cannot tolerate continual flooding and will die off if this occurs. Thus, the reed is a useful indicator of water level.

The flowering spike is large and plume-like, and turned a little to one side, which also helps to make it wind resistant. The many flowers or spikelets are a dark, purple colour with silky white hairs on the stalk of each spikelet which creates a silvery glistening effect in the light. Fruits are rarely found, and the Reed spreads and reproduces mainly by forming side shoots from the main rootstock. It gradually invades areas of open water and causes extensive silting because of the accumulation of mud and plant detritus around the stems.

The hard leaves and stems decompose very slowly and are of very little nutritional value in the ecology of the pond. The parts underwater, however, are often overgrown with algae upon which snails and other aquatic animals feed. Many small creatures may be attached to these submerged stems, and loose stands of Reeds provide a welcome shelter and spawning ground for fishes and amphibians as well as nesting sites for birds such as the Reed Warbler and Sedge Warbler.

The Reed is valuable for many purposes including thatching, building, and weaving into mats; and the young plants can be used as fodder. In Rumania and Poland it is harvested in large quantities as raw material for the paper and chemical industries.

It is found all over the world apart from a few tropical regions.

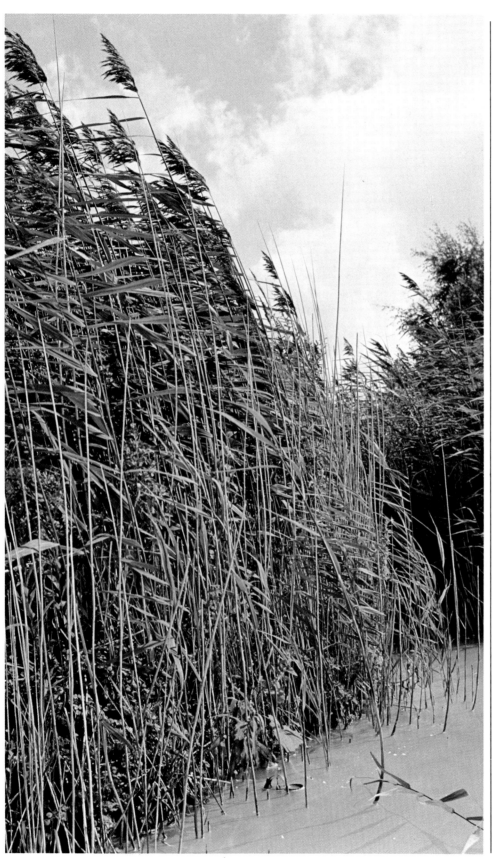

Reed Sweet-grass
Glyceria maxima
This graceful grass is often found in abundance at the edge of freshwater and brackish ponds and lakes.

The tall, erect stems, often up to 2 metres (6·5 feet) high, are yellowish green in colour and grow from an extensively creeping rhizome. This spreads rapidly and can form dense rafts of vegetation in the swamp zone of ponds. The luxuriant, long, green leaves are about 1·5 centimetres (0·6 inch) wide, keeled at the midrib, with sharp cutting edges and a brownish band at the base where the sheath joins the leaf.

Large, branching, tufted flower spikes, from 20 to 40 centimetres (8 to 16 inches) across, are produced during the summer. The tiny, pale-green flowers eventually become brownish or purple as they mature. They are wind pollinated.

Although the Reed Sweet-grass often grows in dense patches, casting heavy shadow and choking out other emergent water plants, it is softer and less invasive than the Common Reed and Bulrush, and decomposes more rapidly than these. It is a useful plant to man in providing winter fodder for farm animals and, when mixed with other large grasses and sedges, it can be used for thatching.

The Reed Sweet-grass is commonly found in most temperate and subarctic regions of the world.

Floating-leaf and emergent zone

Most of the plants growing in this zone (and all subsequent zones) are true aquatics because they thrive only when growing in water; they show many of the adaptive features described earlier.

At the margin of the pond are plants growing in shallow water, rooted in the mud, but with at least some of their leaves floating on or projecting above the water. The flowers are usually borne above water, too, although the ripening of the fruit may occur underwater, as in some water-lilies and water-crowfoots.

The water-lilies are some of the most beautiful members of this plant community. They often extend into deeper water, their large, floating leaves sometimes covering extensive areas of the pond.

It is a common feature of plants in this zone to produce two (or even three) different kinds of leaf. Thus, the water-crowfoots and Arrowhead have different-shaped floating and submerged leaves. The submerged leaves are usually finely divided to present a very large surface for the absorption of salts and dissolved gases from the water. They are also flexible and less resistant to water movement than are the broader floating or aerial leaves. Some botanists do not believe that these reasons alone give an adequate explanation for the different types of leaf, and recent research seems to indicate that leaf form is a response to the type of food available to the plant in the growing season. At the beginning of the season the dissected form of leaf is produced, but later in the year, as the carbohydrate content of the plant increases, flat, floating leaves are formed.

Some of the pondweeds, *Potamogeton* spp, occur in this part of the pond, and many species have submerged and floating leaves.

Plants such as Bogbean, Water-plantain, and Amphibious Bistort can also be found here, although these may also extend into the swamp community, and Amphibious Bistort is equally at home on dry ground.

Water Horsetail	49	*Equisetum fluviatile*
Water-crowfoot	49	*Ranunculus peltatus*
White Water-lily	50	*Nymphaea alba*
Yellow Water-lily or Brandy-bottle	50	*Nuphar lutea*
Mare's-tail	51	*Hippuris vulgaris*
Amphibious Bistort	51	*Polygonum amphibium*
Fringed Water-lily	52	*Nymphoides peltata*
Water-plantain	52	*Alisma plantago-aquatica*
Arrowhead	53	*Sagittaria sagittifolia*
Broad-leaved Pondweed	53	*Potamogeton natans*

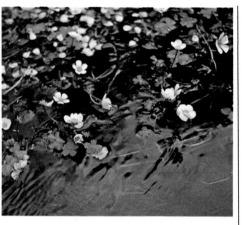

Water-crowfoot
Ranunculus peltatus
The water-crowfoots, all species of *Ranunculus*, include interesting examples of water plants possessing two different kinds of leaves. The submerged leaves are finely divided into a number of branching, hair-like filaments, while the long-stalked floating leaves are flat, lobed, and usually rounded.

R. peltatus is common in ponds, lakes, and slow streams throughout Europe and North Africa.

It has stiff, branching, submerged leaves and kidney-shaped floating leaves with three to five rounded lobes.

The showy white flowers are borne above the water on long, tapering stalks in early spring and summer, sometimes covering large areas of water. Each flower is solitary, from 2 to 3 centimetres (0·8 to 1·2 inches) in diameter, with five white petals which have yellow honey guides at the base. The flowers are attractive to insects such as bees and flies which help to bring about pollination. A number of yellow stamens surrounds the female parts in the centre of the flower. After pollination, these develop into a mass of small, hairy fruits called achenes.

Water-crowfoots overwinter at the bottom of the pond with parts of the floating stems stuck into the mud. They provide food and shelter for animals living in the pond, and usually have many organisms attached to their underwater parts.

Many different species of water-crowfoot are found throughout the world. In tropical climates they are confined to cold, mountainous regions.

Water Horsetail
Equisetum fluviatile
This species grows in standing water, its thin, smooth, green, and mainly unbranched stems reaching from 50 to 150 centimetres (20 to 60 inches) in height. The stems are striped with ten to thirty very fine grooves, and the central hollow within is larger than in any other species. The leaf sheaths around the joints are green with black-tipped teeth.

The fertile stems are very similar in appearance, apart from the terminal cone which bears the sporangiophores. These appear in early summer, each cone being from 1 to 2 centimetres (0·4 to 0·8 inch) long. The spores are ripe by midsummer. *See* horsetails, page 36.

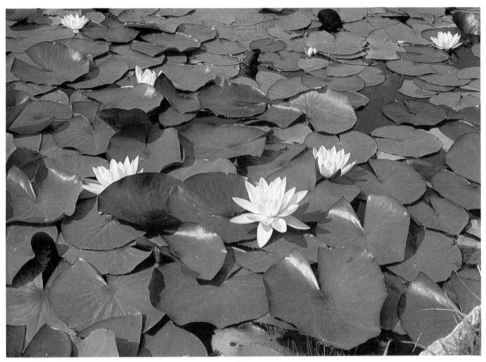

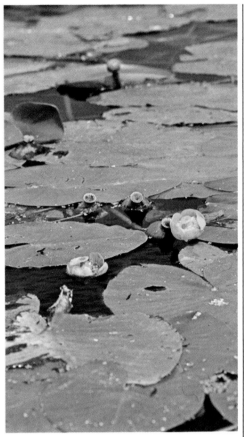

White Water-lily
Nymphaea alba

This water-lily lives in fairly deep water with its stout, rooting rhizome anchored in the muddy bottom, and its circular leaves and large, waxy flowers floating at the surface on long stalks. Water-lilies are well adapted to living in an aquatic environment – the large, flat leaves have stomata on the upper surface only, enabling oxygen for respiration and carbon dioxide for photosynthesis to be absorbed from the air above. The tough, waxy surface of the leaves helps to prevent them becoming waterlogged. The undersides of the leaves have no stomata and, being thin-walled, can absorb gases and salts from the water.

The leaves of water-lilies are useful to many creatures in the pond, because they provide shade and covering in hot, sunny weather, and a place for small animals to hide away from predators. The large, flat discs provide resting platforms for insects, amphibians, and other small creatures, while beetle larvae use the leaves for food.

Many interesting forms of life can be found attached to the undersides of the leaves, including the jelly-like masses of snails' eggs, eggs of aquatic insects, colonies of moss animals, and the oval larval cases of the china-mark moth, *Nymphula* spp.

In the White Water-lily the long leaf stalks are round in cross-section and contain many air spaces which link up with air spaces in the leaves above, and the submerged stem below.

The flowers, 10 to 20 centimetres (4 to 8 inches) in diameter have four outer sepals and from twenty to twenty-five spirally arranged white petals, merging inwards with the many yellow stamens, which surround the central ovary with its radiating disc-like stigma. The flowers close up at night and only open on fine, sunny days. They are pollinated by beetles, small flies, and other insects which crawl over the flowers, probably attracted by their warmth and smell as they open. Nectar is not produced in this species but the stamens provide food and are often chewed and eaten by beetles. This water-lily is known to be self-fertile and may quite often be self-pollinated.

The fruit develops underwater as a spongy green berry which splits to release as many as 2000 seeds that rise to the surface and float away to disperse the species. The seeds have many air spaces in their walls making them buoyant.

The plant dies down in autumn. Food reserves are stored in the rhizome from which new shoots arise in spring.

It is widely distributed in Europe, north and central Asia, North Africa, and north-west America. Many other varieties and hybrid species (often specially cultivated) are found throughout the world.

Yellow Water-lily or Brandy-bottle
Nuphar lutea

This water-lily tends to live in slightly deeper water than the White Water-lily and is often dominant in the muddy part of the floating-leaf zone.

The stout rhizome, which may reach a length of 3 metres (10 feet), bears knobbly leaf scars on its upper side and many roots below. Large, thin, translucent, cabbage-like leaves which have short stalks and are submerged, develop first from the rhizome, followed by the long-stalked, oval, floating leaves. These leaves, up to 40 centimetres (16 inches) across, are thick and leathery with a waxy coating on the upper surface from which water runs off easily. The leaf stalks are generally at an angle, but become more upright as the water-level rises, keeping the leaves at the surface. The stems contain many wide air spaces and are roughly triangular in cross-section.

The brilliant-yellow, solitary flowers, 4 to 6 centimetres (1·6 to 2·4 inches) across and globular in shape, are borne above the water in summer on very long stalks. The five outer sepals are much

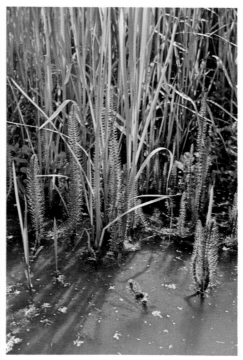

Amphibious Bistort
Polygonum amphibium

As its name implies, the Amphibious Bistort grows equally well in water and on dry ground. It is highly adaptable to varying environmental conditions and is especially well suited for ponds which are drained in winter, or those with a frequently changing water-level.

This perennial plant overwinters with a creeping rhizome and has aquatic and terrestrial forms which differ considerably. The aquatic form, shown in this photograph, is a partially submerged plant, with a smooth, floating stem containing air spaces. It has long-stalked, floating, dark-green, leathery leaves, from 5 to 15 centimetres (2 to 6 inches) long, which are glossy and tapering with a truncate base.

The pinkish-red flowers are borne in stout spikes, about 2 to 4 centimetres (0·8 to 1·6 inches) long, above the surface of the water. Each tiny flower has five petals, five stamens, and two styles and stigmas above the single ovary. After fertilization each ovary develops into a spherical, brown, shining fruit.

The terrestrial form is a smaller plant and differs in having erect and slightly hairy stems. The leaves are narrower with shorter stalks which are hairy.

The stems and leaves of the aquatic form provide shelter and food for many animals in the pond. The floating leaves are usually loosely spread on the pond's surface enabling light to reach life in the water below.

Many *Polygonum* species occur throughout the world, mainly in northern temperate regions. Many species grow in wet places and may withstand temporary flooding, but only a few (ten to twenty species) are truly aquatic and many of these are tropical. *P. amphibium* is found in Britain, Europe, Asia, North America, and South Africa.

bigger and more obvious than the spoon-shaped petals within. The petals have nectaries on their lower side which smell of alcohol (hence the name Brandy-bottle) and are attractive to insects, mainly small flies and beetles, which pollinate the flowers. The numerous stamens are shorter than the central pistil which has a flattened, disc-like stigma. The fruit is green and bottle-shaped (another reason for the country name, Brandy-bottle) and, on ripening, breaks away from the plant and floats about on the surface until disintegrating into several white, spongy segments containing the seeds. The seeds eventually sink to the bottom, ready to germinate in the mud below.

In unfavourable conditions only cabbage-like submerged leaves are produced. Unlike the floating leaves, which can form an almost continuous cover on the surface and prevent light and air reaching below, the submerged leaves are useful in adding oxygen to the water.

The Yellow Water-lily is found in temperate regions of the northern hemisphere. It is very rare in North Africa.

Mare's-tail
Hippuris vulgaris

Mare's-tail prefers calcareous water and may be present even at high altitudes around the margins of ponds (where it is usually half submerged) as well as in deep stagnant water. It looks very like a horsetail, Equisetaceae, but it is not closely related and is a true flowering plant, unlike *Equisetum* spp.

A perennial creeping rhizome gives rise to long, unbranched, hollow stems bearing whorls of six to twelve thin, dark green leaves. When growing at the margin of the pond, these shoots stick up out of the water with their leaves stiffly horizontal, resembling a miniature coniferous forest. Below water, the leaves are paler, larger, and drooping and, in deep water, trailing stems up to 1·5 metres (5 feet) long may be found. These long, feathery plumes are reminiscent of a horse's tail.

The flowers, just discernible in the picture, are tiny, greenish, and inconspicuous and are borne singly in the axils of the aerial leaves in June and July. There are no petals and each flower consists solely of one stamen with a reddish anther and one pistil. Plants living in very deep water are usually totally submerged and have no flowers. The fruit is a small, smooth, ovoid nut.

This plant is found only in temperate and cold regions of the northern hemisphere.

Fringed Water-lily
Nymphoides peltata

This attractive aquatic plant belongs to the same family as the Bogbean but looks more like a water-lily. The creeping rhizome gives rise to long-stalked floating leaves which are rounded and heart shaped, from 3 to 10 centimetres (1·2 to 4 inches) across, purplish below, and purple spotted above.

The flowering stems are long and floating with opposite leaves. They bear clusters of two to five stalked, yellow flowers which stand erect above the surface, supported by the floating stem leaves. Each flower, about 3 centimetres (1·2 inches) across, has five yellow petals, fringed at the edges, and five outer sepals united into a tube at the base. The flowers are pollinated by insects which are attracted to the nectar secreted from hairy nectaries at the base of the petals. The flask-shaped, capsular fruits develop below the surface of the water as the flowering stems bend downwards to carry them below.

This species occurs in ponds throughout central and southern Europe; also eastwards, through temperate Asia to Japan. It is naturalized in North America. There are about twenty other species found in still and slow-moving water throughout the world.

Water-plantain
Alisma plantago-aquatica

The Water-plantain is a distinctive perennial herb found growing in muddy soil at the edges of ponds. It has a thick, short, tuberous rhizome and, like the Arrowhead, produces thin, ribbon-like submerged leaves before the large, long-stalked aerial leaves which develop in a basal rosette. These aerial leaves are very large, with the blade up to 20 centimetres (8 inches) long, broadly ovate with a tapering tip, and five to seven parallel veins which give it a superficial likeness to the Great Plantain, *Plantago major*, although *Alisma* is not closely related to the true plantains (family Plantaginaceae).

The inflorescence is tall and stately, from 20 to 100 centimetres (8 to 40 inches) high, with flowers in widely separated branching whorls at the top of the bluntly three-angled stem. The flowers are usually pale lilac in colour, up to 1 centimetre (0·4 inch) in diameter, each consisting of three ovate, green sepals, three rounded petals which are larger than the sepals and have a yellow patch at their base, six spreading stamens, and a rather flat, central head of fifteen to

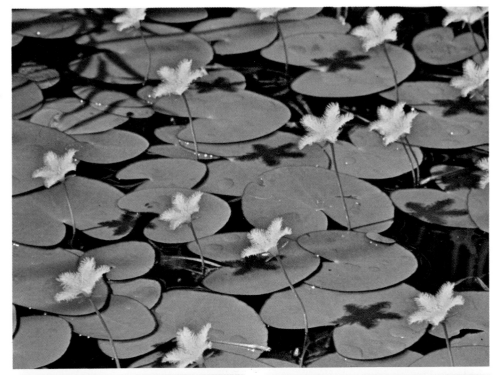

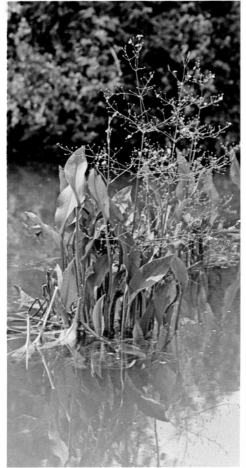

thirty carpels. The delicate flowers are produced throughout the summer and only open during the afternoon. They are visited by insects which come to find the nectar produced in glands on either side of the base of each stamen. The seeds are buoyant and able to float for several weeks which aids their dispersal.

The thick fleshy base is rich in starch and in some parts of the world is used as food (by the Kalmucks, a Mongolian race of central Asia). Although the plant contains an acrid juice, it can be eliminated by a drying process. The fruits and leaves are eaten by a wide variety of animals including birds.

This species hybridizes with *Alisma lanceolatum* which has narrower, spear-shaped leaves and is less common than *A. plantago-aquatica*.

Several species of water-plantain are found throughout the world, but mainly in northern temperate regions where the plants are native.

Arrowhead
Sagittaria sagittifolia

It is easy to see that this plant derives its name from the distinctive arrow-shaped leaves which stand above the water on long stalks. The plant is commonly found growing in shallow water and on muddy soil at the edges of ponds. It is an interesting aquatic plant with three different kinds of leaf.

Submerged, translucent, grass-like leaves are produced first in spring from the underground tuber, followed by oval, long-stalked, floating leaves and finally, by the typical arrow-shaped, aerial leaves which have three-angled stalks.

The three-angled flower stem, which may be from 30 to 90 centimetres (1 to 3 feet) tall, bears flowers in whorls of three (sometimes four or five) female flowers below the male flowers which have longer stalks and open later. Both types of flower have three dullish-red sepals and three large white petals with a dark violet patch at the base. There are numerous purple stamens at the centre of the male flowers and a dense, globular head of many carpels in the centre of the female flowers. These ripen into tightly packed, winged, beaked nutlets (or fruits) which are often eaten by fishes and waterbirds. The seeds which are flattened and full of air, are adapted to dispersal by wind and water.

The Arrowhead overwinters by producing walnut-sized, purplish-blue tubers, which are rich in starch and are sometimes fed to pigs. These are borne at the end of slender runners which develop from the base of the plant. In autumn the tubers become detached and in spring they sprout into new plants. The Arrowhead can spread extensively in ponds and, in deeper water, it takes on a different form, producing only ribbon-like submerged leaves and no flowers.

Various species of arrowhead occur throughout the world, in both temperate and tropical regions.

Broad-leaved Pondweed
Potamogeton natans

The pondweeds, *Potamogeton* spp, are a large family of aquatic plants found in ponds all over the world. It is often difficult to distinguish between the species, because the vegetative form can vary greatly according to conditions in the pond. There is also considerable hybridization between different species.

Many species are completely submerged, but the Broad-leaved Pondweed, *P. natans*, one of the commonest, has floating leaves

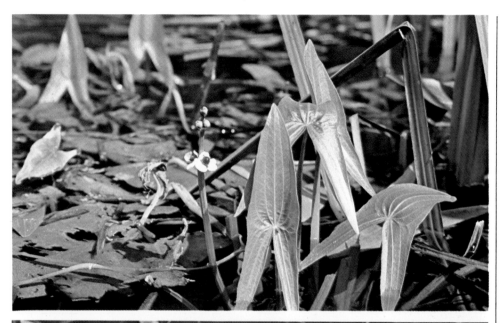

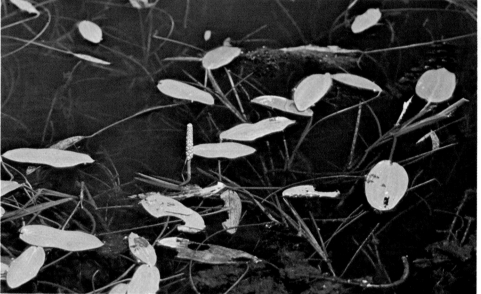

as well as submerged ones. The long, branching rhizomes of this perennial plant penetrate the mud at the bottom of the pond and give rise to a mass of shoots, some spreading more or less horizontally in the water, others more erect, bearing the leathery, flat, oval leaves, 6 to 8 centimetres (2·4 to 3·1 inches) long, which float at the surface. These leaves have long stalks at the base of which is a long, sheathing scale. The submerged leaves are pale in colour, thin, needle-like, and delicate, and they die off at an early stage before flowering time.

The tiny, pale-green, petal-less flowers are borne in dense cylindrical spikes, from 3 to 8 centimetres (1·2 to 3·1 inches) long that project above the water on stout stalks. Flowering occurs throughout the summer and the flowers are wind pollinated. Each flower bears four stamens and, after pollination, four tiny, olive-green fruits, each with a short, straight beak at the top, are produced.

The leaves and stems of Broad-leaved Pondweed are richly colonized by all kinds of small animals, and the floating leaves form convenient platforms for many creatures. An examination of the underside of these may reveal the egg masses of snails, eggs of aquatic insects, the oval larval cases of the china-mark moth and many other colonizers.

Submerged plant zone

These plants, totally submerged in the deeper water and rooted in the mud, show some of the greatest adaptations to the aquatic way of life.

All gaseous interchange has to take place under water, and the leaves of these plants are usually small and very numerous (for example, many pondweed species, *Potamogeton* spp and Canadian Waterweed), or very thin and finely divided (such as the water-milfoils) offering a large surface area for the absorption of gases and mineral salts from the water. The leaves have no stomata or breathing pores, and water regulation and gaseous exchange take place all over the plant surface.

The stems of these submerged plants are usually limp and weak, the leaves pale, flimsy, and translucent. The plants would be quite unable to support themselves on land, but in water there is no need for them to develop the tough fibres and woody tissue of land plants, because they are permanently supported by their watery environment. Their pliant form also enables them to adapt to movements and changes in water-level if these occur.

Most of these submerged plants project their flowers above water where pollination occurs and seeds are formed. Some species in deeper water, however, may form their flowers and fruits under the surface.

A wide variety of plants grows in this zone, including many flowering plants as well as the underwater mosses, *Fontinalis* spp, and that curious group of primitive plants, the stoneworts.

Stonewort	55	*Chara fragilis*
Willow Moss	56	*Fontinalis antipyretica*
water-milfoils	57	*Myriophyllum* spp
Common Water-starwort	58	*Callitriche stagnalis*
Water-violet	58	*Hottonia palustris*
Canadian Waterweed	59	*Elodea canadensis*

Stoneworts CHAROPHYTA

The stoneworts are a small, cosmopolitan group of aquatic, non-flowering plants closely related to the algae. They are, however, highly specialized and different enough from other algae to be placed in a separate group of their own.

They are submerged plants, often growing in dense masses in still or slow-running water which may be fresh or slightly brackish. They can be found in ponds or lakes where they may occur at depths below those at which higher plants thrive.

The name 'stonewort' refers to the hard, brittle nature of many species, caused by the deposit of calcium carbonate on their cell walls as a result of photosynthesis. This white, chalky deposit may cover the entire plant and is often seen on species of *Chara* (commoner in alkaline waters) but not on the genus *Nitella*. Plants which are not heavily encrusted have a rather shiny, green, translucent appearance.

The stoneworts are of economic importance and have been used, for example, in water purification, as food for fish and farm stock, and in the manufacture of polishes. Due to their accumulation of calcium carbonate they provide good fertilizer and can be gathered in the autumn and made into compost. They give shelter to fishes and other animals in the pond. They have an extremely unpleasant, fishy smell.

There are two main groups of stonewort – *Nitella* spp (with forked branchlets) and *Chara* spp (with unforked branchlets).

Stonewort *Chara fragilis*

This photograph (1) of *Chara fragilis* shows that the plant body consists of delicate, long, branching stems with whorls of branchlets at intervals along them (2). The central axis or stem is only one cell thick, and the interval between each whorl of branches comprises a single, long cell. In *Chara* species an outer layer of elongated cells (the cortex) ensheaths the stem but *Nitella* have no outer cortex. The plant is anchored to the substrate by means of colourless rhizoids and may reach a height of up to 30 centimetres (1 foot).

In summer the male and female reproductive organs are borne on the branchlets, usually close together on the same plant (3). The female oogonium can be seen as a green, oval, flask-shaped structure with an outer envelope of five elongated spiral cells. A single egg is contained within. The male antheridium

is spherical, orange in colour, and has a beautifully sculptured outer covering which breaks apart on maturity into eight triangular-shaped sections. Many motile sperm cells are released and these make their way to the female cell to fertilize it. After fertilization the egg develops into a dark, thick-walled spore which falls from the plant and will eventually give rise to a new plant.

Vegetative reproduction sometimes occurs by means of whitish, starchy swellings, called bulbils, which are produced from the lower part of the stem and give rise to new plants.

Mosses MUSCI

Bryophytes (mosses and liverworts),
reproduce in a different way from
flowering plants. As in the Pteridophyta
(ferns and horsetails), spores are produced
instead of seeds and there is an
alternation of a sexual and asexual
generation in the life-history. Unlike
pteridophytes, however, the gametophyte
generation of mosses and liverworts is
the larger and more obvious stage. It
comprises the leafy plant we are familiar
with, and bears male and female sex
organs. After fertilization, the egg cell
grows into a spore-bearing capsule which
is the asexual, sporophyte stage. The
spores released from this eventually grow
into a new moss or liverwort plant.

Mosses are not widely represented in
ponds and, although various species may
grow on the rocks, trees, and boggy
ground surrounding the water, very few
species are truly aquatic. The Willow
Moss, *Fontinalis antipyretica*, is one such
species.

Willow Moss

Fontinalis antipyretica (**1**)
This underwater moss is the most
common and widely distributed of the
water mosses (*Fontinalis* spp). It occurs in
running and still waters and, depending
on environmental conditions, may exhibit
several different forms. Plants occurring
in fairly deep water have stems which
can grow up to a metre (3·3 feet) in
length. The stems are branched, plumose,
floating, and submerged, and are usually
attached at their bases to stones or tree
stumps. The leaflets, sharply keeled,
tapering and lance shaped, are borne in
three ranks on the stem.

The spore-bearing capsules are rarely
produced when the plant is totally
submerged, but if the water dries up
enough to leave the stems high and dry,
the flask-shaped capsules are produced on
short, lateral shoots (**2**). At the mouth of
the capsule is a ring of bright, red, hair-
like teeth which remain closed in wet
conditions (**3**) but, in dry conditions, open
out so that the ripe spores inside may be
distributed (**4**).

The moss remains green in winter and
is a welcome shelter at all times for small
pond creatures such as insects, rotifers,
and even young fishes.

The Willow Moss is found throughout
the northern temperate zone as well
as Ethiopia and South Africa. Other
Fontinalis spp are found in temperate and
subarctic regions of the northern
hemisphere

1 ▲ 2 ▼

3 ▼ 4 ▼

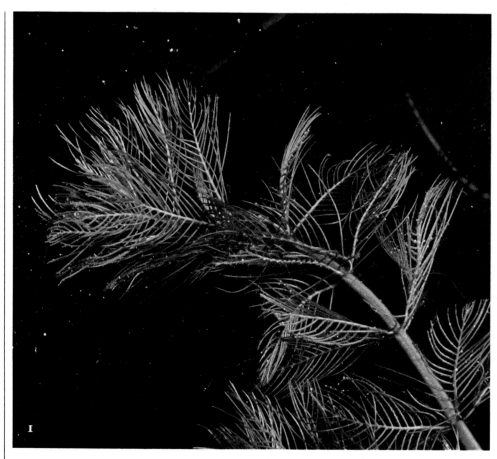

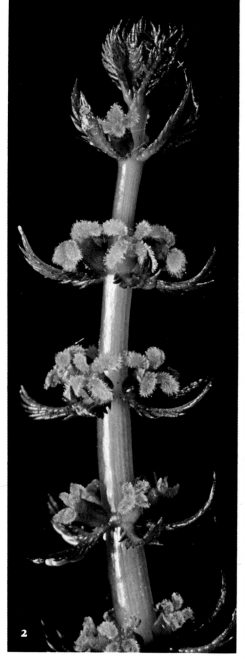

Water-milfoils

Myriophyllum spp

The most characteristic features of the water-milfoils are the whorls of comb-like, feathery leaves. These plants are commonly found in fairly deep water and are usually totally submerged apart from the stiff flower spikes which rise above the water-level in the summer. Some species, living in deeper water, flower under the surface. A creeping rhizome-like stem anchors the plant to the bottom and the feathery, pinnate leaves are borne on the stem in whorls of four (Spiked Water-milfoil, *M. spicatum*) (1) or five and six (Whorled Water-milfoil, *M. verticillatum*).

The tiny reddish-green flowers (2) are borne in the axils of comb-like bracts arranged in whorls of four or six on the flowering shoot. Male flowers are found at the top of the inflorescence, female flowers at the bottom, while intermediate flowers often have male and female parts. The petals and sepals are very reduced or totally absent, and the male flower has two, four, or eight stamens while the female, shown in the photograph, has a two- or four-celled ovary with four feathery styles. The flowers are adapted to wind pollination, the stamens having long anthers on very flexible stalks. Four-lobed fruits are formed in the autumn.

Whorled Water-milfoil also reproduces by means of winter buds, which are dark-green, club-shaped bodies formed in the leaf axils or at the ends of shoots in the autumn. These buds are compressed, modified stems, about 2 to 17 millimetres (0·1 to 0·7 inch) long with many small, closely packed leaves arranged in whorls of four. They eventually drop from the parent plant and, after overwintering at the bottom of the pond, give rise to new plants in the spring.

The water-milfoils offer shelter to many small pond animals, some of which are attached to the plants. They also provide good feeding places for fishes and other predators.

Water-milfoils are widely distributed throughout the northern hemisphere, in standing or slow-flowing water. Most species are aquatic or amphibious, and can be found in a variety of habitats. *M. spicatum* is very widespread and may become a pest.

In Java, the tips of *M. aquaticum* shoots are eaten as a vegetable.

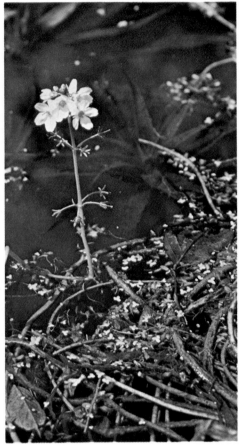

Common Water-starwort
Callitriche stagnalis

The water-starworts are true aquatic plants. They exist mainly as submerged plants and have weak, branching, thread-like stems bearing opposite pairs of simple, linear to ovate leaves often with forked tips. Seen through the water from above, the alternating pairs of leaves often appear to cross and form a star, hence the name, starwort.

Small rootlets growing from the side of the stem attach the plant loosely to the muddy bottom, although it may sometimes be found floating freely. Some species produce floating leaves which are a different shape to the submerged leaves and may form a terminal rosette at the surface of the water.

Common Water-starwort is a common pond plant although it can also occur in terrestrial form on muddy ground. The aquatic form has stems from 25 to 100 centimetres (10 to 40 inches) long and leaves about 4 millimetres (0·15 inch) long which are spoon shaped with a stalk-like base, the uppermost ones forming floating rosettes at the surface. The tiny, green, petal-less flowers are borne in the axils of the floating leaves, the male flowers, in the axils of the upper leaves, maturing before the female flowers lower down the stem. The male flower has only one stamen, which is 5 to 8 millimetres (0·2 to 0·3 inch) long. The female flower, relatively large in this species, consists of a four-celled ovary with two long styles. These can still be seen projecting when the fruit ripens. The fruits, about 1·5 millimetres in diameter, are ovoid and deeply divided into four lobes, each with a conspicuous wing around its edge. Each lobe contains one seed. Pollination is usually by wind but it may also occur underwater in submerged forms.

The water-starworts are important in providing a rich supply of oxygen for animal life in the pond. Many animals, including the freshwater shrimp, *Gammarus pulex*, live among their leaves. In winter, water-starworts sink to the warmer water at the bottom of the pond where they remain until spring.

Water-starworts are found, mainly in temperate climates, throughout the world in ponds, lakes, ditches, and puddles.

Water-violet
Hottonia palustris

This delicate flowering perennial can be found growing in shallow water of ponds and ditches. The submerged, pale-green, floating stems root in the mud and bear numerous finely divided, pinnate, feathery leaves, very similar in appearance to those of water-milfoils. These submerged leaves are arranged spirally or alternately along the stem although, at the base of the flowering shoots, they are compressed into a whorl which helps to support the tall vertical stems.

The flowers are the only parts of the plant to emerge above water. They are borne on erect aerial stems up to 40 centimetres (16 inches) tall and are arranged in whorls of three to eight. The stalked flowers are primrose-like in structure, consisting of five petals which are pale lilac in colour with a yellow centre. They contain nectar and are pollinated by various insects. There are five stamens surrounding an ovary with a thread-like style and knob-like stigma. As in primroses, the flowers are of two types, pin eyed or thrum eyed, a device for

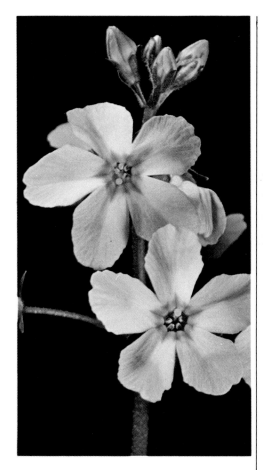

Canadian Waterweed
Elodea canadensis

Canadian Waterweed is widespread in freshwater habitats and spreads rapidly in stagnant or slow-running water. The amazing luxuriance of its growth is a striking example of the efficiency of asexual (vegetative) reproduction. It multiplies almost exclusively by fragmentation of its extremely brittle, slender stems. Each fragment is immediately independent and capable of growing into a new plant. It also reproduces by means of winter buds consisting of tightly wrapped leaves on a short shoot which develop in the autumn and grow into new plants in the spring.

The Canadian Waterweed is a submerged, translucent, aquatic plant, attached to the bottom and rooting from the nodes. Its branching, slender stems bear leaves in whorls of three (rarely four). The pale-green leaves are stalkless, ovate, and rounded at the end with a spiky tip. The leaf margins are finely saw toothed.

The vegetative form can vary considerably according to conditions in the pond. In nutritionally poor or shady conditions, the plant is often pale and spindly with leaves widely separated, whereas in bright, sunny, and nutritionally favourable conditions, the growth is bushy and more robust, with darker green leaves more closely packed on the stems.

Male and female flowers are borne on different plants although, in Europe, the male flowers are almost unknown and female flowers are only rarely produced. The solitary flowers arise on long, thread-like stalks from the axils of upper leaves out of a tubular two-lipped sheath. Each flower, about 5 millimetres (0·2 inch) in diameter, is greenish purple in colour, with three outer sepals that are broader than the three inner petals. The male flowers, which have nine stamens, usually break off from the plant and float to the surface, whereas the female flowers (with a central ovary and three bilobed stigmas) reach the surface by elongation of their slender stems. The flowers are water pollinated, the stamens exploding to release the pollen which scatters on the water's surface and is carried to the emerged stigmas of the female flowers. Under the microscope it can be seen that each pollen grain is covered with fine hairs or spines. These trap air and enable the pollen grains to float, as well as making them water repellent. Small, ovoid, capsular fruits, containing one to five cylindrical seeds, are produced after fertilization.

Canadian Waterweed is a rich source of oxygen for aquatic animal life and, in sunny conditions, bubbles of gas can often be seen escaping from its foliage. It is greatly valued as an aquarium plant.

Canadian Waterweed originated in North America and was introduced into Britain and then into Europe in the mid-nineteenth century where it multiplied rapidly and soon became a menace to boating, fishing, and swimming. It flourished vigorously for several years but then declined and it is no longer a serious problem here although it is widespread throughout Europe and has now become established in Asia, Africa, Australia, and New Zealand. It is still considered a pest in many areas.

ensuring cross-pollination. In pin-eyed flowers the stigma is on a long style and projects well beyond the stamens which are attached half way down the flower tube. In thrum-eyed flowers the stigma is on a short style and well below the stamens which are at the top of the flower tube. Occasionally the flowers do not open and it is thought that self-pollination then occurs. After pollination the flowering stems bend over into the water where the seeds ripen. These develop inside round, green, five-valved fruits, which later burst open to release their seeds.

Winter buds, consisting of tightly folded leaves around a growing point, are formed at the end of special runners. These are capable of surviving the winter ready to sprout into new young plants the following spring.

This plant is found in many parts of Europe and northern Asia. Another species, *H. inflata*, grows in eastern North America. It has very inflated stems and smaller flowers which are usually self-pollinated.

Free-floating plant zone

The plants in this group are not rooted in the mud at all, but float freely at or just below the water surface where they can avail themselves of the light necessary for photosynthesis. They often occur over fairly deep water and can sometimes form extensive carpets across the surface.

Although some are rootless, many of the floating plants do have roots which hang loosely and are used to assimilate water and its dissolved substances, as well as serving as balancing organs.

Apart from the small, ubiquitous, and often abundant duckweed species, other free-floating plants include the water ferns, *Salvinia* spp and *Azolla* spp, Floating Crystalwort, *Riccia fluitans*, the bladderworts, *Utricularia* spp, and larger plants like Frogbit, *Hydrocharis morsus-ranae*, Water-soldier, *Stratiotes aloides*, and the rootless Rigid Hornwort, *Ceratophyllum demersum*. Rigid Hornwort is one of the most highly adapted aquatics (hydrophytes) which flowers and is even pollinated underwater.

Many microscopic plants, such as various species of algae, float freely in the water where they form, together with many microscopic animals, that special aquatic community called plankton.

Liverworts HEPATICAE

Liverworts are small, simple, non-flowering plants, closely related to mosses. Many grow on rocks and walls near water, particularly in mountainous districts where they may be submerged after rain or snow melt. They can usually tolerate flooding.

Floating Crystalwort
Riccia fluitans

Floating Crystalwort is a true aquatic liverwort and is usually found floating just below the surface of ponds, lakes, and ditches although it can also grow on wet mud and it is in these conditions that the plant is most likely to fruit. It is characteristically found in nutrient-rich waters.

When floating, the plant consists of a flat, green, dichotomously branching, spreading thallus with no roots or long scales hanging below, as in some of the other floating liverworts. The plant tissue contains many large air chambers which enable it to float and also to store oxygen. It is a valuable oxygen-producing plant but, if it is allowed to spread, it can form a dense cover which cuts off light to the fauna and flora living below.

On muddy soil, the plant produces star-shaped, violet-tinged, small rosettes which are anchored in the soil with a few thin, root-like structures called rhizoids.

Reproduction is mainly vegetative through separation of parts of the thallus. Sexual reproduction is also possible, although it is seldom observed and may be rare.

Floating Crystalwort may be found throughout most of the world.

Water Fern
Azolla filiculoides

Although it is commonly called Fairy Moss, this small, free-floating plant is actually a water fern. The stems of this small fern are from 1 to 5 centimetres (0·4 to 2 inches) long. They lie horizontally on the water surface, branching regularly, and are densely covered with small, overlapping, alternate leaves to form broad, flat fronds. At certain points, small branches and simple roots hang down into the water. The leaves are divided into two lobes, the upper lobe thick, green, and borne above the water, while the lower lobe is thin, rather colourless, and more or less submerged. The upper leaf lobes usually contain the blue-green alga, *Anabaena azollae*, which is responsible for their

bluish coloration. These algae fix atmospheric nitrogen which is then available to *Azolla*, while the latter shelters the algae and possibly also provides them with carbohydrates.

Fertile plants, although rarely found, produce spores which are borne in sporangia in the axils of leaves on the underside of the plant. The spores germinate in the water to form minute prothalli, the sexual generation of the fern, from which new *Azolla* plants eventually grow. Vegetative reproduction occurs by the separation of the growing branch ends of the plant, and *Azolla* can

sometimes spread to cover large areas of water. It is virtually non-wettable and, if pressed underwater, immediately bobs up to the surface when pressure is removed. The fronds are often tinged with pink and become a deep reddish colour in autumn.

The Water Fern originates from warm, temperate and subtropical parts of America and has become naturalized in Britain and Europe. It is also native to Australia and New Zealand. There are several other species of *Azolla* and the plant is now almost cosmopolitan because of introductions.

Water Velvet
Salvinia natans

This small, free-floating water fern has floating stems, which can grow up to 20 centimetres (8 inches) in length. The stems are irregularly branched, without roots, and bear leaves in whorls of three, two of which are green, ovoid, and floating and the third, a colourless, finely divided, submerged, root-like frond which grows vertically down and takes on the function of a root. The floating leaves, about 1 centimetre (0·4 inch) long, open out flat when first formed, but later become tightly packed and folded together as they are in the photograph. Special basket-shaped, water-resistant hairs grow on the upper surface of these leaves, while the hairs on the under surface are simple in structure and not water resistant. The leaves contain many air spaces which makes them buoyant.

Fertile plants produce hairy, spherical sporangia at the base of the floating fronds. When ripe these release many floating spores which disperse and ultimately give rise to the sexual generation (the prothallus) while still inside the spore.

Water Velvet is commonly found in warm freshwater habitats throughout the world, mainly as a result of introductions. It is a popular plant in ornamental ponds and tropical aquariums. It prefers fairly hard water and, under favourable conditions, it can grow and spread extremely rapidly forming large areas of dense vegetation and decaying debris up to 25 centimetres (10 inches) thick. In Sri Lanka it has infested waterways and ricefields with alarming speed and is a serious pest in south-east Africa and southern India.

Rigid Hornwort
Ceratophyllum demersum

Rigid Hornwort is one of the freshwater plants most highly adapted to the aquatic way of life. It lives totally submerged and cannot tolerate being out of water. It has no true roots, although pale-coloured offshoots sometimes arise which anchor it temporarily in the mud. In general, the plants float freely and upright in the water, fairly near the surface in spring but, later in the year, often sinking near to the bottom. Here they may grow to form dense masses which provide shelter for many small pond creatures, including snails, worms, and insects.

The flexible, branching stems can grow up to 100 centimetres (40 inches) long [usually from 30 to 60 centimetres (12 to 24 inches)]. The dark-green, thin, finger-like leaves are borne in whorls up the stem. The leaves, which fork into two (or four) are stiff, often brittle, and rather rough to the touch owing to the presence of two rows of minute, spine-tipped teeth along the ultimate branches.

Flowers develop only rarely, in warm and sunny conditions, and are small, green, and inconspicuous. Male and female flowers are borne separately (but on the same plant) in the axils of different leaves. There are no proper petals, merely a ring of eight to twelve toothed, leaf-like segments which surround either the clusters of stamens (as in a male flower) or the single one-celled ovary with its long, slender style (as in a female flower).

Pollination occurs underwater, a remarkable adaptation to the aquatic way of life. When ripe, the stamens of the male flowers become detached and rise to the surface where they split open to release the pollen. The pollen then sinks, some of it falling on to the stigmas of the female flowers, bringing about fertilization. Fruits develop later and they are ellipsoidal in shape, 4 to 5 millimetres (0·16 to 0·2 inch) long, bearing three long spines, one of which is the persistent style. The fruit becomes black when ripe and contains one seed.

Hornworts are perennials and propagation occurs almost exclusively by vegetative means; by fragmentation of the plant and by the development of so-called 'winter leaves'. These are small, thick, terminal segments of the foliage which accumulate starch during the autumn, and later become detached from the plant. They overwinter in the pond and grow into new plants in spring.

Soft Hornwort, *Ceratophyllum submersum*, differs from Rigid Hornwort in having leaves which fork three or four times. It is a brighter green and softer in texture, being only sparsely covered in spines. The fruits have one spine only, the spine being much shorter than the fruit.

Hornworts occur throughout the world except in the colder regions.

Greater Bladderwort
Utricularia vulgaris (**1**)

The bladderworts are strange insect-eating, aquatic plants, found among the free-floating flora of lakes and ponds, usually where the water is rather poor in nutrient salts, such as in peaty pools on moorland. They float submerged just below the surface and have no true roots but the stems are branched and root-like, and the leaves are finely divided and bear many bladders (or utriculi) which catch small aquatic animals.

Greater Bladderwort occasionally produces flowers (**2**) which are golden yellow and are borne on long shoots that rise above the water during the summer. The flowers resemble those of the figwort family, Scrophulariaceae, the petals being fused into an upper and lower lip with a spur at the back. Globular fruits containing many tiny seeds are produced in the autumn but these are rarely found.

The bladders, no more than 3 millimetres (0·1 inch) in length, are ingenious devices for catching small aquatic animals, which subsequently die, decompose, and are then slowly digested by the plant. This additional nitrogen source makes up for food deficiencies in the waters frequented by bladderworts. Each bladder has an aperture at one end around which several stiff bristles project outwards into the water forming a kind of funnel. The aperture is closed by a hinged valve or trap-door which opens inwards (**3**). When small creatures touch the sensitive bristles (they are apparently attracted by mucilage glands near the entrance to the bladder) the trap-door opens and water rushes into the bladder, carrying the creatures with it. The trap-door then snaps shut and the animals eventually die. The inner surface of the bladder bears glandular hairs which digest and absorb the liquid containing the decomposing animal remains.

Bladderworts produce winter buds apart from reproducing vegetatively and forming fruits. These winter buds develop in late summer and autumn and are taken down to the bottom of the pond when the parent plant dies back and sinks. They remain there until spring when they become detached from the now disintegrated plant and, after expansion of the leaves and the development of air spaces, float to the surface to develop into new plants.

There are approximately 200 species of bladderwort distributed throughout the world, mainly in tropical regions. Greater Bladderwort is native to Britain and

1

2

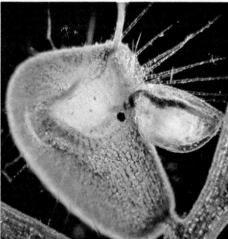

3

temperate Europe, Asia, North Africa, and North America where it grows in lime-rich waters. Lesser Bladderwort, *U. minor*, has a similar distribution but has smaller, paler flowers and usually grows in lime-poor waters in bogs.

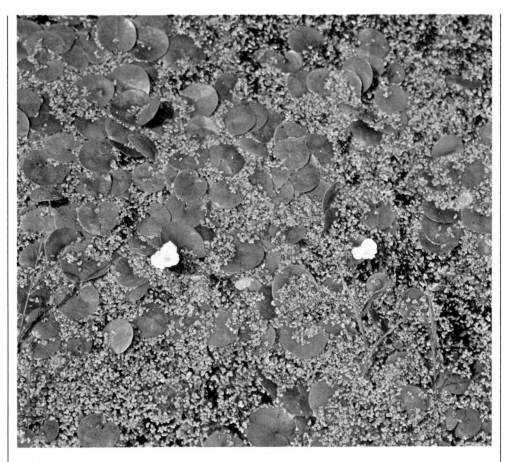

Water-soldier

Stratiotes aloides

This unusual plant is a member of the floating community in still waters of ponds and canals but is found only locally, and usually in calcium-rich waters. The name 'Water-soldier' refers to the very sharp, saw-edged, sword-like leaves which grow in a rosette from the short, stout stem. The scientific specific name, *aloides*, indicates that the plant resembles an aloe in form.

The plant is normally totally submerged just below the surface, where it often monopolizes its stretch of water to form a dense sward. From the base of the stem several long, unbranched roots hang down into the water and these are of great importance in balancing the plants. Some roots may terminate in a pad-like growth which reaches to the bottom mud, but most plants float freely, being rooted only temporarily when they are young seedlings. In the leaf axils buds are produced which develop into runners from which new plants (offsets) are formed. 'Winter buds' are also produced from the leaf axils.

In spring the plants rise to the surface so that their leaves project above the water. The white flowers, 3 to 4 centimetres (1·2 to 1·6 inches) in diameter appear in midsummer, male and female on separate plants. Each flower arises from within two leafy bracts and has three green sepals and three conspicuous, rounded, white petals which encircle the sexual parts in the centre. Male flowers are grouped together and are stalked with twelve fertile stamens surrounded by several sterile stamens. The female flowers are solitary and unstalked with a six-celled ovary in the centre.

Male plants are extremely rare in Britain and consequently the seed is not set. In places where male and female plants occur together, the female flower produces a ripe, egg-shaped fruit which projects horizontally from the two bracts and ripens underwater.

When flowering is over, the plants sink and become totally submerged once again and, as winter approaches, they drop right to the bottom of the pond where they remain until the following spring. In deeper water the plant is often permanently submerged

The floating and submerging of the plant is said to be caused by changes in the amount of calcium carbonate on the leaves. This can sometimes be seen as a white deposit and is produced by the

Frogbit

Hydrocharis morsus-ranae

Frogbit is locally common in ponds, canals, lakes, and ditches where it may cover large areas. It sometimes roots in shallow water but it is normally free-floating at the surface. The unbranched roots hang down into the water and may become closely matted when many plants are growing together. Each plant produces a rosette of long-stalked floating leaves, the blades about 4 centimetres (1·6 inches) in diameter and similar in shape to water-lily leaves.

The white, three-petalled flowers are borne, male and female separately, on the same plant. Male flowers are short stalked and are borne mostly in threes; female flowers have longer stalks and occur only singly. In many places only one sex is found and fertile seeds cannot then be produced. If the 4 to 8 millimetre (0·16 to 0·32 in) fruit forms, it ripens underwater and is berry-like, round to elliptical, with six ribs on the surface. It contains a lot of mucilage and bursts irregularly at the tip to release numerous small, rather spiny seeds about a milli-metre long.

The plants spread and reproduce mainly by vegetative means. Stolons grow out from the leaf axils and these produce new plants at their tips so that colonies of connected plants eventually build up. In the autumn other stolons, which hang down in the water, produce a different sort of 'winter bud' at their tip. These egg-shaped buds, 1 to 1·5 centimetres (0·4 to 0·6 inch) long, are rich in starch and, when ripe, they detach themselves from the stolon and sink to the bottom. They remain dormant until spring, when they become lighter as the starch reserves are used up by the developing embryo plant. They then float up to the surface and grow into new plants.

Frogbit is widely distributed throughout the Old World and has been introduced into North America. A similar species, *H. dubia*, is found in Australia.

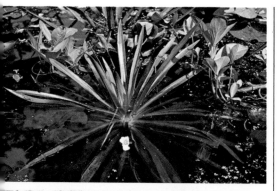

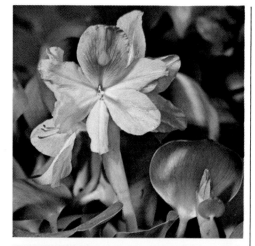

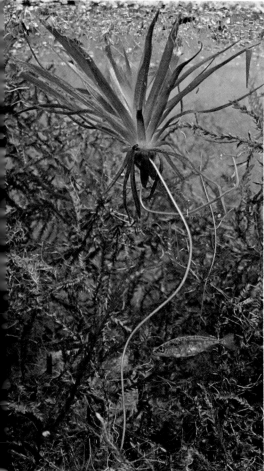

Water Hyacinth
Eichornia crassipes

Water Hyacinth is essentially a tropical freshwater plant. The plant is propagated vegetatively by runners which arise in the leaf axils and give rise to new plants which are then linked together, so that large, thick masses of vegetation soon build up. The plants are free-floating, from 10 to 30 centimetres (4 to 12 inches) tall, consisting of a cluster of leaves which rise well above the water surface, and numerous, slender, feathery roots which hang below and may reach from several centimetres to 1 metre (3·3 feet) in length.

The leaves vary in form depending on the growing conditions, but the leaf stalks are usually swollen and spongy, containing much air so that they function as floats. The leaf blades are broadly ovate (almost square in shape) with fine, longitudinal veins. The beautiful hyacinth-like flowers, pale lilac in colour, are borne in a terminal spike high above the water. Each flower has six petals, the upper one with a yellow, blue-bordered central blotch. The six stamens and female style and stigma project from the centre. Each flower opens for one day only and quickly withers. The flowers on one spike may open together.

Many minute, ribbed seeds are formed inside a three-celled capsular fruit, but this only happens in inflorescences which become submerged after their stalks have bent downwards. After the capsule splits open the seeds sink to the bottom and germinate on the mud. The seedlings soon break free of their rootstock and float to the surface.

In adverse conditions, seeds can remain viable for at least fifteen years, which aids the long-term success of the species.

Water Hyacinth was first described from Brazil in 1823 and, later, it was introduced into many countries for its beauty as an ornamental plant in garden ponds and water gardens. Unfortunately, because of its ability to proliferate and spread in stagnant or slow-moving water, it has become a serious pest in many warm and tropical parts of the world, blocking up waterways, impeding the passage of boats, as well as blocking irrigation channels, choking pumping stations, and obliterating fishing grounds.

Water Lettuce
Pistia stratiotes

The Water Lettuce is a tropical, free-floating plant, found in a wide variety of aquatic habitats.

The ovate, bluish-green leaves are densely hairy, 13 to 15 centimetres (5 inches) long, with parallel veins which are often strongly ribbed beneath. The leaves arise in a rosette from the short, floating stem which has several long roots hanging freely beneath it. The plant spreads by means of several short runners which radiate out, each to produce a new plant at its tip. The process is repeated until many connected plants develop, and these later separate as the runners break down.

The flowers are small and difficult to see, because they are hidden away inside the plant at the bases of the leaves. Each inflorescence consists of one female and several male, petal-less flowers enclosed within a whitish sheath-like leaf or spathe, about 2 centimetres (0·8 inch) long. Pollination is carried out by insects, as in other members of the arum family. Each inflorescence of *Pistia* bears only one fruit. The single fruits are 6 to 10 millimetres (0·2 to 0·4 inch) long, green and ovoid, with a beak-like tip. They usually contain many seeds.

Water Lettuce is common throughout the tropics and, in many regions, it has become a serious pest, because it multiplies rapidly and often completely covers the surface of ponds, lakes, and slow-flowing rivers. The plant is commonly used in garden pools and aquariums, and has been introduced in some temperate regions.

plants, during photosynthesis, as a result of the removal of carbon dioxide from water rich in calcium bicarbonate. Many small animals live in the leaf axils of the Water-soldier where they are well protected from fishes and other predators by the spiny leaves.

Water-soldier occurs in Britain, Europe, and north-west Asia as a native plant but elsewhere it has been introduced.

65

Duckweeds LEMNACEAE

Duckweeds are among the commonest
floating plants on ponds and sometimes
become so abundant that they cover the
whole surface like a green carpet. They
are among the most highly adapted of all
aquatic plants to life in water.

Each plant is only a few millimetres in
diameter and consists of a leaf-like frond
which is really a green stem, with one or
several long, thin roots dangling into the
water but not reaching the bottom. The
roots are used for absorbing water,
minerals, and other food substances, and
they also help to balance the plant. Tiny
flowers with no petals are occasionally
produced but only in shallow water
exposed to plenty of sunlight; it is rare to
find them. The plant reproduces mainly
by forming side shoots, which break off
and either float away or are carried to
new places on the feet of waterbirds.

Many waterbirds, including ducks, are
fond of eating duckweed or 'duck's meat',
as it is also called, and other small
animals in the pond may feed on it too.
The plants provide shelter for many small
animals, and several aquatic insects, such
as pond skaters or water boatmen, may
lay their eggs on the roots and on the
undersides of the floating parts.

If duckweed becomes too abundant in a
pond, however, it can be harmful to the
creatures living below because it cuts off
the supply of air and light and may also
use up too many of the nutrients, such as
calcium, which are vital for other plants
and animals.

Some species of *Lemna* seem to thrive in
very foul water with a high organic
content – too poor in oxygen for many
animals to survive.

As winter approaches, smaller
duckweed fronds with undeveloped roots
are produced; these accumulate starch
reserves, sink to the bottom under their
own weight, and remain there throughout
the winter. In spring, as the starch
becomes used up in respiration, and air
spaces develop in the tissues, the fronds
become lighter and float to the surface
again. These winter buds are of great
importance for the survival of the species,
because flowers are rare and seeds not
often produced. There are about ten
species of *Lemna* known throughout the
world, and most of them are widespread.

Common Duckweed, *Lemna minor*, (**1**)
is the commonest species, with round or
egg-shaped, swollen green fronds, about
2 to 3 millimetres in diameter. Each frond
bears one root only on the underside.

The fronds of Greater Duckweed, *Lemna*

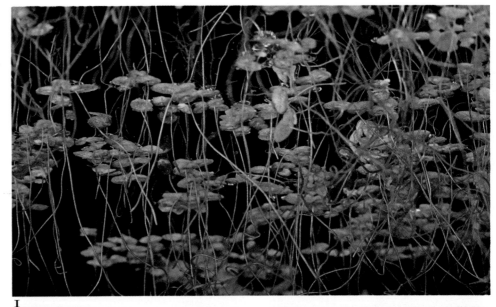

1

2

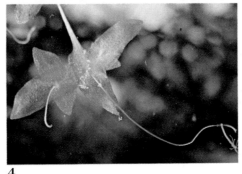

3

4

5

polyrrhiza, (**2, 3**) are circular and about
5 to 8 millimetres (0·2 to 0·3 inch) in
diameter, green above and violet or
reddish on the underside. A tuft of roots
hangs down below each frond. This is one
of the commonest species in the world and
is found in most countries except Africa.

Ivy-leaved Duckweed, *Lemna trisulca*,
(**4**) spends most of its life completely
submerged and only floats at the surface
during flowering. The elliptical, leafy
fronds bear one root only and taper
at one end into a stalk. The ivy-leaf

appearance occurs when two new fronds
develop, one on each side of the original
frond. These fronds often stay attached in
groups.

The Rootless Duckweed, *Wolfia arrhiza*,
(**5**) is one of the smallest known
flowering plants with a diameter of only
0·5 to 1·0 millimetres. It usually occurs
among other duckweeds and has rather
swollen fronds. There are no roots and it
is extremely rare to find flowers. The
plant is widely distributed in most sub-
tropical areas of the world.

Algae

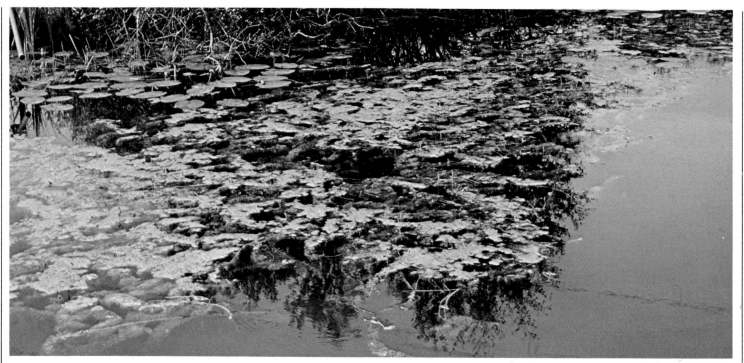

The algae are the simplest forms of plant life and are widely distributed over the Earth, often occurring in vast numbers and usually in aquatic conditions. The majority lives in the sea where the larger species are known as seaweeds; some of these can grow up to 100 metres (330 feet) in length. A large variety of smaller types can be found in freshwater habitats, however.

Many of the algae which live in pond water are no bigger than a pin head, while some are so small they can only be seen individually under a microscope. They may be composed of one cell only, or of irregular masses of cells, while other larger species are made up of filaments of cells placed end to end in a single row. The most advanced and complicated species are the stoneworts which are comparable in size and form to higher plants. Stoneworts are found rooted in the submerged plant zone and have been described under that section.

Most algae have a simple structure with no differentiation into the leaves, stems, and roots that occurs in higher plants. They all possess the green pigment chlorophyll in their cells although, in some algae, this is obscured by the presence of other pigments so that they appear blue-green, red, or brown. Like higher plants they are able to manufacture food and build up living material from simple chemical substances by photosynthesis using the energy from sunlight. In warm, favourable conditions algae can multiply so fast in a pond that the water turns green (or blue-green). Many tiny animals feed upon them, and these in their turn are food for larger animals in the community. Thus, the algae are an important primary food source for living creatures in the pond.

The classification of algae into different groups is based on their colour differences and metabolism as well as on other important differences in structure, development, and life history.

Their number and the variety of species may vary greatly from one pond to another depending upon the chemical composition of the water, its temperature, and on light conditions. There may also be a seasonal change of forms. In summer, for instance, green and blue-green algae usually predominate while diatoms are the most abundant in winter.

Blue-green algae
CYANOPHYTA

The blue-greens are the simplest and the most primitive of all algae, considered by many biologists to be more closely related to bacteria than to other algae.

Their characteristic colour is caused by the presence of a pigment, phyco-cyanin, although other pigments may also be present giving the violet, brown, or yellow appearance seen in some species. Unlike pigments in most plants, these are evenly distributed in the protoplasm and not organized into chloroplasts within each cell. The cells are simple in structure with no distinguishable nucleus. Reproduction takes place mainly by simple cell division and no sexual method seems to exist.

When conditions for growth are favourable (usually in late summer and autumn) some species of blue-green algae multiply rapidly to form large floating masses or 'blooms' at the surface of lakes and ponds (1). They are buoyed up by bubbles of gas within the cells, and often produce foul-smelling and poisonous substances which are harmful to aquatic animals in the pond. These blooms may also cause oxygen deficiencies in the water. (Some green algae, such as *Botryococcus* spp, are also known to form blooms.)

There is a great variety of shapes among the blue-green algae. Some species are unicellular, but many consist of cells grouped together into gelatinous, colonial masses, or into long filaments which may appear like strings of beads or smooth threads. In some filamentous types, the cells are roughly similar, while in others there is a marked differentiation into a foot and a tip. Most species are immobile although some filamentous forms show strange gliding and undulating movements in the water.

Some species float freely among the plankton of the pond, but many attach themselves to stones, twigs, and other submerged plants where they can often be detected as a bluey green slime.

Blue-green algae are widely distributed throughout the world, occurring in such extreme and unlikely situations as the areas around hot thermal springs, and the ice of glaciers. They are often the first plants to colonize such barren habitats because they can use atmospheric nitrogen to build proteins.

1

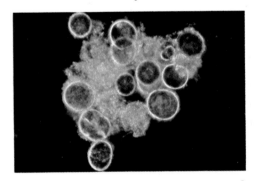

2

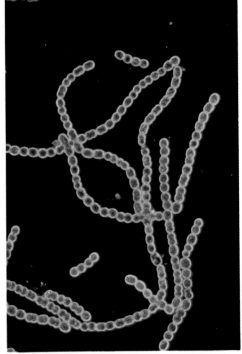

The cells of *Chroococcus* spp (2) occur singly or in pairs, fours, or more depending upon how many times the original cell has divided. The blue-green or brownish contents are surrounded by a tough, sheath-like outer coat. It is found more commonly in boggy pools. ×200.

Anabaena oscillarioides (3) is a filamentous blue-green alga looking rather like a string of beads. It is commonly found floating in the plankton of lakes and ponds. Each cell measures only 10 microns across.

3

Yellow-green algae
CHRYSOPHYTA: XANTHOPHYCEAE

In these algae the yellowish-green colour of the chloroplasts is caused by an excess of the pigment β-carotene, and starch is replaced by oil or an insoluble carbohydrate called leucosin as the normal food storage material.

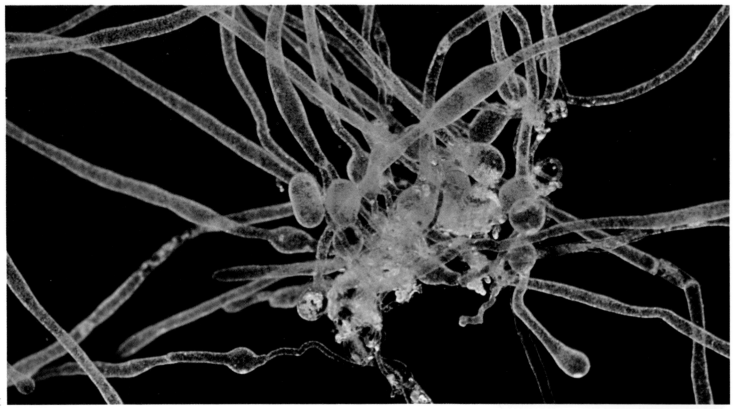

1

The siphon alga, *Vaucheria* sp, (1) is rather uncharacteristic in being bright green in colour. It is a filamentous alga, commonly found in stagnant or slow-moving water and usually in temperate climates, unlike many other yellow-green algae which are tropical.

The plant consists of long, green, irregularly branching filaments which have no internal cross-walls and are not divided up into a number of cells. Each strand is, in fact, one long tube, hence the name 'siphon alga', and the many nuclei and small chloroplasts are scattered throughout the protoplasm.

Vaucheria occurs in dark-green, mat-like masses, its filaments, rough to the touch, arising from a colourless basal portion which lies on the mud of well-aerated ponds, or even on the damp earth nearby.

The plant reproduces vegetatively by means of fragmentation of the filaments. When conditions are favourable it also produces spores asexually. The ends of some of the branches swell out and become divided off from the rest of the filament by a cell wall. The cell contents darken and form into a motile spore, bearing many hair-like flagella. This eventually bursts forth and swims around for a short time, by means of the flagella, before finally settling down on the mud and developing into a new plant.

Sexual reproduction also occurs, usually in unfavourable conditions. The male and female sex organs (2) develop, close together on the same plant, from the cell wall. The yellow, rounded structures are the female bodies or oogonia, each containing one egg cell. The other curved, tube-like structure between them is the male organ or antheridium. From this, many motile male cells are freed which swim to the egg cell and fertilize it. The resulting zygote develops into a thick-walled resting spore, able to withstand the unfavourable conditions of drought or cold. When these are past it germinates directly into a new plant.

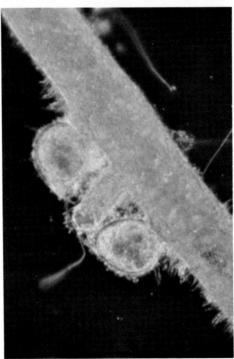

2

Diatoms
BACILLARIOPHYCEAE

Diatoms are microscopic, single-celled algae in which various brownish-green pigments mask the colour of the green chlorophyll which is also present. The chloroplasts are very conspicuous in the living cell and vary in shape and number in different species.

Diatoms occur in abundance in ponds, either as free-floating members of the plankton community or attached (but not parasitic) on to other algae and higher plants. They also occur in large numbers on the bottom flora and the surface of the mud where they often form a brownish, slimy covering. Some diatoms are found singly while others are grouped together into chains or filaments, usually held together or enclosed in a slimy, gelatinous envelope.

Under a microscope the individual cells are a beauty to behold. The cell walls are composed of silica, a hard flinty substance, which is virtually indestructible and, on the death of the diatom, does not decay but remains as a glass-like skeleton. These outer cell walls are often beautifully sculptured into fine lines, pits, or projections which vary between different species. Each diatom cell is formed of two halves or 'valves', one of which fits over the other like the lid of a box. The sides of the box, where the two valves overlap, is called the 'girdle', and the appearance of the diatom will obviously vary greatly according to which way on it is being viewed.

Reproduction occurs mainly by cell division, normally at night. The two valves become pushed apart, the cell contents separate, and a new valve is then produced on each of the two new cells. Sexual reproduction takes place on rare occasions when two individuals merge together to form an auxospore, which ultimately develops into a new diatom.

In favourable conditions diatoms reproduce rapidly and, as a result of their photosynthesis, help to augment the oxygen supplies in the water. The product of their photosynthesis is not starch, as it is in most green plants, but a fatty oil which accumulates in the cells. This constitutes a valuable food supply for many pond creatures and, in spite of their hard, indigestible covering, diatoms are eaten by many of the smaller aquatic animals.

Diatoms are divided into two orders: the Centrales, with a circular shape; and the Pennales which are elongated and often boat shaped.

In all the pictures of diatoms shown here, the cells have been specially treated to show the fine sculpturing and ornamentation on the cell walls. Living cells look very different; the inner contents show more clearly but the detail of the walls is obscured by this and also by the layer of slime which usually covers the outside of the living diatom.

CENTRALES

Here is a diatom of the Centrales group (1), found in freshwater habitats in North America. The walls are covered with many spots or pits, and a ring of spines projects from around the edge. In many of these disc-shaped diatoms the chloroplasts are numerous, discoid, and scattered throughout the cell.

Very few members of this group are freshwater species, although *Melosira* sp (2) is one which is commonly found in ponds and ditches. The circular cells, with valves that bear very fine spots or spines, are usually found joined together in short filaments, from 5 to 100 microns in diameter. The living cells contain numerous brown chloroplasts.

PENNALES

These elongated diatoms are notable for the absence of spines or projections although they have other characteristic markings. Most species have a long slit-like groove, called a raphe, running along their length and actually opening through the cell wall. This seems to be associated with movement because these diatoms are capable of gliding or of moving along in the water in a jerky fashion. No one understands fully how this movement occurs but it is thought to be associated with the production of a film of mucilage around the diatom. Most diatoms belong to the Pennales and several freshwater species are illustrated here. The chloroplasts cannot be seen in the pictures but, in most species, they consist of two or more long, plate-like structures situated on either side of the raphe towards the outer edges of the cell.

Navicula sp (3) is a boat-shaped diatom with pronounced ridges on the valves. There are many species varying from 2 to 200 microns in length, often creeping on the mud in ponds and other freshwater habitats.

Pinnularia sp (4) is larger than *Navicula* at 20 to 400 microns. It has blunt, rounded ends, and thick striations along the valve walls. It is found on the mud of ponds, lakes, and rivers

Diploneis sp (5) is another boat-shaped species very like *Navicula*, but more dumb-bell shaped. It occurs in similar situations to *Navicula*.

Pleurosigma sp (6) diatoms are recognized by their beautiful s shape. They can be up to 200 microns long and live on the mud of ponds and lakes.

The colonial diatom, *Fragilaria* sp, (7) consists of many narrow, rectangular cells which form long, flat, filamentous chains. It is common in ponds and ditches.

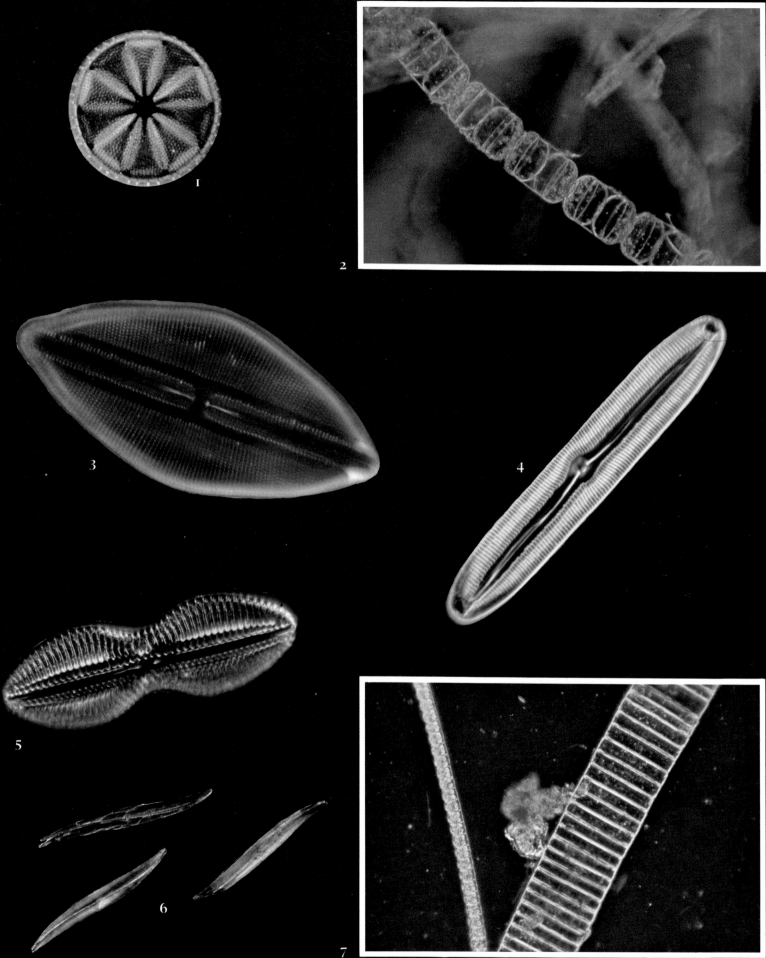

Green algae
CHLOROPHYTA

The green algae are well represented in the pond habitat by several diverse types. The simplest forms are single cells; others consist of aggregated groups of cells, some with a gelatinous covering, some in the form of hollow spheres, or flat plates of cells, or filaments of cells joined end to end. In the green algae the chlorophyll in the cells is not masked by other pigments, and so they appear green in colour. Starch is usually formed as a result of photosynthesis and this accumulates round special bodies called pyrenoids, in the chloroplasts.

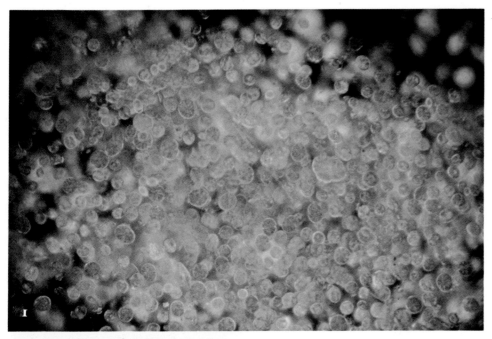

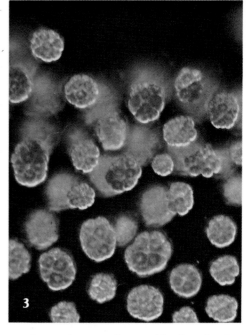

Chlamydomonas sp is one of the simplest single-celled green algae, and is commonly found in almost any body of standing freshwater. This picture (1) shows a mass of individuals in a tiny drop of pond water, magnified about 100 times. Each ovoid cell is, in fact, motile and, under higher magnification (about 400 times) two whip-like flagella can be seen at one end. These beat vigorously and propel the organism through the water. A red eye spot is situated near the flagella. The large dark body at the opposite end of the cell is the pyrenoid. The cell wall is smooth and thin (2).

Chlamydomonas multiplies rapidly and can soon turn the water green. Reproduction is mainly asexual, the cell contents dividing into two to eight separate cells, which are then released from the parent cell as free-swimming individuals. Sexual reproduction occurs on some occasions; here individual cells divide up within to form a large number of tiny bodies. These escape from the original cell and then fuse together in pairs to form zygotes. They develop tough outer cell walls and become resting spores resistant to adverse conditions. When

conditions become favourable they divide inside into a number of zoospores which are released and become new motile *Chlamydomonas* individuals.

Pandorina sp is commonly found in ponds, ditches, and puddles. It consists of an oblong or spherical colony of cells, usually sixteen in number although there may be from four to thirty-two cells depending on the species. The colonies can be up to 50 microns in diameter. The cells are packed tightly together and appear rather flattened (3). They are connected to each other by very delicate strands of protoplasm, but there is no large central space, as there is in the next species, *Volvox* sp. Each colony is enclosed in a gelatinous substance with an outer watery sheath and seems to move through the water with a definite 'front' and 'back' end. Each cell has two long flagella as in *Volvox*. The colony reproduces asexually by first becoming non-motile and sinking to the bottom, after which each cell divides several times to produce a daughter colony within the parent. The parent eventually disintegrates to release the new motile daughter colonies.

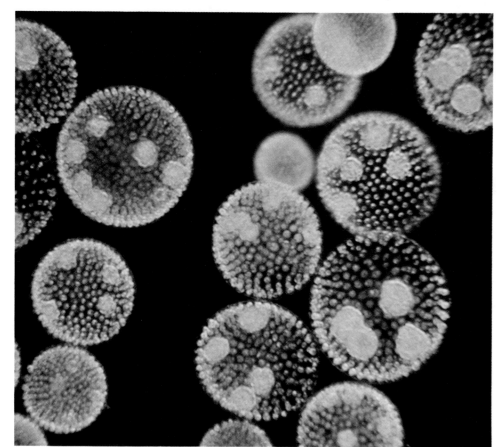

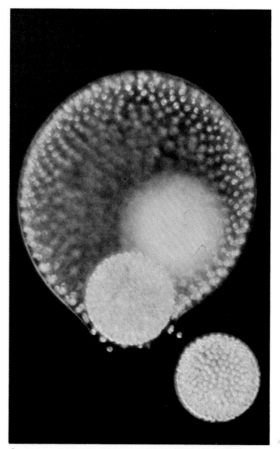

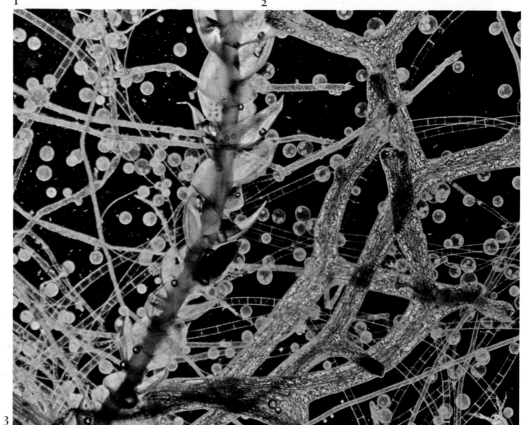

Volvox sp (**1**) is about 0·5 millimetre in diameter and just visible to the naked eye. It is made up of a large number of tiny cells arranged in the form of a hollow sphere. The cells are held together by a jelly-like substance and are connected to each other with thin strands of protoplasm.

Each cell has two whip-like flagella which project into the water, beat to and fro, and cause the whole sphere to revolve and move slowly through the water. New individuals are formed when certain cells enlarge, lose their flagella, and start to divide, eventually producing small, hollow spheres of cells with a pore at one side. When cell division stops, the small spheres turn inside-out and flagella are formed. These young daughter colonies hang down into the parent cavity and, when mature, break away to float inside or, alternatively, burst out to the exterior (**2**). Those retained within are eventually released through the wall of the parent colony and float off to start a new life of their own. If the parent takes a long time to break open it is sometimes possible to see up to four generations inside one parent colony.

Sometimes male and female reproductive bodies are formed inside the parent. Eggs and sperm are released into the water, where fertilization occurs. The resulting zygotes develop into resting spores with reddish-brown contents and thick outer walls. These grow into new colonies when circumstances become suitable.

The picture (**3**) shows many tiny *Volvox* colonies among other plants including a filamentous green alga, the leafy fronds of Crystalwort, and a piece of Willow Moss.

73

Desmids DESMIDIALES

The desmids are a specialized group of single-celled green algae rather similar to diatoms in size and diversity of shape. Like diatoms, they are amazingly beautiful when viewed under the microscope. Their cells seem to be composed of two halves, but in fact, are merely constricted across the middle of the cell.

Spines or other projections often arise from the thin cell wall, and these may function as an antipredator device, making them unpalatable to the minute animals likely to feed on them. As in other green algae, chlorophyll is the only pigment contained in the chloroplasts and starch is formed by photosynthesis.

Most desmids are free floating although some do become attached to other plants by the coating of mucilage which surrounds them. They are commonly found on the surface of the mud and on submerged water plants, where their presence may be seen as a green film. They are exclusively freshwater plants occurring most commonly in soft (acidic) or peaty waters, although a few tolerant species can survive in hard calcareous waters. There are many different species.

Desmids reproduce vegetatively by dividing into two at the constriction point. Sexual reproduction also occurs from time to time, whereby two individuals merge together becoming surrounded by a layer of mucilage. The cell walls break open and the contents unite to form a zygospore, which is very resistant to adverse conditions and gives rise to one or two new desmids only when conditions are favourable. The zygospores are usually round, covered in spines and very characteristic in appearance.

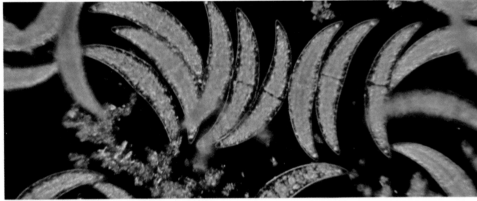

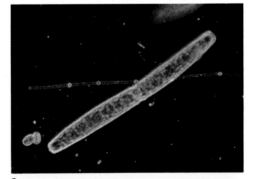

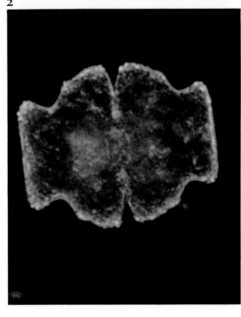

Closterium sp, the crescent-shaped desmid, (**1**) is widespread and common in many kinds of ponds. There are many holes or perforations usually arranged in rows in the cell walls, and mucilage is secreted through large pores near each apex of the cell. It is thought that this is responsible for the desmid's ability to move itself slowly through the water. The clear spots at either end of the cell are apical vacuoles of unknown function. They contain crystals of gypsum (calcium sulphate) which, under a microscope, can be seen to move around. Recently, crystals of barite or barium sulphate ($BaSO_4$) have been found – they are thought to be used as gravity sensors. Some biologists believe that these vacuoles may play a part in the excretion of waste products from the cell. The centre of the cell is mainly taken up by the long axial chloroplast. The pyrenoids can be seen as dark spots along its length. Some species of *Closterium* have relatively large, conspicuous, crescent-shaped cells reaching nearly 1 millimetre in length. Others, particularly the floating, planktonic ones, may be much smaller, thinner, and almost straight.

Pleurotaenium sp (**2**) is a straight, blunt-ended desmid which can be up to 1 millimetre in length. It is only slightly constricted at the centre and the walls in this region are characteristically wavy. It is usually found in boggy places.

Euastrum sp (**3**) is common in acid pools and boggy places, often among the bog moss, *Sphagnum.* The cells are somewhat flattened with angular lobes and the ends are often deeply notched. The cells are from 10 to 200 microns long.

Filamentous green algae
ZYGNEMATALES

Spirogyra sp (**1**) is a well-known green alga of the filamentous type, its long, unbranched threads forming soft, green, hair-like, floating masses in almost any body of still freshwater. Under the microscope it can be seen that each separate strand is made up of a single row of cylindrical cells joined end to end. Within each cell the chloroplasts can be seen as spiral bands and, sometimes, the starch grains, formed as a result of photosynthesis, can be observed scattered along these bands where they form around the pyrenoids.

The filaments of *Spirogyra* are covered with mucilage which makes this alga slimy to the touch unlike a filamentous alga such as *Vaucheria* which is hard and rough in texture.

Any of the separate cells in a filament is apparently able to divide into two increasing the length of a plant. The filaments commonly fragment and reproduce by vegetative means. Sexual reproduction also occurs (usually in spring and summer) by a process called conjugation when two adjoining filaments come together. Their opposite cells develop swellings which enlarge, meet, and eventually fuse together. The dividing cell wall breaks down and through this conjugating tube the contents of one cell passes into the other and fuses with it(**2**). An oval, thick-walled, orange spore (zygospore) is formed which is eventually released on

1

2

the disintegration of the surrounding cell walls (**3**). This develops into a new *Spirogyra* plant when conditions are favourable. It may germinate almost at once (accounting for the abundance of plants in autumn) but usually remains dormant until the following spring. A similar kind of spore may be formed in the cells of a plant that has not conjugated, another form of asexual reproduction.

3

Spirogyra is a valuable oxygenator of stagnant waters. It can, however, also be a nuisance when it forms dense masses which choke up the habitat and prevent the growth of other plants in the pond.

Red algae RHODOPHYTA

Most of the red algae are marine, and familiar to many people as the red seaweeds found in rock pools and on the seashore.

There are relatively few freshwater genera and these are usually brown or blue-green in colour, rather than the definite red of the many marine types. The main pigment is phycoerythrin, often masked by other pigments such as phycocyanin. Some genera such as *Asterocytis*, are epiphytic on other algae.

Batrachospermum sp is often encountered in freshwater habitats. It is often called the frog spawn alga or bead moss because it appears as a mass of branching, tiny strings of beads bearing some resemblance to frog spawn. These strings are highly organized brownish-green filaments, up to several centimetres long, usually attached at one end to submerged stones, twigs, or other substrates. Under a lens it can be seen

that the 'beads' consist of whorls of tiny filaments and, among them, there are often dark, round bodies containing spores. These are formed as a result of sexual reproduction and, when released, give rise to new plants. In common with all other red algae, there are no motile reproductive cells. *Batrachospermum* can also reproduce asexually by forming different types of spores.

FUNGI

The fungi comprise a large group of primitive, flowerless plants varying greatly in size and shape from the one-celled yeasts through a wide range of moulds, mildews, smuts, and rusts to the larger toadstools, puffballs, and so on. The types that occur in ponds are usually referred to as water-moulds and they can be found growing on dead or living plants and animals, often appearing as white and rather fluffy patches.

Fungi do not possess chlorophyll so that they are incapable of manufacturing their food by photosynthesis. To survive, they have to obtain their food by living as parasites on living organisms or as saprophytes on the dead remains of living organisms. The absorption of nutrients from their host takes place through microscopic tubular threads or hyphae which interweave like a cobweb in and around the host and make up the body or mycelium of the fungus. These hyphae, which penetrate the host tissue, produce chemicals called enzymes which break down the complex organic material into an easily digested form.

Sometimes the tips of some hyphae become darker in colour and often slightly swollen. They develop into bodies called sporangia, which become separated from the rest of the mycelium by cross-walls. The sporangia burst open to release large numbers of tiny, free-swimming spores which grow into new plants as soon as they find a suitable substrate. Sexual reproduction also occurs, resulting in larger, thick-walled, and more resistant types of spores, which can survive adverse environmental conditions.

The Saprolegniales is one of the commonest groups of water-moulds. Most of them are saprophytic and they perform a useful function in the pond by breaking down dead plant and animal remains.

Other types are parasitic, and may cause disease and even death of the animals and plants they live on. Some species attack freshwater fishes, entering the skin wherever there has been some slight wound or bruise and eventually producing the fluffy white fungus growth, often seen on parts of the body. This can spread until quite large areas are covered and may eventually cause death. Goldfish and other fishes of garden ponds and aquaria often become infected and the disease can cause havoc in trout waters.

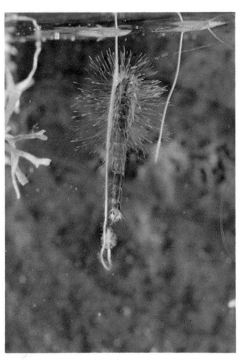

This picture shows the radiating hyphal threads of a saprophytic fungus which is growing on the dead and empty case of a midge pupa. The adult midge has emerged from this to take up its aerial life above the surface of the water.

BACTERIA

Bacteria are traditionally classified as simple plants but are sometimes thought to belong to a separate kingdom, neither animal nor plant. They are among the smallest known organisms, from 0·5 to 5 microns long, and countless millions of them inhabit the soil, air, and water, as well as the bodies of living things. Naturally, they occur in ponds and here, together with fungi, they play an essential part in the decay and disintegration of dead animal and plant life by breaking down the complex organic substances of these into simpler nutrients which are released into the water becoming available for metabolism by plants. Food supplies are therefore kept in circulation and there is very little waste.

Bacteria are single-celled organisms with a very simple structure, consisting of a central area of protoplasm surrounded by an outer membrane. There is no distinguishable nucleus. They are commonly rod shaped (bacillus) although there are spherical (coccus) and spiral (spirillum) shapes, too, and some of the coccus types occur in groups or chains. Most bacteria are incapable of movement and depend on currents of air or water for dispersal. Some species, however, have tiny flagella projecting from the cell membrane and these, by vigorous lashing, can propel the organisms through the water.

Bacteria multiply rapidly by simple cell division into two. Some species also occasionally form spores. These are extremely resistant to drought or other adverse conditions and can survive for months or even years before becoming active. They are lighter than dust and may be widely dispersed by the wind before settling.

Chlorophyll is never found in bacteria although some species of sulphur bacteria contain a photosynthetic pigment (blue, purple, brown, or red) which is used to convert simple chemical materials into living matter. Most bacteria are unable to carry out photosynthesis, however, and obtain their food by breaking down the organic matter of living or dead creatures, feeding either as parasites or saprophytes. In both cases the bacteria produce special enzymes which convert the complex organic substances into simpler nutrients, some of which they absorb and the rest they release into the surroundings.

Parasitic bacteria can, of course, be harmful causing disease and death of the creatures they live on. The saprophytic ones, however, which are free living and able to obtain their food from the decomposition of dead tissues, are usually beneficial and of vital importance to the cycle of life in a pond. It is their metabolic activities we shall consider here.

Most bacteria need oxygen for their metabolism although some can live without it and others can only survive in the absence of oxygen.

Certain types of aerobic bacteria, those which can only survive in the presence of free or dissolved oxygen, are responsible for the initial breakdown of dead organic tissues into simple inorganic substances such as water (H_2O), carbon dioxide (CO_2), nitrate ($-NO_3$), sulphate ($-SO_4$), and phosphate ($-PO_4$). Oxygen is used up in the process and this may become seriously depleted in the water. Under certain conditions the decomposition of any remaining organic matter may be carried out by anaerobic bacteria, those which do not require free oxygen, resulting in end products such as methane or marsh gas (CH_4), ammonia (NH_3), and hydrogen sulphide (H_2S). Hydrogen sulphide gives off a characteristic smell of rotten eggs, while bubbles of marsh gas can often be seen rising to the surface, sometimes igniting to produce a ghostly flame known as 'will-o-the-wisp' and 'jack-o-lantern'.

Some of the compounds produced by these anaerobic bacteria are extremely poisonous to life in the pond and others may be a nuisance to man. Certain types of sulphur bacteria occur in large masses in ponds. Some are capable of breaking down hydrogen sulphide to form sulphur, others of oxidizing sulphides to sulphates and sulphuric acid which causes corrosion of iron and steel pipes. Various types of 'iron' bacteria can, if present in abundance, create havoc by clogging up filters and the inside of iron water pipes in reservoirs and waterworks. The iron bacteria occur in stagnant, badly oxygenated waters containing iron. They obtain their energy by oxidizing the ferrous salts in water to form a rust-like precipitate of ferric hydroxide, which accumulates around them. Aggregations of these rusty red, filamentous bacteria can easily be seen covering stones, submerged plants, and the bottom mud of such ponds. Other kinds of 'iron' bacteria form the iridescent 'oily' patches which occur on the surface of some pools and puddles.

This picture shows a mass of rod-shaped bacteria seen under a high-power microscope, magnified about 800 times.

The darter dragonfly uses a convenient perch as a launching pad from which to pursue passing prey. The large eyes, strong grasping legs, and rapid flight enable the dragonfly to capture other insects on the wing. The immature stage is spent underwater where the nymph relies on stealth and camouflage to approach and seize unsuspecting insects, tadpoles, and baby fishes.

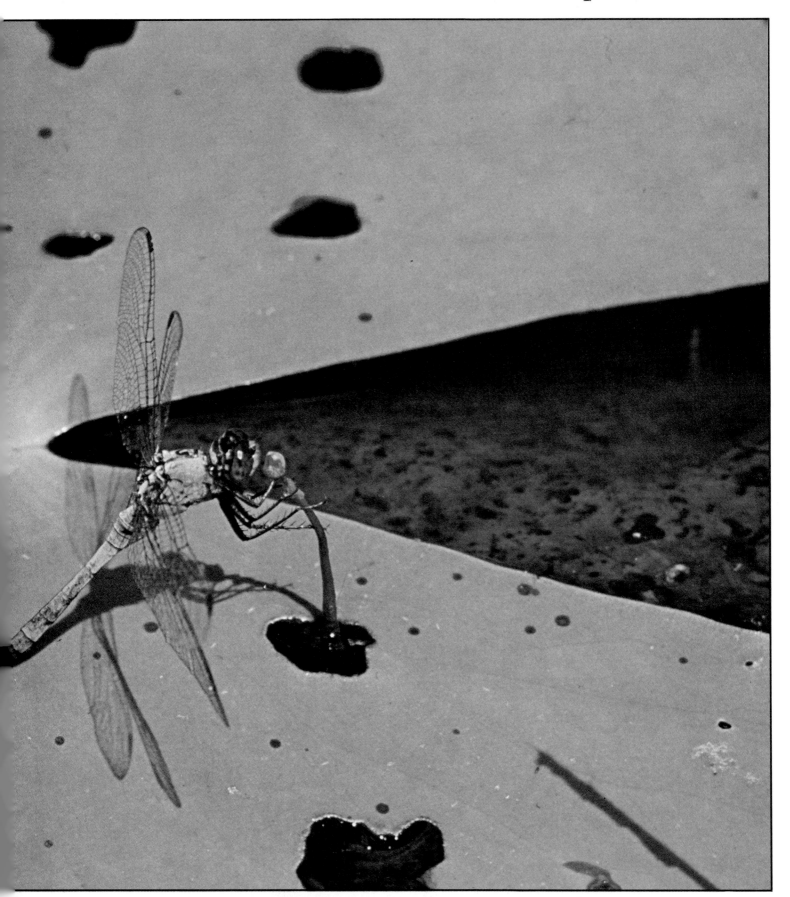

Breathing

All pond animals must obtain oxygen to survive. Unlike green plants, they cannot produce oxygen within themselves and store it in their tissues, so they have developed various ways to obtain it either from the atmosphere or from the water itself.

Fishes have the most intricate system for obtaining dissolved oxygen from the water. A fish closes its mouth after taking in water and expels the water past the gills and out through the gill slits on the side of the head. The gills are copiously supplied with blood vessels and, because blood and water are circulating rapidly, the exchange of gases is rapid and efficient; oxygen enters the blood and waste carbon dioxide diffuses into the water.

Some amphibians and reptiles spend much of their time in the water but they have retained lungs and nostrils, and are dependent on atmospheric oxygen. The nostrils of frogs are somewhat raised, and turtles' noses may be long so that both kinds of animal can obtain oxygen without revealing their presence. Similarly, the Spectacled Caiman, *Caiman crocodilus*, can remain largely submerged.

The abdomen of rat-tailed maggots, *Eristalinus* spp, has a telescopic extension which contains the two large breathing tubes so that their openings can be taken to the surface while the grub remains in the mud 75 millimetres (3 inches) below. This enables the larva to live in stinking mud of low oxygen content. Water scorpions, *Nepa* spp, also have long thin extensions to the abdomen which are poked through the surface when the insects crawl backwards up weed but, in this case, the respiratory siphon is not extensible.

Many insects collect a bubble of air at the surface, stay below until it is exhausted, then dart quickly to the surface to renew their supply. The Great Diving Beetle, *Dytiscus marginalis*, hangs head down while it takes in air, which it carries beneath the wing covers whereas the Great Silver Water Beetle, *Hydrophilus piceus*, rises to the surface head first and uses a modified antenna to conduct air to the reservoirs where it remains trapped among fine hairs. For insects such as *Hydrophilus* or the backswimmer, *Notonecta*, the bubble or film of air behaves as a physical gill and enables the insect to remain submerged for much longer than *Dytiscus* can. As oxygen is removed from the bubble more of the gas diffuses into it from the outside. In the same way the insect expels carbon dioxide which diffuses out of the gill into the surrounding water. Gradually the nitrogen present escapes into the water and the bubble diminishes in size so that periodically it has to be replaced at the surface.

Most immature stages of insects, as well as the adults, contain a network of tubes called tracheae to conduct oxygen to all parts of the body. In nymphs and larvae that obtain their oxygen from the water there are no respiratory openings to the outside; oxygen diffuses from the water into the tracheae through the thin body wall. The larva of the phantom midge, *Chaoborus*, respires in this way by gaseous exchange with the surrounding water through the skin. In nymphs of damselflies and mayflies, and the larvae of caddisflies, the area for gaseous exchange is increased by feathery or flattened extensions to the body which contain tracheae. Damselflies have three flattened, leaf-like tracheal gills at the tail end. Mayfly nymphs have feathery or plate-like tracheal gills on the abdominal segments. Most nymphs of caddisflies also have abdominal outgrowths, and those that live in cases undulate the body to maintain a flow of water past the gills.

Some insect larvae do not have a tracheal system at all and respire by means of gaseous exchange between the surrounding water and the blood system through the thin body wall. Pouch-like gills filled with circulating blood may be present to increase the surface area through which oxygen and carbon dioxide are exchanged. Insect blood is normally colourless, but some midge larvae

1 a Great Silver Water Beetle, *Hydrophilus piceus*, uses modified antennae to conduct air to the reservoirs
2 water scorpion, *Nepa* sp, takes in air through an elongated pair of appendages at the end of the abdomen
3 the Great Diving Beetle, *Dytiscus marginalis*, hangs head down from the water surface and takes in air which it carries beneath the wing covers
4 a rat-tailed maggot, *Eristalinus* sp, takes in air through two large breathing tubes contained in an extension of the abdomen
5 the phantom larva, *Chaoborus* sp, breathes through its skin by gaseous exchange with the surrounding water
6 a newtpole has external gills

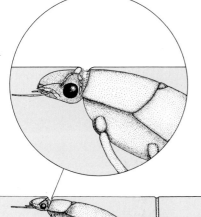

(Chironomidae, pages 186–89) are bright red because their blood contains haemoglobin, the same pigment found in human blood. Haemoglobin combines very rapidly with oxygen, and its presence enables bloodworms to live in water where the supply of oxygen is poor, as in farmyard ponds rich in decomposing organic matter.

Some insect larvae and pupae have evolved a very interesting method of obtaining air by tapping the air spaces between cells in the roots and stems of water plants. This solution to underwater respiration has arisen independently in several different kinds of insect. Three different families of fly have representatives in Britain that tap plants for air, but the chrysomelid beetle, *Donacia*, is the easiest example to find. The larva has a pair of dagger-like terminal spiracles that it stabs into air spaces in the roots of plants such as the Reed Sweet-grass. The pupa, concealed inside an oval brown cocoon which the larva attaches to a root under water, draws air from the plant in the same way.

The water spider, *Argyroneta* sp, has a unique method of building up a store of air. Having spun a loose silken canopy between the stems of submerged plants, it carries down bubbles of air from the surface and releases them below the bell. Silk is added until there is plenty of air space inside in which the spider can feed and mate and, in the case of a female, construct her egg cocoon.

Finally, there are many small animals that are either so minute, as in the case of the protozoans, or are so flattened, as in planarians, that gaseous exchange can take place through the surface without any need for special adaptations.

Some small pond animals cheat, as it were, by living in the pond under conditions normally only found in a river, where the running water makes oxygen more readily available. The spongefly, *Sisyra* spp (page 160), feeds on the freshwater sponge surrounded by flowing water. The current is caused by the

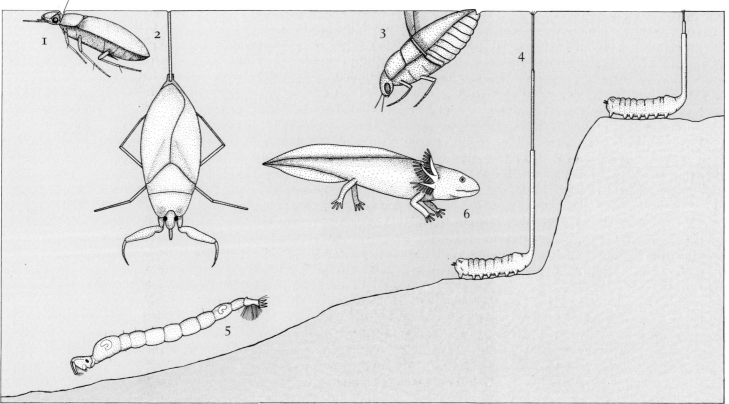

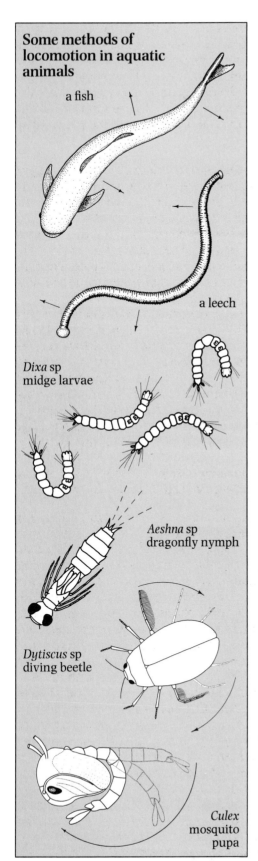

Some methods of locomotion in aquatic animals

a fish

a leech

Dixa sp
midge larvae

Aeshna sp
dragonfly nymph

Dytiscus sp
diving beetle

Culex
mosquito
pupa

beating of tiny flagella in the cavities of the sponge as it draws water into itself through many small apertures before expelling it through a few large pores. The watermite, *Pentatax* spp, (page 125), lives in the mantle cavity of the freshwater mussel, and it, too, benefits from the current of water circulated by the action of the cilia on the large curtain-like gills.

Swimming

Not all pond animals can swim; many spend their lives crawling about on the bottom or among the vegetation. The buoyancy of water reduces the effect of gravity, and pond animals use little or no energy in supporting their weight. Those that can swim do so by pushing against the water in a number of different ways.

Fishes are the masters of their element, but then they have known none other. The body flexes sideways back and forth like a spring and the waves of muscular contraction mean that at any point in time there are three or four pressure points pushing against the water. The fins serve for balance, steering, and braking. Eels and water snakes employ the same sinuous, sideways movements and, because they are long and thin, they have more pressure points but less total thrust because of their circular cross-section. On the other hand, both eels and snakes move rapidly on land, whereas the typical laterally compressed fish flaps helplessly when out of water.

Large leeches swim in a similar way to fishes except that they undulate up and down in a most graceful manner (page 116). The flat, scaly tail of the beaver provides propulsion in the same way.

Insects use a variety of methods to swim. Midge larvae move erratically through the water by alternately curling the body into a circle and jerking it out straight (page 178). The hawker and darter dragonfly nymphs progress by a kind of jet-propulsion. Water is sucked in through the anus into a chamber containing six double rows of tracheal gills. For respiration the water is gently taken in and expelled so that the gills receive a continuous supply of oxygenated water. If it is alarmed, however, the nymph expels water rapidly from its anus and shoots forward several centimetres, a procedure that can be repeated until the danger is past.

Many adult and immature insects can swim by using their legs, which are fringed with hairs to increase the area that is pushed against the water. The larva of the Great Diving Beetle (page 161) swims rather clumsily by paddling with its legs. The adult on the other hand, is one of the most accomplished of swimming insects; it is beautifully streamlined and the copiously fringed hind legs thrust powerfully in unison. On the power stroke the hairs splay out to give maximum contact with the water; on the return stroke the hairs lie against the beetle's leg and offer minimum resistance. It has been calculated that nearly three-quarters of the thrust of the legs comes from the hairs. By contrast, the Great Silver Water Beetle, which is distinctly larger than *Dytiscus*, is less streamlined in shape and has legs with a poorly developed fringe of hairs. Moreover, because the hind legs beat alternately, not in unison, the result is a cumbersome and wavering progress through the water.

Whirligig beetles, *Gyrinus* spp, are rapid and very precise swimmers. The segments of the last two pairs of legs are expanded to form overlapping flat plates that constitute a most efficient paddle on the thrust stroke, while the elements separate to offer little resistance on the return stroke. The backswimmers, *Notonecta* spp, and the water boatmen, *Corixa* spp, have long, outstretched hind legs fringed with hairs that are used like oars.

Surviving against the odds

A pond is one of the most extreme environments on Earth. The water in a pond heats up and cools down far more than it does in a lake or in the sea because it is shallow. It is even possible that a pond may dry up altogether. In temperate climates there is the chance that during prolonged cold weather the water could freeze down to the very bottom, with dire consequences for the animal life, although in practice this is unlikely. It is not surprising that pond animals exhibit various ways of overcoming or avoiding the rigours and catastrophes of their environment.

Drought When a pond dries up completely, the loss of life is not, perhaps, as severe as might be expected. Many adult insects, such as pond skaters, water beetles, and backswimmers, fly away to seek water elsewhere. Frogs and turtles can also migrate. On the other hand, fishes are trapped in their environment and are doomed to die. Even so, some tropical fishes have evolved a method of ensuring that their species survives in ponds that disappear in the dry season. The parents burrow into the substrate to lay eggs in the mud and these survive the ensuing desiccation, whereas the adult fishes all die. When the rains return the eggs hatch to produce another generation of 'annual' fishes.

Some tardigrades and rotifers survive in a desiccated condition and in this form they can be blown about by the wind (*see* pages 102 and 112). Other animals bury themselves in the mud where a certain amount of moisture may be retained. Leeches, snails, and some crustaceans secrete a protective layer of mucus around themselves after entering the mud or detritus on the floor of the pond. The formation of resistant protective cysts is common in freshwater protozoans and is induced by various adverse environmental conditions such as drought, cold, or lack of food. Such cysts are very resistant to desiccation, freezing, and high temperatures; they may remain viable for years and resume activity within minutes of contact with water.

Some animals, such as mosquitoes, have very short life cycles, and certain frogs living in arid parts of the world have a tadpole stage that only lasts a month.

Winter Winter poses problems of its own for pond animals in temperate climates. Frogs and turtles pass the cold season hibernating in the mud at the bottom of the pond. As long as it remains inactive the frog's oxygen requirements can be met by breathing through the skin. The turtle's respiratory requirements are satisfied in another way; when dormant it obtains enough oxygen from water taken into the cloaca, the common opening of the excretory and reproductive systems. The cloaca is lined with copious blood vessels and functions as a kind of gill. Other animals, such as water snakes and salamanders, hide away beneath logs and boulders on the shore and become inactive until the warmth of spring returns.

Many of the smallest pond inhabitants pass the winter in a highly specialized phase. The encystment of protozoans has already been mentioned. In the case of sponges the body dies in autumn and disintegrates during winter. Before this occurs, the sponge produces numerous spore-like bodies called gemmules, a resting stage that can withstand repeated freezing; if they are kept dry they are known to remain viable for as long as three years. Each gemmule germinates in spring to produce a new sponge. The moss animals produce disc-shaped bodies called statoblasts which float on the surface and become entangled in vegetation where they give rise to new colonies in spring. Many small crustaceans, such as waterfleas, produce large, thick-walled eggs in autumn that can withstand freezing and drying. In spring they hatch to produce females that reproduce by parthenogenesis, that is, without being fertilized by males. Other small pond inhabitants, such as rotifers, may also produce tough, overwintering eggs.

The leaflike appearance of the water scorpion conceals one of the many deadly pond predators. A tadpole approaching within reach is embraced by the raptorial front legs. Hollow mouthparts pump digestive juice into the victim's body before sucking up the resultant soup.

The long tube at the hind end of the water scorpion is used for taking in air at the water surface.

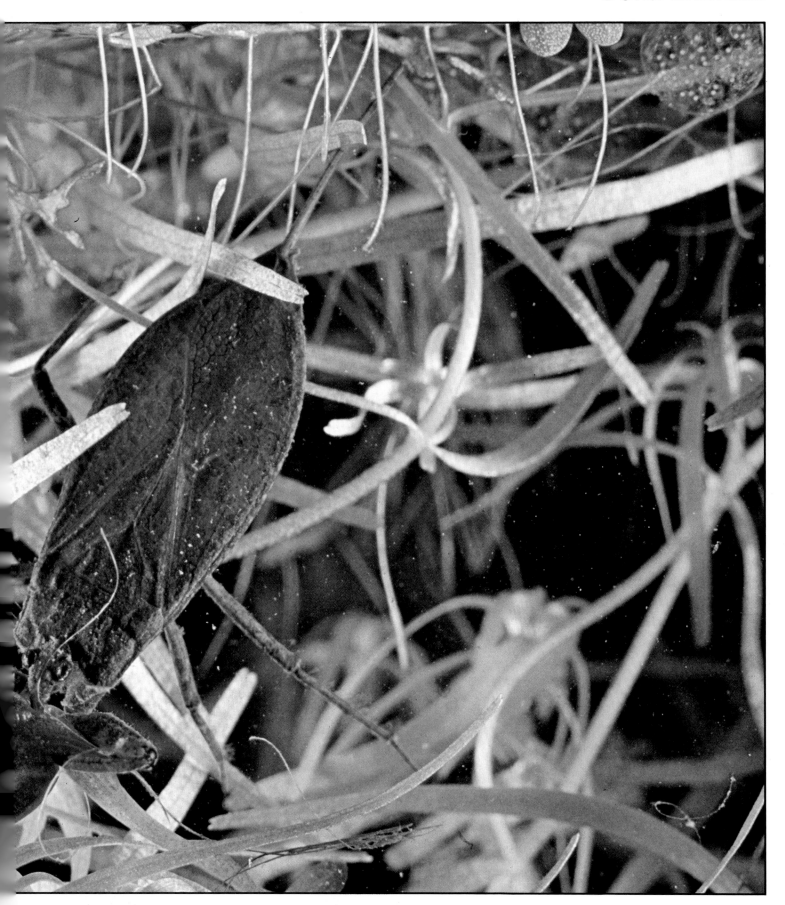

PROTOZOA

The Protozoa are unique in consisting of a single cell that performs all the bodily functions of feeding, digestion, excretion, respiration, and reproduction. Many of these functions take place in specialized parts of the protoplasm and protozoans can reach a high degree of complexity.

Protozoa are usually less than 0·5 millimetres in diameter – some are as small as 0·002 millimetres across – but others are as large as the smallest multicelled animals. Most are free living but some are attached and lead a sedentary existence. Many kinds of protozoans are found in freshwater where they may be present in huge numbers. Locomotion results either from the lashing of flagella, the beating of cilia, or from flowing extensions of the body called pseudopodia. Many protozoans eat bacteria and diatoms while others eat their own kind. Food may either be ingested at any point in the body surface or directed by cilia to a definite mouth. The intake of oxygen and the disposal of waste products take place by diffusion through the body surface. The concentration of salts in the bodies of freshwater protozoans is much higher than in the surrounding water so that water continuously enters the animal through the external membrane by osmosis. The excess water collects in structures called contractile vacuoles which, at intervals, discharge it to the outside. The simplest protozoans show how artificial the distinction between the animal and plant kingdoms is, because some of them contain chlorophyll which enables the animals to utilize sunlight to build up starch-like products from carbon dioxide, salts, and water.

The commonest method of reproduction in protozoans is asexual, the animal simply dividing into two or more individuals. This permits a rapid increase in numbers when conditions are suitable. In sexual reproduction two protozoans come together after reaching full size and partially fuse their bodies while they exchange nuclear material; they then separate and each divides several times.

Most protozoans are able to form a tough cyst around themselves when conditions become unfavourable, for example, when a pond begins to dry up during a severe drought. Cysts may be widely dispersed by the wind, hence the apparently magical appearance of protozoans when dried grass is placed in water. This is why these animals used to be called Infusoria because an easy method of obtaining specimens is to make an infusion of hay in water.

Many protozoans are internal parasites of other animals and some cause serious disease in man. Malaria occurs across the tropical regions of the world and is associated with small bodies of standing freshwater in which the mosquito carrier breeds.

The classification of the Protozoa is a complicated subject. It is convenient to treat them as if they have evolved from a common ancestor but the Protozoa really have only one feature in common; they each consist of a single cell. In all other respects the Protozoa are a largely unrelated collection of microscopic organisms which can be divided into four main groups, the Mastigophora, Sarcodina, Sporozoa, and Ciliophora.

MASTIGOPHORA (=FLAGELLATA)

These protozoans possess one or more flagella used for propulsion. It is convenient to divide them into Phytomastigophora and Zoomastigophora. The former have one or two flagella and contain chlorophyll so that they behave as plants. Most of the free-living mastigophorans, such as *Euglena* spp, belong here. The zoomastigophorans have from one to many flagella and contain no chlorophyll. The majority are not free living; they are either parasitic, symbiotic, or commensal in other animals. *Trypanosoma* spp cause sleeping sickness in man and nagana

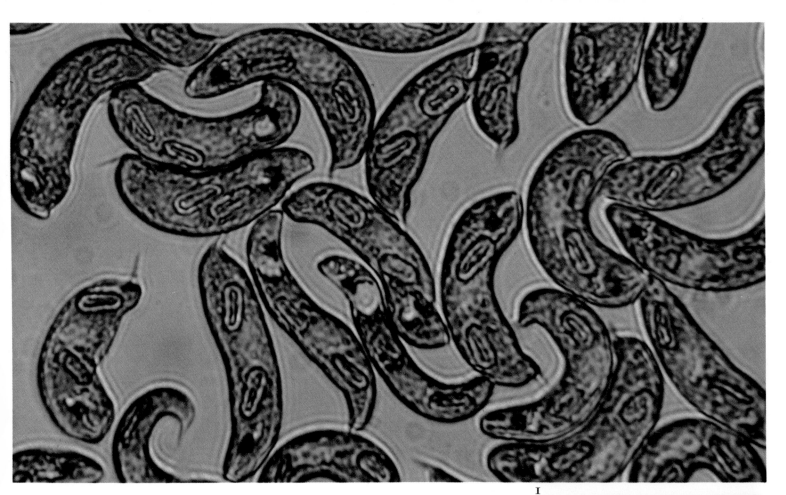

disease in cattle whereas termites depend entirely on zoomastigophorans in their guts to digest the wood they eat because they lack the necessary digestive enzymes.

Euglenas EUGLENIDAE

Euglena (**1**) is the best-known genus of the plant-like members of the Mastigo-phora. Euglenoids are worldwide in distribution and are often abundant in stagnant ponds, particularly when animal excreta becomes washed into them as it does in many farmyard ponds. In such cases, the water may be turned green and turgid by the countless myriads of tiny bodies.

In *Euglena spirogyra* (**2**) and its allies the cell membrane forms the only body covering and it is elastic enough to permit changes in shape such as bending and bulging. Chloroplasts containing chlorophyll are present in the body; these enable *Euglena* to use the energy of the sun to manufacture complex organic substances from inorganic sources such as carbon dioxide and water. Unfortunately, the single flagellum is difficult to see even under a microscope. The photographer has to choose between overexposing the organism to reveal the flagellum or portray *Euglena* in its true colours but without its whip. The flagellum beats about once a second and pulls the protozoan forward on a spiral course while at the same time the animal rotates about its long axis.

Euglena reacts to light using a photosensitive area near the base of the flagellum. As would be expected in an animal that uses sunlight to manufacture food, *Euglena* reacts positively to light and swims towards the source of illumi-nation. In the absence of light, *Euglena* loses its chlorophyll, becomes colourless, and feeds as a saprophyte.

Like most flagellates, *Euglena* reproduces asexually by dividing into two along the longitudinal axis. This produces two daughter cells that are mirror images of each other. Repeated division leads to rapid increase in numbers.

SARCODINA

Adult Sarcodina protozoans capture prey using extensions of the body called pseudopodia which are also used for locomotion in those kinds that are motile.

Three kinds are found in freshwater, those that are naked, those that live in a shell or test, and those known as sun animals in which long, thin pseudopodia radiate out from a circular body.

Naked amoebas AMOEBIDAE

Amoeba sp is an example of a naked amoeba, a protozoan that is mainly found in freshwater, although a few occur in the sea and others are found to a depth of 2 metres (79 inches) in the soil where they live surrounded by a film of water. The best kind of pond in which to find amoebas is one containing plenty of decaying leaves. The small grey speck of protoplasm that constitutes an amoeba is just visible to the unaided eye.

An amoeba has no body symmetry and it constantly changes shape as pseudopodia stream out from the leading edge and the animal flows across the mud on the bottom of the pond. The body consists of two well-defined areas of protoplasm: an internal granular endoplasm; and a clear, thin, outer layer of ectoplasm. The ectoplasm is of firmer consistency than the endoplasm over which it forms a retaining skin. During movement, however, the ectoplasm and endoplasm undergo changes. At that point on the body surface where a pseudopodium is going to appear the ectoplasm becomes liquid, and internal pressure causes endoplasm to flow into the bulge. The outer layer of the pseudopodium then changes to ectoplasm. It would seem that the two kinds of protoplasm are merely different phases of the same thing.

The amoeba uses its pseudopodia to engulf small organisms such as bacteria, algae, diatoms, other protozoans, or even small multicelled animals such as rotifers. The picture series (1 to 4) shows how the pseudopodia extend around the prey, in this case a ciliate protozoan called *Paramecium* sp, until it is completely enclosed and escape is impossible. The prey ends up in a food vacuole which may contain water or, as in this case, it may be empty. After digestion is finished, any waste is voided through the body surface at the posterior end if the amoeba is moving. If the animal is stationary, waste is released through any part of the body surface.

As in *Euglena*, asexual reproduction is by division. Before dividing, the pseudopodia are withdrawn; constrictions appear on opposite sides and slowly travel across the body until they meet to produce two daughter cells that soon increase in size to become as large as the original parent.

Granular-shelled amoebas DIFFLUGIIDAE

Difflugia sp (1) is an example of an amoeba that is enclosed in a shell or test, with a central hole through which the pseudopodia can be protruded. The test is made from particles of sand that the animal first ingests so that they become coated with a sticky secretion before being used as building blocks for the construction of the shelter. The test is pear shaped with a single aperture at the narrow end. In this picture the test is viewed from the broad end and the opening, at the far end, can be seen indistinctly, with a single pseudopodium emerging and projecting beyond the diameter of the test. As it flows along in typical amoeboid style, *Difflugia* carries its home with it. *Difflugia* and *Amoeba* are often found together. Asexual reproduction by division is the rule, but the presence of the test makes the process rather more complicated than in the naked amoeba. Before division can begin most of the protoplasm is extruded through the opening and a second test is made from sand grains. The two-shelled *Difflugia* then divides so that each portion of protoplasm has its own test.

Smooth-shelled amoebas ARCELLIDAE

The shell of *Arcella* sp (**2**) is shaped like a dome with a flattened lower surface in the centre of which there is a circular hole for the extrusion of pseudopodia, as in *Difflugia*. Unlike the latter, however, in which sand grains are incorporated in the test, *Arcella* secretes a smooth shell made of chitin, the same substance from which the skeleton of insects is constructed. *Arcella* is one of the commonest of the testate amoebas and is found on the muddy surface at the bottom of freshwater ponds, particularly those rich in organic matter.

Sun animals ACTINOPHRYIDAE

This (**3**) is one of an amoeboid group called heliozoans or sun animals in which the shape is spherical and the pseudopodia, which are long and thin, radiate outwards like soft spines so that the animal is reminiscent of the sun and its rays. These protozoans are particularly abundant in ponds where there is a lot of decaying vegetation. The outer layer of the body is full of vacuoles which make the animal buoyant so that it drifts around as a member of the freshwater plankton. The radiating pseudopods are used for capturing minute organisms for food; they function as sticky traps to which the food adheres before it becomes absorbed into a food vacuole in the body.

5

6

SPOROZOA

This is a heterogeneous assemblage of protozoans that parasitize vertebrates and most phyla of invertebrates. The life cycle is complex and usually involves both asexual and sexual generations and sometimes two hosts. *Plasmodium* sp, which causes malaria, one of the most widespread and serious of human diseases, is transmitted by a mosquito that breeds in small bodies of freshwater. The sporozoan most likely to be seen in ponds is *Glugea* sp which causes white nodules on the bodies of fishes, especially on the Three-spined Stickleback, *Gasterosteus aculeatus*.

7

CILIOPHORA

There are some 6000 described species of ciliates so that they comprise the largest group of Protozoa. They also form a well-defined and homogeneous assembly which have in common cilia or compound ciliary structures that serve for propulsion and food collection. Most of the ciliates also differ from other protozoans in having a definite mouth. Characteristically, they also have two types of nuclei, one vegetative (the macronucleus) and the other reproductive (the micronucleus).

Ciliates are common in freshwater. Most, such as *Paramecium* spp, are free living and motile; others are partly motile and partly sessile, such as *Stentor* spp. Some species are sessile with a dispersal stage, for example, *Vorticella* spp and *Campanella* spp, while other ciliates are symbionts and commensals. A few are parasitic and, among these, the species most likely to be seen in ponds is *Ichthyophthirius* sp which attacks fishes.

Slipper animals PARAMECIIDAE

Paramecium is the commonest ciliate found in ponds. As with other protozoans, *Paramecium* is particularly abundant in ponds where there is plenty of decaying vegetable matter because bacteria are the main food of the ciliate. The common name of slipper animal refers to the elongate shape, rounded at each end, with a narrow groove or gullet leading to the mouth, so that it looks rather like a soft

1

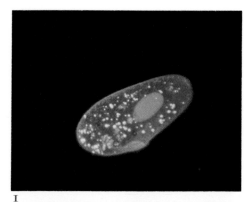

2

slipper. To find out whether water contains ciliates, hold a glass container of it against a black background. The animals should be easily visible to the unaided eye as semitransparent, rapidly moving specks.

The body of *Paramecium* has a definite skin or pellicle which gives the animal a constant shape although it bends when navigating through a swarm of its own kind. Rows of cilia cover the whole surface although, in more advanced ciliates, the cilia are restricted to certain parts of the body. The beating of the cilia is synchronized to propel the animal through the water. In the effective stroke, each cilium is held out at right-angles to the body for maximum thrust but, during recovery, it bends back to minimize water resistance for the same reason that an oarsman 'feathers' his oar. *Paramecium* swims a spiral course while rotating about the long axis, just as the flagellate, *Euglena*, does. When necessary, *Paramecium* and other ciliates can reverse the action of their cilia to swim backwards. Thus, when an obstacle is met, the ciliate backs off, turns slightly to the right or left, and tries again to go forward. This manoeuvre is repeated until the obstacle is avoided. The lateral groove or peristome, which leads to the mouth, is lined with fused cilia which produce a current that drives food particles down the gullet where they become enclosed in a food vacuole and are digested.

The position of the contractile vacuoles is always fixed in ciliates. In *Paramecium* there are two vacuoles, one at each end of the body. The vacuoles open through a permanent canal leading to the outside. The pellicle is, in fact, very complex in structure. In its deeper layer it contains peculiar explosive structures called trichocysts. A trichocyst consists of a long thread-like shaft ending in a barb and it can be discharged almost instantaneously. In some ciliates the trichocysts are thought to anchor the animal while it feeds; in others they are used for capturing prey or for defence.

Most ciliates are able to survive adverse conditions by forming a tough resistant cyst, but *Paramecium* has not been seen to encyst and it is thought that it spreads from one pond to another in drops of water adhering to birds or other animals.

The ciliates differ from other classes of Protozoa in possessing two types of nucleus: a large macronucleus, which controls the normal day-to-day activity of the animal; and, embedded in its side, the much smaller micronucleus, which is concerned solely with reproduction. In some of the pictures of *Paramecium* (1) the macronucleus is very obvious because it appears blue although, in life, it is colourless and is almost invisible. Peter Parks, who took these pictures, discovered by accident a method of producing a blue nucleus when he was experimenting with lighting effects through his microscope. It has proved to be a very useful technique.

Asexual reproduction by division into two is the usual method of increasing rapidly the population of *Paramecium* (2) but, eventually, vitality decreases and the only way to restore vigour to the population is for nuclear exchange between individuals to take place; in other words, there must be a form of sexual reproduction. When this is about to take place, *Paramecium* behaves sluggishly and, eventually, individuals pair up and join together at the peristome (3). It is thought that the cilia secrete an adhesive substance which joins the animals together. The protoplasm of the two protozoans next fuses in the area of contact and there follows an exchange of nuclear material between the respective micronuclei. The macronuclei are eventually resorbed and will later be replaced by the products of division of the micronuclei. When the two animals separate they are referred to as exconjugants and, in their reinvigorated condition, they are ready to return to asexual reproduction. It has been found that some strains of *Paramecium* can have as many as 350 successive asexual generations before the need for a sexual generation becomes so paramount that without it the population would die.

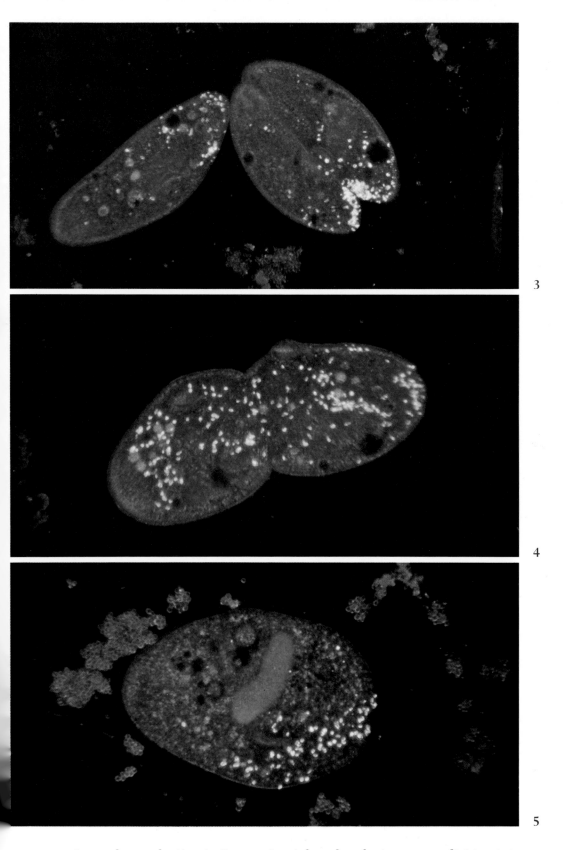

3

4

5

Asexual reproduction in *Paramecium* takes place by transverse division into two parts. This photograph (**4**) was taken when the nucleus had already divided and the constriction at right-angles to the long axis was about to produce two daughter cells. Picture (**5**) shows a recently formed daughter *Paramecium*. Its squat shape shows that it has only just been produced by division. Later it will assume the typical outline of a slipper.

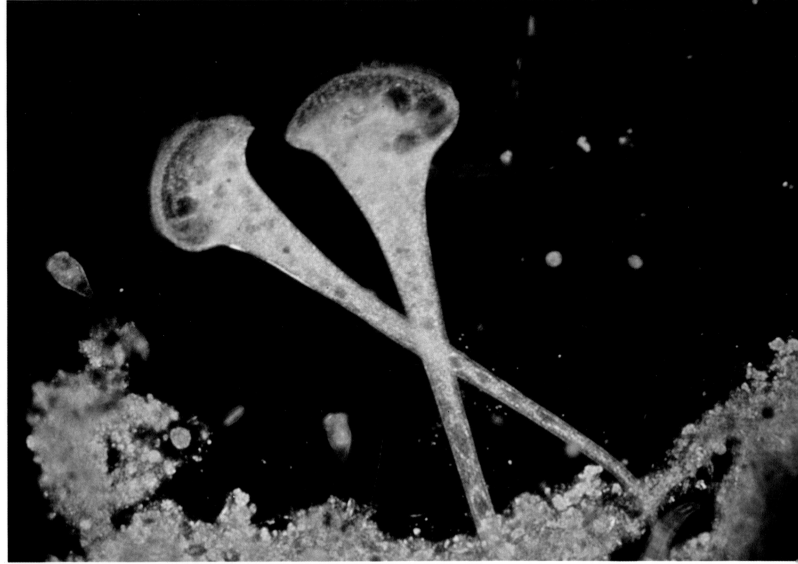

Trumpet animals STENTORIDAE

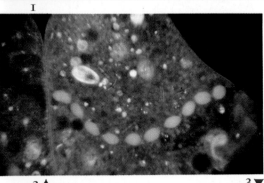

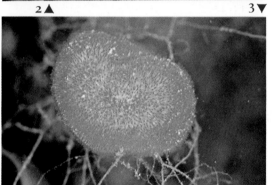

When *Stentor* sp (**1**) is attached to a plant or to debris and is extended in the feeding position, it is shaped like an elongate funnel. Any disturbance makes the whole body contract to become an insignificant blob of protoplasm. To find new feeding grounds, the animal swims by means of the cilia that cover the body but, to do this, the head and tail are drawn in to form a compact shape. *Stentor* can be very colourful; there are green, blue, and amethyst-coloured species.

The open end of the funnel is surrounded by a crown of larger cilia which beat to produce a current that draws particles of food down into the gullet, as in *Paramecium*. Feeding is selective in that non-nutritive particles are rejected by reversing the ciliary beat so that unwanted material is wafted away. This photograph (**2**) shows a characteristic feature of *Stentor* and its allies; the macronucleus is in the form of a string of beads. During asexual reproduction the particles condense to form a single nuclear mass before division occurs.

As the leaves of autumn fall into the pond and the water plants begin to die, the population of bacteria explodes because there is so much decaying vegetation. This leads to an increase in numbers of those protozoans and rotifers that feed on bacteria and this in turn leads to an increase in the population of *Stentor* which feeds on other protozoans as well as on rotifers.

Stentor polymorpha (**3**) is a social ciliate in which the individuals are anchored in a mucilaginous base which they secrete communally. The green colour is the result of symbiotic algae in the bodies of the ciliates.

Bell animals VORTICELLIDAE

Vorticella spp (1, 2) derive their popular name of bell animal from the bell-shaped body at the end of a thread-like stalk. *Vorticella* is regarded as a specialized ciliate because it has lost the general body covering of cilia and only retains three ribbon-shaped membranes of long cilia around the open mouth. The undulations of the membranes create a current of water leading into the gullet. The long stalk consists of a single spiral fibre which can contract like a spring. *Vorticella* is found in social groups – not colonies, because the individuals are attached independently – and they are easily recognized by the irregular 'popping' movements which go on all the time as individuals contract and elongate. The bell closes during contraction of the stem. Although *Vorticella* is sessile for most of its life, there is a free-swimming stage shaped like a barrel that disperses the species.

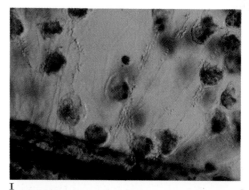

Asexual reproduction takes place by simple division of the bell-shaped part. One of the daughters swims away to settle down elsewhere in company with others of its kind while the other daughter remains on the stalk. Sexual reproduction in the form of conjugation occurs between individuals that have left their stalks to become free swimming.

Bacteria are a major element in the food of *Vorticella* so it is no surprise to find that its population reaches a peak in autumn when vegetable decay is at a maximum.

Campanella spp (3) are colonial bell animals because the bells arise from a common stalk which cannot contract. When disturbed the heads close and nod.

HOLOPHRYIDAE

The disease known as 'ick' is caused by a large ciliate, *Ichthyophthirius multifiliis*, (4) up to 1 millimetre in diameter, which is parasitic beneath the skin of many freshwater and marine fishes. In a heavy infection the symptoms are obvious; the body and fins of the host are covered in white spots. In ponds the Three-spined Stickleback is the most frequent sufferer. Fishes of all ages are killed when infection is heavy. The life cycle is simple which enables the disease to spread very rapidly. When the parasite becomes an adult beneath the host's skin, it leaves the fish and forms a reproductive cyst inside which it divides repeatedly so that, within a day, as many as 2000 young individuals are produced. The young ciliates, which are elongate and covered in cilia, leave the cyst and swim actively in search of hosts. Those that find fishes within three or four days burrow into the skin where they rapidly grow to the circular adult shape.

Ichthyophthirius is one of the aquarist's greatest enemies because it flourishes in heated tropical tanks. The optimum temperature for reproduction and development is 25 to 27 °C (77 to 80·6 °F), at which the entire life cycle can be completed in three days. It is a difficult disease to control and the best chance of success may be to add to the aquarium a solution of 0·2 per cent malachite green at a rate of approximately 3 millilitres to 55 litres (12 gallons).

In addition to 'ick' the diseased stickleback in the photograph has patches of fungus, particularly on the fins. It is probable that the fungus obtained a foothold because the fish had been debilitated by the parasitic ciliate.

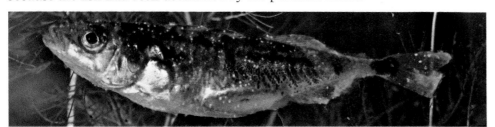

Sponges
PORIFERA

Freshwater sponges SPONGILLIDAE

Most sponges are marine but members of the family Spongillidae occur in freshwater throughout the world.

In Britain, *Ephydatia fluviatilis* (1) is found in ponds where it forms irregularly shaped encrusting growths on stones, roots, and stems. A sponge can be distinguished from algae of similar colour and shape by the minute spines or spicules which stick out from the surface and can be seen clearly in the photograph. They are made of silica and support the sponge (2).

A constant flow of water carrying food particles and oxygen is drawn into the body of the sponge through numerous small pores. The water leaves through a few large apertures carrying waste products with it. Freshwater sponges are usually greyish or yellowish white in colour. Green specimens occur when cells of the sponge contain many single-celled algae, *Chlorella* spp, which, when there is enough light, produce chlorophyll. The sponge benefits by receiving food and extra oxygen from the alga, while the alga makes use of waste carbon dioxide which the sponge, like all animals, produces during respiration. But sponges living in dark situations, manage perfectly well without the alga.

In summer, sponges reproduce sexually; sperm cells, released into the water, are drawn into another sponge where they fertilize the eggs. Development takes place inside the parent until a larval stage, known as a planula, is released in numbers through the exhalent apertures. The planula (3) is ciliated all over and swims about for a few hours to distribute the species before it settles down and gradually changes into a tiny sponge. The photograph shows the planula of a marine sponge which is indistinguishable from its freshwater relative.

Towards autumn a large number of overwintering gemmules are produced inside the sponge (4). They can be seen as brown spots the size of pin heads scattered throughout the sponge body. Each gemmule consists of a group of sponge cells protected by a tough, horny covering. At the onset of winter the sponge dies and the gemmules sink to the bottom of the pond to lie dormant until spring when each gives rise to a minute sponge.

When freshwater sponges are removed from the water and are teased apart under a low-power microscope it soon becomes obvious that they provide shelter for a host of small animals belonging to many different groups – roundworms, flatworms, segmented worms, rotifers, crustaceans, baby snails, and the early stages of various insects. In the case of the larva of the spongefly, *Sisyra* spp, an insect related to the lacewing flies of the order Neuroptera, the sponge provides not only shelter and a well-oxygenated environment, but food as well. *Sisyra* larvae live exclusively on and inside freshwater sponges, feeding on the cell contents which they extract through their long needle-like mouthparts (page 160).

1

2

3

4

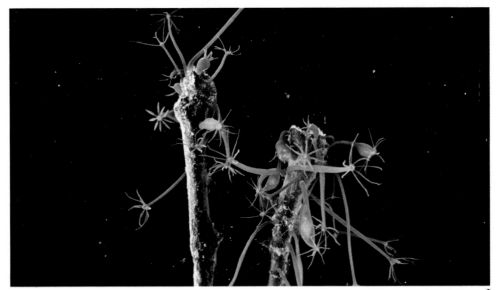

1

2

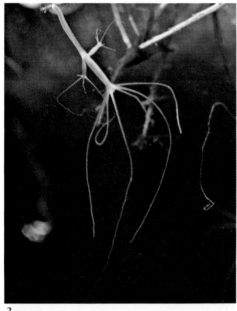

3

Hydra and its relatives
COELENTERATA

HYDRIDAE

Like the sponges, most coelenterates are marine; they include the sea anemones, jellyfishes, and corals. Only one order, the Hydrozoa, has freshwater representatives and of these the best known are *Hydra* spp which occur in still water throughout the world. Weedy ponds are the best places to find hydras, particularly when there is plenty of floating vegetation, water-lily leaves, or duckweed from which hydras can hang down. The animals are easily overlooked because, when disturbed, they contract into small, nondescript blobs. If some leaves are taken home and floated in an aquarium tank, the hydras soon extend and are easily recognized. Hydras move towards light and tend to collect on the tank face nearest the window. The animal moves slowly by looping over from base to tentacles to base.

Chlorohydra viridissima (**1**) is a beautiful green colour and, as with the freshwater sponge, the colour results from the presence in the inner body cells of the minute alga, *Chlorella* spp. The tentacles are shorter than the body length which may reach 20 millimetres (0·8 inch).

The brown hydra, *Hydra oligactis*, (**2**) has tentacles that may extend to several times the body length of up to 25 millimetres (1 inch). Hydra tentacles are studded with specialized cells, called cnidocytes, (**3**) which paralyse and hold on to daphnia and other small crustaceans which form the main food. The cnidocytes contain various types of nematocysts, harpoon-like structures which are ejected by pressure. Some nematocysts pierce the prey and inject a paralysing fluid; others produce a smooth, entangling thread or a sticky thread. When a small animal is captured, the tentacles guide it towards the mouth opening and into the gut cavity where digestion is rapid.

When food is plentiful and temperature is favourable, hydras reproduce asexually by forming buds (**2**). The body wall extrudes to form a blister at the end of which a mouth opens and tentacles develop. Eventually, a constriction forms at the base of the new individual and it separates from the parent.

Hydras also reproduce sexually. The individuals are hermaphrodite and produce both male and female cells. The sperm cells develop in small surface thickenings near the mouth (**4**), and are released into the water. A single, large, round egg develops in a thickening near the basal end of the hydra. The egg is fertilized in situ and, after being encased in a protective covering, it is released and sinks to the bottom or becomes attached to a water plant. In spring a young hydra emerges from the egg.

4

Flatworms
PLATYHELMINTHES

1

2

Flatworms have bodies that are symmetrical about the long axis, and are not divided into segments. They are flattened from above downwards and lack a body cavity. The flattened shape allows the oxygen needed for respiration to diffuse to all parts of the body. The mouth is the only opening into the gut; it serves not only to take in food but also to excrete the waste products of digestion. Most flatworms are hermaphrodite but there may be elaborate ways of preventing self-fertilization.

Flatworms can be divided into three distinct groups. The Turbellaria, or flatworms proper, are free-living forms; many are marine, a few live on land in damp, warm places, and the remainder are found in freshwater where they may be very numerous. The Cestodes or tapeworms are all internal parasites armed with suckers on the head and often with powerful grappling hooks as well. The Trematodes or flukes are also all parasitic either on the surface or inside the host animal. One or more ventral suckers provide the organs of adhesion. The liver fluke, which causes liver rot in sheep and cattle, is the best-known example. The flukes are not considered further in this book.

TURBELLARIA

Flatworms are found, often in great numbers, in ponds ranging from fresh to stagnant, although each species is fairly specific in its requirements. The body is covered in cilia which are particularly numerous on the underside where their beating enables the animal to glide smoothly over any surface including that of the water itself. The cilia also create currents (hence Turbellaria) which assist respiration by bringing a flow of water, and oxygen, into contact with the animal.

There are two types of flatworm, the triclads and the microturbellarians.

TRICLADIDA

The triclads include the larger species, known as planarians, which range in size up to 4 centimetres (1·6 inches) and are white, grey, brown, or black in colour. The name 'triclad' refers to the gut which consists of three main branches each profusely subdivided. Planarians are carnivorous, feeding on small pond animals or recently dead bodies, and the muscular pharynx is extruded through the mouth to suck off pieces of the prey. Some planarians have remarkable powers of regeneration; if an individual becomes cut in half, each portion will grow into a complete animal. Reproduction is by means of cocoons containing eggs that hatch into small planarians.

Planarians DENDROCOELIDAE

Dendrocoelum lacteum (1) is a typical planarian. The colour is white although this will be influenced by the contents of the gut if the animal has recently fed. In contrast (2) shows an unidentified black species that was found in large numbers in a pool at 1672 metres (5500 feet) on the Dargo High Plain of Gippsland, Victoria, in Australia.

D. lacteum is a common planarian, particularly in organically rich ponds where the concentration of calcium carbonate is high. Its distribution is closely linked to that of the waterlouse, *Asellus* sp (page 132), which seems to be the main food. D. lacteum moves quickly for a planarian and this enables it to capture arthropods (*see* pages 120–97) alive although it will also feed on dead bodies. The presence of food is detected by organs of smell situated in grooves near the head. Small pieces of liver and raw meat dropped into the water will soon attract any hungry planarian in the vicinity. When prey is captured, the pharynx is extruded and the victim's fluids are sucked in while small pieces are torn from the body and swallowed. (3) shows the partly extruded pharynx of a planarian that has just finished feeding. (4) is a dark-ground picture which reveals the internal

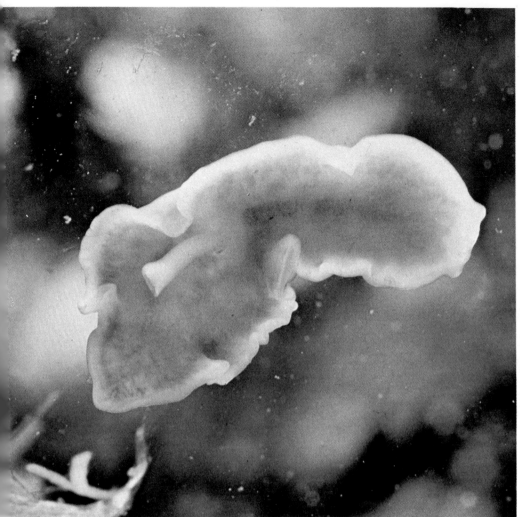

4

5

structure of *D. lacteum* and, in particular, the division of the gut into three branches.

Each flatworm is hermaphrodite but it is necessary for two individuals to come together to fertilize each other's eggs. Several eggs are laid together in a cocoon that is attached to a plant or stone. The cocoon of *D. lacteum* is spherical, brown in colour, and unstalked. It varies from 1 to 3 millimetres in diameter. Other planarians produce spherical cocoons on stalks or oval cocoons attached directly to the substrate. The young are small versions of the adult. Some planarians live for more than a year but *D. lacteum* matures in less than a year and dies after reproducing. In the northern hemisphere most species lay their eggs in spring and the rest do so in midsummer. Asexual reproduction does not occur in *D. lacteum* but other planarians divide in two and each regenerates the missing portion. The rear end of the planarian remains anchored while the front end moves forward until the animal breaks in two just behind the pharynx.

MICROTURBELLARIA

(5) is an example of the other type of flatworm, the microturbellarians. This group includes very small species of Turbellaria seldom exceeding 2 millimetres in length. They are especially abundant in ponds that contain vegetable matter because their food consists of algae and diatoms as well as minute animals. The gut is a simple sac which may have side pouches. The mouth varies in position; it may be either at the anterior end or towards the middle or hind end of the animal. Winter is passed as hard-shelled eggs which do not develop until the temperature rises in spring. Summer reproduction is by eggs or, in certain species, by transverse budding whereby a string of individuals arises behind the parent.

Tapeworms CESTODA

In the tapeworms the adult is always found in a vertebrate. The head is attached firmly to the wall of the host's gut by means of suckers sometimes assisted by hooks. The body consists of identical sections each carrying both male and female reproductive organs. There is no mouth or gut and the tapeworm absorbs liquid food through its body wall from the gut of the host. New sections are continually added by transverse division behind the head and the worm increases in length with age. The body is usually flattened and the tapeworm resembles a length of opaque white ribbon which may reach, in certain species, a length of 15 metres (49 feet).

Ripe eggs are passed to the exterior in the faeces of the host but, to complete the life history, one or two intermediate hosts are required. The hosts may all be land animals or they may be aquatic in which case the host for the adult tapeworm is a fish. If the intermediate hosts are aquatic it is usual for the adult host to be a bird or mammal.

PSEUDOPHYLLIDAE

The adult tapeworm, *Schistocephalus gasterostei*, lives in the alimentary canal of birds that feed on fishes. Segments containing ripe eggs become detached from the posterior end of the tapeworm and pass to the outside in the droppings. If the eggs land in freshwater they hatch into free-swimming, ciliated larvae which bore inside small crustaceans such as *Cyclops* spp (page 130–1) where they undergo further development before forming a cyst. Nothing more happens unless the *Cyclops* is eaten by a fish, usually a stickleback. The cysts then become active again and grow enormously in the abdominal cavity so that a large projection appears at the front end of the fish's body beneath the gill covers (1). If the parasite is artificially removed at this stage, or is inadvertently released from the fish by a predator, as may happen if the fish is devoured by a large dragonfly nymph, we see a white subadult tapeworm as shown in (2). In nature the life cycle is not completed unless the parasitized fish is eaten by a bird such as a kingfisher or heron. The parasite then undergoes the last phase of its development into an adult tapeworm which becomes anchored firmly by the head to the gut lining of the host.

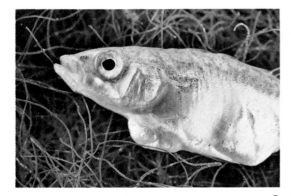

1

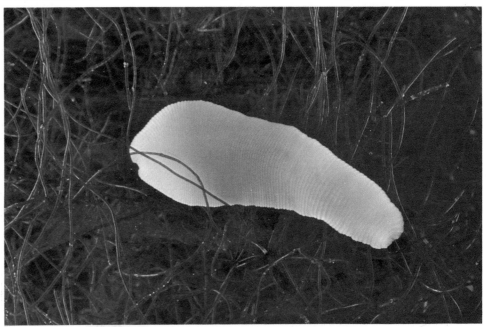

2

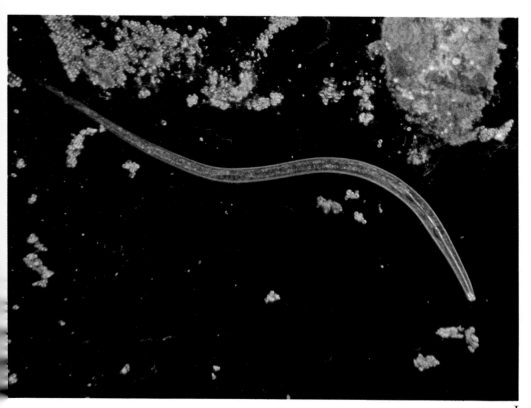
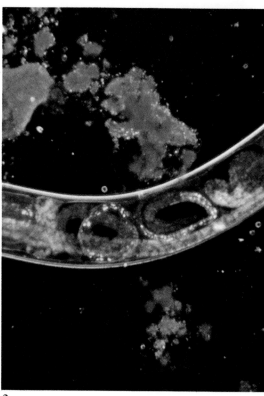

Roundworms
NEMATODA

Most freshwater species of roundworm are small, only 1 to 2 millimetres long with the largest reaching 8 millimetres (0·3 inch). They can be instantly recognized by the characteristic way in which they move by lashing the whole body into successive s-shaped curves. Roundworms have thin, colourless bodies that are cylindrical in section and are not divided into segments. The shape usually tapers towards the head and tail. Pond species are most abundant in the mud and decaying vegetation on the bottom or among the roots of aquatic plants.

Usually the sexes are separate and the females produce large numbers of hard-shelled eggs although some produce living young. The eggs hatch into miniature copies of the adult. An important adaptation to survival is the roundworm's ability to form a resistant coat around itself; this cyst can withstand desiccation or other adverse conditions.

It is best left to the specialists to identify the genera and species because the 10 000 or so different species that have been recognized so far look superficially very much alike! Naturally most research has been devoted to those nematodes that cause disease in man's crops and livestock and in man himself. Comparatively little is known about the life histories and ecology of the many freshwater species. Many genera of roundworms, and some species too, are found around the world.

This is a typical aquatic nematode, or roundworm, (1) collected from a small pond. The blunt end is the head and the body tapers towards each end. The general shape, circular cross-section, and snake-like method of moving make the nematode instantly recognizable.

The photograph (2) shows young roundworms of a freshwater species inside the mother's body. Most female nematodes lay hard-shelled eggs but, in a few species, of which this is one, the eggs hatch inside the mother. When they are born the young roundworms already possess most of the adult features except that some parts of the reproductive system are not developed so that they are sexually immature and cannot reproduce.

Hairworms
NEMATOMORPHA

The photograph shows the form in which hairworms are likely to be found in a pond – a tangled writhing ball consisting of several to even hundreds of intertwined bodies. Individuals range in length from 10 centimetres (4 inches) to a metre (39 inches) but their diameter is only 1 to 3 millimetres. When horses were the common beasts of burden, hairworms sometimes suddenly appeared in drinking troughs, and the superstition arose that they were hairs from a horse's tail that had dropped into the water and had come alive! Their other name of 'gordian worm' refers to the resemblance of their tangled mass to the mythical Gordian Knot.

Only the adult stage of a hairworm is free living. They occur in all types of freshwater habitat in the temperate and tropical regions of the world. The young, on the other hand, are all internal parasites of insects and crustaceans. The sexes are separate and seem to be equally abundant. Males are always smaller than females and the posterior end of the body is often curled and, in some genera, it is forked as well. Like the nematodes, the body is round in section; there is no distinct head, and a mouth is either absent or non-functional in the adult which apparently does not feed. Whereas nematodes are white or translucent, hairworms are always opaque and coloured grey or various shades of brown.

The females are very inactive but, once they become sexually mature, which happens soon after they become free living, the males crawl or swim to them with whip-like motions of the body. After copulation, the males die. The females lay vast numbers of eggs strung together in long mucilaginous strings attached to plants. A string 15 centimetres (6 inches) long may contain 500 000 eggs and a female may lay about four million eggs over a period of several weeks before she dies.

After about a month the eggs hatch. The larvae are 1·2 to 1·5 millimetres long and are armed with large hooks at the head end as well as a proboscis that can be pushed in and out. The larvae must now invade the bodies of insects or crustaceans but no one is certain how they achieve this. Some observers have reported that the larvae use their proboscis to bore into the legs of aquatic nymphs; others have observed one-day-old larvae encysting in mucus on grass blades. The assumption is that the grass may be eaten by grasshoppers or other insects and this would explain how hairworms come to parasitize terrestrial arthropods. Once inside the host the larva enters the body cavity and the proboscis degenerates. Large numbers of cysts are likely to be swallowed by wrong hosts such as worms, snails, and fishes, and, when this happens, the larva either dies or re-encysts in the tissues instead of developing further. In the event that the wrong host is later eaten by a correct host the larva again becomes active and burrows into the body cavity where it continues its growth.

The larva now develops into a long, pale worm that takes up food through the body wall and increases in length until it completely fills the body of the host. After a development period of three to five months the hairworm leaves the host which usually dies. The worm completes its life in water, as already mentioned, and there are indications that hosts containing hairworms seek out water thus ensuring the completion of the worm's life history. This small group of animals contains 230 species throughout the world and many genera are cosmopolitan.

Four species of hairworm are widely distributed in Britain, one species of the genus *Gordius* and three species of the genus *Parachordodes* but, as in the case of the roundworms, identification has to be left to specialists. The same genera occur in the United States, along with several others, but the detailed biology of the different genera and species of hairworm has been little studied anywhere in the world.

Wheel animals
ROTIFERA

Rotifers are among the most characteristic and beautiful of freshwater animals. They are found everywhere; in gutters, waterbutts, and puddles as well as in ponds and lakes. Not only are they abundant in numbers of individuals but more than 500 species have so far been identified in Britain alone. Rotifers were for long the delight of the early microscopists who studied the many varied and bizarre forms. They were called wheel animals because of an organ called the corona at the anterior or head end of the body. The corona bears long cilia which beat to create a current that carries food particles towards the mouth and to propel the animal through the water. Rotifers are small, ranging in size from 0·1 to 2 millimetres and they may be smaller than some protozoans. They are much more advanced in structure, however, possessing separate nervous, excretory, digestive, and reproductive systems. The usual body form is cylindrical although some are almost spherical and others are very long and thin. The corona, with one or two circlets of cilia, is the feature that distinguishes the rotifers from the other microscopic pond inhabitants. Behind the head end there is a middle portion or trunk which terminates in a tapering foot ending in two pointed toes. The corona and foot can be partially retracted inside the trunk so rotifers can be expected to show considerable changes of shape.

Most rotifers are free swimming and are always on the move among the vegetation or creeping over stones. Some species are sessile, anchored in one place by a sticky secretion produced by paired glands on the foot. Other rotifers live inside tubes that are constructed from particles or secreted by the cells of the skin.

Nearly all rotifers collected will be females; the males are rare and are small, degenerate animals lacking a gut and therefore unable to feed or survive for any length of time. In fact, the males are little more than swimming bags of sperm. During most of the year the females produce large, unfertilized eggs that hatch into more females. If the water is overcrowded with rotifers, or drought threatens, or a drop in temperature warns of the onset of winter, the females produce small as well as large eggs and males suddenly appear. The males mate with the females which then produce large, tough eggs that are able to survive unfavourable conditions. When better times return, the resistant eggs hatch into females and the normal life cycle is resumed.

Some rotifers also have the ability to encyst by secreting a tough skin around themselves when the environment becomes adverse. The cysts can survive extreme conditions of heat, cold, or dryness for months or even years, and they may be widely distributed by the wind. If a cyst arrives in freshwater it swells up and the rotifer resumes its normal shape and mode of life.

PHILODINIDAE

Species of the genus *Rotaria* are among the commonest rotifers found in ponds. The photograph (1) shows a typical sessile species in which the body is elongate and is divided into three regions, the 'head' bearing the corona and two red eyes, the trunk which is the widest part of the body, and the foot which is long in sessile forms and terminates in a pair of toes containing glands that secrete an adhesive substance. Most planktonic rotifers have no foot and, in others that swim continuously, it may be absent or reduced.

The mouth leads into the pharynx or mastax which is another structure peculiar to all rotifers and is the principal feature used in their classification. The mastax is more or less oval in shape with thick, muscular walls. Internally there are large projections that mesh together and grind up food. Some rotifers are predatory and grasp their prey by protruding the mastax out through the mouth. In such species the mastax terminates in a pair of pincers. When it moves, *Rotaria* sp can swim by means of the coronary cilia or it can crawl by 'looping', that is, by

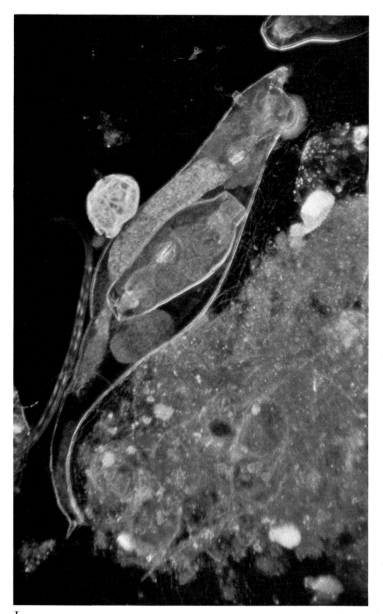

1

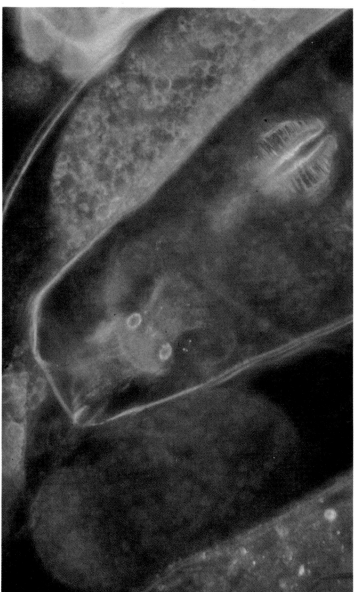

2

bringing the foot up to the head and stretching forward in a leech-like manner. Most female rotifers lay eggs but a few genera, including *Rotaria*, are unusual in being ovoviviporous, that is, the eggs hatch inside the uterus of the female and the young are born alive. In the photograph (**1**) a single embryo is seen inside its mother and (**2**) shows a close-up of the same youngster in which the two red eyes and the grinding mastax are clearly visible.

FLOSCULARIIDAE

This sessile, colonial rotifer, *Lacinularia* sp, (**3**) was photographed in Victoria, Australia. Although it is commonly referred to as 'colonial', it would be better to regard it as a social rotifer. The individuals in the group are each separately anchored in a common ball of mucus and any one of them can withdraw its foot and swim away, as happened while the photograph was being taken.

3

Rotifers are probably the most cosmopolitan animals found in ponds. It seems that the presence of a particular genus is determined by the ecological conditions rather than by the geographical location. For example, so far in Australia more than 300 species of rotifers belonging to seventy-four genera have been identified. All the genera are either cosmopolitan or are very widespread. No endemic genera have been found although some of the species probably occur nowhere else.

Hairy-backs
GASTROTRICHA

I

The hairy-backs are a small group of tiny animals, usually about 0·5 millimetres long and never exceeding 1·5 millimetres, that show some affinities with both the nematodes and flatworms. Gastrotrichs are not really uncommon but, being so small, they tend to be overlooked. They usually occur in association with protozoans and other microorganisms that form a community on the bottoms of ponds, puddles, and ditches. Their food consists of bacteria, algae, protozoans, and organic detritus which is sucked into the mouth by a pumping action of the pharynx. There is usually a distinct head separated by a short neck from the rest of the body which terminates in a pair of 'toes'. The dorsal surface of a hairy-back is convex and is covered in plates, scales, or spines (hence the common name). The lower surface is flattened and has rows of cilia which propel the animal with a gliding motion.

The freshwater gastrotrichs are all females and reproduce without mating. Each female lays a few very large eggs attached to weed or stones. The eggs are of two types: one type hatches almost immediately when conditions are favourable; while the other type is resistant to adverse conditions, and tides the species over until the environment becomes suitable again.

Hairy-backs have been rather neglected by freshwater specialists and there are undoubtedly many species yet to be discovered and many observations to be made about their biology. So far only 150 species have been named throughout the world.

This specimen of *Chaetonotus* sp (1) was collected from a small garden pond in Oxfordshire in Britain. Gastrotrichs are not particularly abundant but they can be found in almost every pond, and the genus *Chaetonotus* is cosmopolitan. The forked tail contains adhesive glands which play the same part in attaching the animal to the substrate as they do in rotifers.

Moss animals
ECTOPROCTA

Most moss animals are marine but several genera occur in freshwater where they are not uncommon although they are often overlooked. Some species look rather like the egg chains of pond snails and, unless they are closely inspected, they may be wrongly identified. When removed from water, moss animals resemble blobs of jelly attached to leaves and stems or encrusting twigs or stones.

Ectoprocts are colonial and are mostly sessile although some species are able to move very slowly, a few centimetres a day. The common name refers to the greyish-green colour and texture of many ectoprocts which give them a superficial resemblance to a patch of moss. The individual animals are minute and are enclosed in a sheath or embedded in jelly (2).

The most obvious feature, when undisturbed, is the lophophore, a circular or horseshoe-shaped structure bearing many ciliated tentacles (4). Powerful muscles enable the lophophore to be withdrawn or extruded at will. The slightest disturbance causes withdrawal and some species will not expand again for several hours. Rhythmic movements of the cilia on the tentacles cause a current of water to carry minute food particles into the mouth. Seen under a low-power microscope against a dark background there are few, if any, more beautiful sights in the freshwater world than a colony of moss animals fully extended.

The internal structure consists of a u-shaped gut and a simple muscular nervous and excretory system. Moss animals reproduce in three ways: sexually; by budding; or by producing statoblasts. Each animal is hermaphrodite and pro-

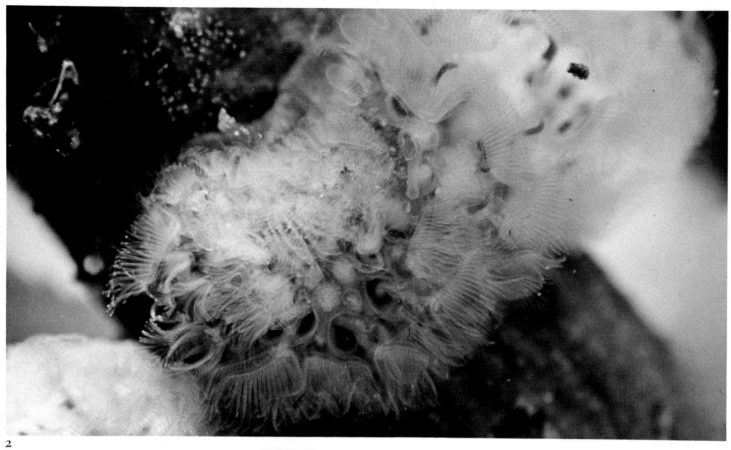

2

3

4

duces a single egg which, after fertilization, develops in situ into a ciliated larva. After a short free-swimming existence the larva settles down and gives rise to a new colony. Budding takes place around the edge of the colony and some moss animals eventually form huge masses. Statoblasts are highly resistant resting bodies which enable the moss animals to survive the winter in climates cold enough to kill the adults when the water temperature drops in late autumn. A statoblast consists of a group of undifferentiated cells enclosed inside a tough, resistant coat (3). Different species produce statoblasts of characteristic shape and ornamentation and they are assuming importance in the identification of moss animals.

Snails, limpets, and mussels
MOLLUSCA

The molluscs comprise a large group of soft-bodied unsegmented animals of complex anatomy and diverse specialization. Most species are marine but snails and slugs have invaded the land successfully, and various snails, limpets, mussels, and cockles are common in freshwater and are important members of the life in ponds.

The most obvious molluscan feature is the protective shell; it either encloses the body or the animal can be withdrawn into it when danger threatens. The shell is secreted by a fold of the body wall called the mantle and consists largely of calcium carbonate, commonly known as chalk or limestone. The amount of calcium salts in the water will determine which species of mollusc can colonize a pond. For example, if there is relatively little calcium present, small, thin-shelled species of snail will be found, whereas, with abundant calcium, the larger, thick-shelled species can flourish.

The foot, a muscular development of the ventral surface of the body, is another characteristic of molluscs. It is used for movement. The molluscs are divided into two main classes, the Gastropoda and the Bivalvia and, because they differ greatly in their structure and mode of life, it is convenient to consider them separately.

Water snails and freshwater limpets
GASTROPODA

In the gastropod molluscs the shell is in one piece and is arranged in a series of whorls of increasing size. The smallest whorl, at the apex, represents the size of the shell of the newly hatched animal. At each stage in growth the mantle secretes another whorl to keep pace with the increase in body size. The foot forms a wide, flat sole containing slime-producing glands at the head end. The musculature of the foot produces transverse waves of contraction of the sole and, as each wave pushes back, the snail is moved forward. The foot glides on a mucous film laid down by the slime glands.

Aquatic gastropods always seem to be active except when the water temperature is near freezing. However, they move slowly as they creep over stones and plants, or on the underside of the water film, searching for algae and other plants on which they feed. Freshwater gastropods are almost entirely herbivorous; they scrape fragments from the food plants using a movable file-like structure in the mouth called the radula. As the animal feeds, the mouth opens and closes rhythmically. The mechanism can be seen very clearly when a snail browses across the glass of an aquarium tank covered in algae. The radula bears rows of small teeth and the shape and arrangement of these provide useful specific characters. The teeth wear down and are replaced by new ones as the radula grows forwards.

Freshwater gastropods breathe either by taking free air into a lung-like structure or by absorbing oxygen through membranous gills. The gill breathers live mainly in streams and rivers where the water contains plenty of oxygen. They also possess a chalky plate called an operculum on the top of the foot which can be closed tightly over the opening into the shell when the body of the animal has been withdrawn for safety. The pond-living gastropods have a lung in the form of a cavity between the mantle and the dorsal wall of the body. To replenish its air supply, the gastropod must come to the surface of the water. However, the animal's oxygen requirements are supplemented by diffusion of oxygen from the water into the body tissues so that, when oxygen is plentiful, the snail makes rather infrequent visits to the surface. The lung breathers, known as the pulmonates, do not possess an operculum but certain species, living in countries such as Australia where there is a prolonged dry season, are able to survive when their habitat dries up by secreting a calcified mucous plug to close the mouth of the shell.

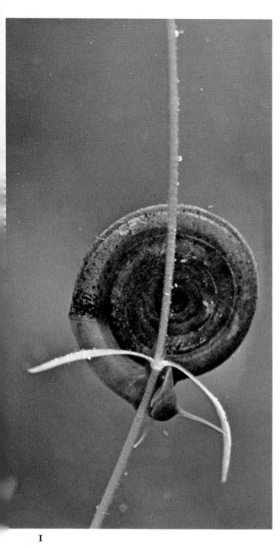

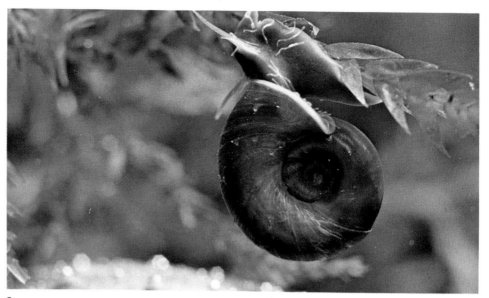

1

2

Pond-living gastropods are hermaphrodite. Some species fertilize their own eggs while, for others, cross-fertilization is the rule. Another variant is for the male and female reproductive systems to mature at different times so that, at any given moment, the snail is either an active male or female but not both.

Some freshwater snails are of great medical or economic importance as intermediate hosts to flukes that infect man and his stock. Bilharzia disease in humans is caused by a parasite that spends part of its life cycle in an African pond snail. The oriental liver fluke passes from pond snail to fish to man where it migrates from the gut along the bile duct to the liver. Because the Japanese eat a lot of raw fish the infection level may reach 35 per cent in certain districts.

The Sheep Liver Fluke, *Fasciola hepatica*, is a worldwide problem to farmers causing loss of condition or death to large numbers of sheep. The fluke's eggs are voided in the sheep's droppings and hatch into larvae that make their way to water and invade the bodies of certain freshwater snails. There they give rise to another kind of larva in large numbers in the liver. Eventually, yet a third kind of larva is produced which leaves the snail and encysts on grass at the water's edge. If the grass is eaten by a sheep, the parasite leaves the cyst and migrates along the bile duct from the intestine to the liver where the fluke feeds on blood and turns into an adult about 2·5 centimetres (1 inch) in length. Man is also at risk because a larva may encyst on wild watercress in ponds and will develop to the adult if the cress is eaten by man. The resulting disease is difficult to diagnose. It should be remembered that washing the watercress in salty water does not kill the fluke larvae.

Trumpet snails PLANORBIDAE

The members of the genus *Planorbis* are called trumpet snails, and have their shells coiled in a flat spiral. All the species have long thin, non-retractile tentacles with eyes at their base. The foot is small and is rounded at each end. When the snail moves, the shell is held vertically upright. The Round-spired Trumpet Snail, *P. spirorbis* (1), is one of a number of species in which the shell is composed of a large number of whorls.

The Ram's Horn Snail, *P. corneus*, (2) is a large species of trumpet snail with a shell more than 25 millimetres (1 inch) in breadth. The snail is unusual in that the pigment, haemoglobin, is present in the blood which is therefore red in colour. The normal colour of the snail is brown but sometimes albinos are found with a transparent shell. The resulting crimson snail is a most beautiful animal.

The Ram's Horn Snail lays about sixty eggs in a flat gelatinous mass attached to a plant. The species is prized by aquarists who use it to control excess vegetation. In the wild it is fairly common and tends to be found in large ponds.

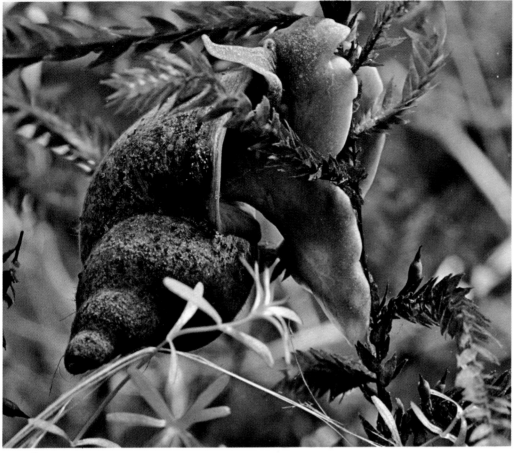

1

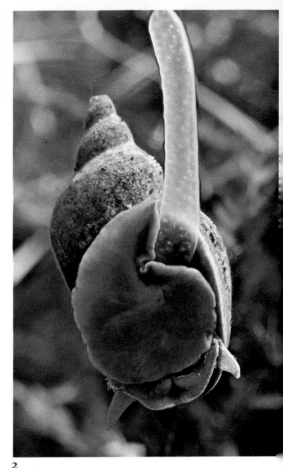

2

3

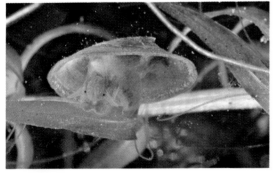

4

Pond snails LYMNAEIDAE

The pond snails belong to the genus *Lymnaea*. They have thin, brownish shells which are conical in shape with a pointed spire. The tentacles, which have an eye at the base, are flat and triangular in shape and are not retractile. The largest species is the Great Pond Snail, *L. stagnalis* (1), which can reach a length of 55 millimetres (2·2 inches) and is common in large ponds in Britain and Europe. It has also become established in Australia and is found in the middle states of the United States and in Asia. Unlike most water snails, which are strictly plant feeding, the Great Pond Snail will scrape away with its radula at decaying animals.

The eggs (2) of the Great Pond Snail are laid in large, sausage-shaped, gelatinous capsules attached to plants and, in particular, to the large, flat surface on the underside of water-lily leaves.

The Wandering Snail, *L. peregra*, (3) is the commonest species in British ponds. The last whorl and the opening into the shell are very large. The eggs are laid in a double row in long gelatinous masses and it is a particularly good species in which to observe the development of the young snails.

Freshwater limpets ANCYLIDAE

The shell of the Lake Limpet, *Acroluxus lacustris*, (4) is shaped like a rather flattened helmet with no trace of coiling or twisting. The length is twice the breadth and the somewhat hook-shaped apex is inclined to the left. The shell is very thin and is easily broken; the edge is soft and fits into any irregularities when the limpet is alarmed and pulls itself tightly down. So firmly does the mollusc cling to stone or plant that it is difficult to remove it without causing damage to the shell. When it moves along on its foot, very little of the animal is visible as the shell swings slowly from side to side. The photograph was deliberately taken from a low angle so that the foot and mantle, head, tentacles, and little black eyes can be seen. The limpet lays a few eggs embedded in a flattened gelatinous capsule attached to a stone or plant. Similar freshwater limpets occur throughout the world.

Freshwater mussels and cockles
BIVALVIA

The bivalves are laterally compressed molluscs with a shell consisting of two valves hinged together dorsally and joined by a ligament. Modifications to the shell are often adaptations to the environment. Freshwater mussels living in rivers have heavy valves and strong hinge teeth, whereas those that live in a quiet pond environment, like *Anodonta* spp, have thin shells and lack hinge teeth. The shell shape of *Anodonta* varies quite a lot, depending upon the amount of water movement, depth, and other ecological factors. At one time there were thought to be eighty-eight different species of *Anodonta* in central Europe but, eventually, it was realized that there were only two species exhibiting many variations.

The bivalve head is smaller than that of a gastropod and lacks sense organs and radula because the animal is a filter feeder and not a scraper. A bivalve moves using its muscular foot; it is wedged shaped and is protruded through the anterior end of the shell to push the animal along. When the valves of the shell are open, at the posterior end of the animal a lower inhalant siphon and an upper exhalant siphon can be seen which are part of the water circulatory system through the mantle cavity. A current is produced by the movement of cilia that cover the pair of gills on either side of the foot. The flow of water through the mantle cavity provides a constant supply of oxygen to the gills and it also carries the minute items of vegetable and animal matter on which the mollusc feeds.

As water passes through the gill network, food particles are trapped on a sticky secretion before being passed on by the cilia to the mouth at the base of the foot. Some bivalves, mainly the smaller species, are hermaphrodite but, in most cases, the sexes are separate.

Freshwater mussels UNIONIDAE

The Freshwater Swan Mussel, *Anodonta cygnaea*, (1) is one of the several different kinds of large freshwater mussel that occur in Europe and North America. In the southern hemisphere their place in pond ecology is occupied by mussels belonging to a related group. Freshwater mussels are not found in ponds where the bottom consists of unstable sand or mud; they require a stable, sandy, silty, or muddy bottom.

The two shells of a mussel are hinged together down the back. In the Swan Mussel the shells reach a length of 15 centimetres (6 inches). When alive and undisturbed the shells are held slightly open, except along the hinge line, and the muscular foot, which is used for digging and movement, may be partly extruded. About two thirds of the animal is usually buried in silt or mud but the two siphons protrude at the posterior end (2). The upper siphon draws water into the mantle cavity and the lower siphon expels it. Mussels appear to be able to control what enters their body because, if a noxious substance is present, the inhalant siphon reverses and ejects a current of water to drive the unwanted material away.

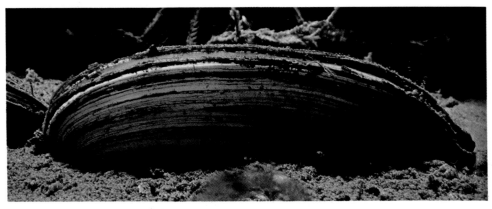

1

2

One visitor, presumably not welcome, is the Watermite, *Pentatax bonzi* (page 125) which is commonly found living in the gill chambers of mussels. There it finds food and also benefits from the constant stream of fresh, oxygenated water entering the host through the inhalent siphon.

In large species of mussels the sexes are separate. The females produce thousands of eggs during the summer which pass from the ovaries and become lodged in the outer gills where they are fertilized by sperm entering through the inhalent siphon. The following spring the embryo develops into a parasitic larva called a glochidium. Vast numbers of these are ejected into the surrounding water.

The photograph (1) shows two free-swimming glochidia after they have left their mother mussel. The glochidium is a minute bivalve with a sharp tooth at the free end of each of the strong, triangular shells. A sticky, thread-like structure, the byssus, emerges from the centre of the animal. The glochidium swims by snapping its tiny shells together. If it is not to die it must become attached to a fish host because the glochidium is a true parasite. Some make contact with a fish while they are swimming while others become entangled by the byssus in pond vegetation. The lucky ones manage to hook into a passing fish using the teeth on their shells but most larvae fail to find hosts and die. Many species of freshwater fishes are used by young mussels but the Three-spined Stickleback seems to be the commonest host.

Picture (2) shows glochidia that have clamped on to the tail of a Three-spined Stickleback; the fins or tail are the usual site for attachment. The tissues of the fish will form a cyst around each larva which will then obtain its food from the blood of the host. A new bivalve shell develops under the old one and, after about three months, the glochidium has changed into a miniature replica of the adult mussel. The tiny mussel now drops off the host and leads a free existence on the muddy bottom of the pond.

1

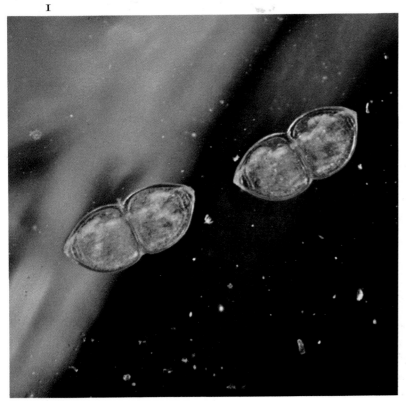

2

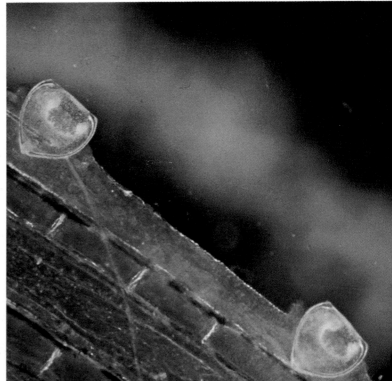

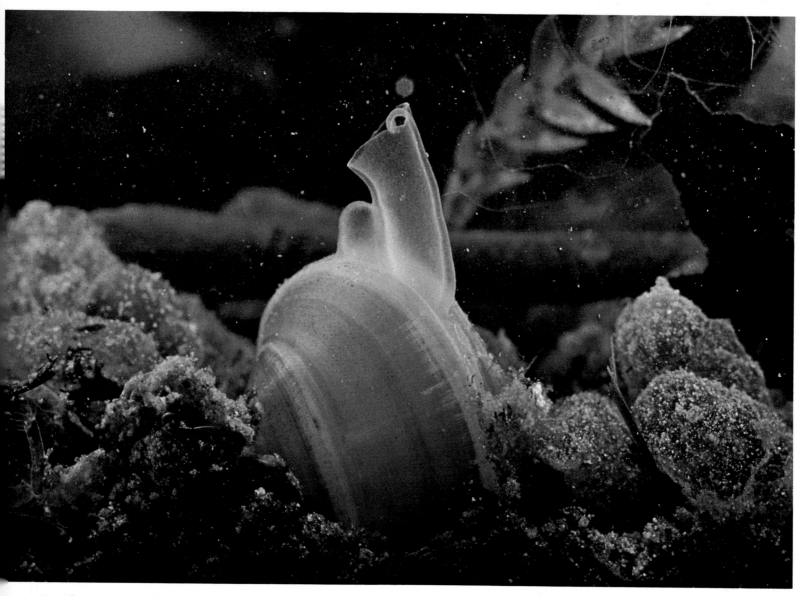

Freshwater cockles SPHAERIIDAE

Orb-shell cockles of the genus *Sphaerium* are cosmopolitan. The shells are rounded so that the mollusc is almost spherical and, when it is closed up, it greatly resembles a small stone. When the siphons are extruded, however, they are quite long and the cockle no longer resembles a pebble.

Cockles are unusual among the bivalves in being hermaphrodite. Only ten to sixteen eggs are produced at a time; they are not laid in the water but are retained inside the shells until they have hatched and grown into small replicas of the adult. Then they are released to live independently. There is no parasitic stage.

Small cockles such as *Sphaerium* are able to crawl up plant stems as are the related and even smaller pea-shell cockles of the genus *Pisidium*. These little bivalves are also cosmopolitan and can be distinguished from *Sphaerium* because they have only one siphon. Movement up vertical surfaces is achieved by extending the foot and attaching it at the tip by a secretion. The retractor muscles then pull the body forward and the foot is again extended.

Cockles are sometimes found firmly attached to the feet of wading birds and, no doubt, this helps to disperse them within a country and between countries.

Many kinds of fishes feed on small molluscs such as cockles by swallowing them whole. Molluscs with thicker shells can be opened and the soft contents devoured by mink in Britain and the United States and by racoons and by certain turtles in the United States.

Water bears TARDIGRADA

The Tardigrada is a small group of tiny, specialized animals of doubtful origin. The short cylindrical body is somewhat flattened underneath and bears four pairs of stubby legs tipped by claws. The gait is lumbering rather like a bear, hence the common name, 'water bear'. There is no separate head; the mouth has a pair of sharp stylets used mainly for feeding on vegetable matter. To feed, the animal usually drills a hole into a plant cell and sucks out the contents.

Most tardigrades live in freshwater, including ponds and lakes, although the best place to find them is on cushions of moss or lichens. If moss is soaked in water for several hours in a small container and is then vigorously squeezed and removed, under a low-power microscope, tardigrades will be visible among the debris on the bottom. If the moss is dry there may be an interval of a few hours before the animals are seen moving about. This is because in dry or cold conditions tardigrades contract and lose water; they become oval in shape and are called tuns. In this form they are resistant to drought, cold, and heat and are dispersed by the wind. When moistened the tuns swell rapidly and soon resume activity. One species of tardigrade survived at $15\,^{\circ}C$ ($59\,^{\circ}F$) for six years, and immersed in liquid air at a temperature of $-200\,^{\circ}C$ it revived after twenty months. Temperatures up to $103\,^{\circ}C$ ($217\,^{\circ}F$) were tolerated.

The sexes are separate and the males are often smaller than the females. Eggs are laid which hatch into miniature replicas of the parents.

The photograph (1) shows a species of water bear belonging to the family Scutechiniscidae. All members of this family are red in colour; this one was found in a small garden pond.

A colourless, more transparent species showing one of the paired black eyespots on the head (left end of animal) can be seen in this photograph (2).

1

2

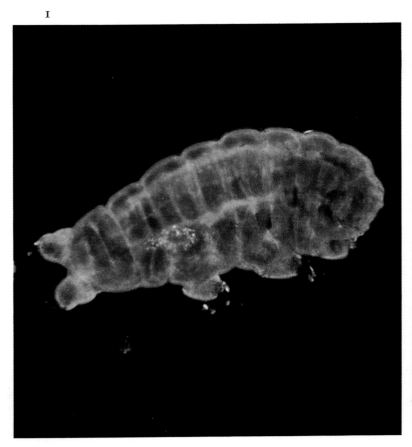
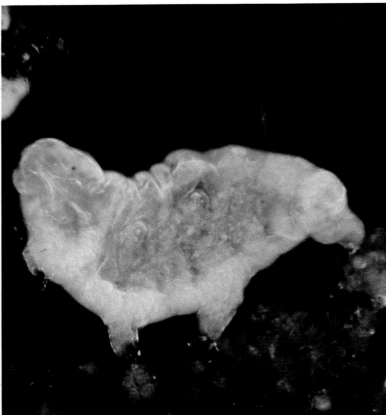

True worms
ANNELIDA

There are many kinds of elongate worm-like animals but, to the biologist, only the members of the Annelida are regarded as 'true worms'. Of these there are about 9000 species, most of which live in the sea. Terrestrial species such as the well-known earthworms, are moderate to large in size – a giant Australian earthworm reaches 3 metres (10 feet) in length – whereas freshwater worms are moderate to small in size and adults may not exceed 0·5 millimetres.

One of the chief diagnostic features of an annelid is the elongate body marked off into obvious segments by rings or annuli (hence the group name). The number of segments varies from a few to several hundred according to species. Each segment contains the same basic arrangement of musculature, blood vessels, nerves, and excretory organs. The reproductive organs are restricted to certain anterior segments. In general, annelids are hermaphrodite and cross-fertilization is the rule. The digestive system runs in a straight line from an anterior mouth to a posterior anus; a worm is really a tube within a tube!

Annelids have soft bodies covered by thin flexible cuticles which often bear segmentally arranged bristles. There are no limbs. Between the body wall and the gut is a fluid-filled cavity, the coelom. The coelmic fluid cannot be compressed so that, when the circular muscles contract, the segments must increase in length; contraction of the longitudinal muscles causes a reduction in length. The coelom is divided into segmental compartments by partitions, so different parts of a worm's body can elongate and contract independently.

The worms can be divided into three main groups: the Polychaeta (many bristles); the Oligochaeta (few bristles); and the Hirudinea (leeches). The polychaetes have muscular, paired lateral projections from the body walls. They are almost entirely marine and include the ragworms and lugworms. Freshwater species are extremely rare so we have not included them in this book. Oligochaetes include the well-known terrestrial earthworm and its allies as well as many freshwater species. On each segment of the body, several stout chaetae emerge separately from the skin. The leeches all have a sucker at the hind end and a smaller sucker surrounds the mouth. Most leeches are found in freshwater.

OLIGOCHAETA

The oligochaetes are well represented in ponds where they either burrow in the bottom mud or move freely among detritus, algae, and plant roots. Many species are transparent which is an excellent way of avoiding being detected and, under the low-power microscope, the internal structure can be clearly seen. Many aquatic oligochaetes tolerate relatively low oxygen levels, or even a complete lack of oxygen for short periods, by having the red respiratory pigment haemoglobin in their blood. The affinity of haemoglobin for oxygen ensures that the worm makes the best use of such oxygen as there is in stagnant or polluted water.

The eggs are laid in a cocoon that is secreted by a glandular girdle, called the clitellum, situated near the front of the body. The eggs hatch into young worms, in contrast to most polychaetes which start life as free-swimming, ciliated, planktonic larvae. Asexual reproduction occurs in many freshwater worms; a transverse division at the posterior end of the body separates off a new, or daughter, individual which finally breaks off.

In some cases a chain of daughters is produced. As might be expected, oligochaetes have great powers of regeneration. Some oligochaetes can form cysts when conditions become unfavourable by secreting a tough, mucous covering around themselves. Cysts are made in summer to combat desiccation, or in winter when the water temperature becomes very low.

Oligochaete worms are most useful members of the pond fauna; they pass huge quantities of mud and detritus through their bodies to extract sufficient nutrients for their needs and assist in the decay of vegetable matter.

Aquatic worms are found in the greatest numbers in shallow water; when the depth exceeds 1 metre (39 inches) the worm fauna decreases rapidly, with the exception of *Tubifex* spp and its relatives which may be found in high concentrations on the bottom of deep ponds.

LUMBRICULIDAE

Lumbriculus variegatus (1) is a very common worm in still water and greatly resembles an earthworm although it belongs to a different family. The general colour is red-brown with a slight green coloration superimposed anteriorly. It swims with spiral undulations and forms resistant cysts camouflaged by particles of debris. Sexual specimens are rare and *Lumbriculus* multiplies by division.

Tubifex worms TUBIFICIDAE

Tubifex worms (2) are usually 3 to 4 centimetres (1·2 to 1·6 inches) long with red blood which clearly shows through the transparent body. They live in groups in tubes which they construct in the mud and can be found in water extending from the pond shallows to depths where other oligochaetes cannot survive.

The worm feeds by passing mud through its body to extract any digestible material. Therefore, the head is buried in the mud and the tail waves freely in the water. A patch of red on the pond bottom will consist entirely of tubifex worm tails which will disappear rapidly into their tubes when disturbed. The waving tail serves as a gill into which oxygen enters by diffusion, and the haemoglobin in the blood makes the extraction of the vital gas more efficient. By waving their tails the worms create currents which enable them to extract oxygen from a larger volume of water. Because the head end of the worm is buried in the mud, it has access to very little oxygen, and the poorer the oxygen supply the further the worm backs out of its tunnel so that a larger area of its body is exposed.

Tubifex worms lay their eggs in oval capsules and their numbers can increase very rapidly. They are a valuable food for many fishes.

Nymph worms NAIDIDAE

The photograph (3) shows an example of the large family, Naididae, of which there are many genera found in ponds around the world. They are probably the commonest freshwater worms and range in size from 3 to 25 millimetres (0·1 to 1 inch) in length. Eggs are sometimes laid but the usual method of reproduction is by asexual budding involving a transverse division of the parent worm into two or more new individuals. Usually there are definite splitting zones and, in some species, a new zone forms before separation has taken place in the old one. Such delayed divisions produce chains of individuals.

Naids are either transparent or are coloured pink. The specimen shown is a transparent species, except for the contents of the gut, and it would obviously be difficult to see it against the detritus and mud on the bottom of a pond.

Most naids feed on dead organic matter, particularly vegetation, although some species prey on small invertebrates and have a very large mouth into which they suck their victim.

Chaetogaster limnaei (4) is an example of a naid worm that is commensal on water snails, in this case on the Ram's Horn Snail (page 107). The worm is colourless and up to 8 millimetres (0·3 inch) long and several may be found attached to the snail's body. Presumably the worms benefit from being able to shelter in the snail's shell and possibly they obtain more food as they are carried around.

1

2

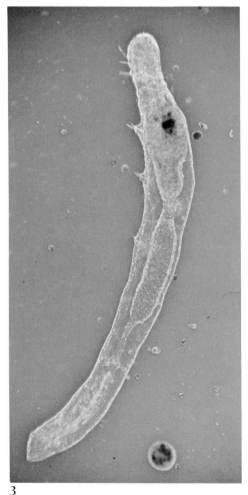

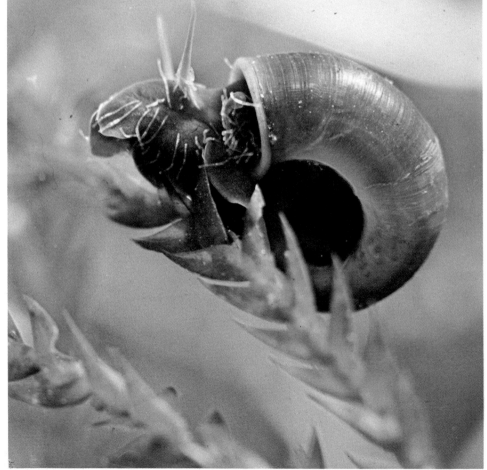

3

4

Leeches
HIRUDINEA

Leeches are easily recognized by the two suckers, of which the one at the hind end is the most obvious. The smaller sucker that surrounds the mouth is not well developed in some species. Other features are the absence of chaetae or bristles, the dorsoventral flattening, and the oval shape assumed at rest. Leeches also have fewer internal segments than there are external rings. Leeches have pairs of eye spots at the head end of the body and their number, size, and disposition are used to identify species.

The posterior sucker is the main organ of attachment to a host animal or to vegetation. Both suckers are used when the leech moves. Having taken a firm grip with the posterior sucker the body stretches forward and the anterior sucker clamps down. The rear sucker is then released and brought forward next to the front sucker. Thus, the leech progresses in a series of looping movements. Some leeches swim in a most graceful manner by undulating the body up and down.

Some leeches are marine, some are terrestrial in warm, humid climates, some occur only in freshwater, and some are amphibious, occurring both on land and in water. Most leeches feed on blood and they do this in one of two ways. Some leeches have a proboscis and no jaws; they feed on the blood and soft tissues of other animals that have a body wall which is delicate enough to be penetrated by the proboscis. Fishes, water snails, and other invertebrates are common hosts. The larger kinds of leech have jaws with which they can pierce the skin of vertebrates. The blood-sucking leeches feed infrequently because their gut is divided into compartments to hold a very large meal. When a leech feeds it produces an anticoagulant salivary fluid so that the host's blood flows freely and does not clot during storage.

Most leeches are external parasites but some aquatic species enter vertebrate hosts through the nostrils while they are drinking. In general, a muddy or silty environment is not favourable for leeches because clean stones and vegetation provide a better basis for attachment. There is evidence that leeches are more active at night than during the hours of daylight.

Fish leeches PISCICOLIDAE

The Fish Leech, *Piscicola geometra*, (1) is a proboscis leech. It lacks jaws but is armed with a muscular proboscis with which it penetrates the body of its prey. The manner in which proboscis leeches manage to do this is not clear but it is possible that an enzyme is secreted to assist penetration. It is rare for mammals to be parasitized; presumably their skins are too tough.

Members of the family Piscicolidae are temporary or permanent parasites on fishes, mainly marine, but the Fish Leech is a freshwater species that is fairly common in ponds, as well as in running water, throughout the Holarctic region. In the United States, the genus *Piscicolaria* fills the same ecological niche. Oddly, Australia has no fish leeches.

The Fish Leech is up to 5 centimetres (2 inches) in length and is of a greenish or reddish-brown colour. There are two pairs of large eyes at the base of the head sucker. The body shape is long and narrow and, in cross-section, the leech is more cylindrical than most of its kind. The anterior and posterior suckers are exceptionally large and have radiating markings which give them a frilled appearance. Most leeches can contract in shape a lot when disturbed or prodded but the Fish Leech contracts very little. *P. geometra* is a very active leech that moves quite fast by means of the looping method which is so typical of leeches.

The Fish Leech is a temporary parasite, that is, it does not spend all its life attached to a host. When the leech is ready for a blood meal it attaches itself by the large posterior sucker to a water plant and extends its body more or less straight out like a twig as shown in the photograph (1). It can maintain this position for

1

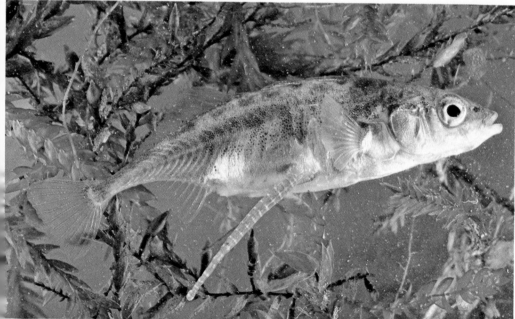

2

days if necessary until a fish approaches or brushes past. At once, the leech attaches its mouth to the fish and releases the hind sucker. The leech remains on the host for a few days imbibing its blood until it is fully gorged and drops off (2).

A small fish, like a stickleback, may have two or three leeches attached to its body and a large carp may have as many as a hundred. After feeding, the leeches mate on the body of the host. They then leave to deposit their brown, ribbed cocoons, each 1 to 1·5 millimetres long and oval in shape, on water plants and submerged stones. In the fish leeches the cocoon contains only a single egg.

1

2

Leaf leeches GLOSSIPHONIIDAE

Theromyzon tessulatum is known as a leaf leech because of its flattened, leaf-like shape. Leaf leeches inhabit freshwater where mostly they suck the body fluids and soft tissues of snails and other invertebrates. A few, including *T. tessulatum*, are parasites of fish and waterfowl. It is cosmopolitan in distribution occurring in Europe, Asia, and North America.

The body length varies from 2 to 5 centimetres (0·8 to 2 inches). When the leech stretches forward, the flattened body becomes nearly parallel sided, with the head region slightly dilated and, when the leech contracts, it becomes oval in shape. The colour is greenish grey with six rows of yellow spots on the back, and there are four pairs of eyes. During its development the leech has four periods of growth when it feeds on the mucous lining in the nostrils and throats of water birds. Between bouts of feeding it leaves the host to become free living. When mature, there is a long period of mating before the leech lays her eggs enclosed in thin, transparent cocoons attached to a stone. The mother is unusual in that she sits over her eggs as shown in the photograph (1). When the eggs hatch, the young leeches attach themselves to the ventral surface of their mother which carries them around for about five weeks (2). A leech with young has been observed to enter a duck's nostril.

Worm leeches ERPOBDELLIDAE

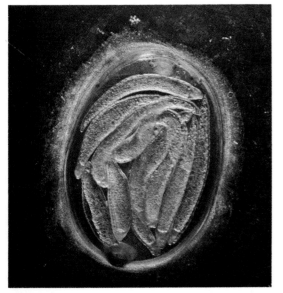

Erpobdella octoculata belongs to the group known as worm leeches which have neither proboscis nor jaws but have instead a long, muscular pharynx with which they either gulp small invertebrates or feed on carrion. They live either in freshwater or in moist soil.

The worm leeches are elongate and flattened. *Erpobdella octoculata* of Europe reaches 6 centimetres (2·4 inches) long and is variable in colour. It occurs in rivers and ponds in hard and soft water. In soft-water ponds, it is likely to be the most numerous leech. It feeds by gulping fly and other insect larvae, cladocerans, small oligochaete worms, and it may even enter the shells of aquatic snails to suck out the contents.

The smooth, brown, oval, leathery cocoons, each containing up to thirty eggs floating in albumin, are attached to plants or stones. The cocoon in the photograph was deposited against the glass of an aquarium tank and the embryos, almost ready to hatch, can be seen clearly (3).

E. punctata, which is 10 centimetres (4 inches) long, and various shades of grey in colour, is the commonest leech in North America. Its habits and egg cases are similar to those of *E. octoculata* except that it may also attack fishes, frogs, and occasionally man.

3

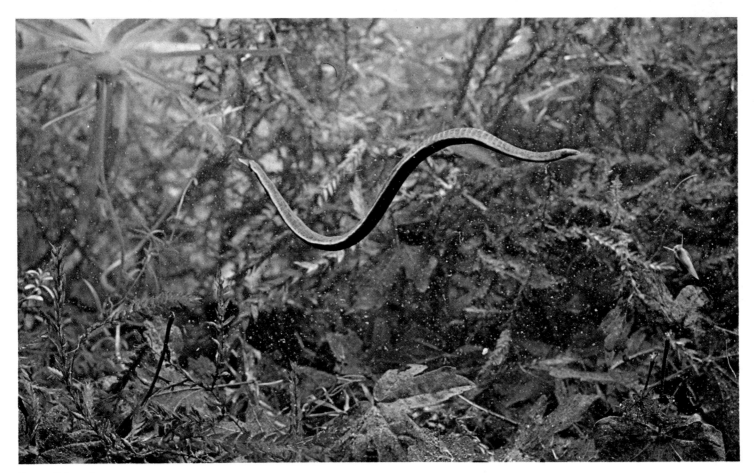

Jawed leeches HIRUDIDAE

The Horse Leech, *Haemopsis sanguisuga*, and its relatives have three disc-shaped jaws armed with teeth, and the majority are blood suckers. When the animal feeds, the anterior sucker is attached to the host, and the teeth cut through the integument as the jaws swing back and forth like sections of a circular saw. The incision is anaesthetized by an unidentified substance which is why a human remains unaware that a leech is at work on his or her body. The leech has a powerful pharynx that can maintain continuous suction and, while feeding, the leech secretes a substance called hirudin which prevents the blood coagulating. This is why the wound, although small, continues to bleed for about half-an-hour after a leech has been removed from a human.

The family Hirudidae to which the Horse Leech belongs, contains the largest and best-known leeches. *Haemopsis sanguisuga* is widely distributed in Britain and the rest of Europe. At rest it is about 6 centimetres (2·4 inches) long but can extend to 15 centimetres (6 inches). The colour is varied, from light to dark green or brown and both upper and lower surfaces have black spots. There are five pairs of eyes. The jaws have two irregular rows of fourteen blunt teeth that cannot penetrate the skin of vertebrates.

The Horse Leech is atypical in that it is not a blood sucker; the food is swallowed whole and consists mainly of worms although small fishes, tadpoles, and snails may be taken. Contrary to country lore, it is harmless to horses. When the Horse Leech swims the dorsoventral muscles remain contracted which flattens the body; waves of contraction pass along the longitudinal bands of muscle to produce vertical undulations which result in a very graceful mode of swimming as is seen in the photograph. The Horse Leech leaves the water to deposit its cocoons in damp soil beside the pond.

Haemopsis marmorata, the Horse Leech of North America, has similar habits. *H. grandis*, another pond species, reaches 30 centimetres (1 foot) long and is the largest North American leech.

Spiders, mites, crustaceans, insects
ARTHROPODA

The arthropods exceed all other animals in number of species and individuals. They have occupied every conceivable ecological niche and, in freshwater, about three-quarters of the species belong to this phylum.

The main features of the arthropods are the skeleton on the outside of the body (exoskeleton) and the paired jointed limbs which are specialized for different purposes – walking, swimming, feeding, respiration, sensory, reproduction. The animal's body is covered by skeletal plates that are hardened by a process similar to tanning leather. The change in colour that accompanies the hardening can be seen as an adult beetle emerges from the pupal case (pages 166–7). Each plate of the exoskeleton is joined to its neighbours by a thin, yet tough membrane that permits movement of the parts of the body. This type of skeleton confers much greater protection than does the thin cuticle of a worm. It also provides a firm anchorage and leverage points for the muscles that operate the limbs. The segments of the limbs are joined in such a way that they can move in one plane only. Arthropods can move their limbs with greater power and precision than other invertebrates.

In terrestrial arthropods the loss of water is greatly reduced by the incorporation of wax in the outermost layer of the skeleton. There are some disadvantages to wearing a non-living external skeleton. Firstly, it imposes the need to shed the skeleton, that is to moult, so that the animal may increase in size, and this is a time of great danger because, for a while, the body is soft and defenceless against predators. Secondly, there is a limit to ultimate size because the skeleton becomes increasingly unwieldy. It is no accident that the largest arthropods live in the sea where they derive maximum buoyancy from their environment.

There are two evolutionary lines in the arthropods, the Chelicerata and the Mandibulata. In the Chelicerata the body is divided into two portions, a combined head-thorax, called a cephalothorax, and an abdomen. There are no antennae and the first two appendages in front of the mouth are called chelicerae and are modified for feeding. The first two appendages behind the mouth are called pedipalps and are adapted for different functions in the different orders. Apart from some mites, one species of truly aquatic spider, and several that live on the water surface, there are no freshwater representatives in the Chelicerata.

Spiders
ARANEAE

Nursery web spiders PISAURIDAE

The spider most likely to be seen on small bodies of still water belongs to the genus *Dolomedes* (*see* opposite), generally known as fisher spiders in North America and Australia, and by the misleading name of raft spider in Britain. These spiders do not ensnare their prey in webs; they rest on a leaf on the water surface with one or more legs touching the water so that they can detect any ripples created by an insect trapped in the surface film. The spider then rushes across the water surface, having first taken the precaution of attaching a silken line to its resting place, seizes and poisons the prey by biting it, and carries it back to the leaf to be consumed at leisure. The name fisher spider is most appropriate because, while filming the spider at Oxford Scientific Films, we noticed that it attracts small fishes by dappling the water with one leg. When a fish approaches within 20 millimetres (0·8 inch), the spider lunges into the water, seizes the fish, and hauls it on to a leaf. The spider may pursue its prey beneath the surface of the water, but this is not surprising because, when alarmed, *Dolomedes* can immerse itself entirely for a considerable period, breathing air trapped in the hairs surrounding the body.

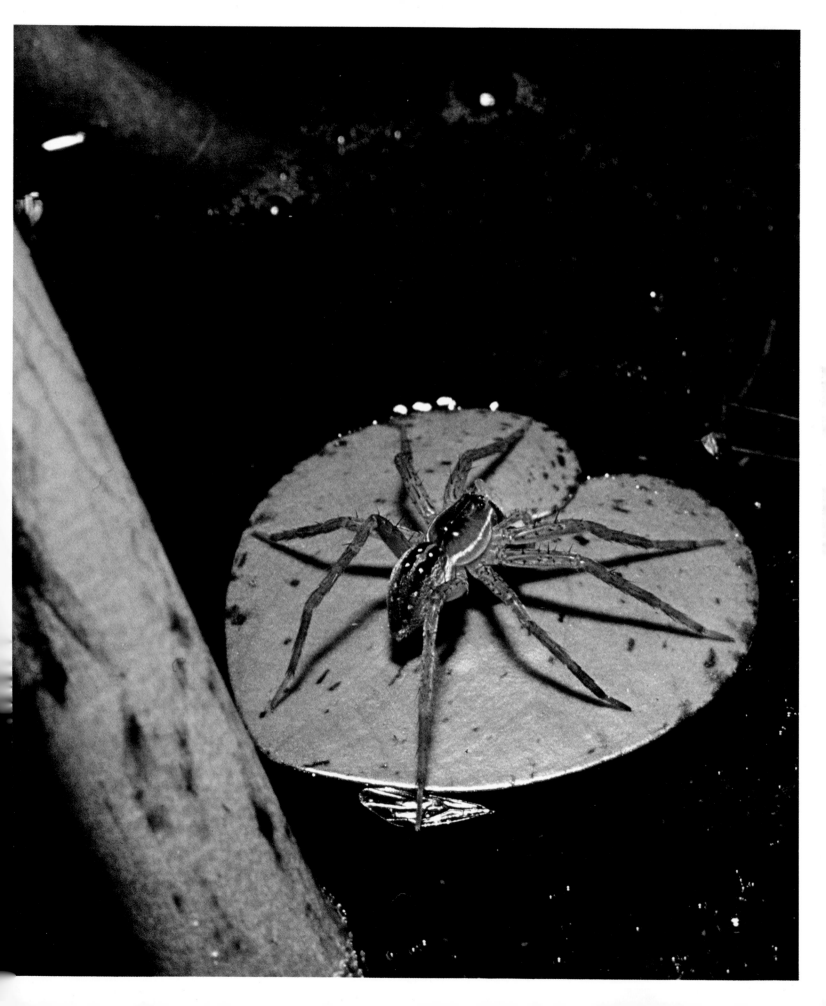

Dolomedes is a handsome spider, heavily built with powerful legs. It is a pleasing brown colour with a yellow stripe running along the outer edge of cephalothorax and abdomen, and white spots on the upper surface of the abdomen. Large specimens reach 25 millimetres (1 inch) in body length, excluding the legs; these are females, and the males are much smaller.

Courtship may be prolonged. The male slowly, and with frequent pauses, approaches the female while waggling his outstretched front legs rapidly up and down. Finally he touches her and, if he is not repulsed, he inserts each palp once into the female's orifice. The expansion and contraction of the bulb when sperms are injected takes only a few seconds; then the male retreats to safety. The female encloses her eggs in copious silk to produce a large round egg sac which she carries around slung beneath her body for two to three weeks. At intervals she dips the egg sac in water to keep it moist. Shortly before the eggs are ready to hatch, the mother suspends the sac in low vegetation and spins around it a loose, silken tent. She sits on guard on the outer walls of the tent. But first she takes the precaution of unravelling the outer threads of the egg sac to enable the young to escape. For about three days after hatching, the spiderlings remain together in the tent; then they undergo their second moult and gradually disperse to fend for themselves. In winter the spider hides among damp vegetation with the limbs drawn in to await the warmth of spring before returning to the pool.

Wolf spiders LYCOSIDAE

Most wolf spiders are strictly terrestrial. A few, however, are associated with water, particularly the genus *Pirata* in Europe and other genera elsewhere in the world, such as *Lycosa arenarius* in Australia. Typically, species of *Pirata* are velvety brown spiders from 4 to 10 millimetres (0·16 to 0·4 inch) long with a white band down each edge of the cephalothorax and two rows of tiny white spots on the abdomen. The female carries the egg cocoon attached to her spinnerets.

In the photograph of *Pirata* sp (1) feeding on a fly, you can see that aphids are feeding on the duckweed. Aphids or greenfly are sap-sucking insects that are mostly specific in their choice of host and even the little duckweed plant has its own associated species.

Funnel web spiders AGELENIDAE

There are about 40 000 described species of spider in the world, but only one has adapted to live in water and merits the name Water Spider. *Argyroneta aquatica* is unique in spending its life underwater without any need to come above the surface to moult, feed, mate, or reproduce. Should the water become polluted or the pond dry up, the spider can survive on land. Indeed, the spider lives underwater without getting wet because it is ensheathed in a silvery coat of air trapped in the velvety pile of hairs that cover the body. All the spider's activities, other than hunting and collecting air, are conducted in a diving bell (2). The spider makes the bell by spinning a platform of silk, attached to underwater plants, beneath which the spider releases air collected at the surface. Silk and air are added until a thimble-like shelter has been constructed. To a certain degree, the diving bell functions as a self-perpetuating supply of air; as oxygen is used up more tends to diffuse into the reservoir from the surrounding water while carbon dioxide diffuses into the water. When the oxygen tension of the water becomes low the spider replenishes the supply from the surface.

From the bell the spider makes hunting forays, laying down silken lines as it explores its surroundings. Its taste in food is catholic; it will seize insects trapped on the surface film by coming up beneath them and dragging them under the water and down to the bell. The spider will attempt to catch fish fry by lying in

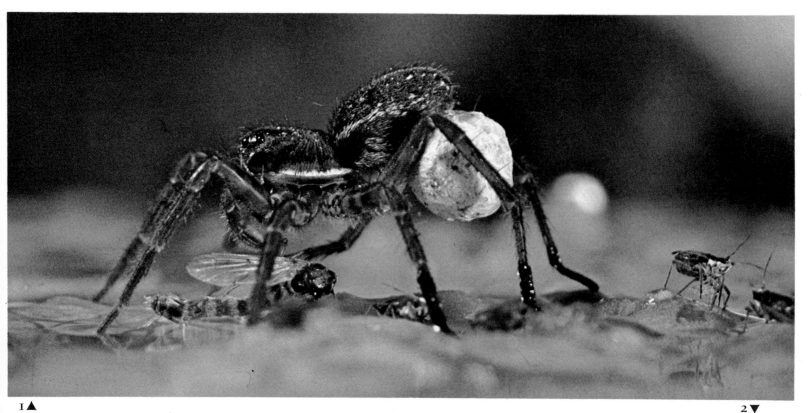

1 ▲

2 ▼

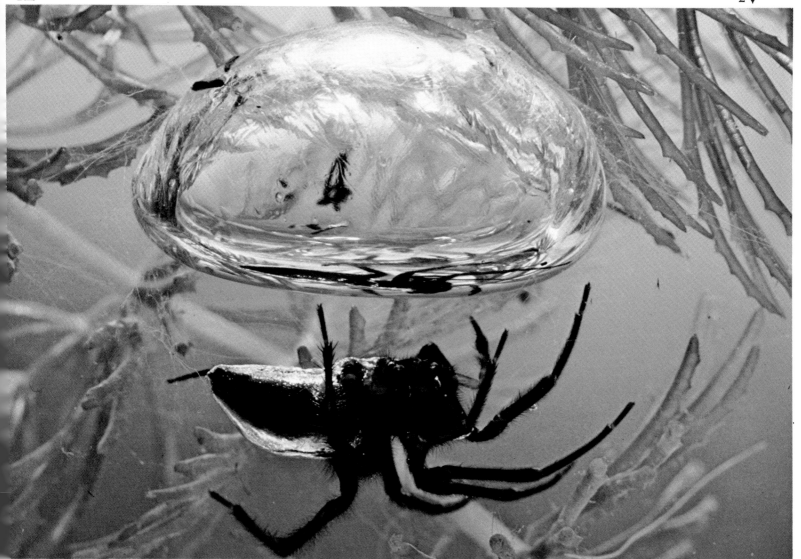

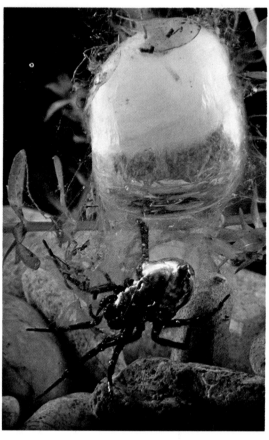

I

wait and lunging at them with its forelegs when they come near. Dead animals are also eaten. Spiders feed by pumping digestive juice into the prey before sucking up semidigested soup. This cannot easily be done in water so all food is taken back to the bell to be consumed in the air pocket.

In many spiders the male is much smaller than the female but the two sexes of the Water Spider show the same size range of 9 to 13 millimetres (0·35 to 0·5 inch) so the male can be larger than his mate. When a male moults to maturity he stocks his palps with sperm in his bell and then goes in search of a mate. If he finds an unreceptive female she warns him off by jerking her abdomen or lunging at him. If permitted to do so he caresses the female with his front legs before mating inside the bell.

Eggs are laid in summer in batches of fifty to 100 enclosed in a dense white egg sac that completely fills the upper half of the diving bell (1). The mother remains on guard in the lower portion of the bell. The eggs hatch in three to four weeks and the youngsters remain in their mother's home for about two weeks until they moult for the second time and disperse. This is the only time when the Water Spider voluntarily leaves its pond. Many of the youngsters climb up plants out of the water and float away on gossamer threads. Most will perish; a few will colonize fresh pools.

At the approach of winter, the Water Spider leaves its bell near the surface and retreats to greater depths where it seals itself inside a tough bell to remain quiescent until awakened by the warmth of spring.

A. aquatica is restricted to Europe but, in Britain it is found in ponds in many parts of the country. Where it occurs, it is usually fairly numerous, although it has plenty of enemies, such as dragonfly nymphs, water beetle larvae, water scorpions, frogs, and fishes. Perhaps the worst predators of small Water Spiders are large ones because spiders are notorious cannibals.

Watermites
HYDRACARINA

Mites are closely related to spiders from which they can be distinguished by having the cephalothorax and abdomen fused together so that the body is in one piece, and is usually oval or round in shape. The adults have eight legs, the same as spiders, but the larvae only have six like insects. At the front of the body there is a narrow beak adapted for piercing and sucking; digestive fluid is pumped into the prey and the liquified food is sucked up in the same way as spiders do. The beak lies between a pair of sensory palps. There are two pairs of widely spaced eyes near the beak and sometimes there is a single median eye as well. There is a tracheal system and spiracles for respiration but the openings to the spiracles are covered by plates through which gaseous diffusion takes place so that aquatic mites do not need to visit the surface to obtain oxygen.

Many mites are aquatic and those that live in ponds have hair-fringed legs and swim actively. River species avoid being swept away by crawling instead of by swimming.

HYDRACHNIDAE

Hydrachna (2) is a common genus in still water. The mites are usually a bright red colour and 3 to 5 millimetres (0·1 to 0·2 inch) long. They are carnivores and suck the body juices out of small crustaceans, insect larvae, and worms. The females lay their eggs, which are also red, imbedded in a gelatinous covering attached to stones or plants (3). The eggs hatch in about three weeks and the six-legged larvae

2

3

4

are parasitic on waterbugs such as *Nepa* spp. A number of small red specks may be found attached to the body and legs of a water scorpion with their beaks embedded in the host's tissues. At a later stage the larvae become free swimming before attaining maturity.

In Britain there are about 200 species of watermite. Some species are widespread and occur in Europe and North America. Many genera, including *Hydrachna*, are cosmopolitan. More than sixty species of Hydracarina have been recorded so far from Australia but there may be many more still to be discovered.

HYGROBATIDAE

Mites of the widespread genus *Pentatax* (*Unionicola*) spend the whole of their lives inside the mantle cavity of freshwater bivalves. *P. bonzi* (4) lives on the gills of the freshwater mussel, on which it was photographed, and also lays its eggs inside the mussel. Many European Swan Mussels contain the mite. In Australia, *P. cirrosa* occurs on the gills of the mussel, *Hyridella australis*.

Crustaceans and insects
MANDIBULATA

Mandibulate arthropods have one or two pairs of antennae on the head and one pair of mandibles. The two largest subdivisions, and the only ones containing aquatic species, are the Crustacea and the Insecta.

The Crustacea is the only large group of arthropods that is primarily aquatic; most species are marine but there are many freshwater forms. This highly successful group shows great ecological diversity, ranging from free-living predators, herbivores, and scavengers to internal parasites in which the adult's body may be so altered that it can only be identified as a crustacean in the larval stage.

The class Insecta contains more than 750 000 described species, and there are very many yet to be described. It is by far the largest group of animals; in fact, its numbers exceed all other animals combined. Most insects are terrestrial but many have invaded freshwater, either to pass their early stages or for the whole of their lives. The sea has scarcely been colonized by insects.

In freshwater ponds the crustaceans and insects are by far the dominant animals in number of species and in biomass, that is, the weight of living matter they represent out of the total weight of animals present.

Crustaceans
CRUSTACEA

The crustaceans are almost exclusively aquatic; they breathe either through gills or through the general body surface. They all have two pairs of antennae and most of the body segments bear paired jointed appendages that are usually forked.

Most of the 35 000 species known in the world are marine but there are six families that have representatives found commonly in ponds everywhere.

Fish lice ARGULIDAE

The fish lice, *Argulus* spp, are small crustaceans which may be found on the body or fins of most species of freshwater fishes. In the photograph *A. foliaceus* (**1**) is seen on the tail fin of a Three-spined Stickleback. *Argulus* is a serious parasite that kills fishes when it is numerous. It has been known for more than 300 years but there is still no successful treatment that can be applied in ponds and rivers. The fish louse feeds by inserting a stout spine into the host and injecting a secretion that breaks down the walls of the blood vessels before sucking the victim's blood. When fully fed, the parasite leaves the host but it can swim quite well and will search for another victim when it is hungry again.

Argulus is so flattened dorsoventrally and so transparent that it is very difficult to see it on a fish. The most conspicuous feature is the pair of well-developed black eyes. Different species of *Argulus* are found throughout the world.

A full-grown *Argulus* is about 3 millimetres (0·12 inch) long. In this close-up photograph (**2**) the pair of large suckers, the main organs of adhesion to the host, can be seen beside the eyes. They serve a second purpose, too. A swimming *Argulus* is naturally regarded as food and may be sucked into the mouth of a small fish. The parasite avoids being swallowed by clamping on to the lining of the fish's mouth. After trying to swallow it, the fish spits out the uninjured *Argulus*.

The sexes mate on the body of a host and once the female has been fertilized she leaves the fish and lays a long ribbon of 200 to 300 eggs on a stone or on debris on the bottom of the pond. The eggs hatch in a month and the minute larvae find their way on to the skin of fishes. The larvae have only two pairs of swimming legs and are quite unlike the adult. There are several moults before the adult stage is reached.

1

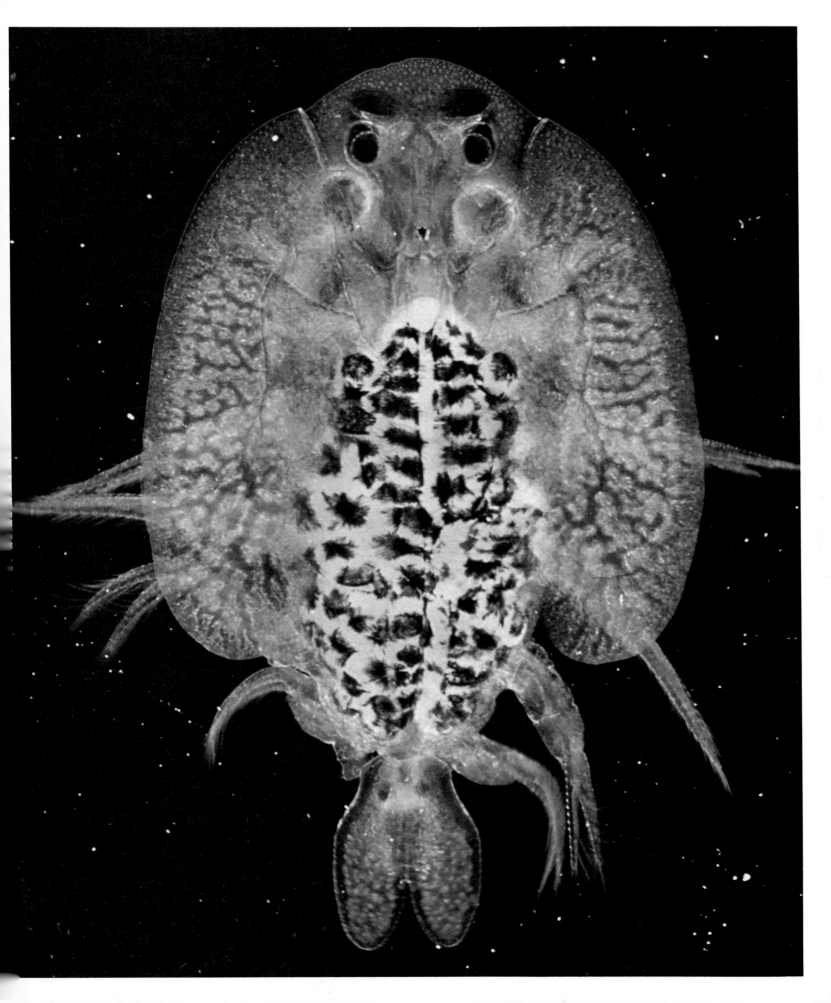

Waterfleas DAPHNIIDAE

Waterfleas, *Daphnia* spp, (1) are the commonest crustaceans in all kinds of still water from ditches and ponds to large lakes where they may be present in vast numbers. They are of immense importance in the ecology of ponds because they feed on minute algae and bacteria which they filter out on their legs and pass forward to the mouth. In their turn they are a favoured food for a host of carnivorous animals, ranging from protozoans such as *Stentor* spp, through *Hydra* spp, to small fishes. The carnivorous bladderworts (page 63) capture them, too.

Waterfleas swim by using the second pair of antennae which are particularly large. Movement is jerky and tends to be upwards and, in the pause between strokes, the animal sinks again. The whole of the body except the head is enclosed in a transparent shell which is part of the animal and is continuous across the back and open on the ventral surface. There is a single, conspicuous, central eye that is sensitive to light so that waterfleas will be found at a certain level in the water depending on the intensity of the daylight. In badly oxygenated water, *Daphnia* spp develop haemoglobin in the blood to assist in the uptake of oxygen, and the animals illustrated obviously come from an oxygen-deficient pond.

The sexes are separate in waterfleas and, during most of the year, only females are found. In summer they lay numerous unfertilized eggs which are kept in batches of seven to twelve in a portion of the shell called the brood pouch (in this case the waterflea is *Daphnia magna* [2]). The summer eggs develop quickly and hatch within a day or two into young females which are miniature replicas of their mother.

When the young waterfleas hatch they remain in the brood pouch for a day or two feeding on a secretion produced by their mother. Then the space between the two sides of the shell widens and the youngsters squeeze out through the gap to begin living a free life (3).

When the environment becomes unfavourable, such as during a severe drought or at the onset of winter, waterfleas lay eggs and some of these hatch into males. Males are smaller than females and the first pair of antennae are larger. After mating the female produces two or three thick-shelled, resistant eggs which are retained in a special compartment of the shell that develops thickened walls. When the mother waterflea moults, the compartment plus eggs sink to the bottom of the pond where the eggs remain dormant until favourable conditions return; then they hatch to produce females that lay many summer eggs so that the population rapidly rises again (4).

Over 100 species of waterflea from Australia have been described so far. Some are endemic although most are cosmopolitan or very widespread. The specimen in the photograph (5) comes from Victoria and belongs to a group that is sometimes referred to as 'bird-like' because the rounded head is drawn out into a structure resembling a bird's beak. The animal is very transparent and looks green because the background is that colour; this is an excellent method of avoiding detection. The brood pouch contains a large number of eggs.

Seed shrimps CYPRIDIDAE

Seed shrimps are small crustaceans belonging to the family Cyprididae and averaging about 1·5 millimetres long. Most species are free swimming and they occur, often in huge numbers, in all kinds of still freshwater – as well as in rivers and the sea. The colour of seed shrimps may be almost white or green or various shades of brown and some are banded or mottled. Seed shrimps are very active and are always on the move. Mostly they are scavengers although some are also predatory. The photograph shows a group of seed shrimps feeding on a freshwater sponge (1 page 130).

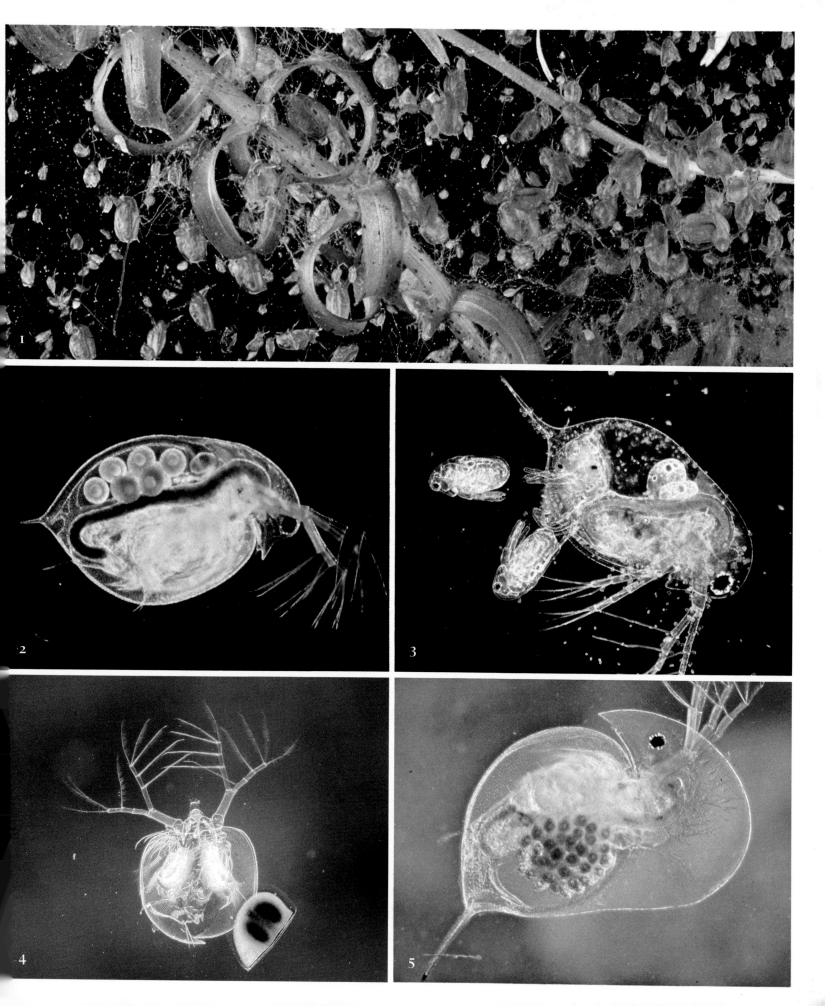

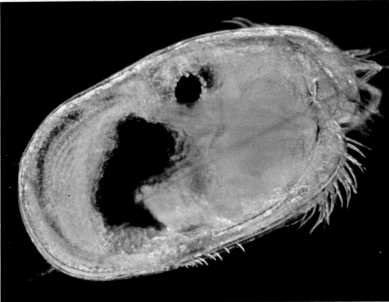

Weedy ponds are a favourable habitat for some species; others, not such good swimmers, are found creeping around on the muddy bottom. Some seed shrimps tolerate a fairly high level of organic content, such as is found in ponds into which farmyards drain. In autumn, decaying leaves are eagerly sought.

Although the shell may be variously ornamented with grooves or pits or setae, or may be perfectly smooth, the general shape of seed shrimps varies little and they are easily recognized. Some species are cosmopolitan, as may be expected in an animal which produces a small, resistant egg transportable in mud on a bird's foot.

The shell of a seed shrimp is complete and is shaped like a bean. It consists of two halves joined together by a central hinge so that the animal resembles a minute bivalve mollusc. When alarmed the whole body is withdrawn, the valves close, and the animal sinks to the bottom of the pond. Seed shrimps swim by moving either both pairs of antennae or by using the second pair only. The front three pairs of legs are modified for feeding and the last two pairs are used for walking and for cleaning the inside of the valves. There is a median eye which shows in the photograph as a large black circle half-way along the dorsal surface (**2**).

In some species both sexes occur but in others males have not been found so far. The eggs are usually attached to water plants. They are remarkably resistant and have hatched successfully from dried mud after as long as thirty years. The form of juvenile that emerges from the egg is enclosed in a bivalved shell like the adult but it has only three pairs of appendages.

Copepods CYCLOPIDAE

Cyclops spp and their relatives, known as copepods, are all of the same general appearance, except for certain parasitic forms that show a great reduction in structure associated with their mode of life. They are small; the largest free-swimming species is only about 4 millimetres (0·16 inch) in length. Unlike the waterflea and seed shrimp, copepods have no shell and the body is divided into three portions, a combined head-thorax or cephalothorax, followed by four or five free thoracic segments terminating usually in a much narrower abdomen that ends in stiff bristles. The head bears two pairs of antennae of which the first are very long. Other paired appendages are present on most of the body segments but they are only visible from below. The mouth parts are used either to grasp food or to filter particles from the water. There are swimming legs on the thorax. In the centre of the head there is a single eye, either black or, as in the species photographed, red in colour (**3**). The best-known genus, *Cyclops*, is named after this feature.

Many copepods are almost colourless and transparent but others are quite strikingly coloured in shades of red, green, or blue.

Males are usually smaller than females and, in some species, one antenna is modified for grasping the female during mating. The male transfers his sperm in a bag called a spermatophore which he attaches to the female where it remains until she dies. As in most freshwater crustaceans, the females produce two kinds of eggs: a kind that develops quickly when the habitat is favourable; another kind to tide the species over unfavourable conditions.

The eggs are laid in one or, more usually, two masses attached to the female by a narrow neck. When females are carrying egg sacs, copepods are instantly recognizable without recourse to a lens or microscope. The eggs are carried for about ten days until they hatch into larvae which take three to four weeks to become adults, having passed through eleven or twelve moults.

Members of one group of copepods feed on their backs and use their limbs to create a current of water flowing over the filtering apparatus. The hairs of the filter are so fine and close together that they can remove individual bacteria. Other species, such as *Cyclops* spp, rush about in the water seizing food whenever they come across it, or they feed on larger dead animals.

Cyclops spp are often found together with waterfleas and, like them, they are a valuable source of food for the immature and adult stages of predatory insects and small fishes.

3

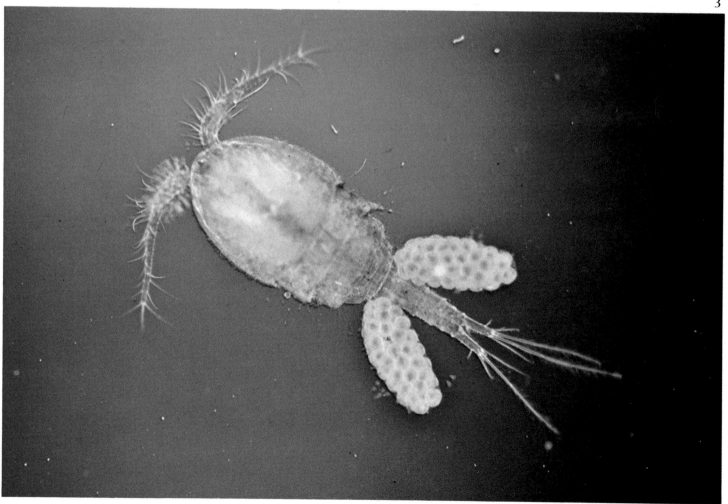

Waterlice ASELLIDAE

The waterlouse, *Asellus* sp (**1**), resembles and is closely related to the well-known woodlouse or slater which is one of the few truly terrestrial crustaceans. Waterlice are 18 to 25 millimetres (0·7 to 1 inch) long and are very flattened dorsoventrally. There is no shell, the head is distinct, the thorax has seven pairs of walking legs, and each of the six segments of the abdomen has a pair of appendages. Beneath her thorax, the female has a brood pouch formed of overlapping plates which arise from near the bases of some of the anterior thoracic legs. There is a pair of compound eyes, except in those species which live in caves in North America and elsewhere and have become blind.

The females lay their eggs in spring and carry them in the brood pouch where they are visible as a white lump near the head when the animal is turned on its back. The young resemble the adults when they hatch and remain inside the brood pouch for a while until they have developed further.

Asellus sp may be very abundant in weedy ponds where they climb among the algae and other plants or crawl about on the muddy bottom. The more evil smelling the pond the more abundant the waterlouse seems to be. It is primarily a scavenger feeding on decaying matter and on algae.

Asellus spp are ubiquitous in the northern hemisphere but, although Australia has a varied crustacean fauna, *Asellus* spp do not occur there nor is there another similar genus.

Freshwater shrimps GAMMARIDAE

Freshwater shrimps are closely related to the waterlice with which they share many features – distinct head, no shell, lateral, stalkless, compound eyes, a thorax with seven pairs of walking legs, a brood pouch, and an abdomen with six segments each bearing a pair of appendages. *Gammarus pulex*, (**2**) however, is compressed laterally, hence the misleading common name of freshwater shrimp. In addition, the gills are on the thorax and not on the abdomen.

Like the waterlouse, the female shrimp carries her eggs in her brood pouch and the young, which are miniatures of the adults, remain with their mother for a short time after they hatch. Freshwater shrimps are more typical of rivers than ponds but they do occur under stones and on the muddy bottom of ponds which are reasonably well oxygenated, which usually means where there is a flow of water in and out. The animal swims actively while on its side with the hind part of the body straight. As soon as it stops swimming, the body resumes the normal curved position. Like *Asellus* spp, the freshwater shrimp is largely a scavenger, feeding on decaying plant and animal matter although, on occasions, it may attack and devour small living animals in the pond.

The genus *Gammarus* is found throughout the northern hemisphere. In the United States these crustaceans are known as side-swimmers. In Australia seven gammarid genera have been reported.

Freshwater shrimps are eaten by fishes and are intermediate hosts for tapeworms and other parasites of frogs, fishes, and birds.

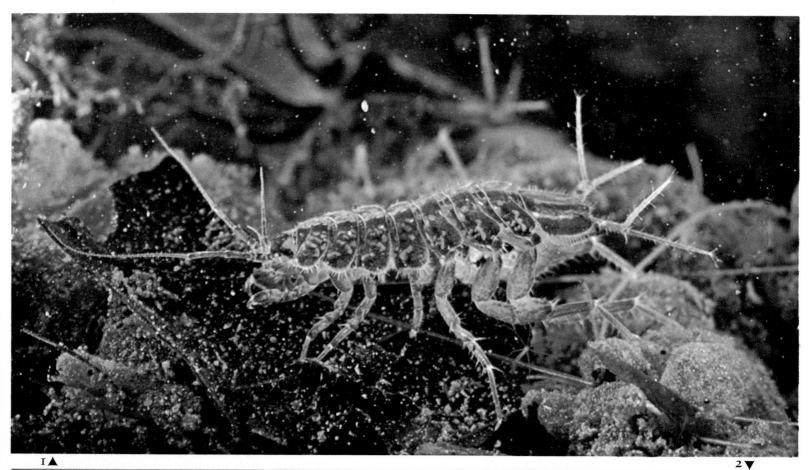

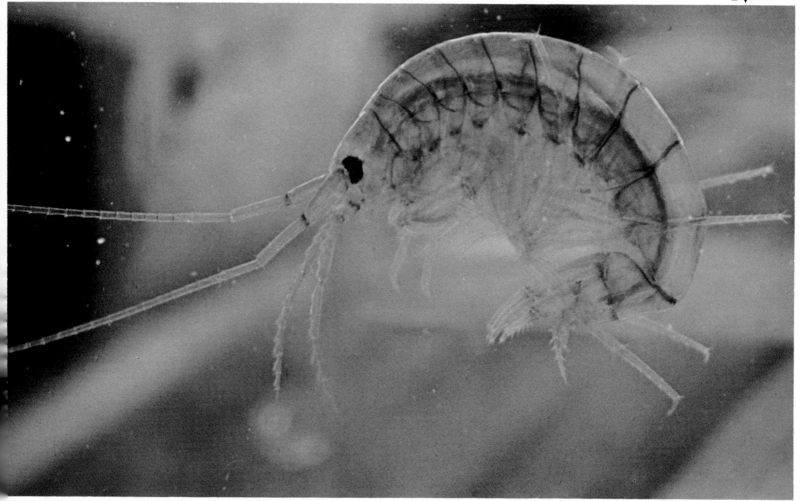

1▲

2▼

Insects
INSECTA

The insect body is divided into three portions: head, thorax, and abdomen. The head carries a pair of sensory antennae, a pair of compound eyes, three simple eyes (ocelli), and three sets of mouthparts. The function of the head is sensory perception and the up-take and manipulation of food. The thorax carries three pairs of legs and usually two pairs of wings; its purpose is locomotion by crawling, running, swimming, jumping, or flying. The abdomen has appendages at the extremity for mating and egg laying; its purpose is digestion, excretion, and reproduction.

The insects fall naturally into two subclasses, the Apterygota which are primitively wingless, and the Pterygota which either have wings or had winged ancestors. The Pterygota in their turn are divided into two superorders, the Exopterygota and the Endopterygota based on the kind of life cycle.

The young of exopterygote insects resemble the adult in general appearance even though the proportions of the body may be different. The chief difference is that the young have no functional wings and are not sexually mature. In general, the immature stages, known as nymphs, eat the same food as the adult and live in the same environment. The wings appear as buds that increase in size at successive moults until, at the final moult to the adult, they become full size and functional. Exopterygotes, therefore, have three stages in the life cycle: egg; nymph; and adult.

The endopterygote insects are considered to be more advanced. The egg hatches into a larva that bears no resemblance to the adult; it may occupy a different environment and live on different food and there are no external signs of wings at any time. The transition to the adult, for example, from a caterpillar to a butterfly, requires a complete breakdown and rebuilding of the larval body. Thus, a pupal stage is included so that the life cycle has four stages: egg; larva; pupa; adult.

Springtails
COLLEMBOLA

The Collembola is one of the four orders of primitively wingless insects that have never developed wings during their evolution. Other primitive features are that there is practically no metamorphosis, that is, change of form, during development and, after they have become sexually mature, the adults undergo several more moults. The popular name, 'springtail', derives from a hinged structure under the abdomen that is released when the insect is disturbed so that it suddenly leaps many times its own height into the air.

Very few springtails are aquatic although they all require a damp environment. None enters water but a few species are found on it supported by the surface tension.

Springtails or snowfleas PODURIDAE
The commonest springtail on the surface of ponds is *Podura aquatica* (1). It is found everywhere in the northern hemisphere and also occurs in Australia. The individual insect is small, not exceeding 1·5 millimetres long but, where there is one, there are usually many thousands and, because springtails have a strong tendency to aggregate, the group is easily detected, particularly because the insect is a uniformly dull bluish-black colour. The rather elongate body is typical of one of the two collembolan suborders. The legs are short and the insects spend most of their time crawling slowly around on and among the duckweed and other floating plants on which they are believed to feed.

I

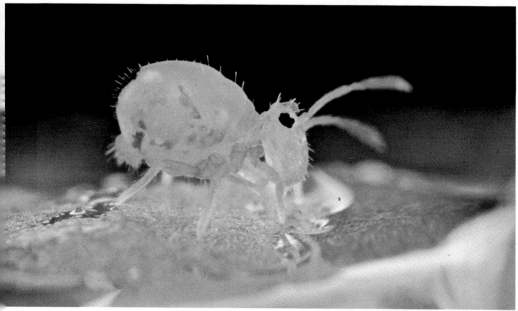

2

The photograph (1) shows that several have recently moulted and one is half-way through the process. Springtails lay groups of smooth, round eggs which hatch into white replicas of the adults and require about five moults to reach maturity.

In climates with a cold winter *P. aquatica* leaves the pond surface in late autumn and retires to cracks and crevices in damp soil near the water.

Mousetail springtails SMYNTHURIDAE

Members of the other suborder of collembolans are very different in shape to *Podura* spp; they are roughly globular with the thoracic and first four abdominal segments fused together. *Smithurides aquaticus* (2) is found on the surface of ponds where it feeds by chewing duckweed. Like *P. aquatica*, it is distributed widely throughout the north temperate zone and also occurs in Australia.

Damselflies and dragonflies
ODONATA

The quick change from effortless hovering to quick, darting flight makes the dragonflies easy to recognize on the wing and they are unlikely to be mistaken for any other kind of insect. The weakly fluttering damselflies do not catch the eye as readily. The adults of both groups are predatory.

They have elongate wings with a complex network of veins and usually a conspicuous black spot or stigma. The eyes are large and prominent as befits an active hunter and their activity is enhanced by the very mobile head (1). The legs are bunched forward behind the mouth for grasping and holding their prey while the powerful chewing mouthparts tear it to pieces. The abdomen is elongate and is usually very slender.

Their method of copulation is unique. The male has a normal genital aperture at the end of the abdomen but, before courtship and mating, he transfers sperm from it to a special structure near the junction of abdomen and thorax. The male mates by seizing the neck of the female with a pair of claspers at the end of his abdomen and the female bends her abdomen forward so that the male can transfer sperm to her from his storage organ. Mating takes place in flight or at rest (2).

The nymphs are all aquatic and have distinctive mouthparts. The lower lip is in the form of an extensible grasping structure called the mask that conceals the other mouthparts (3).

Dragonflies are divided into two groups: the Zygoptera or damselflies; and the Anisoptera or dragonflies.

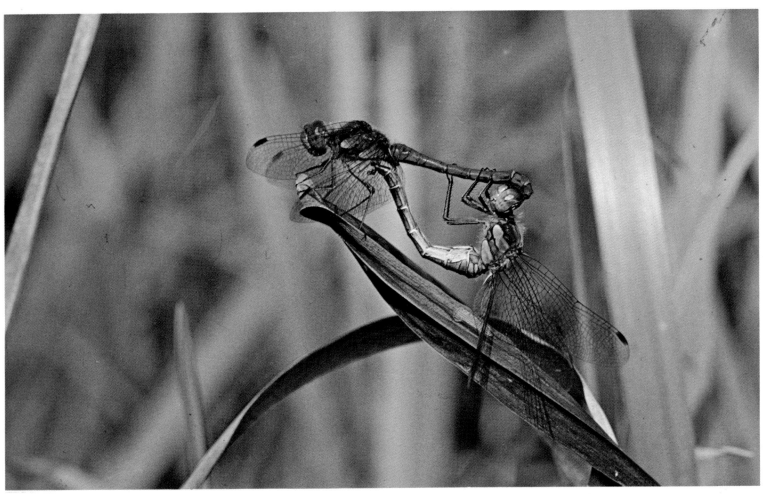

2

I

3

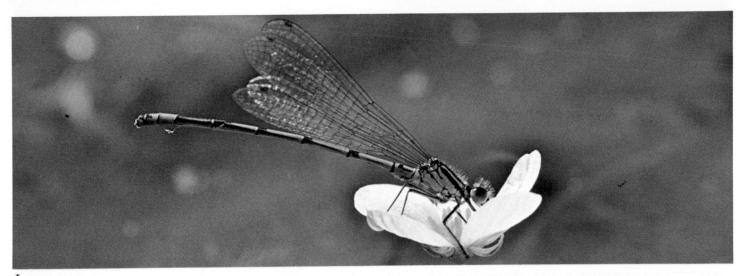

1

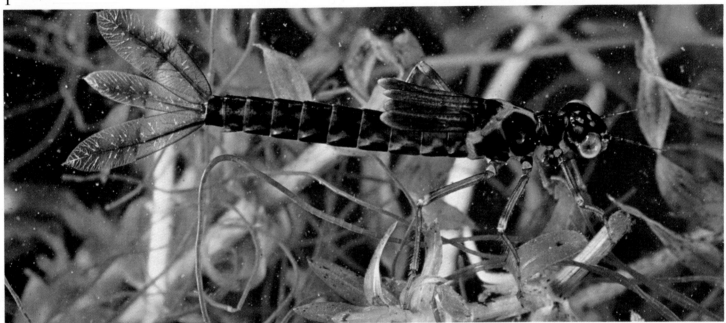

2

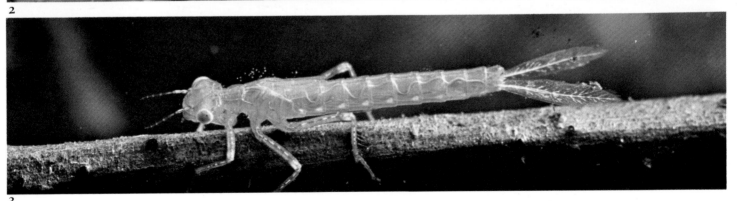

3

Damselflies ZYGOPTERA

These insects are delicate looking with similarly shaped and veined fore and hind wings that are joined narrowly to the thorax. At rest the wings are held vertically above the abdomen (**1**). It is characteristic of adult damselflies that the eyes are separated by a space greater than their dorsal diameter.

Damselfly nymphs are easily recognized by the three leaf-like gills at the end of the long, slender abdomen (**2**). Sometimes, a nymph loses a gill, as in the photograph (**3**), but it seems to survive satisfactorily with the reduced respiratory area.

Dragonflies ANISOPTERA

These stout-bodied members of the Odonata are known as dragonflies. The fore and hind wings are broadly joined to the thorax and are dissimilar in shape and venation. At rest the wings are either held out horizontally or are slightly depressed. The large eyes are never separated by more than their dorsal diameter and often meet in the centre of the head (**1**).

The two main families of dragonfly are the hawkers (Aeshnidae) and the darters (Libellulidae). The hawkers are larger, more robust insects than the stout-bodied darters. The genera *Anax* and *Aeshna* are cosmopolitan. Each dragonfly guards a large territory over which it beats regularly back and forth 'hawking' for insects on the wing. The common name of the darters refers to their habit of repeatedly darting out from a favourite perch to seize a passing insect. Most are Holarctic and some are cosmopolitan.

Unlike that of the damselfly, the dragonfly nymph has no external gills. Respiration takes place inside the rectum where there is a chamber containing six longitudinal folds or gills, each abundantly supplied with vessels for the uptake of oxygen. The rectum can be closed by means of three triangular flaps. Water is alternately taken into the rectum and expelled so that the gills are kept aerated. The nymph either crawls about slowly or moves in a series of forward jerks by the rapid expulsion of water from the rectum. The photograph shows the nymph of a darter dragonfly, *Libellula depressa*, (**2**).

1 **2**

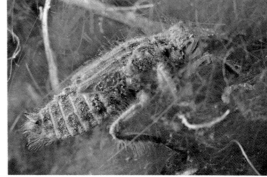

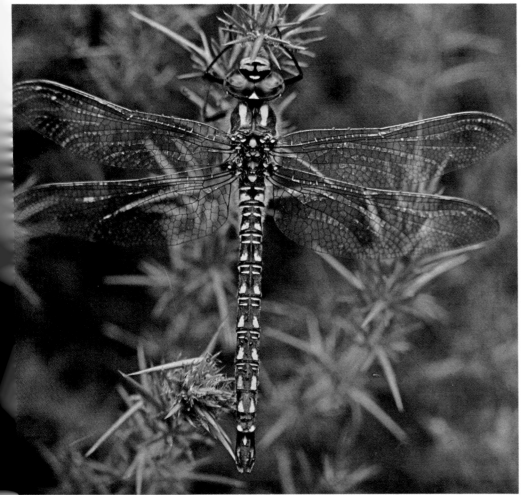

In the damselflies and the hawker dragonflies, the female cuts a slit with her ovipositor and inserts an elongate egg into the stems or leaves of plants near or beneath the water. In some cases the female descends into the water (1). The male usually stays on the surface, as in the damselfly, *Enallagma cyathigerum*, or in some species he may accompany her underwater. The photograph (2) shows a female *E. cyathigerum* in the act of oviposition beneath the surface of a pond.

The darter dragonflies drop their eggs freely into the water while hovering close to the surface. The female dips her abdomen so that she just breaks the surface at the moment the egg is released. *Libellula depressa* does this (3) and the eggs are roundly oval and accumulate in considerable numbers (4). The male may hover above his mate while she is laying her eggs and he will drive away any other males that approach.

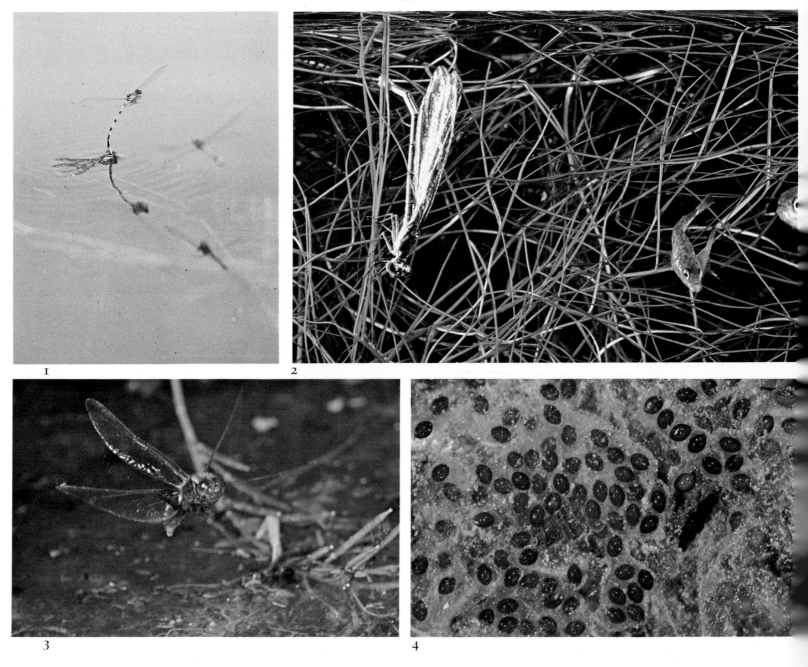

1

2

3

4

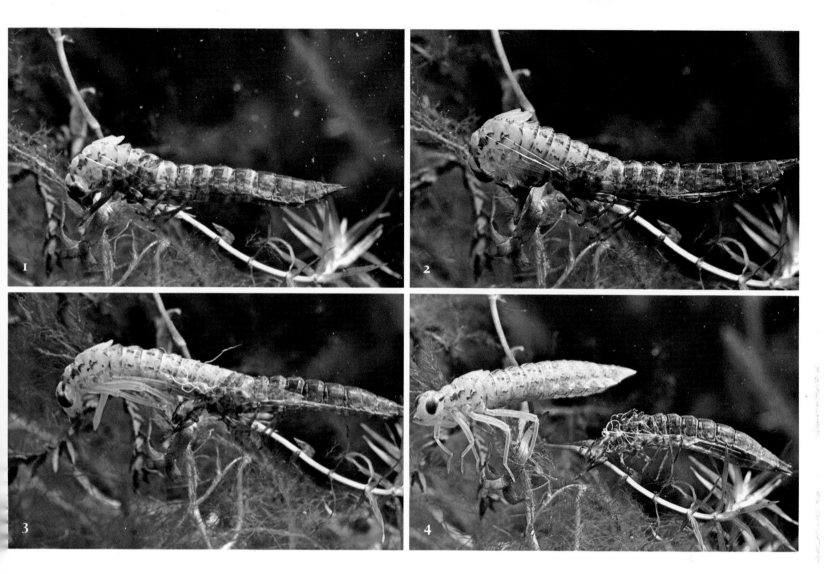

Before the nymph hatches, it swallows fluid in the egg, and the pressure of its head against the inner wall forces open a cap at the head end of the egg. The newly hatched insect is called a pronymph; the whole body, including all the appendages, is sheathed in a thin cuticle which soon splits to reveal the second instar nymph. During development the nymph moults about twelve times and the wing buds make their first appearance at about the sixth moult. 1 to 4 is a series of four photographs showing the nymph of *Aeshna cyanea* moulting from the penultimate to the final nymphal instar, that is, the instar which will produce the adult.

In the first photograph the nymph has inflated the head end by blood pressure and has split the cuticle on the upper surface of the thorax. The pale-green nymph inside is just beginning to crawl out of its old skin. In the second photograph the end of the abdomen has moved forward inside the old skin and, at the head end, two taught, white threads are visible. These are the linings of the two anterior spiracles which are shed at the same time. These spiracles become important when the nymph is ready to change to the adult state, as will be seen later. In the third photograph the spiracular linings have been pulled out and are lying wrinkled still attached to the old skin. The legs are almost free. The final photograph shows the nymph as it begins to move away. Within about twenty-four hours the final instar nymph will have lost the green colour and will have darkened to a deep, brownish black.

The length of time spent as a nymph varies from one species to another. Smaller dragonflies take one or two years and the larger species two to three years to complete their development.

Damselfly and dragonfly nymphs rely on stealth and camouflage to catch living prey which varies in size from waterfleas to small fishes. In (1) a full-grown nymph of *Aeshna cyanea* has caught and is devouring a Three-spined Stickleback. Cannibalism is common, too, within and between species. Movement is slow except when the nymph tries to escape a predator. Nymphs may be green, grey, brown, or nearly black in colour and there is some ability to change colour to match the background. In general, the nymph waits for a victim to pass within reach of the mask which can be extended in a flash to impale the prey on the terminal hooks. When it is not in use, the mask is folded back under the head. If a nymph is very hungry it will stalk its victim.

A sign that the emergence of the adult is imminent is when the nymph takes up a position on a twig, stone, or waterplant so that its head is just out of the water. If it is disturbed, the nymph will retreat beneath the surface but will soon reappear. The caudal or rectal gills of the nymph are useless when it leaves the water so, when the front part of the insect is exposed to air, the two pairs of anterior spiracles begin to take oxygen into the body. We have noticed that, when the eyes of hawker dragonfly nymphs turn from brown to yellow, they will very soon leave the water completely. In (2) the eyes of the nymph of *Aeshna cyanea* are brown; in (3) they have turned yellow and this is a warning for the photographer to be ready for action.

1

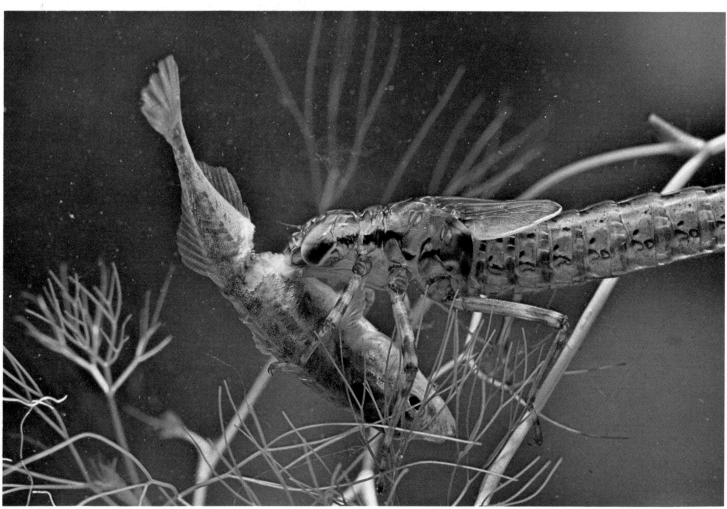

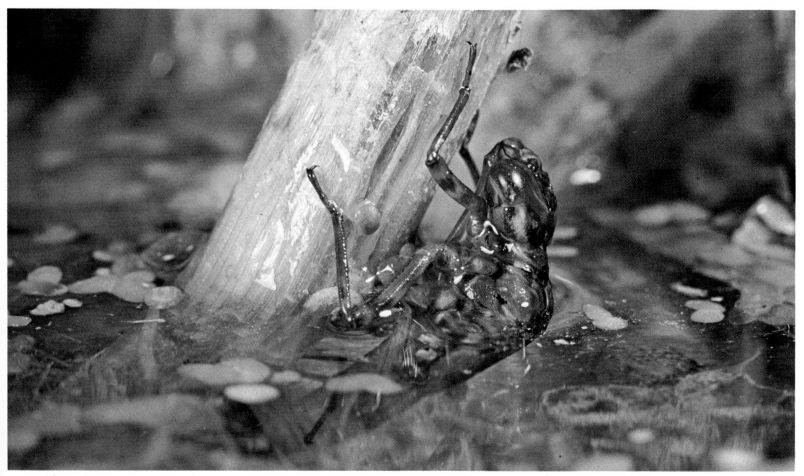

2 ▲

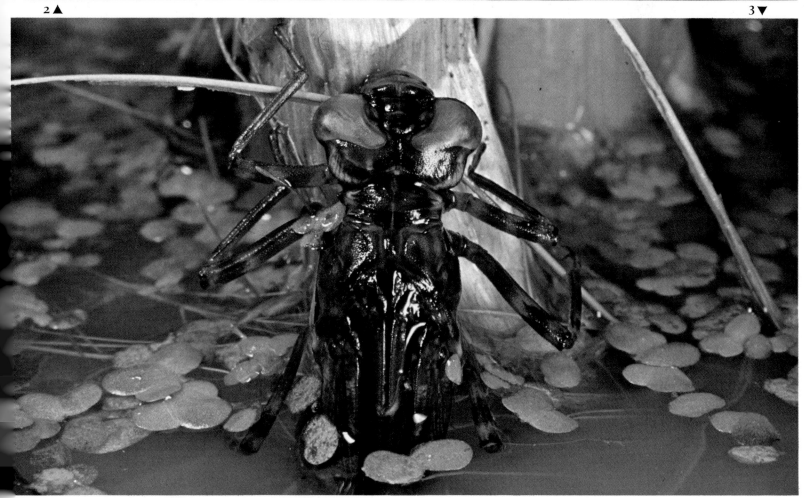

3 ▼

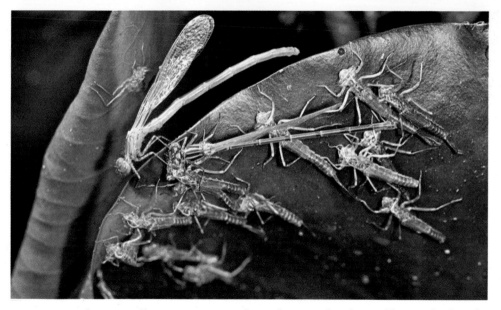

I

Dragonflies usually emerge at night, whereas the damselflies, which take less time to complete the transformation, do so in the early hours of the morning. Emergence tends to be closely synchronized so that large numbers of adults appear over a short period, and the vegetation, trees, and stones around the margin of the pond may be festooned with cast nymphal cases. Picture (**1**) shows nymphs and newly emerged adults of a damselfly on a water-lily leaf.

The photographs (**1** to **15**) show the emergence of the adult darter dragonfly, the Broad-bodied Libellula (*Libellula depressa*). The darters comprise the largest family of dragonflies and are cosmopolitan in distribution. The Broad-bodied Libellula is common in Britain and Europe. The nymph is squat and hairy and merges so perfectly with the muddy bottom of a pond that it is extremely difficult to detect until it moves. When the adult is ready to emerge, the nymph partly leaves the water and rests awhile (**1**). No change in eye colour has been noticed in darter nymphs such as occurs in the hawkers. After an interval the nymph climbs a stem or tree until it is well above the water; then it seeks a place where it can embrace the stem and dig in its claws. The grip of the nymphal legs must be strong enough to support the emerged adult which clings to the empty case for several hours for, if it should fall while still soft and vulnerable, it may be mortally injured. The nymph swings its abdomen left and right several times, presumably to establish that there are no nearby obstructions to a successful emergence. Having made its preparations, the nymph remains at rest except for rhythmical pulsations which indicate that blood is being pumped into the thorax. Gradually, the internal blood pressure increases until suddenly, without warning, the cuticle splits on the upper surface of the thorax and the delicate green of the young adult becomes visible (**2**, **3**). Slowly, the insect works its way out of the nymphal case by waves of extension, gripping, and contraction, just like a worm crawls (**4**, **5**). Soon, the dragonfly is hanging head down, with legs free, held only by the end of the abdomen inserted in the old case (**6**). The insect now rests for ten to twenty minutes without moving until suddenly it jerks up (**7**), grasps the nymphal case with its legs, and, at the same time, pulls the abdomen free. It is now oriented with the head up and the wings hanging down (**8**). Blood is now pumped into the wings so that they begin to elongate (**9** to **13**).

At last, the four wings are full length and lying flat but they still look dull and are soft and easily damaged. Over the next few hours, body and wings harden and the body begins to assume some colour. Although the dragonfly can take to the air after about twelve hours, it will be several days before the insect is fully coloured with wings that sparkle in the light. Until then we refer to the insect as a teneral adult. There is a striking colour dimorphism between the male and female of *L. depressa* – (**14**) is a mature female, and (**15**) shows a mature male.

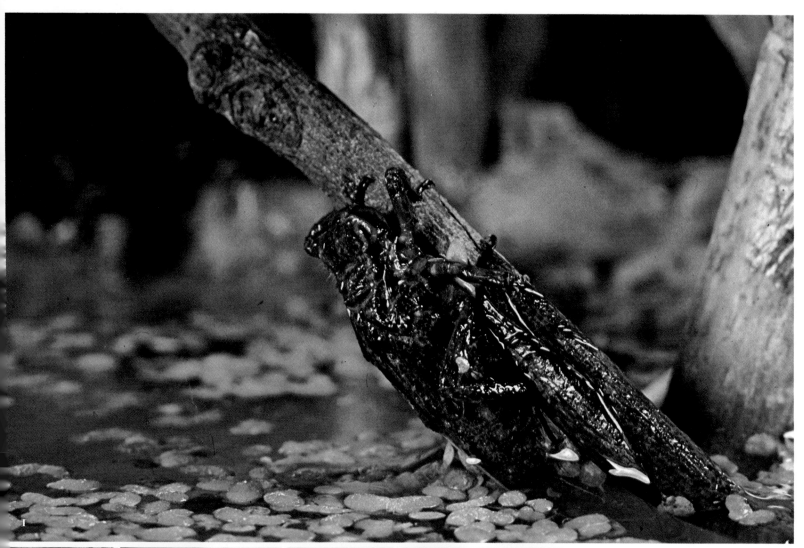

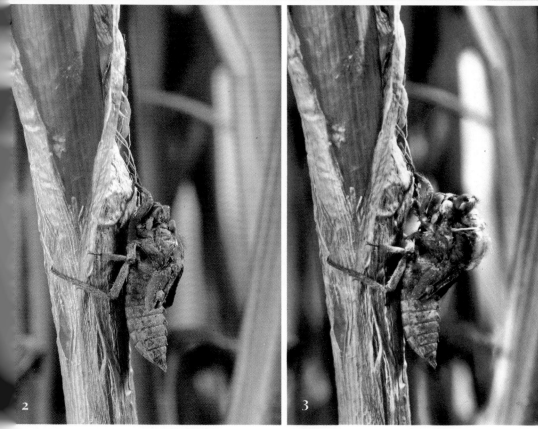

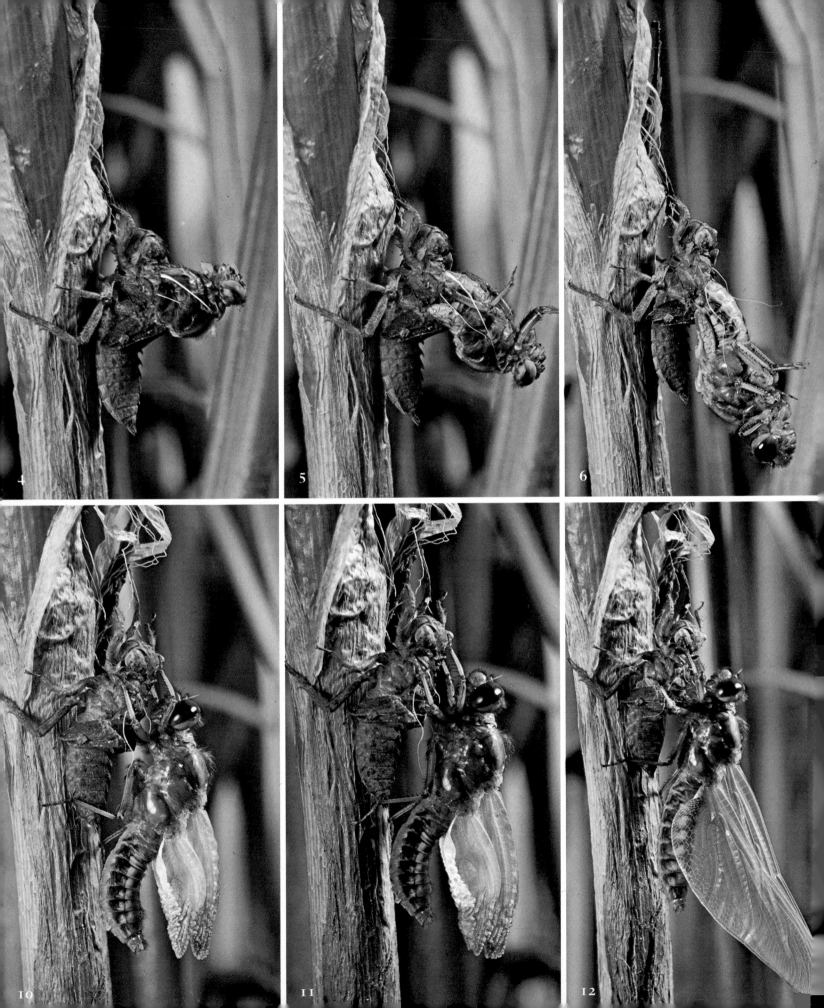

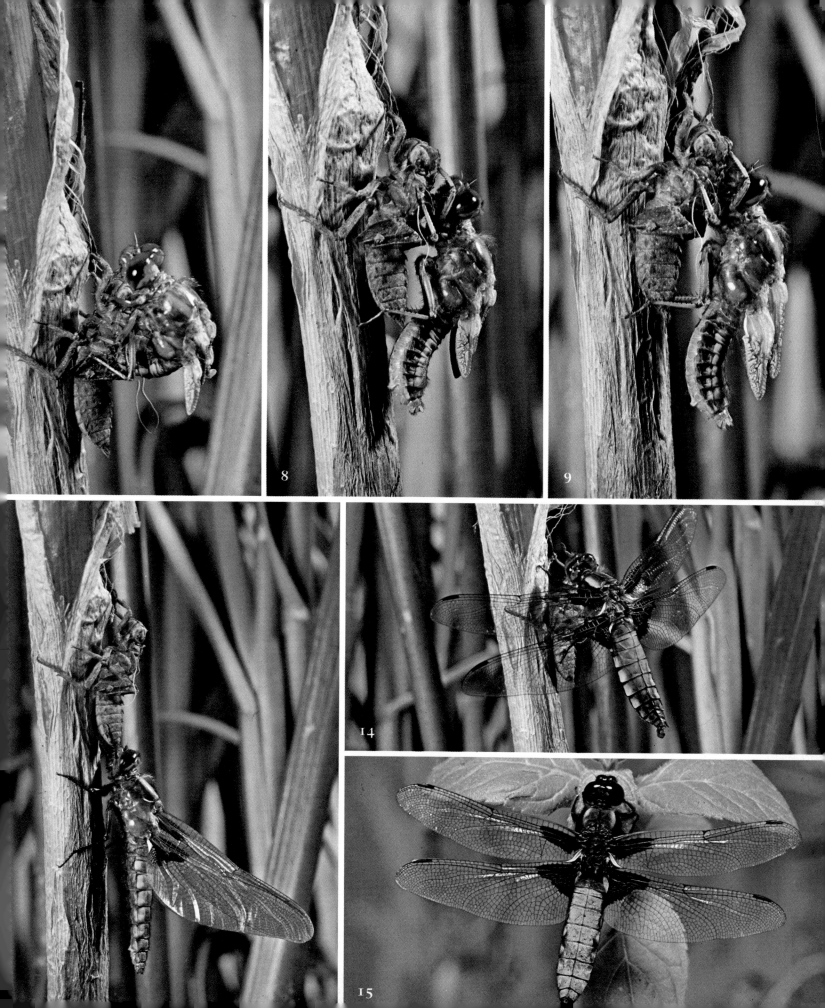

8

9

14

15

Mayflies
EPHEMEROPTERA

Mayflies are among the most familiar insects in summer, clinging to vegetation near still and running freshwater. Another familiar sight is the dance of the males of some species as they flutter swiftly upwards and fall slowly earthwards. Adult mayflies are easy to recognize (2). The triangular forewings are much larger than the hind pair and in all four wings there are many longitudinal and cross veins which make the wings look like pieces of netting. Their texture is membranous and, at rest, the wings are held vertically. The mayfly's body is soft, and the abdomen terminates in a pair of very long cerci, usually with a similar central extension, so that there are three 'tails'. The mouthparts are so reduced that the insect cannot feed and the adult life is very short. It may last from a few hours to a few days, and is wholly concerned with reproduction.

The immature stage of a mayfly is a nymph which is always aquatic. (1) is a nymph of the genus *Cloëon*, which is often abundant in small nutrient-rich ponds. The three abdominal tails are of modest size; they are shorter in some genera and very much longer in others. *Cloëon* spp have seven pairs of small leaf-like gills that beat continuously to keep a current of water flowing over the body surface, and it is thought that oxygen is taken in through the cuticle. *Cloëon* spp nymphs swim very actively among water plants and, when disturbed, they can move with astonishing speed. All mayfly nymphs are essentially herbivorous, feeding on plant detritus, algae, or parts of higher plants. Some nymphs, that live in rapidly flowing streams, have greatly flattened bodies and appendages which offer the least resistance to the water or which enable them to shelter in crevices. The life cycle from egg to adult is usually one year although some species complete two or more generations in that time.

When a mayfly is ready to emerge, the nymph usually floats to the surface and the dorsal cuticle of the thorax splits open at once. The winged insect extricates itself from the nymphal case in a few seconds and, without pausing, immediately flies away. The mayfly is unique in having two winged stages in its life cycle. The winged form emerging from the nymph is called a subadult which can be distinguished from the mature adult by being dull in appearance and possessing shorter tails, although the general shape is the same. After an interval of a day or less, the subadult, which has spent the time since emergence clinging to vegetation, undergoes a unique moult; it casts a delicate cuticle or 'skin' from the whole of its body, including the wings, and issues as the mature adult. The wings soon harden to become transparent and iridescent and the body assumes its full coloration.

Photographs (3 to 6) show a moult from subadult to adult of *Ephemera danica*, a river species and one of the largest mayflies in Britain. Photograph (7) shows the difference in appearance between a mature adult of *E. danica*, resting beside its cast skin, and a subadult of the same species.

Male mayflies dance either singly or in mating swarms. The female approaches a male or enters a swarm and leaves coupled to her mate. Mating takes place in flight and lasts only a few minutes. Soon afterwards the female discharges her eggs into the water, either in a mass, or, in those species that live longer, in smaller numbers at a time. Most mayflies alight briefly on the water surface to lay their eggs but some descend into the water and attach their eggs to stones. Spent females float on the water surface and are greedily swallowed by many kinds of fishes including trout.

Mayfly nymphs are important food for freshwater fishes and fly-fishermen attach great importance to the subadults which they call 'Duns' and the mature adults, known as 'Spinners'. Artificial flies are made in imitation of many kinds of mayfly and are known by popular names such as Green Drake, Black Drake, Spent Gnat, March Brown, Olive Dun, and Red Spinner.

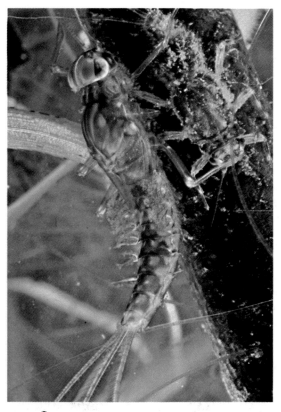

1

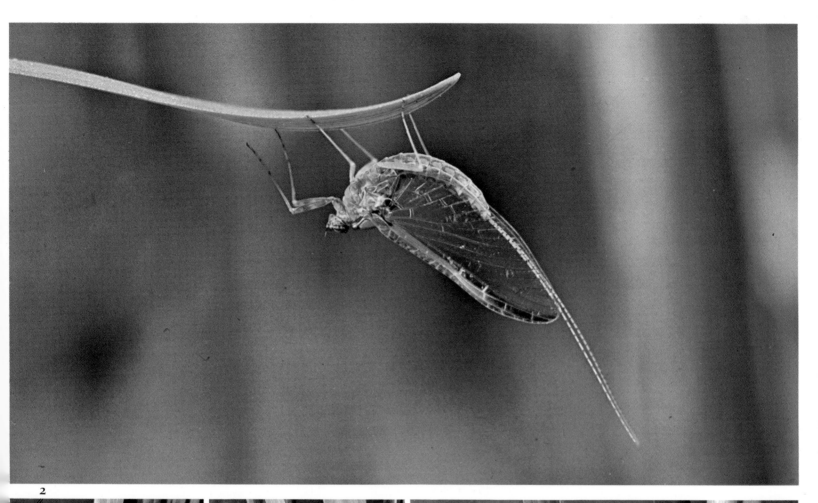

2

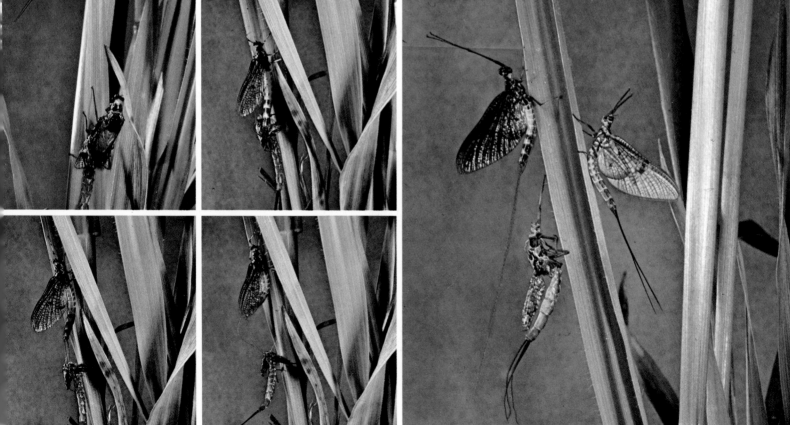

3-6

7

149

Bugs
HEMIPTERA

All insects are 'bugs' to the uninitiated but, to the entomologist, only the members of the order Hemiptera are called bugs. The true bugs are distinguished by their mouthparts, which are always of a piercing, sucking type peculiar to the Hemiptera and suitable only for imbibing liquid food either in the form of sap from plants or blood and other body juices from animals. The four biting elements of the normal biting/chewing type of insect mouthparts have become transformed into four needle-like stylets. One pair of stylets meshes together to produce two canals, one for injection of salivary fluid into the host plant or animal, the other for sucking up the liquid food. The other pair of stylets is closely opposed on either side; each terminates in cutting ridges and works alternately to cut a channel into the plant or animal, so that the central feeding tube can be inserted. When not in use, the four stylets are housed in the elongate lower lip which is dorsally grooved to receive them.

It is usually possible to guess whether a bug is predatory or sap-sucking by looking at the length, thickness, and position of the 'beak'. Sap-suckers have relatively longer and thinner stylets which are straight and, at rest, are held against the lower surface of the thorax. Predatory bugs have a shorter, thicker, and rather curved beak that is not folded back against the thorax.

Most Hemiptera are terrestrial and many sap-sucking species are major pests of agriculture and horticulture. The limited number of aquatic species found in ponds are mostly carnivorous or feed on dead bodies of other insects.

Species with functional wings use them to fly from one pond to another to escape droughts, pollution, or lack of food. Like the mouthparts, the wings are characteristic; the fore wings are partially hardened to protect the large, membranous hind wings.

There are two kinds of aquatic bug: those that live on the surface of the water but do not enter it; and those that spend their lives in the water except when they fly to seek pastures new.

Water measurers HYDROMETRIDAE

Water measurers are thin, elongate insects that walk with measured tread on the surface of ponds throughout the world. The genus *Hydrometra* is cosmopolitan. There are about seventy species in the family and many seem to find that stagnant conditions suit them best. The head is unusual in that it is greatly elongated with

I

the eyes set well back towards the thorax. The antennae are long, whereas in underwater bugs the antennae are short to be out of harm's way. Food consists partly of drowned insects floating on the surface but the water measurer also stabs small animals such as waterfleas and mosquito larvae through the surface film. The four stylets are all barbed so that stabbed prey sticks to the beak.

In Britain, *H. stagnorum* (1), which is about 12 millimetres (0·47 inch) long, overwinters as an adult and mates in May/June. The eggs are laid singly attached at right-angles to a stem or stone at or above water-level. The egg is about 1 millimetre long, narrow and sculptured, and is attached by a short stalk.

Pond skaters or *water striders* GERRIDAE

The pond skaters or water striders, *Gerris* spp. (2) have evolved as fast-moving predators on the surface of ponds, ditches, lakes, or the backwaters of slow-moving streams throughout the world. The front legs are much shorter than the other two pairs and are used for grasping the prey which consists of insects or other small animals dying or trapped on the water surface. The middle legs are the longest and they row the insect over the water by moving in unison instead of alternately as in other bugs. The hind legs function as twin rudders and control the direction of movement. Their claws are also adapted to life on water. Instead of being at the ends of the legs where they would penetrate the surface film, the claws are a short distance back from the tips which bear pads of bristles to spread the load. The indentations on the surface film of the water, made by the weight of the insect, can be seen clearly in the photograph.

Pond skaters overwinter as adults away from water in the northern hemisphere. In spring they mate and lay groups of eggs covered with jelly on plants just below the surface. By midsummer there are nymphs in various stages of development but adults are difficult to recognize because some are wingless, some have short, non-functional wings, some have almost full-size wings, and a few have wings of full length. Therefore, old nymphs with large wing pads, and adults can easily be confused. The five kinds of bug described overleaf are truly aquatic.

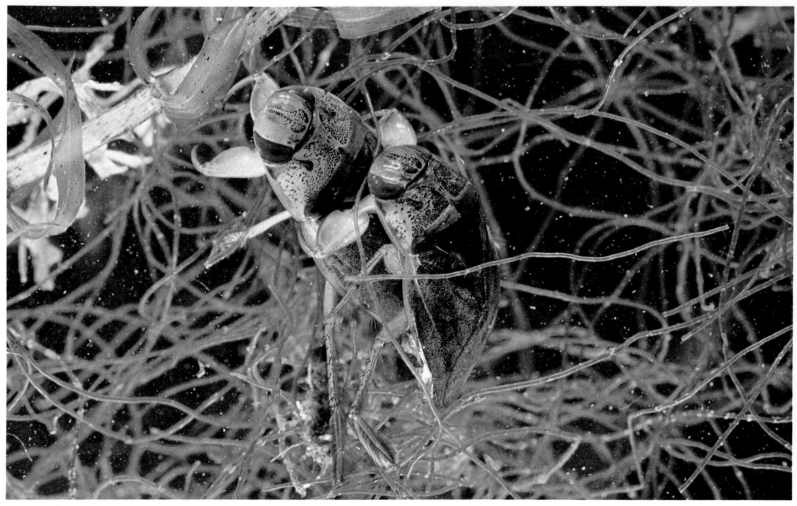

1

Saucer bugs NAUCORIDAE

The saucer bugs have a worldwide distribution and are especially well represented in South America. They are predatory bugs found in fresh and stagnant water where they creep among the aquatic vegetation.

In shape, saucer bugs are oval and dorsoventrally flattened. The wings are fully developed but the flight muscles are so atrophied that the insect cannot fly. If carelessly handled, the bug can pierce the human skin and inject salivary fluid that causes much pain. Periodically, the insects come to the surface to collect air that is retained in a space between the wing covers and the rather concave roof of the abdomen. Air is also trapped in fine hairs on the underside of the abdomen. The fore legs are well adapted for seizing prey, reminiscent of those of the praying mantis. They grab and hold small animals such as insect larvae and *Asellus* spp and *Gammarus* spp from which they suck the juices. The British *Ilyocoris cimicoides* (1) is about 1·5 centimetres (0·6 inch) long. It overwinters as an adult and mates in spring. The female inserts her eggs in rows in the stems of water plants during late April and May. The eggs hatch after about a month and the development of the nymph through five instars to the adult stage takes a further two months or so.

Giant water bugs BELOSTOMATIDAE

The giant water bugs include the largest species of Hemiptera and, in fact, the larger members, such as *Lethocerus grandis* which is 11 centimetres (4·3 inches) long, are among the largest of all insects. There are about 100 species but none occurs in Britain. Giant water bugs are well represented in North and South America, South Africa, Australia, and India. With their elongated oval shape, which is flattened dorsoventrally, their large eyes, a thick, curved beak, and strongly predatory fore legs, these insects are fearsome predators. They should be

handled with great care for the 'bite' is very painful. The hind legs are heavily fringed with hairs as an adaptation for swimming. Most of the time the bug hangs head downwards among the vegetation with the seizing legs open ready to grab any small animals, including fishes, that venture within reach. When a fish is captured, the black stylets can be seen clearly with a hand lens, probing in different directions as the juices are extracted. The salivary fluid that is injected into the victim partially digests the tissues so that the bug sucks up a kind of soup.

The roof of the abdomen is rather concave and the space between the abdomen and wings is used as an air reservoir. To renew its air supply, the bug backs up to the surface and extends a retractile tube that penetrates the surface film. The extensible tube leads to spiracles on the sixth abdominal segment.

Diplonychus eques (**2**) is one of the giant water bugs in which the female cements her eggs to the wing covers of the male which carries them until they hatch. In a Jamaican species the male was seen to come to the surface of the water when the eggs began to hatch and to tilt his body so that the white nymphs slid into the water. Within an hour the young had turned dark brown and had dispersed.

Giant water bugs fly readily and powerfully and travel far from water. They are strongly attracted to light and, at times, they can make life intolerable for the intrepid camper in the South American jungle.

2

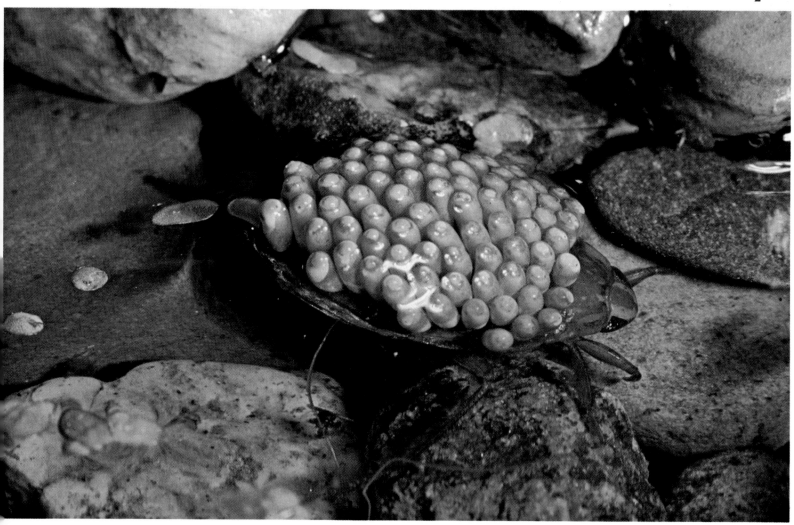

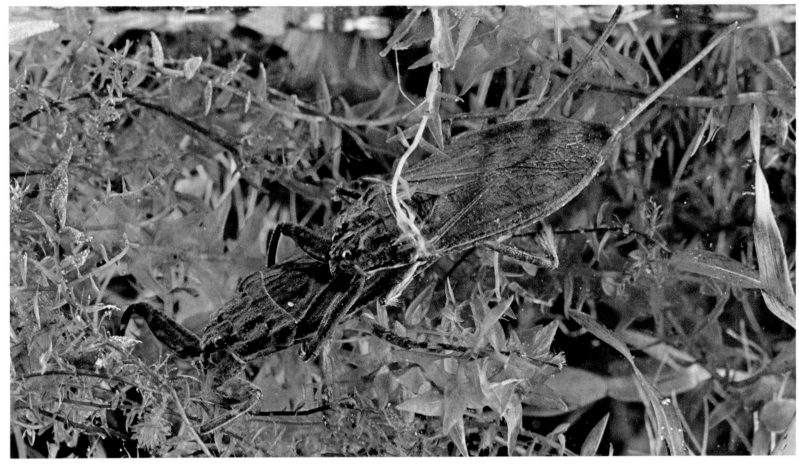

I

Water scorpions NEPIDAE

Water scorpions have evolved two body forms. *Nepa* spp and its allies are oval, greatly flattened, leaf-like forms which rest among the vegetation or on the muddy bottom in the shallows of ponds that are often quite stagnant. *Ranatra* spp and related genera are long and stick-like and are well camouflaged as they cling to the stems of water plants. All water scorpions have well-developed, grasping fore legs and take in oxygen through an elongated pair of appendages at the end of the abdomen. Each appendage is grooved on the inner surface and they are held together by numerous hooked bristles to form a single, complete tube that brings air to the reservoirs beneath the wings. The end of the respiratory tube is surrounded by water-repellant hairs.

There are about 150 species of water scorpion of which only a few are found in the Holarctic and Australasian regions. The largest species of *Nepa* reach an overall length of 7 centimetres (2·75 inches) while the twig-like *Ranatra* can attain 9 centimetres (3·6 inches).

The water scorpion, *Nepa cinerea* (1), reaches a length of 3 centimetres (1·2 inches); it is widespread throughout Britain except in the far north of Scotland. Shallow, muddy, and often fairly stagnant ponds with plenty of weed suit it well. Water scorpions have complete hind wings but most cannot fly because their flight muscles are not developed well enough. Those individuals that can fly distribute the species. When it is handled the water scorpion feigns death and becomes rigid.

The bugs overwinter as adults, and mating takes place from early April until late May. Soon afterwards, chains of eggs are laid after dusk attached to vegetation close to the surface. The elongate oval egg has from seven to nine respiratory filaments at the free end. The egg hatches in three to four weeks and the nymph takes about two months to become an adult. The newly hatched nymph has almost no respiratory tail but, at successive instars, the tail becomes proportionately longer. Indeed, the adult stage can be recognized by the length of the tail.

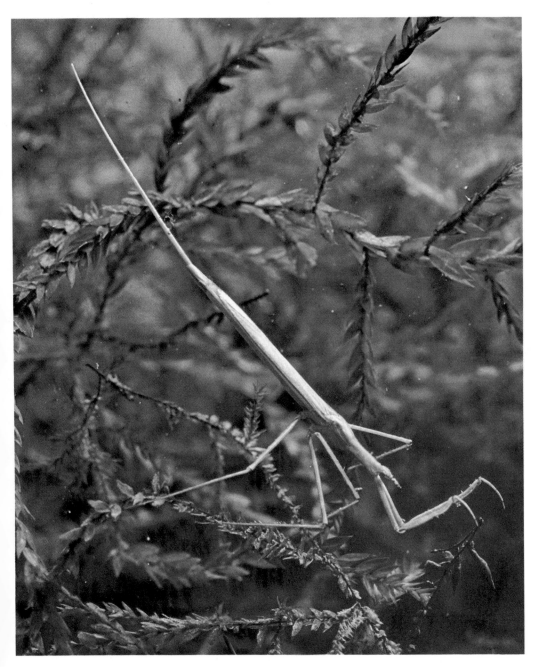

2

Like the giant water bugs, *Nepa* lies in wait with the grasping legs apart, ready to grab any nymph, larva or adult insect, or small fish that comes within reach. The water scorpion is not a selective feeder and will eat whatever comes its way.

Species of *Nepa* occur all over the world. We have even found nymphs and adults living in water-filled ruts made by timber lorries in a forest in Ghana during the wet season.

The needle bug, *Ranatra linearis*, (2) is likely to be found in deeper water than *Nepa* spp, in weedy ponds containing plenty of emergent plants, among the stems of which *Ranatra* lies in wait for passing prey. Tadpoles are included in the diet but the bug can snatch and grasp small prey such as waterfleas with extraordinary precision.

The adults overwinter and mate in spring. The eggs have two processes at the free end and are laid in short rows in the stems of water plants. They hatch in three to six weeks and the nymphs take about two months and five moults to become adults. The young nymph has a comparatively short tail, as *Nepa* nymphs do and, when very small, it spends a lot of time hanging by its respiratory tube from the surface film.

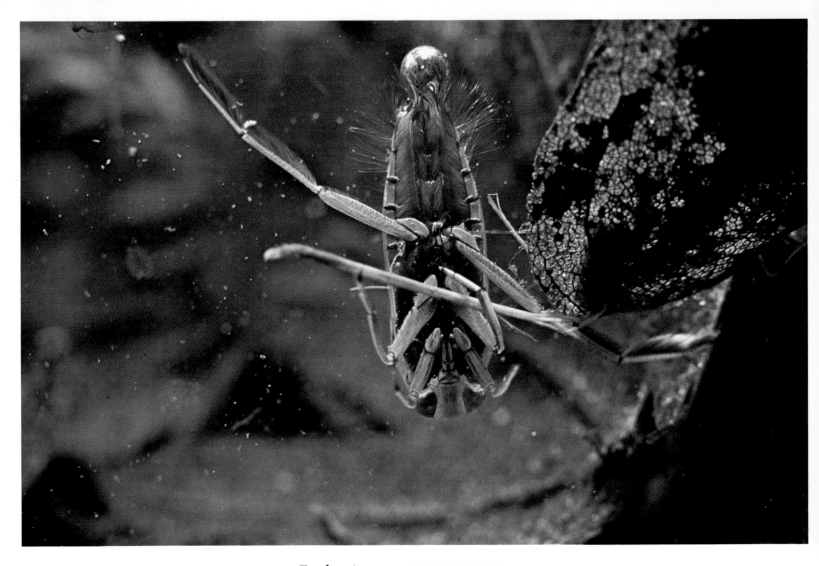

Backswimmers NOTONECTIDAE

The backswimmer, *Notonecta* sp, is a stoutly built bug about 1·5 centimetres (0·6 inch) long. It is easily recognized by the triangular cross-sectional shape which results from the prominent keel along the back. The bug is distinctly boat shaped and this effect is enhanced because the insect swims on its back with the keel downwards. It propels itself with its third pair of legs which are much longer than the others and are fringed with swimming hairs. The hind legs are held straight out and work like a pair of oars sweeping the insect through the water. The body is very buoyant because of a reservoir of air held between hairs on the ventral surface. This causes the insect to glisten like silver and makes it float to the surface when it stops swimming unless it clings to vegetation. The trapped air behaves as a physical gill but, from time to time, the bug must rise to the surface to renew its oxygen supply.

In spring the cigar-shaped eggs are inserted individually into the stems of water plants. The young, which hatch after several weeks, are white with red eyes at first.

Backswimmers are voracious predators and are able to attack animals much larger than themselves. They detect insects such as moths that have become trapped on the water surface but they will also pierce and kill tadpoles and small fishes with their toxic saliva. They should be handled very carefully because they are able to inflict a painful 'sting'.

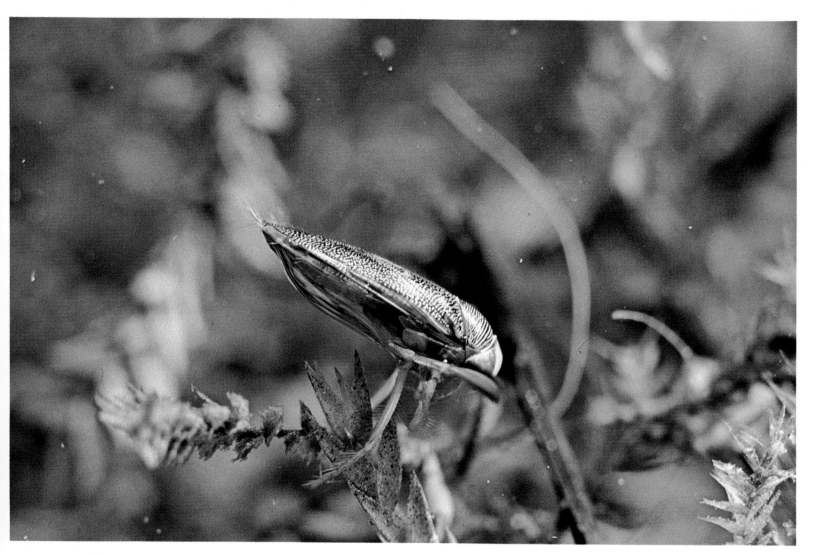

Water boatmen CORIXIDAE

Water boatmen are sometimes very abundant in still water. They range in size up to 13 millimetres (0·5 inch) and they resemble the backswimmers but, instead of having a dorsal keel, they are dorsoventrally flattened and the end of the abdomen is broadly rounded. The most obvious difference is that they swim the right way up. In the male the fore leg ends in a flattened segment armed with one or two rows of strong pegs. During mating the pegs are used to maintain a grasp on the female, and some of them are inserted under the curved ridges of the female's wing cases. During courtship the males produce a shrill chirping noise by drawing a spiny area at the base of each front leg over the edge of the lower lip.

The onion-shaped eggs are stuck singly to stems or leaves. The young nymphs breathe through their skin until the third instar when they change over to breathing oxygen from an air reservoir trapped beneath the wings and renewed at intervals.

Corixids are not buoyant enough to float and, when they stop using their hair-fringed hind legs for swimming, they sink to the bottom. This is probably associated with their unique (for a water bug) method of feeding. Unlike all the other aquatic Hemiptera we have considered, the water boatmen feed on plants almost exclusively. Most species feed at the bottom of the pond using their beak to suck up minute plants, such as diatoms or bits of algae.

There is some evidence that water boatmen are distasteful to certain fishes although others seem to eat them readily. Water boatmen comprise the largest family of freshwater bugs with more than 200 species, and they are found throughout the world from Iceland to New Zealand.

Alderflies and spongeflies
NEUROPTERA

The name, Neuroptera, refers to the nerve-like network of veins in the wings which are similar to those of Palaeozoic fossil insects. The members of the order are among the most primitive of the endopterygote insects and are close to the ancestral stock that gave rise to the scorpionflies, caddisflies, butterflies, and moths, fleas, and flies. The alderfly and the spongefly have aquatic larvae found in ponds.

Alderflies SIALIDAE

Sialis spp and their allies are the least specialized members of the order Neuroptera. *S. lutaria* (1) is the common British alderfly, and is about 14 millimetres (0·55 inch) in length. It is soft bodied with long antennae and dull, heavily veined wings which, at rest, are held up over the abdomen in a tent-like manner. Usually, the adults are found crawling about on vegetation near water, or on large stones by the pond's edge. They do not fly readily but, when they do so, they travel in a straight line and land after a short distance.

The female uses scent to attract the smaller male and mating pairs are a common sight in May and June near water. The female lays as many as 2000 eggs in clusters on reeds or other emergent water plants beside the pond. The eggs are dark brown and cylindrical with a white knob at the free end, and they are stuck to the plant in neatly arranged groups (1). The larva hatches in two weeks by emerging through a longitudinal rupture in the shell. If there is a small circular hole in the egg it means that it has been parasitized by a minute hymenopterous wasp belonging to the genus *Trichogramma*. This parasite is so small that it completes the whole of its development inside one alderfly egg.

Upon hatching, the larvae either fall straight into the water or to the ground and crawl to the water. They are only about 1 millimetre long but they are active swimmers with long hairs on legs, abdomen, and gills. Their appearance is unlike that of the instars to follow. For several days they disperse actively through the surface waters, keeping in the light. Then they moult and thereafter react negatively to light and descend to the darkness of the bottom of the pond where they burrow in the mud. Most species of alderfly have ten larval instars over a period of almost two years. The full-grown larva (2) is about 25 millimetres (1 inch) long, cylindrical in shape, and brown in colour. The head is large and so are the predatory mandibles because the larva feeds on other pond inhabitants, particularly chironomid, caddisfly, and mayfly larvae as well as worms. It is thought that prey is either swallowed whole or first bitten into pieces of manageable size.

The thorax has three pairs of long walking legs. A characteristic feature of the alderfly larva is the seven pairs of segmented abdominal gills. The last segment of the abdomen terminates in a single median gill of similar construction. The larva of the alderfly might be confused with the much rarer larva of a whirligig beetle (page 171), but the beetle larva has a very small head and, altogether, it has ten pairs of plumose gills on the abdomen. The full-grown alderfly larva leaves the water some time between the end of March and early June, and crawls some distance from the pond to find a place to pupate. The selected site is usually in fairly damp, loose soil or in vegetable debris such as occurs in the middle of a clump of sedge. The larva burrows into the soil for about a centimetre (0·4 inch) and constructs an oval pupal chamber in which it pupates without delay. There is no silken cocoon. The pupa is of the 'free' type, that is, the appendages, antennae, legs, and wings are not cemented down to the body as they are in a butterfly chrysalis. The pupa is insulated from contact with the walls of its cell by spines which cover the body and on which it rests like a fakir on his bed of nails. The pupa is motile and digs its way out of the soil before the adult emerges.

The alderfly family is widely distributed in Europe, America, Asia Minor, Siberia, and Japan. Australia has one genus, *Austrosialis*.

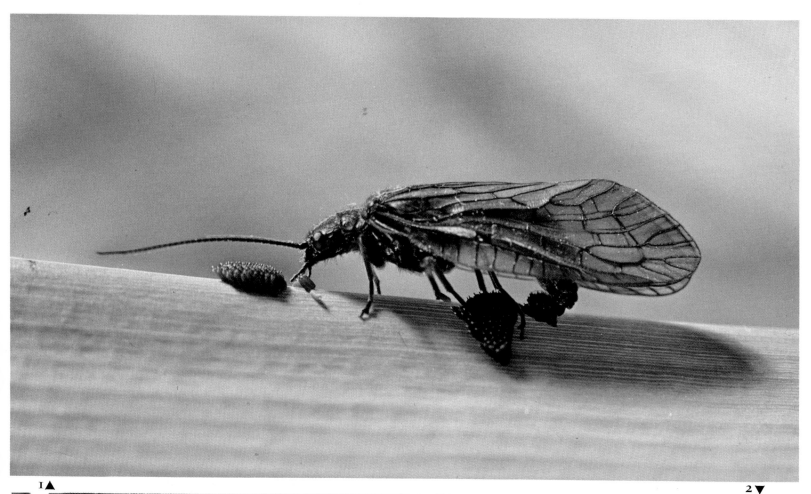

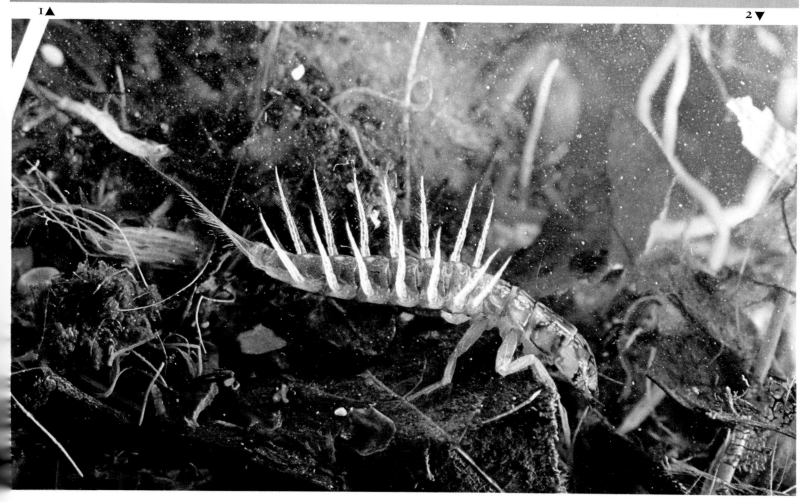

Spongeflies SISYRIDAE

The larva of the spongefly (**1**) is well camouflaged and, because it is only about 5 millimetres (0·2 inch) long when full grown, it is easily overlooked as it feeds on the surface of the freshwater sponge. The European species, *Sisyra fuscata*, is quite common and a single sponge may contain several larvae.

The adult spongefly is a small, delicate, brown insect found near water. The female lays a cluster of very small eggs on leaves or twigs standing in or overhanging water. Each group of eggs is covered with a silken web. The newly hatched larva falls into the water and swims in a jerky manner seeking a sponge. Those that succeed in finding a host either cling to the sponge's surface or penetrate the interior of the sponge by entering through one of the apertures. The mouthparts are highly modified, elongate, and grooved to form a hollow, needle-like tube that curves downwards at the apex. The feeding tube is thrust into the sponge tissue and the contents are sucked up into the body. The antennae are as long as the mouthparts.

The spongefly larva has a stout, hairy body tapering towards the head and tail. It is either pale green or yellowish in colour which matches the two colours of the freshwater sponge. On the ventral surface of the first seven abdominal segments there are paired gills that intermittently vibrate rapidly and may draw attention to the larva. There are three pairs of thoracic legs (**2**).

Just before pupation the full-grown larva leaves the sponge, swims ashore, and climbs out of the water to spin a finely woven, double cocoon on vegetation or under loose bark. There is more than one generation a year.

Seventeen species of spongefly are known from the western hemisphere and about a dozen species occur in Australia.

1

2

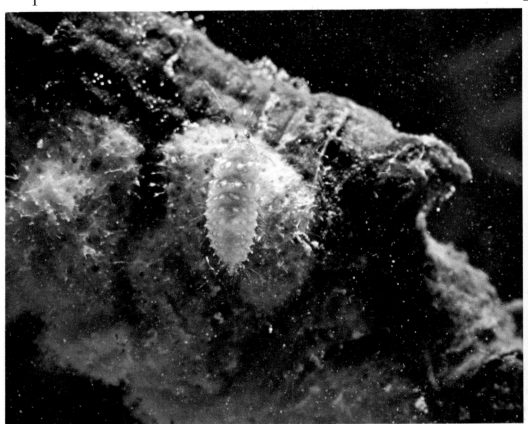

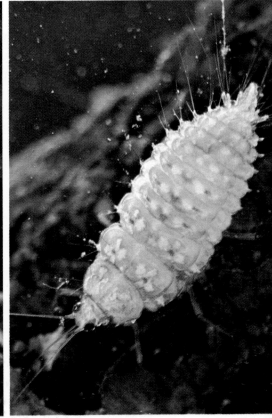

Beetles
COLEOPTERA

The Coleoptera, or beetles, is the largest group of insects with more than 250 000 described species. In fact, it is the largest order in the whole of the animal kingdom. The features that usually enable a beetle to be instantly recognized are the hard and horny fore wings that meet in a straight line along the back. These fore wings are peculiar to beetles; they are called elytra and they cover and protect the membranous hind wings which are usually quite large and are folded beneath them. The hind wings are the organs of flight and the elytra are held up out of the way.

Beetle larvae are very variable in appearance, ranging from active predators with thoracic legs to legless borers in plant tissue; they may be difficult to recognize. From more than 100 families of beetle, however, only a handful are wholly or partially aquatic. Pond-dwelling adult beetles depend for their oxygen supply on atmospheric air and so, as a rule, do the larvae. The pupal stage usually takes place out of the water where respiration presents no problem.

True water beetles DYTISCIDAE

The Great Diving Beetle, *Dytiscus marginalis* (**1** overleaf), and its relatives are sometimes called the true water beetles which is a reflection of their high degree of adaptation to an aquatic environment. They may be distinguished from other water beetles by their thread-like antennae; they are, furthermore, exclusively carnivorous as adults and as larvae. The Great Diving Beetle is the largest and best-known water beetle in Britain and similar species exist elsewhere. It is found in ponds everywhere because it flies readily and can travel long distances. The adults are about 35 millimetres (1·4 inches) long and the sexes can be easily distinguished by the elytra which, in the male, are dark green, smooth, and glossy while, in the female, they are olive brown and furrowed. In addition, each front leg of the male has an expanded area that forms a circular adhesive pad provided beneath with cup-like suckers (**3** overleaf). A glutinous secretion moistens the pads which are used by the male to stick to the smooth thorax of the female during mating. The insect's body is beautifully streamlined and somewhat flattened dorsoventrally. It swims rapidly, propelled by the hair-fringed hind legs beating in unison. Beneath the elytra there is a reservoir of air which is replenished periodically. When the beetle stops swimming it floats to the surface with the rear end uppermost. This brings two large spiracles into contact with the air; the elytra are also raised slightly so that the air supply held between fine hairs on the top surface of the abdomen can be renewed (**2** overleaf).

The adult *Dytiscus* is a voracious predator that is prepared to attack fishes considerably larger than itself. In spring tadpoles are a favourite food, followed later by newtpoles but anything that comes within reach is eaten (**3**). The large mandibles are used to tear up the prey which is swallowed in pieces so that digestion is internal, unlike digestion in the larva.

In spring the female lays her cigar-shaped eggs singly in slits cut by the ovipositor in the stems of water plants (**1** overleaf). The larva is, if possible, even more ravenous than the adult and, in North America, it is known as the Water Tiger. It has a tough, brown head with long, sickle-shaped mandibles. The thoracic legs are fringed with hairs and are efficient oars for swimming. The last two abdominal segments and the terminal lobes are fringed with hairs which enable the larva to hang head downwards from the surface while it takes in air through the last pair of spiracles (**1** page 164).

The larva feeds on a great variety of other animals including molluscs, worms, insects, newtpoles, tadpoles, and small fishes such as sticklebacks. The predator lies in wait with the mandibles open and lunges forward to impale the victim. Each mandible is crossed by a fine groove which is almost roofed over. A digestive

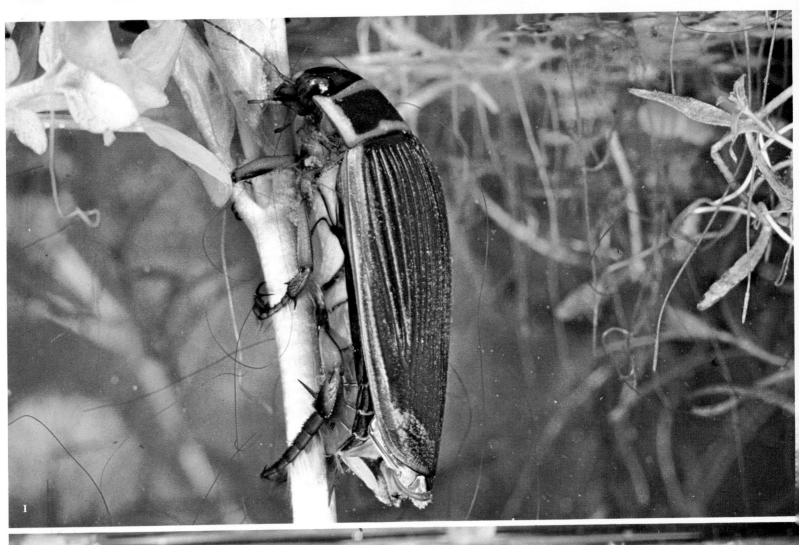

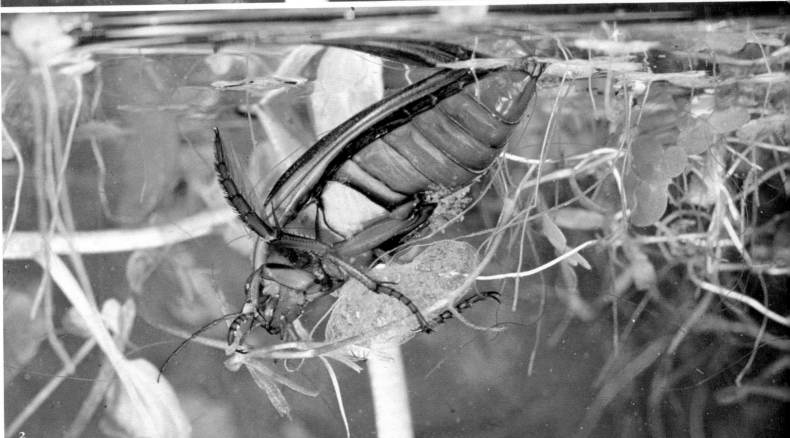

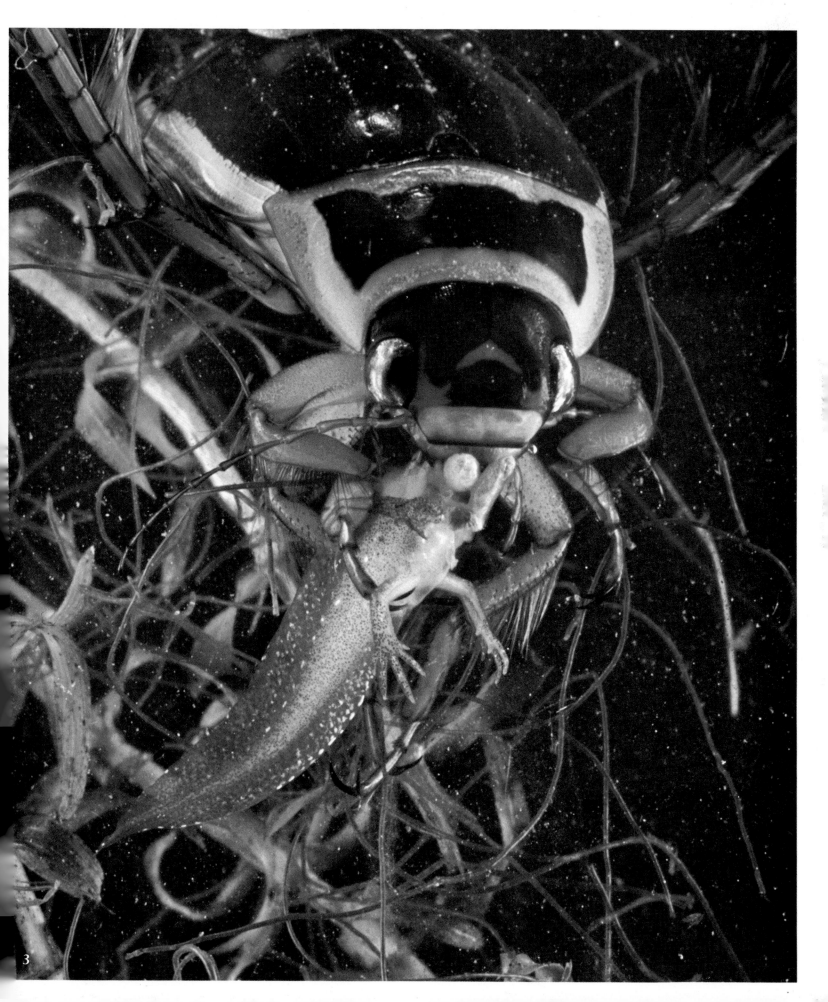

enzyme secreted in the gut is injected along the grooves into the prey so that diges-tion of the tissues takes place externally. Then a pumping action of the pharynx sucks the resulting soup back along the mandibles into the gut.

The larva takes about a year to become full grown by which time it is about 5 centimetres (2 inches) long. When ready to pupate, the larva crawls out of the pond (2) and travels 2 or more metres (6 feet or more) before burrowing into damp soil and excavating a cell 3 to 4 centimetres (1·2 to 1·6 inches) beneath the surface. The pupa (3) takes about three weeks to mature and, after casting the pupal case, the young adult remains underground for a further week to become fully hardened. It then makes its way to water where it passes the winter buried in the mud at the bottom of the pond.

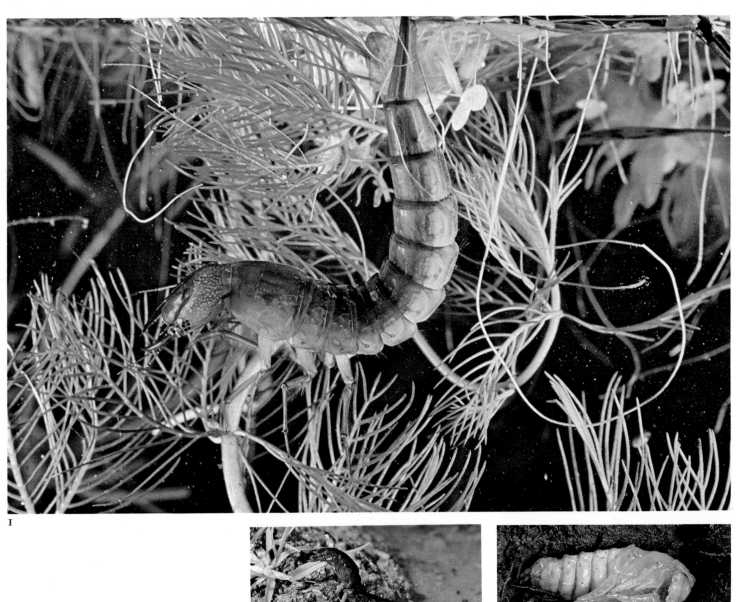

1

2 3

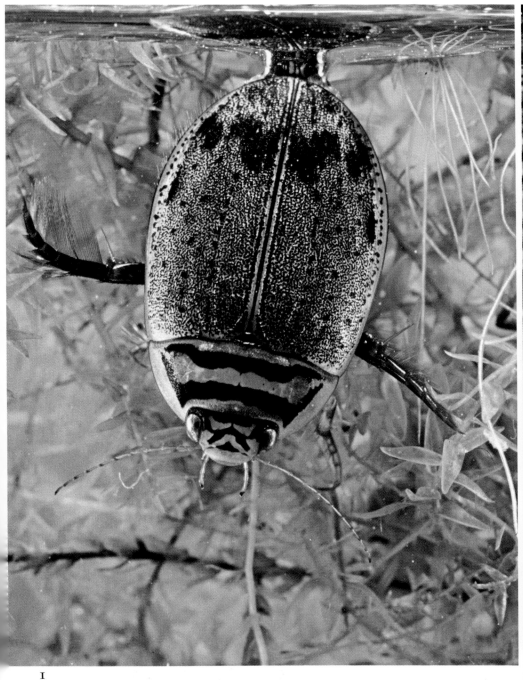

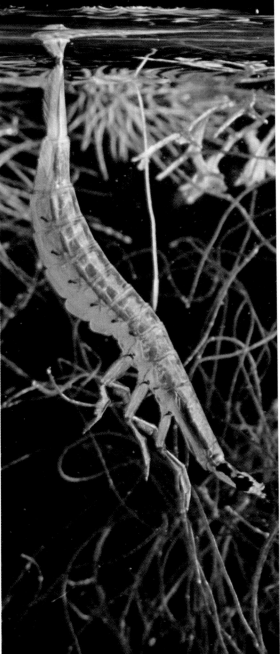

1 2

The Furrowed Acilius, *Acilius sulcatus*, (1) is a common water beetle in British ponds. The adult length is 16 millimetres (0·6 inch) and it shows the same tear-drop shape as *D. marginalis*, with thread-like antennae and swimming hind legs. The male has a sucker pad in which the arrangement and number of suckers are peculiar to the species.

The female drops her eggs at random on the muddy bottom of the pond. The larva of *Acilius* is instantly recognizable by the greatly elongated first segment of the thorax which makes the insect look as if the small head is at the end of a long neck (2). The larva swims quite slowly but gracefully by paddling with hair-fringed thoracic legs.

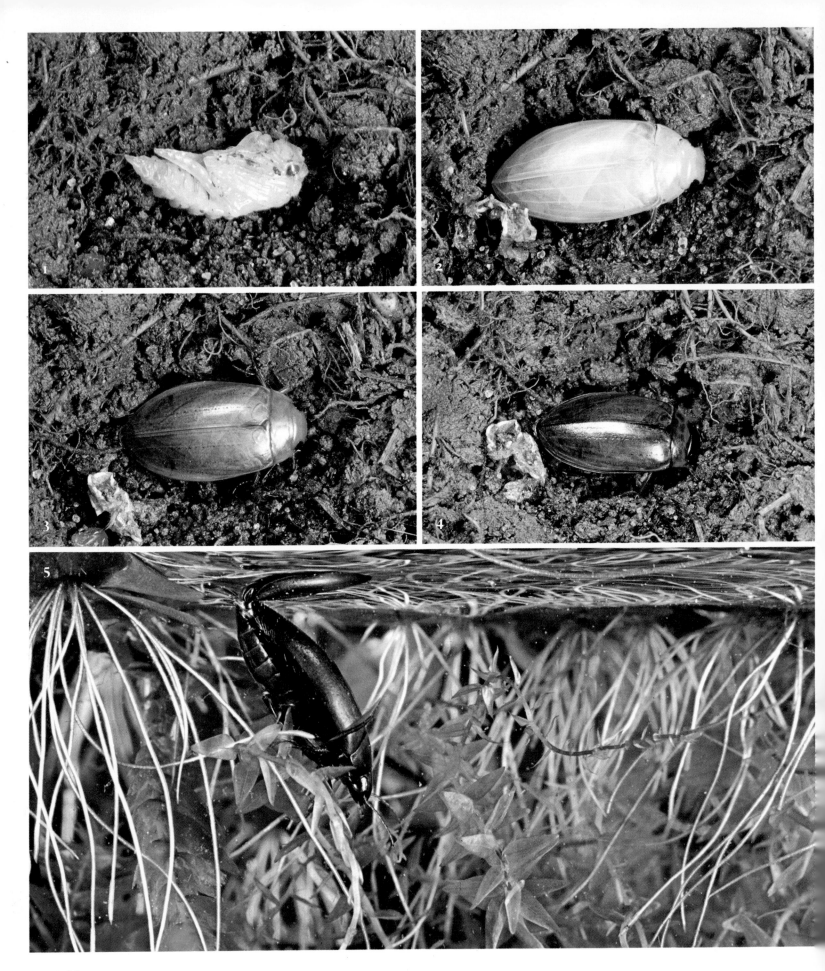

The common British water beetle, *Colymbetes fuscus*, pupates in July in a cell in damp soil adjacent to the pond in which it has developed. The pupa is of the free type such as we have seen in the Neuroptera and remains white except for the eyes which gradually darken towards the end of the three-week pupal period (1). When the adult emerges from the pupal skin, it is very pale at first, except for the eyes (2). Gradually, over a period of several days, the beetle darkens and hardens (3) until, after about a week, it is fully coloured and hardened (4). The beetle now works its way out of the soil and enters the nearby pond (5).

Hyphydrus ovatus (6) is the only British representative of a genus of water beetles found throughout the world including the whole of Australia. The larva is rather swollen and the head has a characteristic beak-like extension. The thoracic legs are of moderate size and fringed with hairs. The body tapers towards the pointed end of the abdomen where there are two cerci of moderate length. The bands of black and yellow on *Hyphydrus* larvae suggest warning coloration; they certainly make it more colourful than most of its relatives.

6

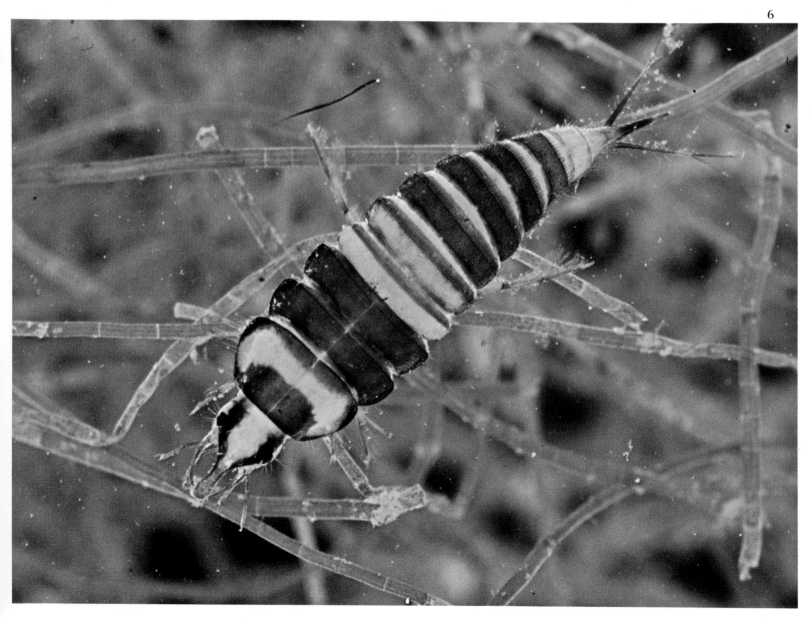

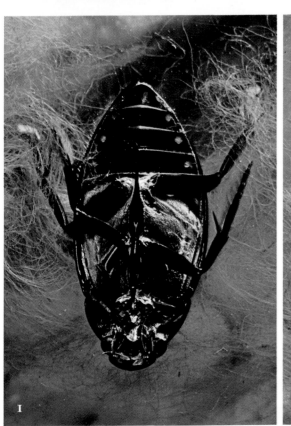

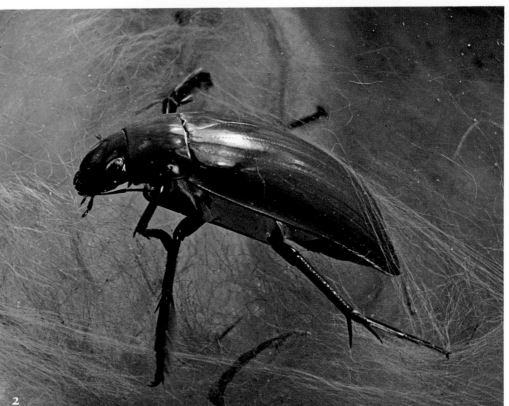

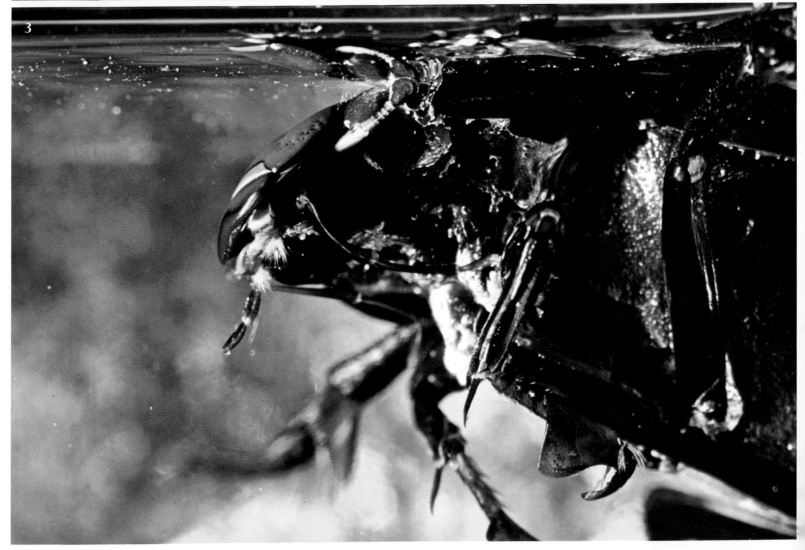

Water scavenger beetles HYDROPHILIDAE

The Great Silver Water Beetle, *Hydrophilus piceus* (2), belongs to a family that contains both terrestrial and aquatic species. *H. piceus* is, in fact, the bulkiest British and European beetle, reaching a length of 5 centimetres (2 inches). The species is identifiable by its size, the dark greenish-black colour, the club-shaped antennae, and the unusually long palps. The palps are sensory organs associated with the mouthparts and they are the chief organs of touch and smell, as the antennae are in other insects. The antennae proper have become modified to serve the special purpose of replenishing the insect's air supply.

A dorsal air reservoir is present beneath the elytra and, in addition, on the lower surface of the thorax, there is a layer of minute unwettable hairs that form a plastron. Provided there is enough oxygen dissolved in the water the plastron functions as a permanent physical gill. There is a continuous exchange of gases and the air supply needs no renewal so that insects that have this plastron can usually remain permanently submerged. The photograph shows the silvery trapped air which gives the beetle its name (1). In winter it is probable that the plastron supplies all the oxygen requirements of *H. piceus* at a time when activity is minimal. In summer, when the oxygen in the water is depleted, the insect visits the surface to supplement its air supply in a manner unique to the family. The beetle rises to the surface head first and breaks the surface film with an antenna by inclining the head to one side. Hairs on the antenna combine with hairs on the head to form a funnel down which air travels to the subelytral reservoir and to the plastron (3).

The male can be distinguished from the female by the presence of an enlarged triangular segment at the end of the front legs. Both sexes possess a sharp spine on the ventral surface which can prick the fingers if the beetle is held carelessly.

The Great Silver Water Beetle is not as well adapted to life in water as the Great Diving Beetle. It is not so beautifully streamlined and, although the middle and hind legs are hair fringed, they do not form such efficient paddles. Also, unlike the Diving Beetle, in which the legs row in unison, those of the Silver Water Beetle move alternately so that progress through the water is wavering and unsteady. Whereas adult dytiscids are all carnivores, most adult hydrophilids are herbivores and *H. piceus* is particularly partial to dense clumps of algae.

The Great Silver Water Beetle mates in autumn, and the beetles overwinter in the mud on the bottom of the pond. In spring the female spins elaborate egg cocoons with silk from glands at the end of the abdomen. Each egg case contains about fifty eggs and floats on the surface. It is supplied with a hollow mast which possibly provides ventilation (4). The eggs hatch in two weeks and the larvae bite their way out through a thin portion of the case. Like the larvae of the Great Diving Beetle, they take in air at the water surface through a pair of enlarged spiracles at the end of the abdomen. Unlike the adults, the larvae are carnivorous and have a large pair of mandibles each provided with four teeth. They feed on snails of the genus *Planorbis* (page 107) which they curl round as shown in the photograph (5) while they bite away the shell progressively to get at the contents. By late summer the larva is full grown and is about 7 centimetres (2·75 inches) long. It leaves the water and pupates in a cell excavated in damp soil near the water's edge. About six weeks later the adult emerges and makes its way back to the pond.

The Silver Water Beetle flies readily and there is a possibility that immigrants occasionally arrive in the south-east of England from the continent.

The Hydrophilidae is a large family comprising about 2000 species which are especially numerous in the tropics. In North America *Hydrophilus triangularis* is slightly smaller than *H. piceus*. They and other members of the family are called water scavenger beetles. Australia has more than eighty hydrophilid species.

4

5

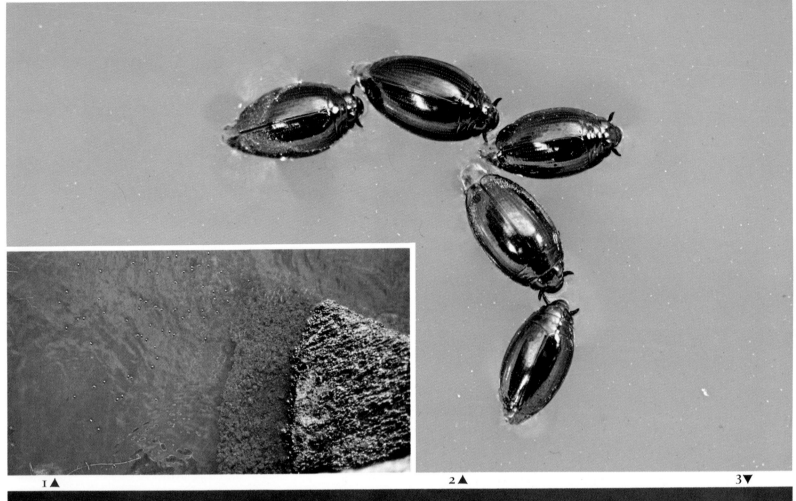

1▲ 2▲ 3▼

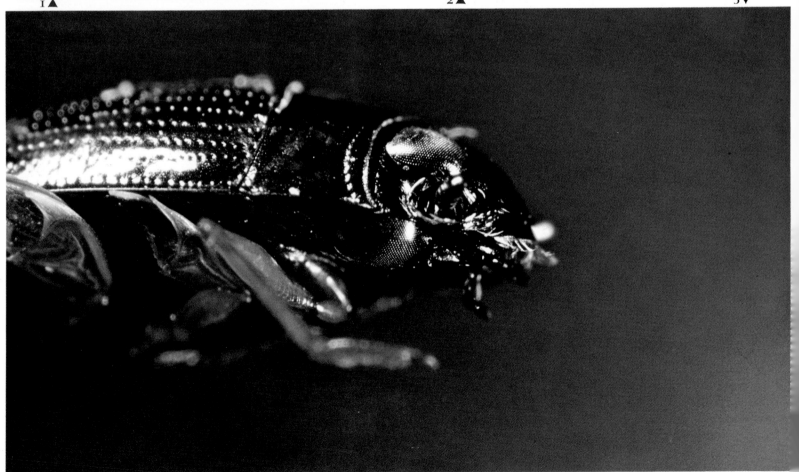

Whirligig beetles GYRINIDAE

There are about 700 species of whirligig beetle in the world. They all look very alike but vary in length from about 4 to 20 millimetres (0·16 to 0·8 inch). They are surface swimmers that gyrate in graceful curves around each other, travelling at such a high speed that they are difficult to follow by eye. The adult beetle is definitely gregarious and, on the surface of a small pond, the individuals are usually congregated in one or two groups, not scattered at random (1).

The body is ovoid in shape, smooth, and more or less flattened dorsoventrally with the tip of the abdomen projecting beyond the elytra. The beetle's colour is usually a steely black with a silvery lustre (2). The fore legs are long and prehensile and, in the male, they may terminate in suckers for grasping the female. The mid- and hind legs are greatly modified for swimming and each segment is short, flattened, and fringed with hairs. On the backward swimming stroke the plates present their broad surfaces to the water and exert the maximum thrust; on the return stroke the plates collapse and offer little resistance.

The eyes are divided into two completely separate parts. It is thought that this division is an adaptation for seeing down into the water with the lower eye and up into the air above with the upper eye (3). The antennae are short and stout and are inserted low down on the head.

Living on the surface, the beetles have easy access to air but, when they are alarmed, they dive down and cling to underwater vegetation. They carry with them a bubble of air attached to the rear end of the abdomen as well as the air in the reservoir beneath the elytra. The adults feed mainly on insects that have dropped on to or become trapped in the surface film. When the low temperatures of winter arrive the whirligigs bury themselves in the mud but, during spells of mild weather, they may return to the surface for a brief period of feeding.

4

The females lay their eggs in spring in small batches attached to the leaves of underwater plants. The larva is easy to recognize unless it is confused with the larva of the alderfly, *Sialis* spp (page 158). The whirligig larva is elongate with very clearly marked segments and it reaches a length of 15 millimetres (0·6 inch) in British species. Each of the first eight abdominal segments bears a lateral pair of hair-like gills copiously supplied with tracheae. The ninth abdominal segment carries two pairs of gills and the last segment is provided with a pair of hooks. The pointed mandibles are perforated by a sucking canal and the method of feeding resembles that of a *Dytiscus* larva. A larva that we kept fed avidly on the larvae of a *Chironomus* sp and ignored mosquitoes, *Asellus* sp, and other potential food. The larva fed by seizing the bloodworm and holding it with the mandibles inserted and motionless while the pharynx pumped regularly. Gradually the *Chironomus* lost its red colour and collapsed, an indication that the body fluids were being sucked out (4).

When full grown soon after midsummer, the larva climbs out of the water up an emergent plant and pupates inside a cocoon made of mud. The cocoons must be quite plentiful but they are seldom found. A month later the young adults emerge and it is in late summer and autumn that whirligigs are particularly abundant.

Leaf beetles CHRYSOMELIDAE

There are more than 20 000 species of leaf beetle throughout the world. Most of them are smooth, oval beetles, often with a metallic coloration. They are referred to as leaf beetles because, as larvae and adults, many feed on foliage.

The reed beetles, *Donacia* spp (1 overleaf), are exceptional leaf beetles because the adults have an elongate shape, and the larvae and pupae live an aquatic life. The adults are terrestrial, 6 to 13 millimetres (0·2 to 0·5 inch) long

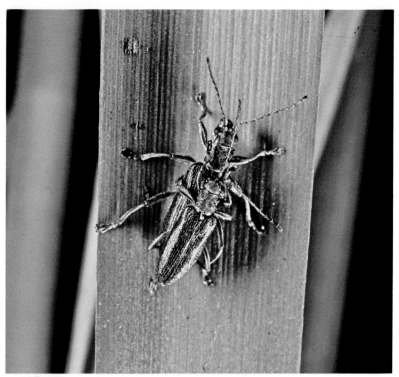

1

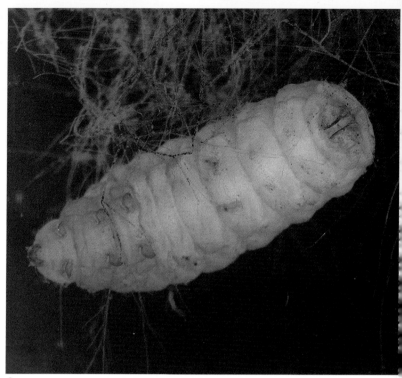

2

3

and are commonly found in the early summer as mated pairs on reeds and other vegetation around ponds. The female bites a hole through the surface of a floating leaf, such as that of the White Water-lily, before extending her ovipositor to lay her eggs on the underside of the leaf around the edge of the aperture. When the larvae hatch, they sink to the bottom of the pond and attach themselves to the roots of water plants by thrusting a pair of dagger-like structures into the plant's tissue. These two spines at the end of the larval abdomen represent an extension of the last pair of spiracles. The *Donacia* larva obtains oxygen indirectly by being connected to the many air spaces in the tissues of a plant such as Reed Sweet-grass, which is a favourite host for this purpose. The larva feeds by gnawing holes in adjacent plant tissues and sucking up sap through specially modified mouthparts.

The larva is a plump, inactive, elongate grub about 8 to 16 millimetres (0·3 to 0·6 inch) long with short thoracic legs. The photograph shows the general shape, the respiratory spines, and the thoracic legs (2). When full grown the larva spins a silken cocoon against a stem or root that may be buried in the mud. At first, the cocoon is pale but it soon turns a rich brown (3). The adult emerges from the cocoon enclosed in a bubble of air so that, when it reaches the water surface, it is dry and is able to fly at once.

The genus *Donacia* is mostly restricted to the temperate northern hemisphere, but one species, *D. australasiae*, has been reported from Australia.

Leaf beetles of the genus *Galerucella* may be numerous on emergent pond vegetation and, although they are not really aquatic, the question of their identity may arise.

Galerucella grisescens is typical of the genus and is 4 to 6 millimetres (0·16 to 0·2 inch) long; it may be abundant on Water-pepper, *Polygonum hydropiper*, standing in the pond shallows. The beetles mate in June to July (4) and the female lays a group of about twenty yellow eggs firmly stuck to a leaf of the host plant (5). After two weeks the jet-black larva chews a ragged exit hole to escape from the egg (6). Adults and larvae feed on the leaves of Water-pepper and, when the insects are abundant, the plant is reduced to a sorry sight. The type of damage caused by adults and larvae is different; the leaf beetle adults chew holes whereas the larvae tend to skeletonize the leaves. Another difference is that the adults feed singly but the larvae are usually gregarious, particularly in the early instars.

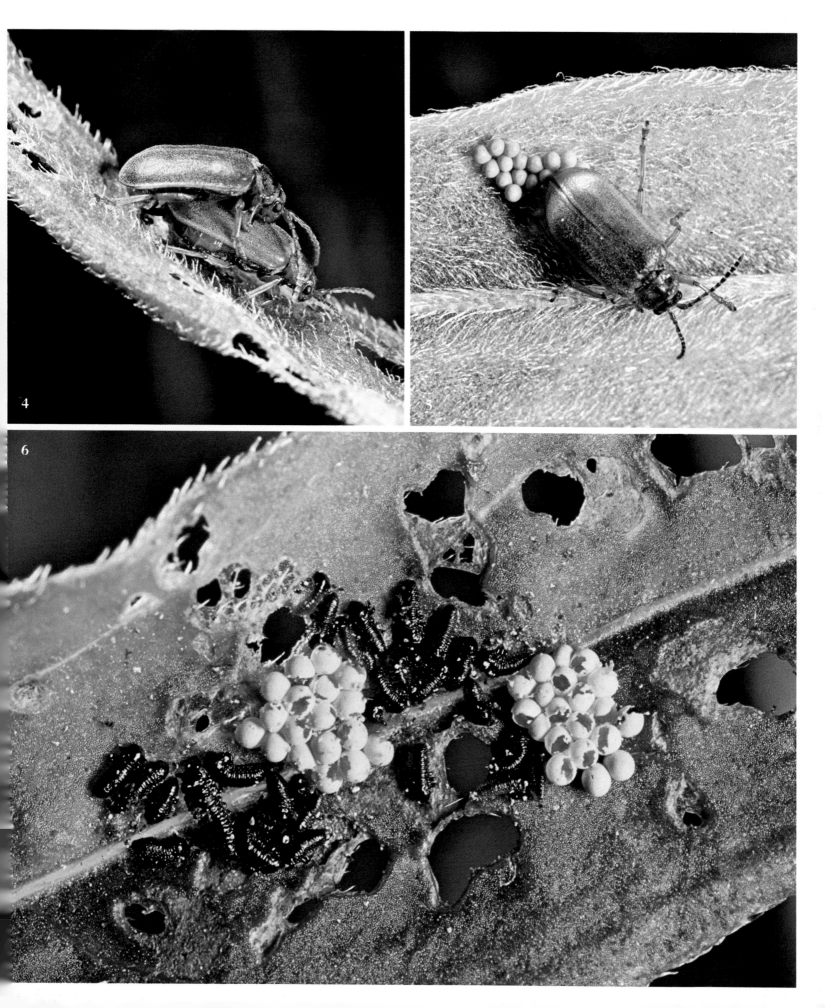

True flies
DIPTERA

The Diptera are the two-winged or true flies. They are easily recognized because they have only one pair of membranous flying wings, the fore wings, because the hind wings have become modified into small balancing organs called halteres. The flies' mouthparts work in a similar way to those of bugs but they are constructed differently. They are used for sucking and usually form a proboscis. Sometimes, a fly's mouthparts are adapted for piercing. The larvae never have thoracic legs and often the head is very much reduced. Most fly larvae have only two pairs of functional spiracles, a small pair on the first segment of the thorax and a large pair on the last segment of the abdomen.

The flies comprise one of the largest orders of insects with more than 85 000 described species. None of the adults is aquatic but many species spend the larval and usually the pupal stages in ponds. The flies are divided into three subgroups as follows:

The Nematocera have thread-like antennae. Their larvae have a well-developed head that is not retracted into the thorax. The mandibles bite horizontally. An adult nematocerid has antennae that are longer than the head and thorax combined and are composed of many similar segments. The aquatic families are: the Tipulidae, craneflies (some); the Ptychopteridae, phantom craneflies (all); the Dixidae, dixa midges (all); the Culicidae, mosquitoes (all); the Chironomidae, non-biting midges (most); and, in all these families, it is the larvae and pupae which are found in ponds.

The Brachycera have short antennae. Their larvae have a reduced head which can usually be retracted into the thorax. The mandibles bite vertically. The antennae of the adult are shorter than the thorax, and usually consist of three segments with the last segment elongate. The aquatic family is the Tabanidae, horseflies (some), and it is only the larvae which are found in ponds.

The Cyclorrhapha have larvae with a greatly reduced head. Pupation takes place inside the last larval instar which forms an oval puparium. The antennae of the adult are short and three-segmented with a dorsal bristle (arista). The aquatic family is the Syrphidae, hoverflies (few), and, again it is the larvae which are found in ponds.

Craneflies TIPULIDAE

Most kinds of cranefly larvae, *Tipula* spp (1), are not aquatic; they are the notorious 'leather jackets' which feed on the roots of grass and other crops and sometimes become serious economic pests. The body form is fleshy and elongate and, in transverse section, the larva is more-or-less cylindrical.

Aquatic cranefly larvae are usually a dirty white or pale-grey colour with a black head capsule. The most notable feature is the respiratory structure at the end of the abdomen which enables the larva to take in atmospheric air. The last two spiracles are very large and are borne on a plate surrounded by either six or eight fleshy lobes. The larva comes to the surface tail first and the lobes open out to form a buoyant float with the spiracles exposed to the air (2). The lobes are thought to assist in respiration by absorbing dissolved oxygen when the larva is underwater. When the larva has finished taking in air the lobes close over the spiracles to prevent the entrance of water as the larva submerges (3).

Most cranefly larvae, like the one illustrated, are vegetarian. The genus *Dicranota* has predatory larvae that feed on tubifex worms in the mud at the bottom of ponds.

The full-grown larva leaves the water to pupate in a chamber in the damp soil at the edge of the pond. The pupa has a pair of long horns, for respiration, on the first thoracic segment; it is active and pushes its way partly out of the soil before the adult emerges.

I

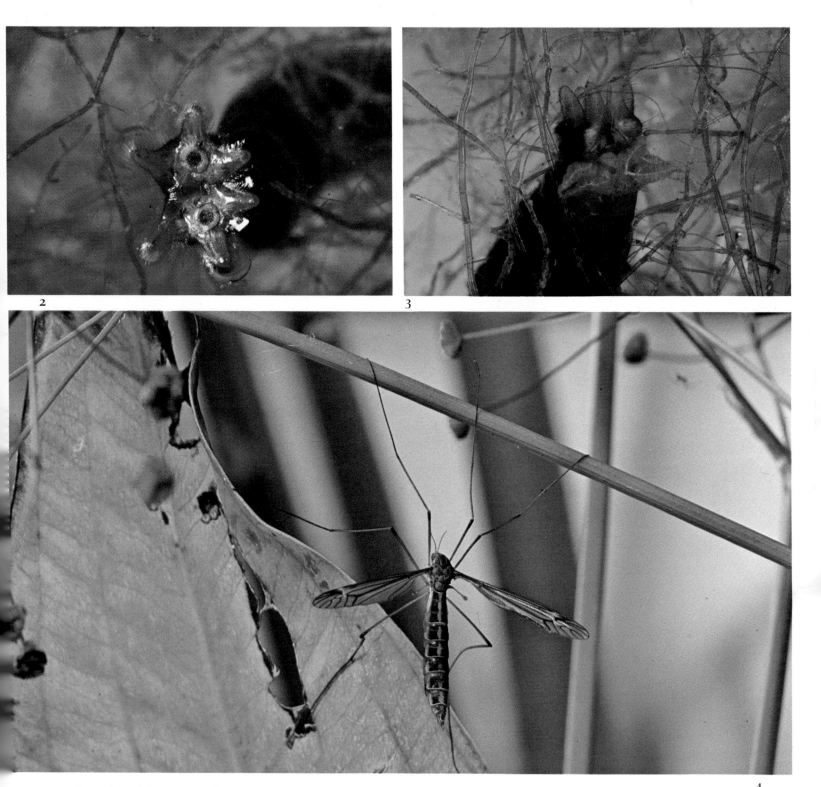

2

3

4

Craneflies (4) are usually common among vegetation near ponds in late summer and autumn. They are also attracted to light. The long legs, which are readily shed, the long narrow fore wings, the long halteres, and the long narrow body, and generally large size, make the craneflies easy to recognize. They can only be confused with adults of the Ptychopteridae, which are called phantom craneflies, but their larvae and pupae are very different. Craneflies with aquatic larvae lay their eggs in the water.

Aquatic tipulid larvae are well represented in Europe, and North America has about thirty species. The situation in Australia is unknown because the life histories of craneflies have not been studied there.

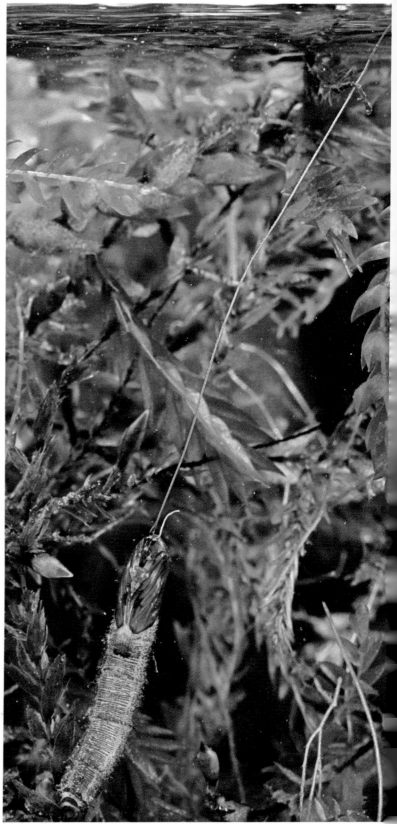

1

2

Phantom craneflies PTYCHOPTERIDAE

The phantom craneflies comprise a small family in which the adults resemble craneflies although the suture on the roof of the second thoracic segment is U-shaped instead of v-shaped and the legs are not shed as a defence or escape mechanism.

In Britain, *Ptychoptera contaminata* (5) is on the wing from May to October and is usually found on low vegetation near water. The larvae are found in muddy, often stagnant water, where they feed on vegetable matter. They are easily distinguished from cranefly larvae by the long, slender tube terminating the body (1). Two small spiracles open at the end of the tube which is formed from the greatly elongated last segments of the body. The respiratory tail can be lengthened or shortened depending upon the depth of water. *Ptychoptera* spp larvae are usually found buried in the mud in shallow water or among the dense roots of emergent plants such as the Water-pepper.

The pupae are also distinctive. They are found in the same location as the larvae, buried in mud or among dense roots. If the water-level changes they are motile enough to move up or down to keep the respiratory tube on the head in contact with the water surface. There are two tubes on the pupal head but one is very short while the other is about twice the length of the pupa (2).

The pupa gradually changes colour from pale brown to nearly black, by which time the adult is ready to emerge. The pupa rises to lie stretched out on the water surface before the roof of the thorax ruptures and the fly quickly works its way out by successive wave-like contractions and extensions of the body (3). The fly rests briefly beside the empty pupal case while the wings harden before flying away (4).

Although there are only seven species of phantom cranefly in Britain and six in the whole of North America, it is an ancient group that occurs in all regions of the world except Australia, where it has not been reported so far.

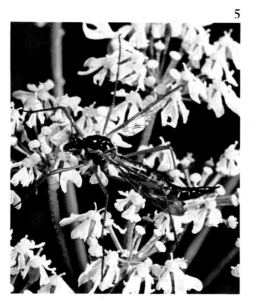

5

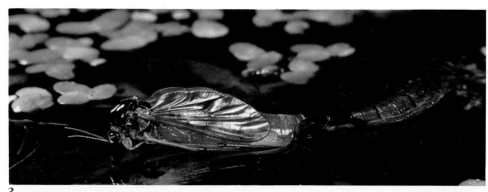

3

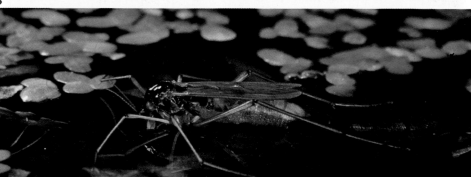

4

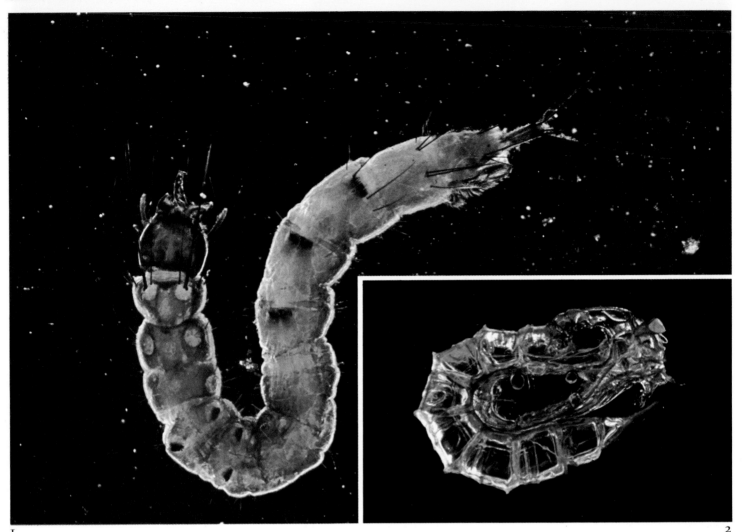

Dixa midges DIXIDAE

The Dixidae is a very small family of little flies that are cosmopolitan in distribution. Mating swarms of adult males are often seen at sunset dancing up and down near ponds; they resemble mosquitoes in general size but neither sex can bite. The larva (1) is found in weedy ponds where it is easy to recognize because it rests with its body in the shape of the letter U, apparently at the surface but, in fact, covered by a film of water. It moves rapidly across the water surface by repeatedly bending the body into U shapes. The full-grown *Dixa* larva is about 8 millimetres (0·3 inch) long with a well-developed brown head supplied with tufts of bristles around the mouth. The vibration of the bristles draws a current of water carrying minute food particles into the mouth. The first thoracic segment bears long, forward-pointing hairs on the front edge. There is a pair of small false legs on the ventral surface of the first and second abdominal segments. Long hairs at the hind end of the body surround the spiracles which can be closed by valves when the larva is submerged.

The pupa rests on the surface of the water curled up in a U shape with the end of the tail level with the eyes. The photograph (2) shows a pupal case after the midge has emerged.

Compared with a world total of over 11 000 known species of craneflies, there are only about 100 species of *Dixa* midge but they occur throughout the world. Most regions have about a dozen species and, like mosquitoes, the larvae may occur in vast numbers and provide valuable food for pond predators including fishes. *Dixa* larvae and pupae are surface dwellers so that, presumably, they are not so accessible to the bottom-dwelling predators such as *Sialis* larvae and *Aeshna* nymphs.

Mosquitoes CULICIDAE

There are more than 1600 known kinds of mosquito in the world. Britain has thirty-six species, North America 120, and Australia over 200. The tropics are especially rich in species but the greatest number of adults occurs in cold northern latitudes where the brief summer may be made unbearable to man by the hordes of mosquitoes seeking a blood meal. In fact, there is considerable host specificity and not all species attack man; many will only take blood from other mammals and some feed mainly on birds, reptiles, or frogs. Only the female is a blood sucker; she needs a meal of blood before she can lay her eggs and her mouthparts form a long, thin proboscis that is adapted for piercing. The male's proboscis is used purely for sucking and he feeds on nectar, so the mosquitoes that trouble man are all female.

The need to suck blood also enables diseases to be transmitted from man to man or from animal to animal. Malaria, yellow fever, and dengue fever are among the serious diseases transmitted by mosquitoes to man. The transmission of the disease organism is not, as a rule, a passive mechanical affair. In the case of malaria, the organism passes through two periods of multiplication during its life cycle. The first is by asexual reproduction in the blood of man; the second is a sexual form of reproduction and occurs in the body of the mosquito where the products end up in the salivary glands ready for injection into the host when the mosquito injects salivary fluid next time she feeds. In Australia certain mosquitoes transmit the rabbit disease, myxomatosis.

All mosquito larvae are aquatic, the majority living in ponds or in even smaller bodies of freshwater such as tree holes, hoof prints, or metal cans. All larvae take in atmospheric oxygen at the water surface, except certain species that connect up with the air in the tissues of aquatic plants through a specially adapted piercing siphon in much the same way as the beetle, *Donacia* (page 172) does. All mosquito larvae pass through four instars of which the last is the longest. In the United States mosquito larvae are called 'wrigglers'. The pupae are all aquatic and are unusual in being extremely mobile.

The two best-known genera of mosquitoes are *Culex* and *Anopheles*. The Common Midge or House Mosquito, *C. pipiens*, is typical. The sexes are easily distinguished by the feathery antennae and slim body of the male whereas the female has a plumper body and antennae with very short hairs. It is 5 to 6 milli-metres (0·2 inch) long. The culicine adult holds itself more-or-less parallel to the surface on which it rests. The female lays as many as 300 conical eggs stuck together broad end downwards to form a slightly concave egg raft about 5 milli-metres (0·2 inch) in diameter (1 overleaf). The raft is unsinkable and unwettable, and each larva hatches through a trap door in the bottom of the egg so that it descends straight down into the water. The larvae are legless with a well-developed brown head and there is a long breathing tube on the eighth segment of the abdomen. The insect spends most of its short larval life suspended head down from the surface film by the breathing tube which terminates in a spiracle surrounded by five small flaps that open out to form a funnel when the larva takes in air (2 page 181). When disturbed, the larva dives down swimming with a violent struggling motion and closing the flaps over the spiracle as it submerges. The last segment of the body has four gill-like structures which are thought to regulate the salt content of the body. The mouth is surrounded by brushes of hairs which vibrate to create a current of water into the mouth, carrying with it particles of suspended matter on which the larva feeds.

Pupation in the water takes place very quickly; the larval skin splits, there are one or two violent heaves, and the pupa kicks itself free. The shape of the pupa is very characteristic: it has a large head/thorax, equipped with a pair of breathing

I

trumpets, and a small abdomen ending in two large swimming paddles. The head end contains an air space for buoyancy and, when the pupa floats head upwards at the surface, the breathing trumpets are in contact with the atmosphere (3). At the slightest disturbance, the pupa paddles down into the depths and remains below until it is compelled to rise for air. In the United States the pupae are known as 'tumblers' which is an apt description for their mode of progress.

The young pupa is pale as seen in the photograph (3); during development it gradually darkens to become dark brown or nearly black. When the adult is ready to emerge, the pupa stretches out its abdomen until it lies flat along the surface (4). Blood pressure swells the anterior end of the adult until it splits the pupal skin on the top of the thorax, which is flush with the surface of the water. Gradually, the adult begins to work its way out by worm-like movements of expansion and contraction. The posterior end of the abdomen can be seen to travel along inside the pupal case and the long, coiled antennae travel round inside the pupal whorls. (5 to 13 pages 182–3) is a series of photographs taken over a period of five minutes. The adult stretches upwards until the ends of the long legs slip out of the pupal sheaths and the insect can drop forward on to the surface film. By this time, the wings are not only free of the pupal skin but they are fully inflated. After resting for a very short time, presumably for the wings to harden, the mosquito can fly off from the pond surface.

Members of the genus *Culex* are found throughout the world and *C. pipiens* is common in North America as well as in Britain and Europe.

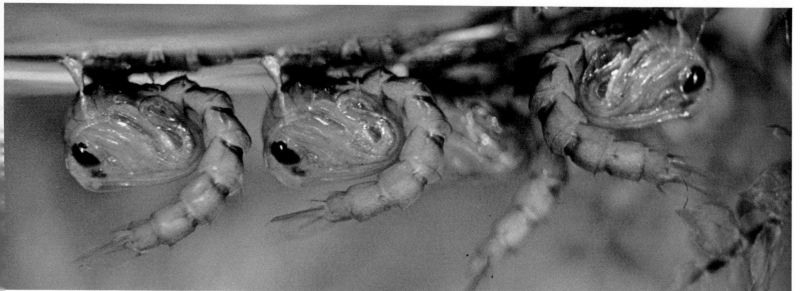

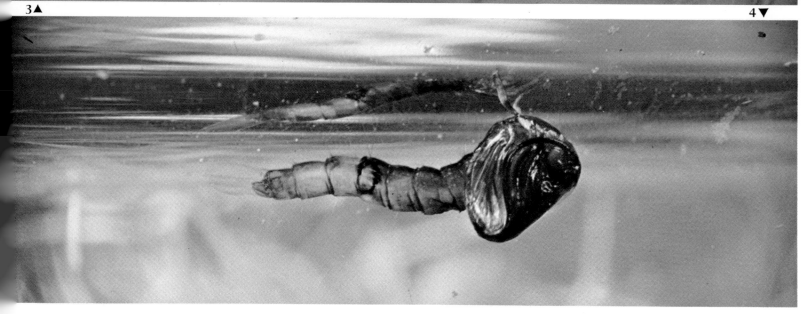

2

3▲ 4▼

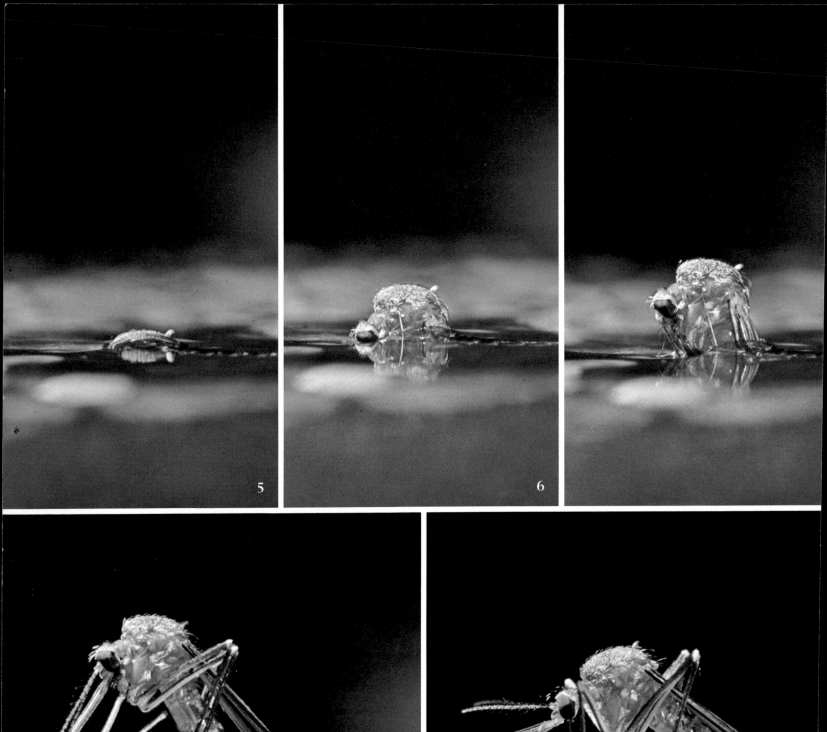

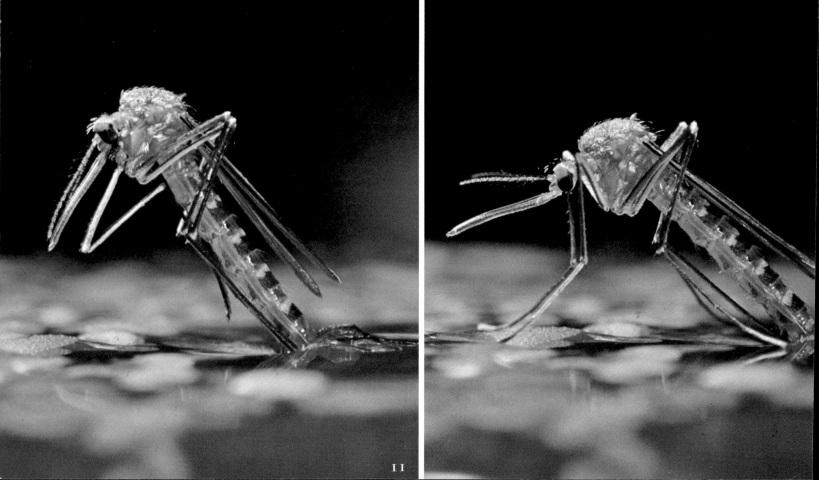

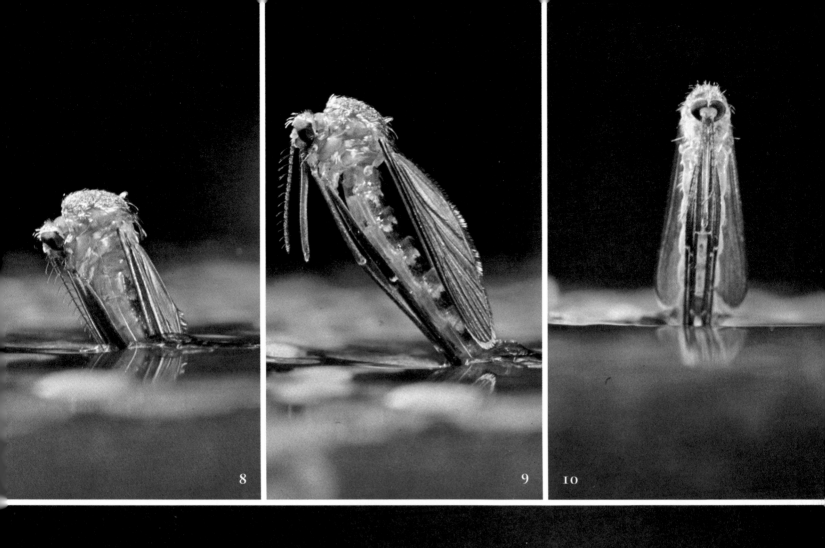

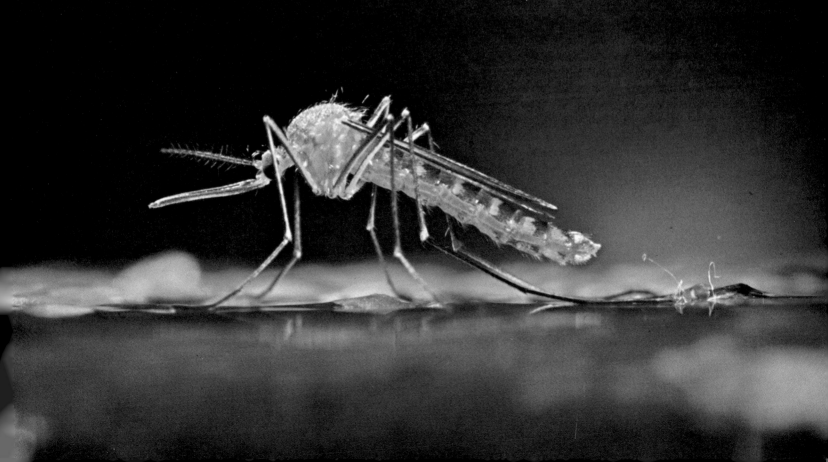

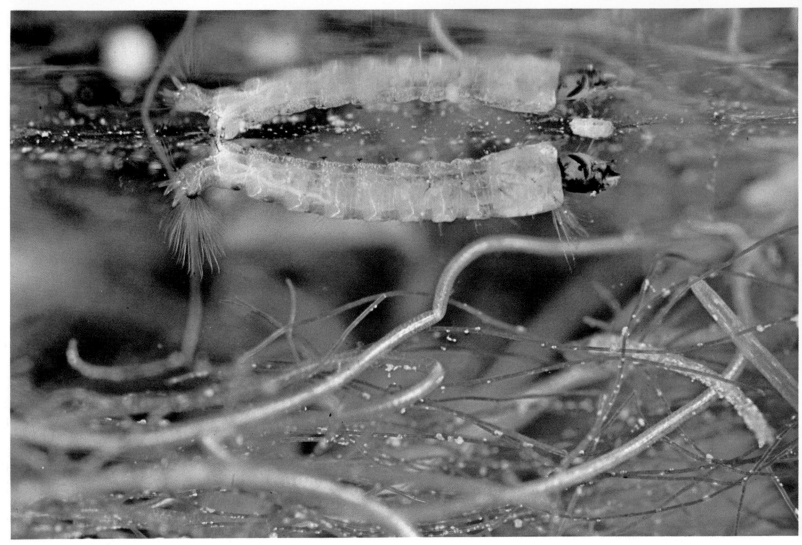

1

The other well-known genus of mosquito is *Anopheles* and it is important to be able to distinguish it from *Culex* because some *Anopheles* can transmit malaria while *Culex* cannot. The adults are easily differentiated when they are at rest; whereas *Culex* holds the body more or less parallel to the surface, *Anopheles* rests with the head down and the abdomen inclined upwards (**2**).

The larva, too, is instantly recognizable because it takes up a different attitude in the water. Instead of hanging down from the surface film at a slight angle to the vertical, the *Anopheles* larva lies along the surface (**1**). *Culex* larvae have long breathing tubes but the *Anopheles* larvae take air directly into spiracles on the eighth abdominal segment and there is no respiratory siphon.

There are further differences between the two genera in the eggs and method of laying. *Culex* lays her eggs in rafts while *Anopheles* eggs are deposited singly. The egg has a small float on each side so that it is buoyant and maintains an upright position.

The *Anopheles* pupa has a lateral spine at the posterior angle of each abdominal segment whereas *Culex* pupae have no such spines.

When a mosquito sucks blood from a human the first impression is a burning sensation where the insect is at work. This is caused by the salivary fluid injected by the fly to prevent the coagulation of the host's blood. The salivary fluid is also responsible for the itchy spot formed on the skin at the site of attack. A person who is heavily attacked by mosquitoes over a period of weeks will develop an immunity to the salivary fluid so that he or she no longer reacts by coming out in spots. But the burning sensation will be felt every time a mosquito feeds.

Pictures **2** to **4** are a sequence showing a female *Anopheles stephensi* feeding on a human's arm.

2 The female mosquito has settled and has closed her wings but has not yet begun to probe with her mouthparts. She will bring the tip of the lower lip (labium) against the skin and then use the four stylets formed from the mandibles and maxillae to pierce the skin to reach a blood capillary.

3 The mosquito is sucking steadily; the proboscis is coloured red by the blood travelling up it, and the abdomen is beginning to be distended by the blood in the stomach. The labium does not enter the wound; it supports the stylets where they enter the skin and is bent back more and more as the stylets probe deeper.

4 The mosquito is still feeding but the enormous distension of the abdomen shows that it is virtually replete. At intervals the fly excretes blood which accumulates to form a large drop behind the insect. The hind legs are resting on the skin and the mosquito has the appearance of being weighed down by the amount of blood taken aboard. Nevertheless, the insect can still fly.

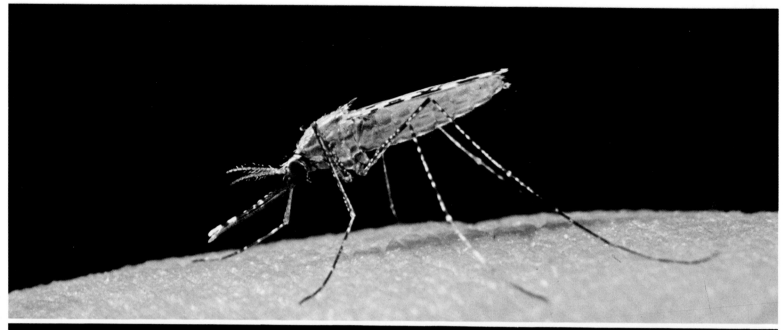

2

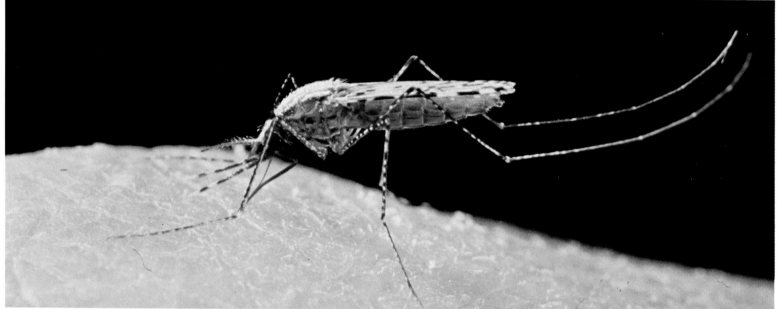

3

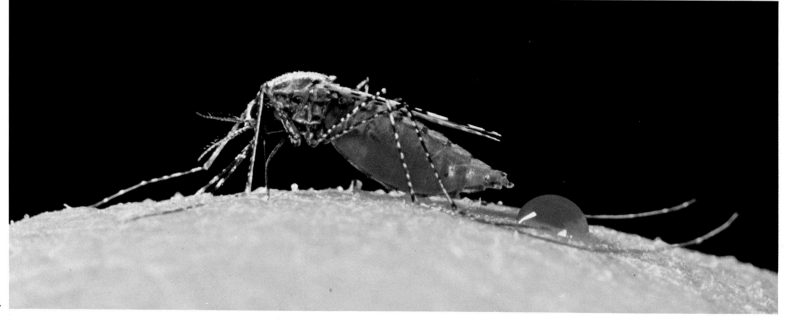

4

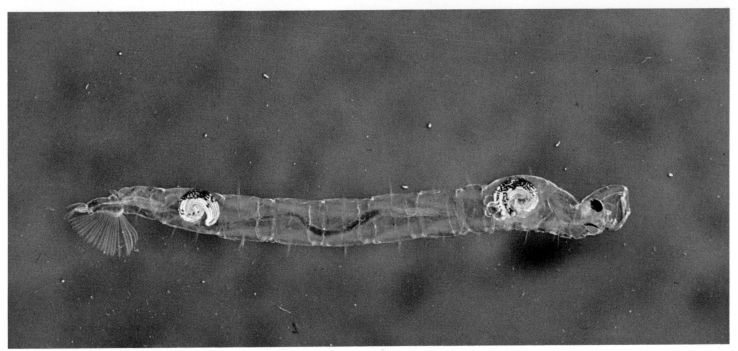

Phantom, ghost, or glass larvae CHAOBORIDAE

The phantom or ghost larvae comprise a highly specialized group of mosquitoes, and the larva cannot be mistaken for any other insect. Fully grown, *Chaoborus crystallinus* is 13 to 15 millimetres (0·5 inch) long and so transparent that it can be easily overlooked (1). The best way to see them is to hold the container against a dark background and shine a light at an angle from behind. The larva hangs motionless in a horizontal position in the water and then gives a sudden flick of the body to reappear motionless a short distance away. The only easily visible structures are the two black eyes on the head and the pair of hydrostatic organs, one at each end of the body. The antennae are most unusual in that they are modified to grasp the small insects and crustaceans on which the larva feeds. Anything suitable that swims within reach is quickly snatched.

The two oval hydrostatic organs are filled with gas and their purpose is to give the larva neutral buoyancy so that, when it is inactive, it neither sinks nor rises in the water. If the larva swims upwards the organs expand, if it descends the organs contract. At the end of the abdomen there is a comb of bristles which probably functions as a stabilizer and rudder. Spiracles are absent and the larva respires by gaseous exchange through the skin. In cold climates the winter is passed as a larva which is active even in the lowest temperatures.

The pupa floats at the surface with the pair of long breathing trumpets in contact with the air (2). The head end is very large and the abdomen is slender terminating in a pair of swimming paddles.

The 6 millimetre (0·2 inch) long adults emerge in spring (3 to 5). The phantom midge has short mouthparts and is not a blood sucker; in fact, it is said not to feed at all. The flies may appear in huge numbers and be attracted to lights.

The strange larvae of *Chaoborus* spp are found all over the world, including America and Australia.

Midges CHIRONOMIDAE

Swarms of midges can be seen in winter or early spring dancing up and down in sheltered places, usually near water. These are mating swarms consisting entirely of males, and the females can be found resting on vegetation nearby. To find a mate a female enters the swarm and is at once mated by the nearest male; the couple then leaves the swarm. Different kinds of midges swarm at different times of the day; many congregate an hour or so before sunset while others do so just before darkness sets in.

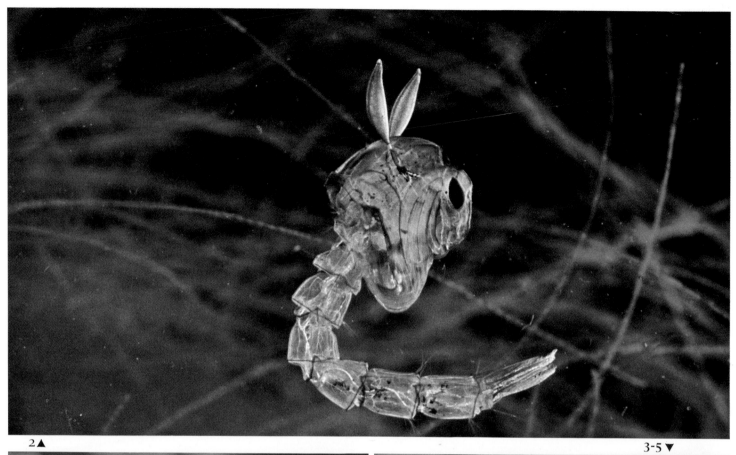

2▲ 3-5 ▼

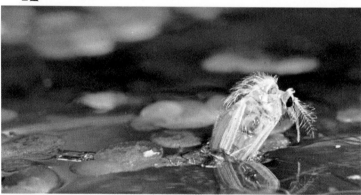 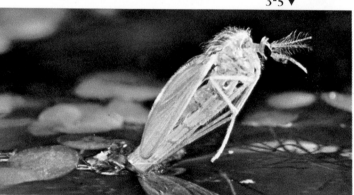

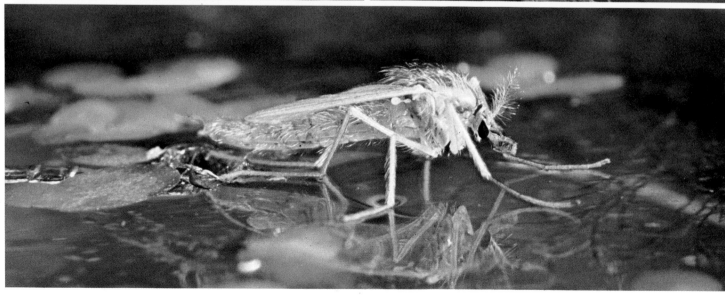

Some adult midges resemble chaoborids in form and size but can be distinguished by the anterior veins on the wings which are more strongly marked than the rest. The males have conspicuously plumose antennae while, in the females, they are only slightly hairy. The mouthparts are poorly developed and mandibles are usually absent. The head is small, often concealed below the bulging thorax. These delicate flies may be confused with mosquitoes but they can be distinguished by the absence of scales on the wings. The larvae are mostly aquatic.

The adult midge, *Chironomus* sp, does not feed and the stomach is shrunken and empty. The female lays her eggs in a ribbon of transparent mucus attached to vegetation or twigs just below the pond surface. The egg mass is up to 25 millimetres (1 inch) in length and is easy to see. The photograph (1) shows a complete egg ribbon, and part of a ribbon. The eggs hatch (2) after about ten days and the young larvae sink slowly to the bottom of the pond where they may be the most numerous inhabitants.

The larval features of *Chironomus* spp apply to most midge larvae and make them easy to recognize. They are distinctly segmented and worm-like with a distinct head, a pair of false legs or prolegs on the first thoracic segment, and another pair on the last abdominal segment. There is a bunch of four tubular gills on the penultimate abdominal segment. Some species (3) have larvae which are red, because they have the red pigment, haemoglobin, in their blood. These larvae make tubes in the mud on the bottom of ponds where the oxygen content may be low. Species with larvae that live among vegetation near the surface have colourless or greenish larvae.

The tube dwellers construct their homes from particles of mud, sand, or vegetable debris, held together by silk. The larva holds on to the tube with the false legs and undulates its body to maintain a flow of water, and hence oxygen, through its home while it feeds on particles of organic matter in the mud.

Periodically, the larva leaves its tube and swims about with jerky movements, often going up to the surface. This is probably done in response to a lack of oxygen. After such an excursion, the larva builds a new tube very quickly. Bloodworms, as the red larvae are called, may be present in vast numbers; they are among the commonest sources of animal food in ponds and are very important to a large range of predators, particularly to certain fishes.

Pupation takes place in the larval tube or attached to the mud. The pupa has large tufts of filaments on the head instead of respiratory trumpets; these wave in the water and absorb dissolved oxygen which enables the pupa to remain submerged until the adult is ready to emerge (4).

The pupal tracheal system is well developed whereas, in the larva, it is poorly represented and has no spiracles. When the time comes for the adult to emerge, the tracheal system contains enough air to enable the pupa to float to the surface, aided by a few wriggles. The series of photographs (5 to 8) shows the emergence of a *Chironomus* sp of the bloodworm variety. When the pupa arrives at the water surface, it stretches out along the surface and pumps blood into its thorax to split the roof of the pupal case. As we have seen in the mosquito, *Culex pipiens*, the adult then emerges but there is one striking difference. As the fly emerges from the pupal case, the thorax and, in particular, the wings are a beautiful red. The thorax was pumped up by the blood to split the pupal case and the wings are inflated with blood to expand them. The photograph shows the blood seen through these structures. As soon as the fly is out of the case there is a muscular contraction and the wings turn grey as the blood is returned to the abdomen.

There are about 2000 species of midge in the world. Britain has more than 370 species, North America is said to have about 200 species, and Australia has 130. But there are likely to be many species yet to be discovered and named.

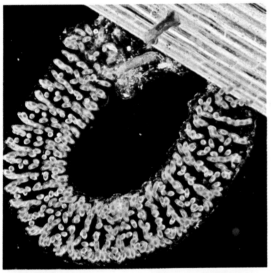

1

2

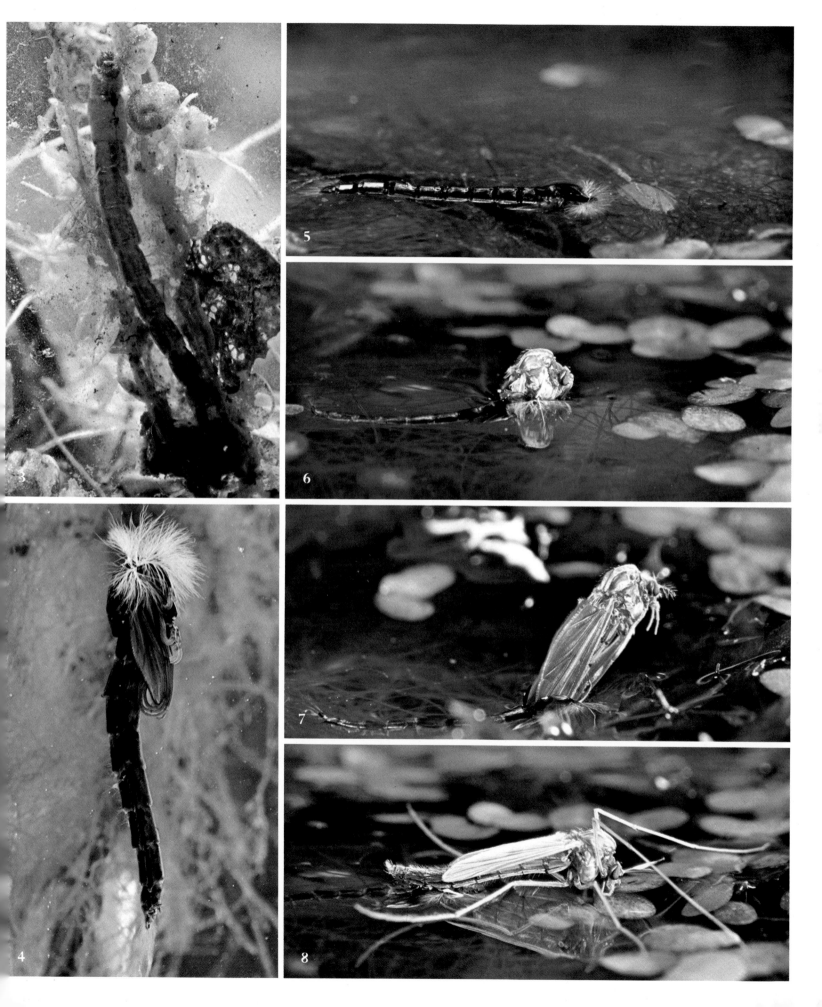

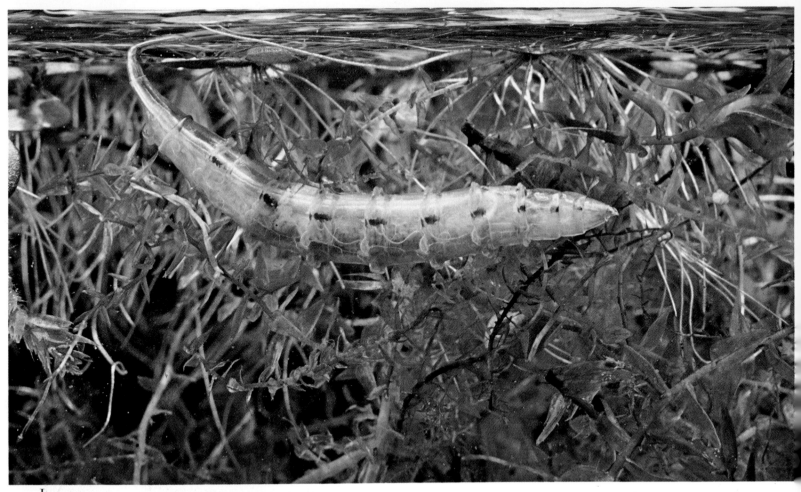

Horseflies TABANIDAE

Horseflies, deerflies, or clegs, as the flies of this family are known, are robust and medium to large in size. The females of many species bite man viciously. The males, on the other hand, suck nectar. Some tabanids have aquatic larvae, others live among damp moss or in soil near water, or in drier situations such as behind the bark of dead trees.

Larvae of the genera *Tabanus* (horseflies) and *Chrysops* (deerflies) are mainly aquatic. The larva of *Tabanus* sp (1) is creamy white, tough bodied, tapered towards both ends, and has a small head that can be retracted into the first segment of the thorax. The first seven abdominal segments have continuous 'welts' around the body which provide a grip when the larva, which is legless like all fly grubs, crawls on the substrate. The eighth abdominal segment ends in a short siphon which is pushed through the surface when the larva comes up for air. The larva of *Chrysops* is similar to that of *Tabanus*. The larvae of both genera have distinct longitudinal striations.

The horsefly larva is carnivorous, tearing up its prey with a pair of strong black, hook-like structures, which are the main mouthparts. Worms, crustaceans, and insect larvae are the chief food. The full-grown larva leaves the water and burrows into nearby damp soil to pupate. The adults are on the wing in summer and the females lay compact masses of spindle-shaped eggs on the leaves and stems of plants growing in water or damp places.

Most adult tabanids are a dull grey or brown in colour although the deerflies (2) are more colourful. The large eyes, however, are among the most beautiful in the insect world with their iridescent green and purple colour interrupted by dark bands or blobs.

Tabanids occur on all continents but they are most numerous, and most troublesome to man and stock, in the north temperate zone.

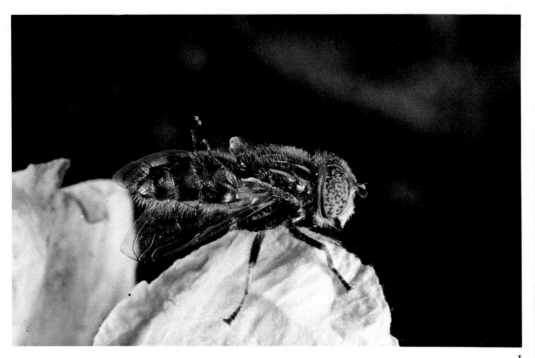

1

2

3

Hoverflies or flowerflies SYRPHIDAE

The members of the family Syrphidae are noted for their ability to hover giving them their common name, hoverflies. In America they are known as flowerflies because they may assemble in large numbers on blossom and are important pollinators. Many species are striped black and yellow and look rather wasp-like; others are very hairy and may resemble bees extremely closely, although the presence of only two wings and the nature of the antennae will immediately establish that they are flies. Most hoverfly larvae are terrestrial and the best known of the few that are aquatic are the species belonging to the genera *Eristalomyia* and *Eristalinus* in which the larvae are known as rat-tailed maggots.

Eristalomyia tenax is a cosmopolitan species known as the Dronefly because it closely resembles a male honeybee. *Eristalinus sepulcralis* (1) is a small, crumpled-looking, dark species 8 to 9 millimetres (0·3 inch) long in which the eyes are covered with dark, irregular blotches. In Britain this fly is found around farmyard pools or on vegetation near muddy water containing much decaying matter. The larva (2) is a typical rat-tailed maggot, well adapted to life in a liquid or semiliquid medium and commonly found in evil-smelling ponds, fouled by effluent from farmyards. In addition, small quantities of water containing a lot of decaying leaves or even small corpses may be used as breeding sites.

The larva is a typical legless fly maggot in which the head, with its pair of black mouth hooks, is retracted into the first thoracic segment. The feature that makes these larvae instantly recognizable is the respiratory tube at the end of the abdomen. The full-grown larva is about 15 millimetres (0·6 inch) long but the respiratory tube can be extended telescopically to about 75 millimetres (3 inches). The larvae are found in shallow water, often buried in mud from which they ingest minute particles of decaying organic matter while the breathing tubes extend straight up to the surface to renew their air supply. The spiracles open in the centre of a circlet of hairs at the tip of the tube.

When it is full grown, the larva crawls out of the water and burrows just inside damp soil or under decaying vegetation to pupate. Occasionally, the pupa can be found floating on the water surface but this is unusual. The pupa remains inside the last larval skin and retains much the same appearance as the larva except that the tail and the body are rather shrivelled and there are two pairs of breathing horns at the front end (3). The female fly lays small groups of eggs on the pond surface.

Rat-tailed maggots are found throughout the world.

Butterflies and moths
LEPIDOPTERA

Butterflies and moths are distinguished from other insects by having the body and wings clothed in broad, overlapping scales. They are the most familiar, easily recognizable, and by far the most colourful of all insects. The adult mouthparts are usually in the form of a sucking proboscis which is coiled up when not in use. The typical larva or caterpillar has three pairs of thoracic legs and five pairs of 'false legs' or pseudopods on the abdomen. The large group of day-flying moths, known as geometers, have caterpillars ('loopers') with only two pairs of pseudopods.

More than 100 000 species of butterflies and moths have been described in the world. None of the adults is aquatic and the few moth caterpillars found in ponds mostly belong to the genus, *Nymphula*, the china-mark moths.

Snout moths PYRALIDAE

Britain and Europe, North America, and Australia all have their own species of *Nymphula* in which the life history is similar to that of the Brown China-mark Moth, *N. nympheata*.

Nymphula caterpillars make oval-shaped holes about 25 millimetres (1 inch) long in water-lily leaves. These holes readily give away the presence of the caterpillars especially if the missing pieces have been fastened on the undersides of the leaves with silk (1). Carefully raising an edge of the leaf fragment will reveal a fat caterpillar, about 20 millimetres (0·8 inch) long, of the typical moth type with three pairs of legs on the thorax and five pairs of false legs on the abdomen. The older larva is covered with hair which makes it unwettable. In its shelter the larva is surrounded by air and, when it pushes its head out through a small aperture to nibble a leaf, the hairs fill the gap between its body and the hole to prevent water entering. The female moth lays her eggs on the undersides of leaves by curling her abdomen round the leaf edge. While the caterpillar is very young, it lives in its shelter surrounded by water and breathes through its skin. Presumably, as the larva gets bigger, it cannot get enough oxygen from water and it must change to living surrounded by air.

Before pupating the caterpillar fixes the case firmly to a leaf with silk and closes both ends securely. The pupa, like the older larva, is surrounded by air. The photograph (2) shows the pupal case with the cover removed.

Owl moths NOCTUIDAE

The caterpillar of the Bulrush Wainscot Moth, *Nonagria typhae*, is not aquatic but is widely found feeding on the Bulrush or Reed-mace around ponds and lakes in Britain and Europe. Evidence of the presence of the Bulrush Wainscot Moth is an open hole in the upper part of the stem near the flower head. If the stem is carefully opened, you will find a pale-brown caterpillar, about 45 millimetres (1·8 inches) long, of the normal moth type with three pairs of legs on the thorax and five pairs of false legs on the abdomen (3). The caterpillar burrows up the stem and pushes the resulting fragments out through an exit hole so that it lives in an open tunnel. The diameter of the tunnel is increased as the larva grows. When the time comes to pupate, the caterpillar seals itself into a cell at the top of the tunnel by making a partition of chewed Bulrush tissue; it then pupates with its head downwards, pointing towards the exit hole (4). The pupa, or chrysalis as it is called in moths and butterflies, is of the obtect type in which the wings and other appendages are fused down to the body and little movement is possible. In due course, the moth pushes its way through the cap blocking the pupal chamber and crawls down the tunnel and out through the exit. Not until it reaches the open air does the moth expand its wings (5). In Britain, larvae of the Bulrush Wainscot Moth can be found during the summer, the pupae in July and August, and the moth is on the wing in August and September.

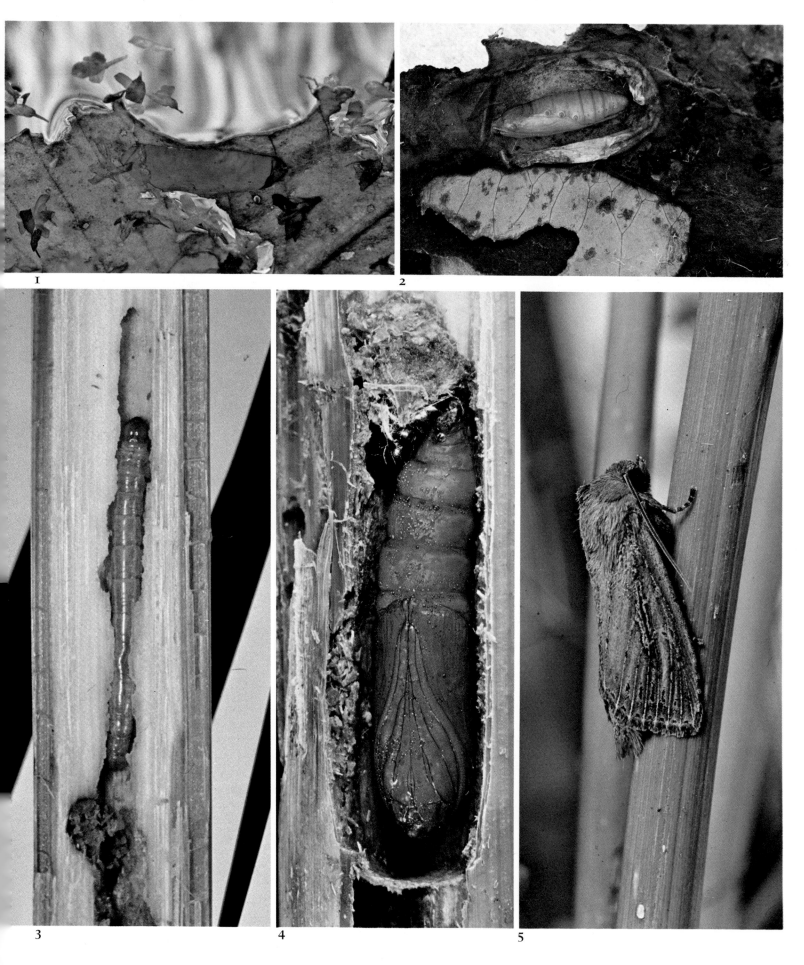

1

2

3

4

5

Caddisflies
TRICHOPTERA

The caddisflies (1) are closely related to the butterflies and moths from which they are separated by quite minor details. Whereas most moths have wings covered by broad scales, caddisfly wings tend to be hairy and usually have no scales or, if scales are present, they are narrow. Caddisflies also have a semitransparent, whitish, hairless spot on both pairs of wings which does not occur on butterflies or moths.

There are about 5000 species of caddisflies known in the world, of which there are 188 species in Britain, 975 in North America, and, so far, more than 300 species have been described from Australia. The adults are weak fliers found near water. They are small to medium-sized insects with long antennae, large eyes, and are mostly on the wing at dusk and dawn. Some are attracted to light.

All caddisfly larvae are aquatic and, because they are common, they tend to be seen much more often than the adults. Most larvae live inside a case made of a material and built to a pattern typical of its own species. For example, (2) makes its case from short lengths of twig arranged in a rather haphazard manner. In general, a caddisfly larva has a tough, brown head, short antennae, and biting mandibles. The thorax is protruded from the case during feeding or crawling, and the roof is well protected with toughened plates. There are long thoracic legs and, on the first segment of the abdomen, there are three papillae which can be extruded to grip the inside of the case. The abdomen ends in a pair of stout hooks which also serve to grasp the silk with which the case is always lined. Along the body there are filamentous gills for extracting oxygen from the surrounding water, and the larva undulates its abdomen inside the case to improve the circulation of water over the gills.

When the larva pupates, it closes the case at both ends except for small apertures to permit the circulation of water. The pupa is of the free type, that is, the wings and appendages are not fused to the body, and there are filamentous gills on the abdomen for respiration. Like the larva, the pupa undulates its body to maintain a current of water through the case.

To lay its eggs the adult usually crawls beneath the water surface and lays a group of eggs enclosed in a gelatinous envelope loosely attached to a stone or plant. Some species drop their eggs while they fly over standing water.

The caddisfly is in the larval stage for nearly a year while the egg and pupal stages each last for about two weeks, and the adult lives for about a month. Caddis larvae are important items in the diet of many freshwater fishes; they are also eaten by frogs, dragonfly nymphs, and by other aquatic predators.

Caddisflies are found all over the world and there are many different families and a great number of species. Some are found only in running water and at least one species is marine. The variety of different cases is legion; almost any material found in a pond may be used by the different species. For example, *Limnephilus flavicornis* (3) makes its case from small mollusc shells whereas a case can also be made from the sporophyte capsules (4) of the aquatic moss, *Fontinalis* sp, (page 56). Another species makes its case from fragments of plant tissue (5) and incorporates a long, trailing element which probably serves as a stabilizer. Leptocerid larvae build narrow, conical cases (6) and this species builds a curved case from sand grains. The larva has long hind legs fringed with hairs with which it can swim with its case. The cases of most caddis larvae are so heavy that the inhabitants can only crawl.

The pupa of the caddisfly is unusual in that it is provided with large functional mandibles, and it is extremely active. Most insect pupa are only able to wriggle but caddisfly pupae are among the most active in the insect world which is understandable because of the difficulty the adult has in emerging. In the adult caddisfly, the mandibles are either absent or very reduced, and it would be unable

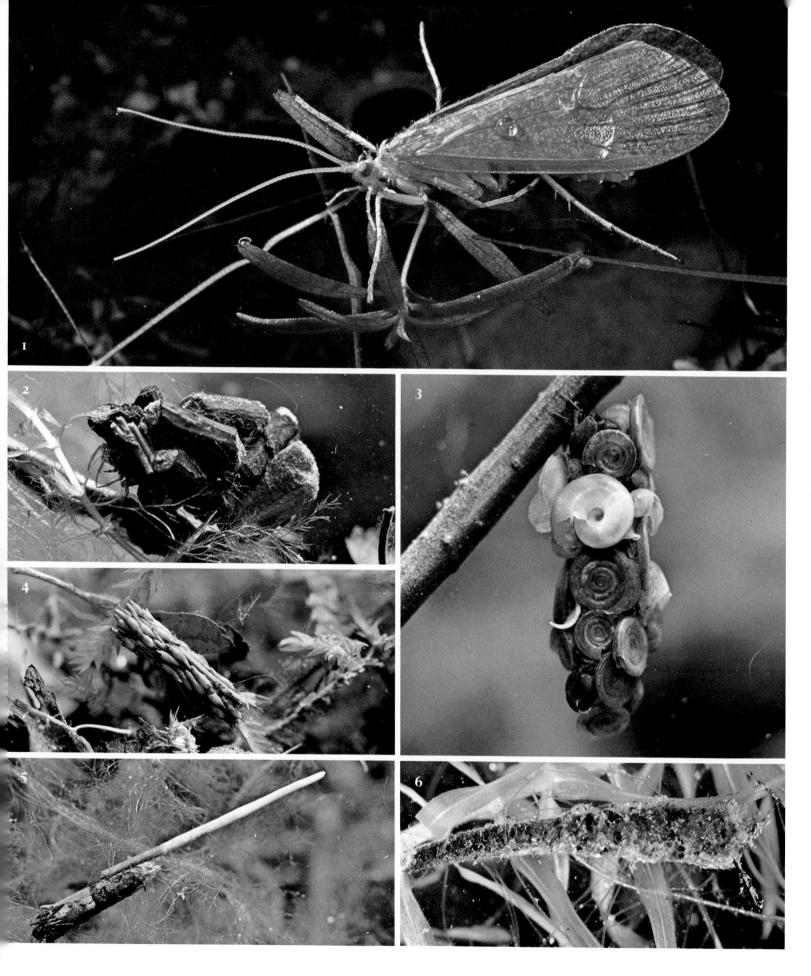

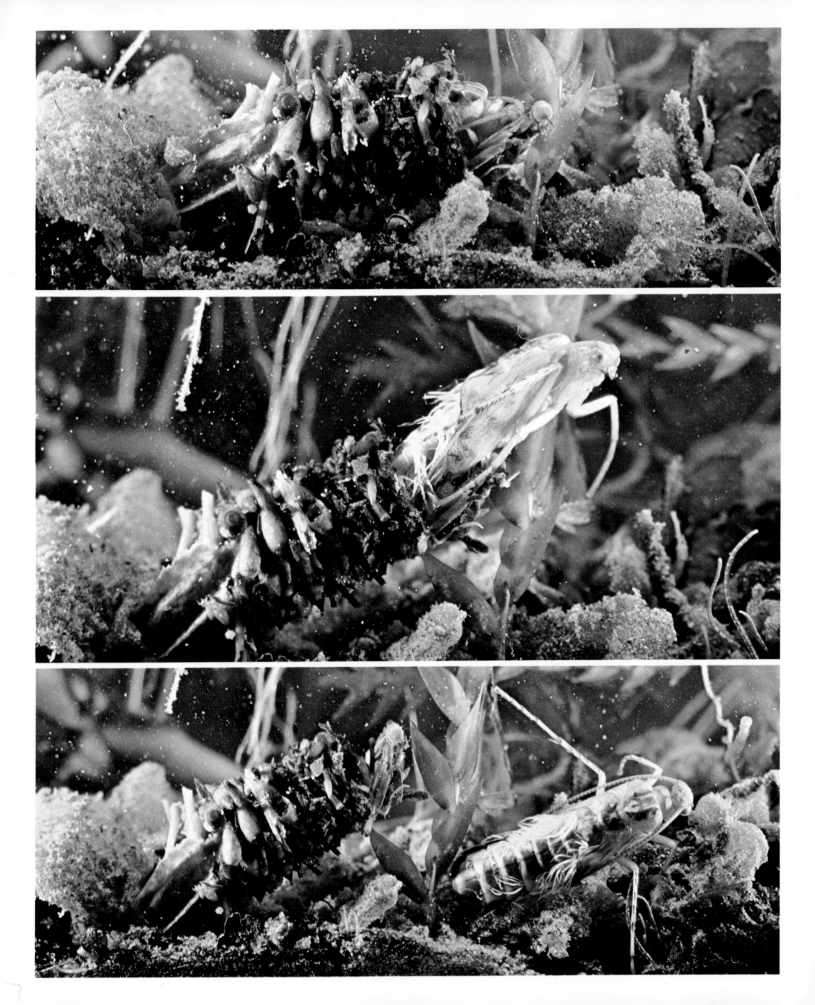

to escape from the sealed pupal case. Even assuming that the pupa prepared an escape route the adult would still encounter respiratory problems if it emerged underwater. The pupa of *Limnephilus lunatus*, like other caddisflies, solves all these difficulties by chewing round the head end of the pupal case until a flap can be pushed open. The pupa then crawls out (**1** to **3**) and, by a combination of crawling and clumsy swimming, it makes its way up to the surface and ascends the stem of an emergent plant (**4**). At a height of 50 centimetres (20 inches) or so, the pupa settles down and begins to expand the thoracic end of the body by blood pressure until the pupal case splits open and the adult emerges (**5**, **6**). By the time the adult is free of the pupal case, the wings are already largely expanded (**7**) and it takes only a few minutes more for this to be completed. The wings are soft at first (**8**) and it takes several hours for them to harden so that the insect can fly.

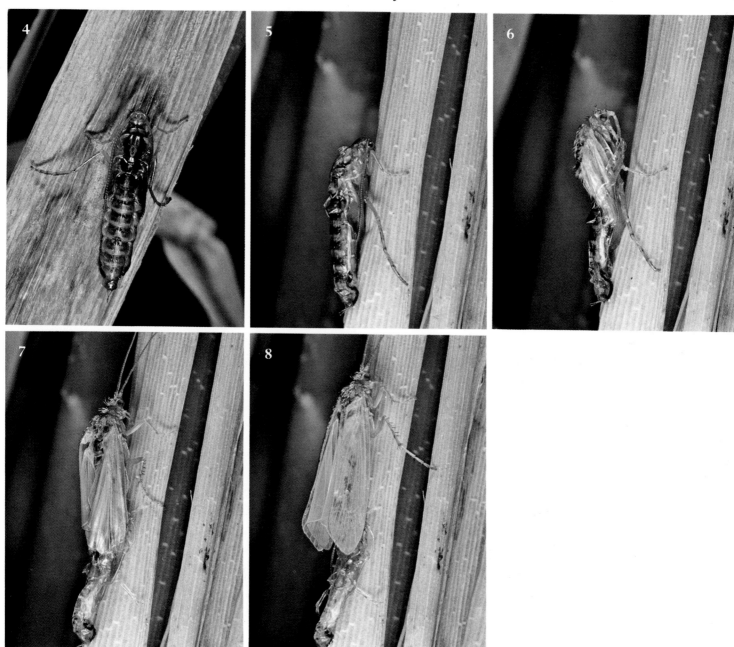

The vertebrates
VERTEBRATA

The vertebrates, or members of the subphylum Vertebrata, include all the animals, such as fishes, birds, or mammals, which have a spinal column or backbone.

Fishes
PISCES

There are three kinds of fishes. The first kind is represented by lampreys which are parasitic on other fishes. Instead of jaws the lamprey has a large sucker by which it attaches itself to the skin of another fish. Inside the sucker there is a rasping tongue armed with sharp teeth which the lamprey uses to scrape flesh off the host leaving an unpleasant but seldom fatal wound.

The second kind includes the sharks and rays which are almost entirely marine; few venture into estuaries or freshwater. The skeleton is formed of cartilage which is softer than bone; the gill slits are exposed and there is no air bladder, which means that these fishes must expend energy to stay off the bottom.

The third kind is the bony fishes in which, as the common name implies, the skeleton is composed of bone. The gill openings are covered by a bony flap, the operculum, and, in most forms, the lungs have become modified into a swim-bladder, filled with a mixture of nitrogen and oxygen gases, which regulate the buoyancy of the fish so that it can maintain its position at any depth without using energy.

The bony fishes are by far the most numerous vertebrates with more than 20 000 species, equal to all other vertebrates combined. The number of individual fishes in the sea is astronomical although man is threatening the existence of some of his favourite food species by overfishing, and pollution is a constant threat to all forms of marine life.

Bony fishes abound in freshwater including ponds. Some fishes can survive under extremely unfavourable foul-water conditions and others can breathe air and live for a while on land. Fishes exhibit a great range of jaw and mouth shapes and they exploit fully the abundant food that is to be found in most lakes, streams, and ponds. Algae and higher plants are eaten and mud is probed and sifted for its organic content. Plankton is filtered from the water by the gillrakers, straining devices that stop solid particles from passing over the delicate filaments of the gills. Some fishes feed on dead bodies while others perform an equally useful function by catching and eating fishes that are diseased, injured, or dying. Like other vertebrates, fishes have organs of sight, taste, smell, touch, and balance but, unlike terrestrial vertebrates, they also have a pressure-sensitive system called the lateral line which spreads over most of the body. This enables fishes to detect disturbances in the water and to determine what has caused them.

Fishes breed in a variety of ways. Many species lay large numbers of eggs attached to vegetation or stones, most of which are eaten by predators in the pond. Other fishes, such as the sticklebacks, build a nest and protect their eggs assiduously. Many cichlids, the southern-hemisphere counterparts of the true perches of the northern regions, hatch their eggs in their mouths and the young are taken into the mother's mouth for protection when danger threatens. A very interesting tropical group is the killifishes or cyprinodonts, some of which are adapted to live in small bodies of freshwater that dry up for part of the year. The female buries her eggs in the mud on the pond bottom before the dry season starts. When the water completely evaporates, all the fishes die but the eggs survive and hatch when the rains come. The youngsters grow quickly so that, within eight months, they are sexually mature and lay their eggs to ensure the next generation. Killifishes or 'annual fishes' live only for about nine months.

Sticklebacks GASTEROSTEIDAE

The Three-spined Stickleback, *Gasterosteus aculeatus*, is the 'tiddler' beloved of small children. It is the second smallest British fish, up to 7·5 centimetres (3 inches) long, and is ubiquitous, living in ditches and ponds as well as in the shallow inshore parts of lakes and slow-running rivers. Out of the breeding season, both sexes look alike and are brownish or greenish above with silvery sides and belly (1). With practice, the sexes can be distinguished because the male has a larger head. The three dorsal spines give the fish its common name and there is also a pair of pelvic spines.

In winter, the fishes move about in shoals containing both sexes but, when spring arrives, the mature males leave the shoal and each selects and defends a territory. The male gradually assumes his breeding colours which make him one of the most attractive of small fishes. The brilliant blue eye, red underparts, red lining to the mouth, and the translucent silvery scales on the back are very different from the winter coloration (2).

The male prepares a nest, first by sucking up sand or mud and depositing it at a distance. In the depression he creates, the male glues down fragments of weed and algae with a mucus secreted by the kidneys. Having built a dome-shaped structure, the male forces his way through to ensure the female can penetrate the nest in due course (3). He attacks any coloured male entering his territory with great pugnacity. Thin females are ignored while fat females are courted even though the swollen condition is caused by parasitism and does not result from ripe ovaries. The red colour releases the urge to attack, and the male will assault any red-coloured object however unlike a fish it is (4). Similarly, a silver-coloured, pear-shaped object, known as a 'sex bomb' by behaviourists, will cause the fish to court just as vigorously as will a female full of eggs.

1

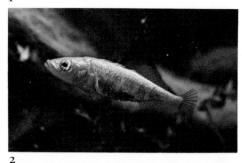

2

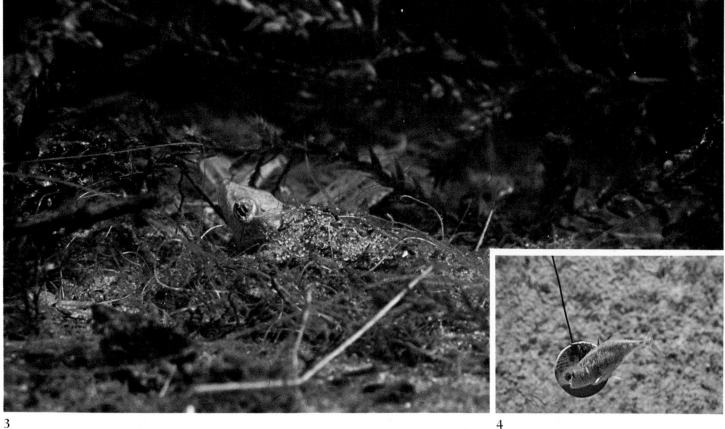

3

4

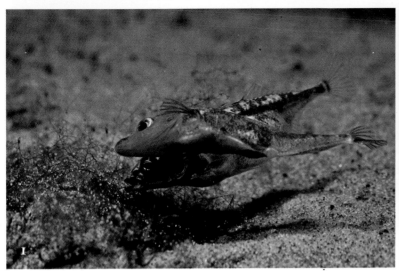
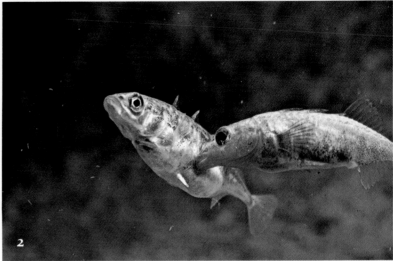

In courtship the male zig zags towards the female, then turns away. If the female is ready to spawn she remains in a 'head-up' position near the surface and turns to watch the male. The male repeats his approach and retreat until the female suddenly follows him down to the nest, where he points out the entrance with his snout while turning partly on his side with his back towards her (1). Sometimes a female is not quite ready to spawn, yet remains to be courted. Eventually, the male behaves as if he is very frustrated; he attacks her with open mouth, and nips her flank (2). If the female is satisfied with the nest, she will wriggle into the tunnel, and the male switches to a new kind of behaviour, putting his snout against her projecting tail and quivering violently (3). Gradually the female raises her tail, a sign that spawning is imminent. When the tail is raised high, between fifty and 100 eggs are extruded and the female quickly departs. At once, the male follows her through the nest and releases his sperm. He then chases the vastly deflated female out of his territory. Several females may spawn in one nest so that it becomes very full of eggs (4).

The care of the eggs and young is the male's responsibility. At frequent intervals he 'fans' the nest with his pectoral fins, pushing a current of water in through the entrance to improve the oxygen supply to the eggs (5). At first the eggs are almost clear; as the embryos develop the male adds sand to the top of the nest and fanning is intensified. After five days, the eyes, the beating heart, and the coiled tail can be seen through the egg membrane. On the ninth day the embryo is fully formed (6). The newly hatched stickle has a large yolk sac containing an oil droplet for buoyancy. Individual pigment cells can be seen clearly, especially on the head (7). The male teases the nest apart and the youngsters shelter within it and are guarded by the male which chases away intruders. Harmless animals, such as caddis larvae, are picked up by the male and dropped at a distance. Any baby that strays from the group is sucked into the father's mouth and spat back into the pack.

When the yolk sac has been absorbed each stickle makes an individual dash for the surface to gulp air and charge the swim bladder. The male tries, usually in vain, to intercept them. Gradually the father begins to lose his bright colours and his protective instincts wane. Ten days after hatching, the young begin to disperse and the male no longer attempts to retrieve them. At first, they feed on tiny particles; as they grow, waterfleas, mosquito larvae, worms, and any other live food of suitable size, including other young fishes, are eagerly eaten. In their turn sticklebacks are eaten by Perch and Pike, although the spines are a good defence against Pike until they reach more than a kilogram (2·2 pounds) in weight.

The Three-spined Stickleback is widely distributed throughout the northern hemisphere. In Europe it is found from the Mediterranean to the Arctic circle. It is distributed across northern Eurasia and in the countries bordering the North Pacific from the Bering Strait to Korea. It occurs in Canada and the United States.

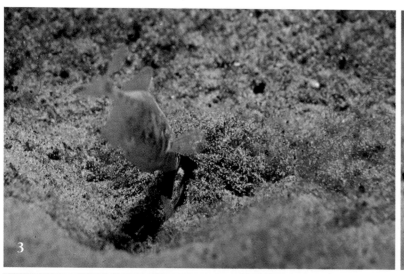

3

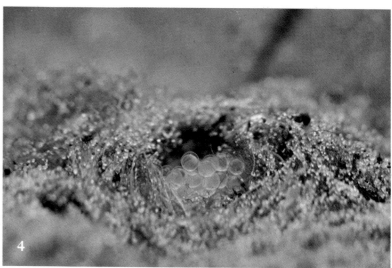

4

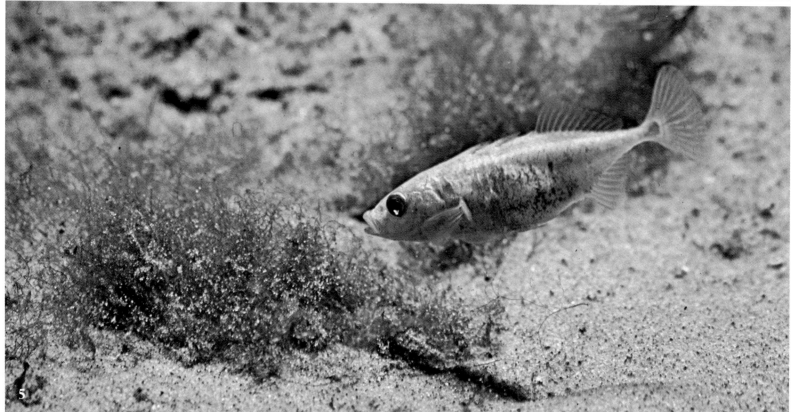

5

6

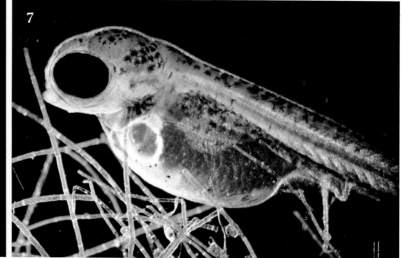

7

The Ten-spined Stickleback, *Pungitius pungitius*, is smaller than its three-spined relative at about 37 millimetres (1·5 inches) long and is less common. It is, however, equally gregarious and pugnacious. The breeding colour of the male is an intense bronze-black against which the white pelvic spines contrast vividly. The male courts the female by 'standing on his head' and erecting the white spines. In this position he swims jerkily towards his nest (1). The nest is an oval ball of algae and weed fastened to water plants near the pond bottom. There is a well-defined tunnel through the nest (2).

The behaviour patterns are similar to those of the Three-spined Stickleback. The female follows the male to the nest, is shown the entrance, enters, and is stimulated by the male quivering against the base of her tail. She then spawns and departs. The male fans the nest and guards the eggs and young until the stickles disperse at about ten days old.

In winter both species of stickleback may occur together. The Ten-spined has eight to eleven short spines (not necessarily ten!) as well as having a thinner base to the tail which is a useful distinction when the spines are collapsed. The Ten-spined Stickleback is widely distributed in the northern hemisphere from Britain, through Europe and Asia, and across North America.

I

2

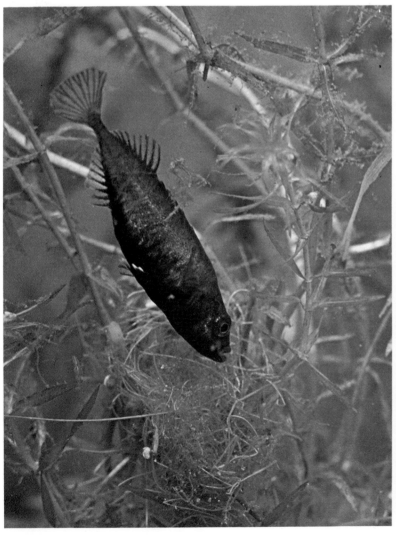

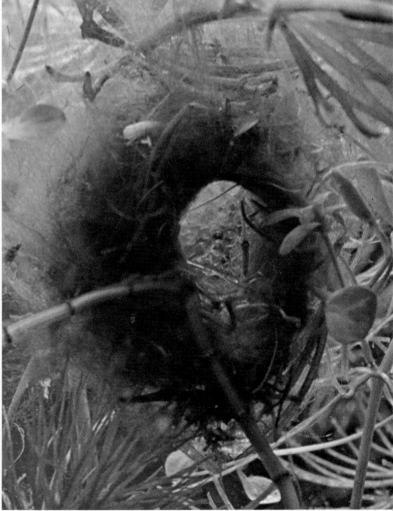

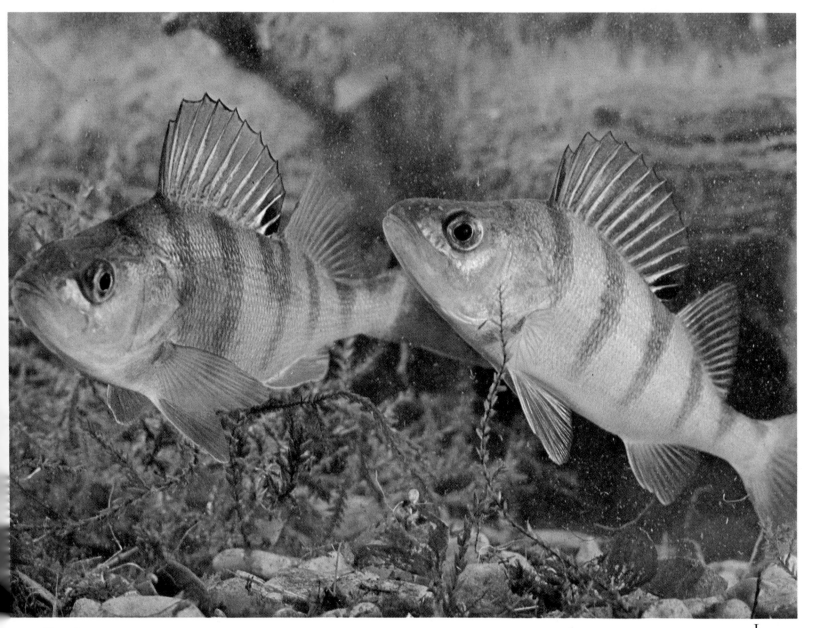

Perch PERCIDAE

The Perch, *Perca fluviatilis*, is a very distinctive fish with its relatively deep body and spiny dorsal fin that is quite separate from the second fin. If the fish is handled carelessly the dorsal fin can inflict a rather unpleasant wound. The body is olive green with a bronze sheen on the sides, and the dark vertical bars make the Perch immediately recognizable. There is a black spot at the end of the spiny dorsal fin (I). The Perch is a predator throughout its life feeding on insect larvae and crustaceans when it is young and on other fishes as it grows larger.

Perch spawn in late April and May, the eggs being laid in long threads that are wound in and out among weeds. In large lakes and slow-flowing rivers Perch can exceed 2 kilograms (4·4 pounds) in weight. It can survive in quite small ponds but then the competition for limited food keeps the fish stunted. It is a popular angling fish and in Europe is commercially important as a food fish.

The Perch occurs across Europe and Russia to Siberia. It has been introduced to Australia, New Zealand, and South Africa for its sporting qualities and palatability.

In Canada and the United States there is a closely related perch, *Perca flavescens*, known as the Yellow Perch, and sometimes treated as a subspecies of *P. fluviatilis* from which it cannot be distinguished externally. Its biology is virtually identical to that of *P. fluviatilis*.

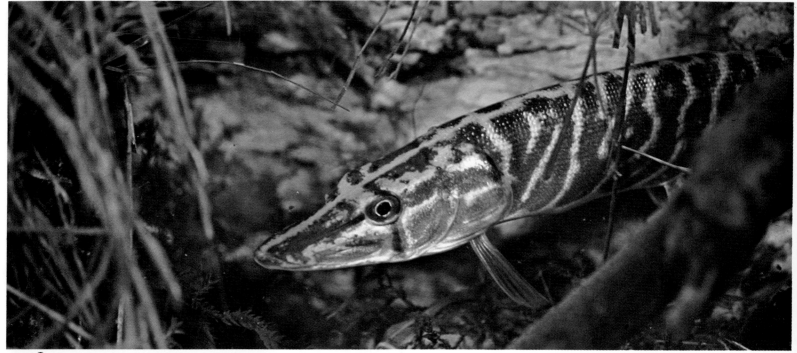

Pikes ESOCIDAE

The pike family is small containing only one genus, *Esox*, and five species, the pikes. In Britain, *E. lucius* is the only species and is known simply as the Pike. In North America, with four species, where pike attain their greatest abundance, *E. lucius* is called the Northern Pike or Great Northern Pike to distinguish it from the Muskellunge, the largest pike of all, and from the Redfin and Chain Pickerels, which are smaller.

The Pike is a fish of quiet rivers, shallow lakes, and large ponds. When hungry it lurks in concealment among reeds and other water plants where its barred and mottled coloration makes it blend invisibly into its surroundings (1). All pike are exclusively predators, feeding at first on insect larvae, crustaceans, and worms and graduating to fishes and amphibians. Large Pike will take water birds and aquatic mammals. The Pike is also an eager cannibal; we once caught a 10·3-kilogram (23-pound) Pike which contained in its stomach, not only the remains of a 45-centimetre (18-inch) long Pike but two linen bags inscribed 'Wiltshire sausages'.

The Pike is the fishy equivalent of the Lion – a predator designed for fast movement over a short distance and not for a long pursuit. It hunts by sight and relies on an element of surprise – a sudden dash from concealment and the prey is either caught or escapes – the Pike does not pursue it. The long, streamlined shape with the dorsal and anal fins set far back near the powerful tail enables the Pike to accelerate rapidly. Fishes are usually grasped crossways and then turned and swallowed head first. The Pike's mouth is armed with many very sharp teeth, some recurved to direct the prey down the throat. Large Pike are far less active; they use their sense of smell to find dead fishes, and anglers use herrings or mackerel fished on the bottom to catch them.

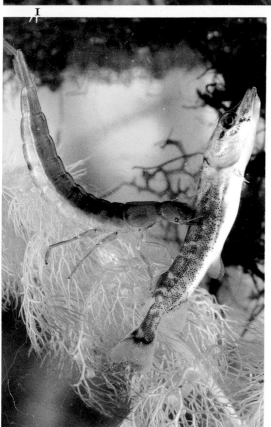

Pike spawn in shallow water in the spring. The females are always larger than the males and, at this time of year, a female will be accompanied by as many as five males. She sheds thousands of eggs among the waterweeds. Baby Pike stay in the shallows where they fall victim to other pond predators. The photograph (2) shows a 3-centimetre (1·2-inch) pikelet that has been caught by a larva of the Great Diving Beetle.

There is a close relationship between the volume of water, the quality of the food, and the ultimate size of the Pike. The largest Pike are found in big lochs and lakes where the fish's weight can approach 23 kilograms (50 pounds). In large

rivers a weight of 12 kilograms (27 pounds) would be exceptional, and, in ponds, 2 kilograms (4·4 pounds) is unlikely to be exceeded.

The Pike is circumpolar in its distribution. It is found across Europe, throughout Russia, Alaska, Canada, and the northern part of the United States.

Finally, a plea on behalf of the Pike. Because it is a predator there are those who will kill it on sight in the mistaken view that this will benefit the fish species on which it feeds. But the Pike tends to catch the diseased and dying, the less alert, and generally inferior fish so that it helps to keep the stock healthy. The removal of Pike will allow the population of prey species to increase, although their size will be less, but ultimately starvation or disease will almost certainly cause the numbers to drop. Predators perform just as vital a service to the community in water as they do on land.

Carps CYPRINIDAE

The Common Carp, *Cyprinus carpio*, is a deep-bodied fish with a large protrusible mouth, sensory barbels, and a long dorsal fin (1). It thrives in ponds and lakes especially where the water is warm and densely weedy. Carp are very resistant to low concentrations of oxygen and can survive where other fishes would die. When they are young they eat small crustaceans and insect larvae; as larger fishes, they eat molluscs, larvae, and larger crustaceans and, in summer especially, they eat a lot of aquatic vegetation. They breed in summer at temperatures around 23 to 24 °C (73·4 to 75·2 °F), and the eggs are laid among vegetation in shallow water with much splashing and rolling. Some parts of Britain are too cool for successful reproduction; elsewhere success may be intermittent according to the warmth of the summer.

Carp are relatively long-lived fishes (up to fifty years in captivity) and, given enough space and food, they normally exceed 10 kilograms (22 pounds) in weight and can attain 20 kilograms (44 pounds). It is a valuable food fish and is widely farmed for this purpose in eastern Europe and Asia because, with its rapid growth, it is possible to produce large amounts of fish per hectare. Because of its importance as a food fish and, because it is highly regarded as an angler's fish, the Carp has been distributed widely by man around the world. Its original home was in the rivers of the Black Sea basin. It is now found across Europe, North America, South America, parts of Asia, Africa, Australia, and New Zealand.

Newts, frogs, toads
AMPHIBIA

Amphibians are vertebrates with a soft, permeable skin through which oxygen passes into the body and carbon dioxide is expelled. The skin must be moist if it is to function properly and amphibians are found either living in freshwater or in damp, humid places. The skin is provided with mucus glands that help to keep it moist. Some amphibians also have lungs as an additional aid to respiration. The life cycle includes an egg, which has no shell, from which an aquatic larva hatches. The larva possesses external gills that project just behind the head and through which there is an exchange of gases between the blood and the water. The transition from larva to adult involves a considerable change of form.

The eggs and early stages of amphibians are easy prey for a variety of pond predators. Tadpoles are easily captured and are eaten by dragonfly nymphs, large bugs such as the Giant Water Bug, the larvae and adults of certain predatory water beetles such as *Dytiscus* spp, and by some fishes. Adult amphibians, especially frogs, are eaten by Pike and other predatory fishes, by birds such as herons, and by reptiles such as the Grass Snake, *Natrix natrix*, in Britain and by various water snakes in the United States. In the United States, the Alligator Snapping Turtle, *Macroclemys temminki*, also feeds on frogs.

The amphibians are divided into three groups that differ in body form and habits. Two of them, the Anura and the Urodela, are closely associated with ponds. The Anura comprises the frogs and toads; the adults have short bodies without tails and the hind limbs are long and powerful. The Urodela comprises the newts and salamanders; they have long bodies and short limbs and they retain the tails which are present in all larval amphibians.

Salamanders and newts
URODELA

There are no salamanders in Britain. Europe has five species and North America has many more of which the Spotted Salamander, *Ambystoma maculatum*, is shown in the photograph (1). Salamanders slide through the fingers when handled because the skin is smooth and slimy. They are secretive, remaining buried in the soil or under stones or logs, only coming out at night in wet weather to feed on worms and other invertebrates. During the breeding season Spotted Salamanders may make mass migrations to lay their eggs in woodland ponds.

The term, newt, is best restricted to those salamanders that enter water to breed and in which the males have an elaborate breeding dress and courtship, that is, members of the genus *Triturus*. The newts are not so slippery to handle; their skins are rougher and are not slimy. During most of the year newts, like the salamanders, live on land and are rarely seen, hiding away during the day and feeding at night on insects, worms, molluscs, and crustaceans. In winter they hibernate in cracks in the ground or under rocks or the loose bark of dead trees.

SALAMANDRIDAE
The Great or Warty Crested Newt, *Triturus cristatus*, is a large, dark, coarse-skinned newt up to 15 centimetres (6 inches) long which is typically brownish or greyish above with darker spots. The lower surface is strikingly marked with a bold pattern of orange and the skin is covered with small tubercles that secrete a distasteful substance, hence, presumably, the warning coloration on the belly. In spring the male develops a high, spiky crest, indented at the base of the tail (2). The two sexes enter the water in ponds which may be very small, sometimes only 2 or 3 metres (6·5 to 10 feet) across and 12 centimetres (5 inches) deep. It is in the breeding season that newts are most likely to be found.

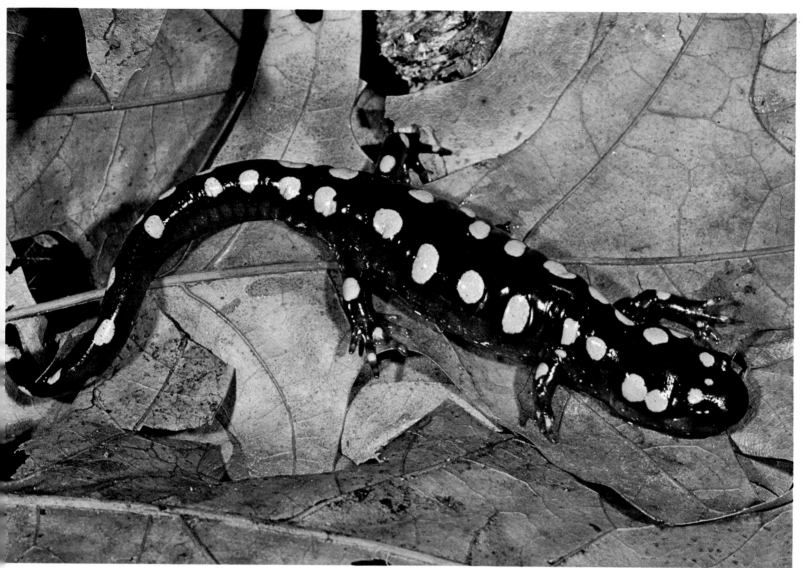

1

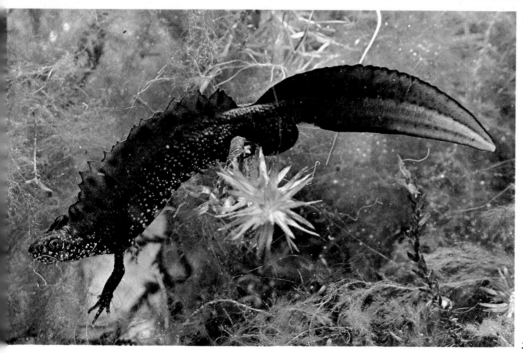

2

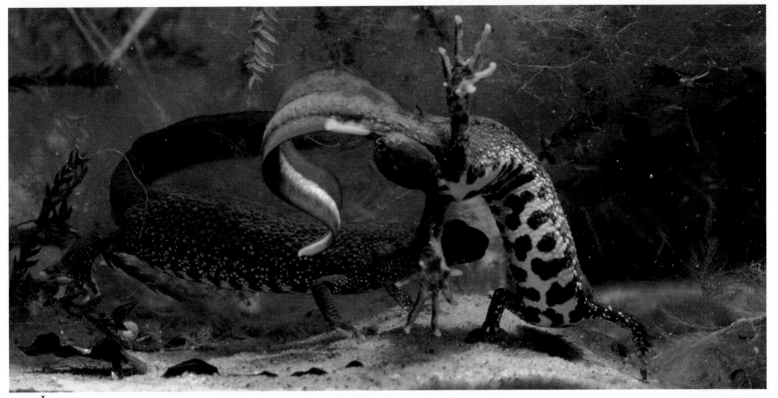

1

2

3

Newts have an elaborate aquatic courtship in which the female plays a passive role. The male parades in front of his mate, facing her with his tail curled round so that the tip is towards her (1). He releases a scent which he wafts towards the female by vibrating his tail tip, while intermittently lashing his whole tail towards her. Finally, the female responds by following him, whereupon he deposits a white packet of sperm, called a spermatophore, on the bottom of the pond. As the male moves away the female walks over the spermatophore and picks it up in her vent where the contents are released to fertilize her eggs.

The eggs are laid singly on aquatic plants by the female using her hind legs to fold a leaf and lay her egg within its shelter (2). The period of egg laying may be fairly extensive and, when it is over, the adults leave the water. The eggs hatch in about a fortnight into delicate newtpoles which have three pairs of external, feathery gills on the side of the head (3). The front pair of legs appears first (cf frog tadpole) and the hind legs later. By the end of four months the external gills have been absorbed and the young newts are breathing atmospheric air. Most of them now leave the water and become terrestrial although a few may continue to be aquatic until the following year.

The Great Crested Newt is widespread across Europe into central Asia. Other species of newts occur in Britain (the Smooth and the Palmate Newt), in Europe (eight species), North Africa, Asia, and North America from Alaska down to California. The American newts of the genus *Notophthalmus* spend more time in water than their European counterparts do.

Frogs and toads
ANURA

Frogs and toads are the most widely distributed of all the amphibians. Collectively, they range from beyond the Arctic Circle, through all the continents, to the southern tips of Africa, Australia, South America, and into many islands including New Zealand. There are about 4000 known species. Although the typical frog, genus *Rana*, is easily distinguished by its smooth skin and long jumping legs from the typical toad, genus *Bufo*, which has a warty skin and short legs for hopping, other genera exhibit many variations and no hard and fast distinction can be made between the frog and the toad.

True frogs RANIDAE

The Common Frog, *Rana temporaria*, (1) is the most widespread brown frog in Europe and, in many areas, it is the commonest species. It is the only native frog in Britain although the Edible Frog, *R. esculenta*, (1 overleaf) and, more recently, the Marsh Frog, *R. ridibunda*, have been introduced.

The Common Frog lives in damp grass and vegetation near freshwater because, like all amphibians, it requires a damp environment. Individuals vary greatly in colour; they may be brown, yellow, red, or grey – patterned with black, red, or brown. There is no constant difference in colour between the two sexes except in the breeding season when the females become suffused with red on the chest and belly (2 overleaf). The female is about 9 centimetres (3·5 inches) long and the male is about 1·5 centimetres (0·6 inch) shorter.

In spring the mature frogs make their way to ponds, often returning to the water where they developed as youngsters and showing great determination to negotiate any barriers erected since that time. The males usually arrive first and,

I

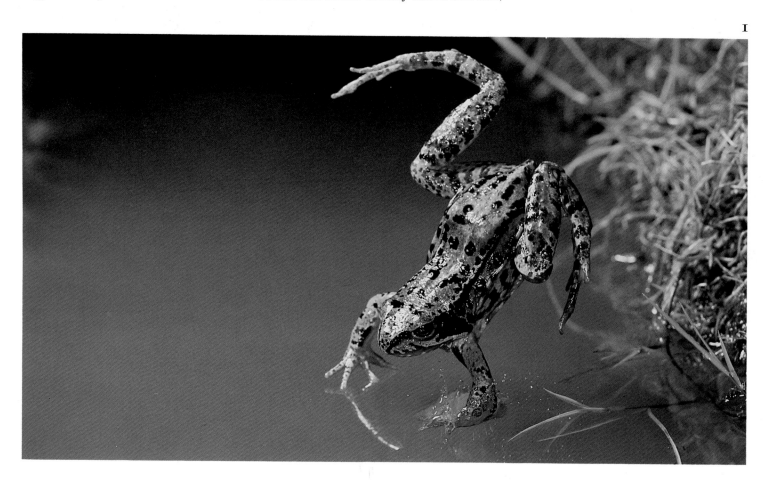

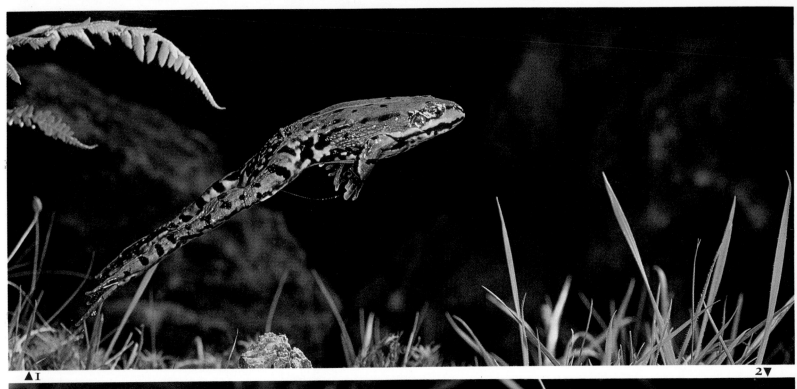

▲1

2▼

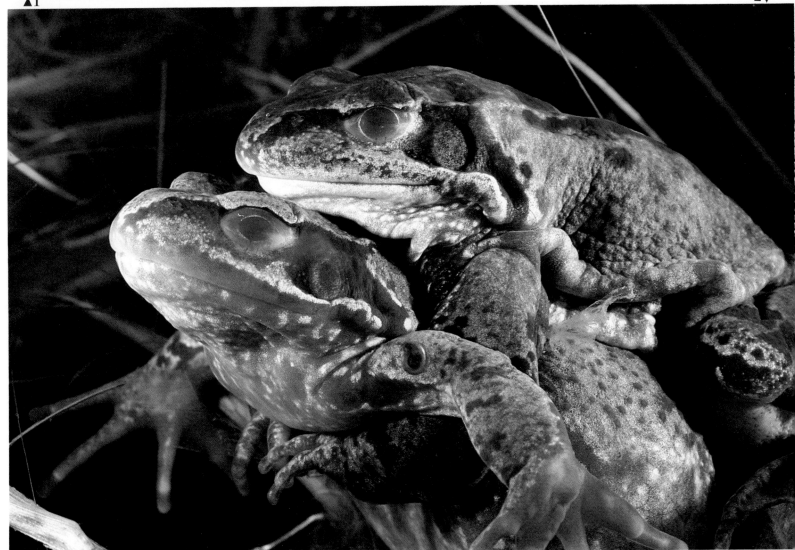

by inflating their throats, croak loudly to attract the females. When the females join the males in the water, no time is lost in pairing. Unlike newts, frogs have no courtship behaviour; the male climbs on the female's back and clasps her tightly under the fore legs (2) so that his hands interlock across her chest. During the breeding season the male develops a thick black pad covered with spines on each thumb to help him grip his mate's slippery body. This piggy-back embrace lasts for hours or even days until the female sheds her eggs which can number up to 3000. At the same time as the female spawns, the male sheds his sperm and fertilizes the eggs. The frogs then separate, and the shrunken female departs.

3

The eggs are enclosed in protective jelly and, although at first they sink to the bottom of the pond, the jelly gradually absorbs water, swells, and floats to the surface to form the familiar frog spawn (3). Meanwhile, the eggs that have been fertilized (4 overleaf), normally the majority, begin to develop within two or three hours of being laid. The first cleavage divides the egg into two cells (5): 30 to 40 minutes later the second cleavage produces four cells (6). After a similar interval, the third cleavage produces eight cells (7), and the fourth cleavage sixteen cells (8). With repeated cleavages the original mass of the egg is partitioned into smaller and smaller units because there has not yet been any growth of the developing organism. By the end of the cleavage stage of development, the original fertilized egg has become transformed into thousands of minute cells (9), each with its own nucleus, from which the embryo will be constructed.

The next stage of development of the embryo is the process of gastrulation which involves the migration of cells in preparation for the construction of the various tissues and organs of the future tadpole (10).

The final stage is called differentiation and involves the conversion of unspecialized cells into all the specific kinds of cell needed in the frog. By the time the tadpoles hatch just two weeks after the spawn was laid, the differentiation of the cells is complete and the future changes in size and shape will be the result of growth and absorption.

The newly hatched tadpoles have external gills behind the head (11). At this stage, they are vegetarian, feeding on algae. Within a month the gills have become covered by a flap of skin (12). By the seventh or eighth week the hind legs are fully developed (13) and the tadpole has functional lungs so that it must visit the surface for air. The diet becomes omnivorous and corpses of other inhabitants of the pond, as well as smaller tadpoles, are attacked with the rasping mouthparts. After three months the tadpole has transformed into a froglet with a tail (14). The tail is gradually absorbed and, by midsummer, the miniature frog, 1·25 centimetres (0·5 inch) long, is ready to leave the pond (15). The mortality rate of tadpoles is heavy because they are caught and eaten by various insects, *Dytiscus* larvae and adults, *Aeshna* dragonfly nymphs, *Ranatra* bugs, as well as by newts, fishes, and birds. Nevertheless, thousands of small frogs may be found dispersing over the surrounding countryside where their natural enemies again take a toll. Those that survive take three years to become mature before they return to water to breed. Adult frogs also have their enemies, such as the Heron, *Ardea cinerea*, and Pike in water or the Grass Snake, *Natrix natrix*, Brown Rat, *Rattus norvegicus*, Otter, *Lutra lutra*, and Hedgehog, *Erinaceus europaeus*, on land.

Frogs eat insects, slugs, worms, and snails. The fingers of the fore legs are used to scrape off any dirt, and the small, sharp teeth give a grip on slippery food. The tongue is attached at the front of the mouth and is moist so that, when it is flicked out, the prey sticks to it.

The Ranidae or true frogs occur in all continents except Antarctica. The big genus *Rana*, with 250 species, is represented by ten species in Europe and by fifteen species in North America.

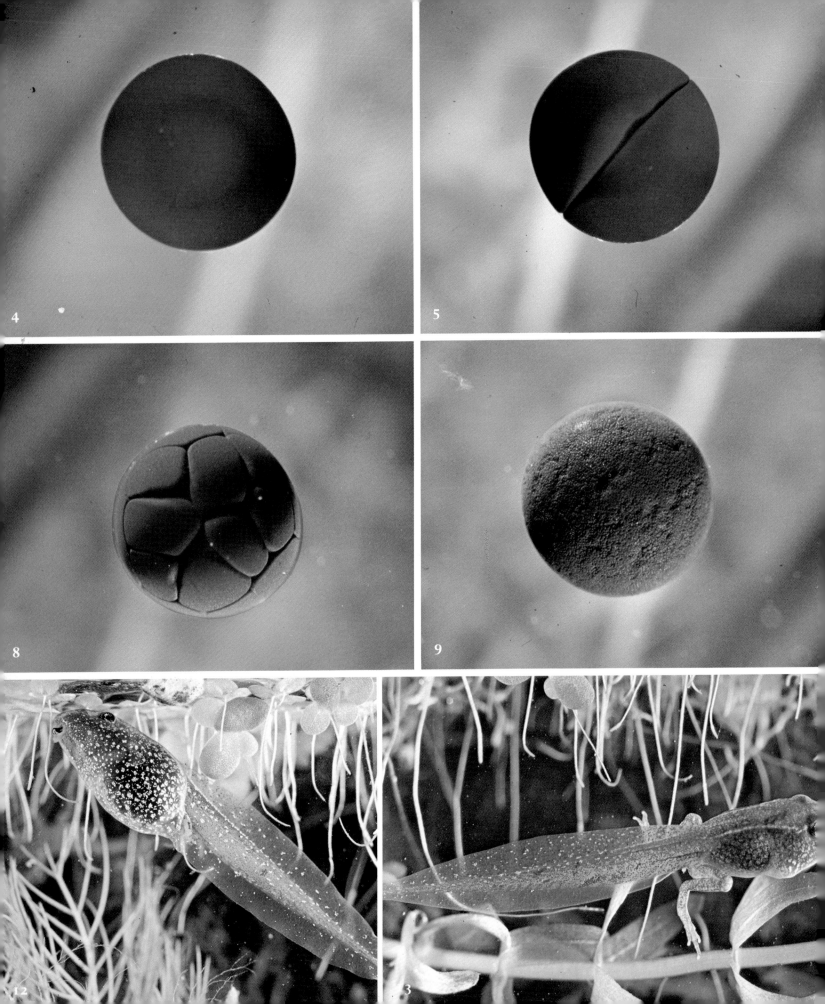

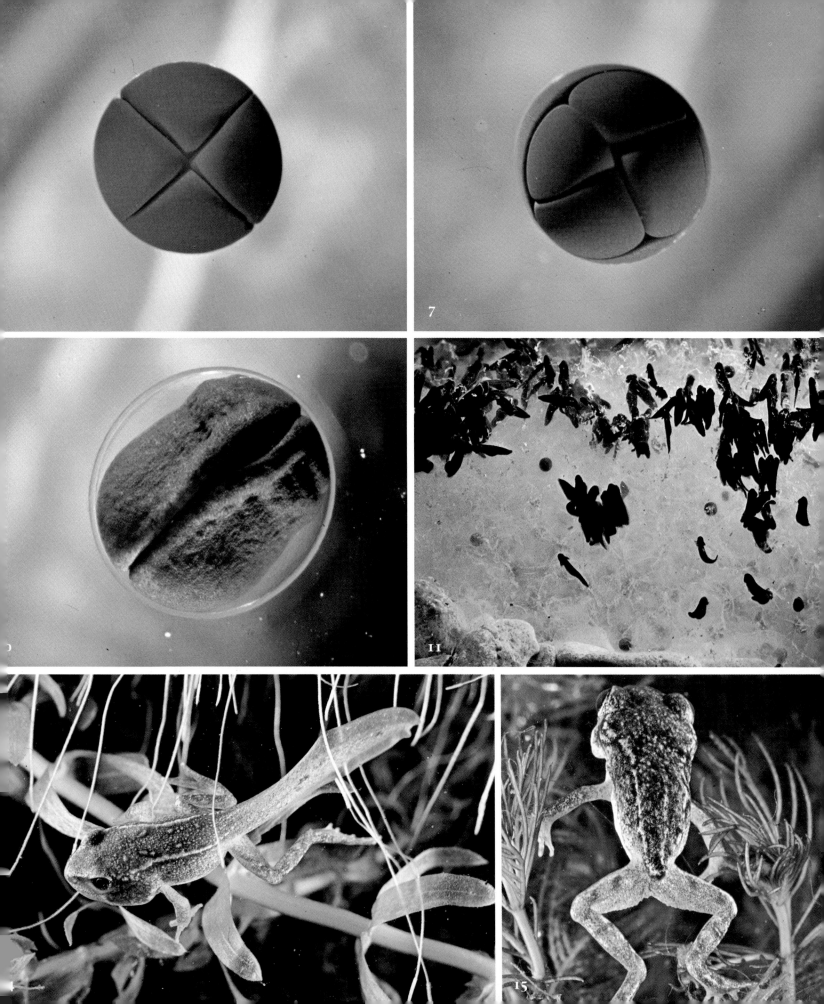

The Bull Frog, *Rana castesbiana*, (**1**) is the largest North American frog with a 20-centimetre (8-inch) body and 25-centimetre (10-inch) hind legs. It eats any animal that its capacious mouth can engulf, including other frogs and even small birds and mammals. It can leap about nine times its own length but the champion jumper is an African frog that leaps forty-five times its own length! Like all amphibians the skin of the frog gives no protection against excessive drying and the animal must live in damp environments when it is out of water. A Bull Frog has been known to live for fifteen years.

Tree frogs HYLIDAE

The Common Tree Frog, *Hyla arborea*, (**2**) of Europe belongs to a large family of frogs, the Hylidae, with about 450 species including representatives on all continents except Antarctica. They are slim-waisted, usually long-limbed frogs, mostly of small size, and the females are much larger than the males.

Tree Frog adults are up to 5 centimetres (2 inches) long and are usually a bright, uniform green in colour although they can change quite quickly and can vary from yellow to a blotchy brown. At the tips of their toes they have disc-like adhesive pads which enable them to climb with ease so that they are often found far above the ground, usually in fairly dense vegetation. The Tree Frog is mainly active at night when it feeds on insects and other small invertebrates. Breeding also takes place at night in ponds. The males develop small nuptial pads on the thumbs and they embrace the females just behind the fore legs. As many as 1000

pale eggs are laid in a floating clump about the size of a walnut. The tadpoles are rapid swimmers and have a deep tail fin extending far forwards on to the back. Unlike most tadpoles, they tend to live a solitary life.

Toads BUFONIDAE

The Common Toad, *Bufo bufo*, is one of the most ubiquitous European amphibians and it is found in a wide variety of often fairly dry habitats. Its body length is about 15 centimetres (6 inches). Like all toads, it is mainly nocturnal, hiding away during the day, usually in a favourite retreat, and emerging at night. When rain falls after a spell of dry weather, Toads may be active during the day. The Toad normally walks about slowly but, when it is alarmed, it moves faster by hopping. When a Toad feels itself threatened by the approach of a larger animal, it swells up to increase its size and adopts a posture with the head down and the hind quarters raised in the air. Scattered over the body there are poison-secreting glands, and the paratoid gland situated on the side of the neck is an aggregation of these glands. The thick, white secretion is acrid and unpleasant to the taste. If a dog seizes a Toad it quickly drops it and foams at the mouth, obviously in discomfort, but no cases are known of a predator dying. There are certain enemies against which the secretion affords the Toad no protection; Crows and Magpies have been seen to disembowel Toads and leave the rest of the carcass uneaten while a rat was observed to remove the skin to get at the flesh. It is wise to wash your hands after handling a Toad and to avoid touching the mouth or eyes.

Toads have a voracious appetite and will eat any suitably sized animal, including young snakes and small mice. Only moving prey is taken; a fly that is motionless will be ignored but, if it begins to clean itself, it will be snapped up by the Toad's forwardly fixed tongue which, in the photograph, is about to be rolled out (1). When food is taken into the mouth it is squashed between the tongue and the eyes which are withdrawn into the head to help push the food down the throat.

Toads spawn at greater depths than Frogs and, although both amphibians may use the same pond, the Frogs stay in the shallows while the Toads keep to the deeper water. Some Toads form pairs when they meet on the way to the pond; others pair in the water. The male Toad has shorter fore limbs than a Frog and his embrace does not extend as far round the body. His grip is extremely strong, however, and he is difficult to dislodge although other males will try to do so and are kicked for their trouble. Several males may manage to cling to a female and she may even be killed as a result. Here two males grapple with a female (3).

The eggs are laid in a long string attached to water weeds (2). The string may measure up to 3 metres (10 feet) in length and contain between 300 and 7000 black eggs which are from 1·5 to 2 millimetres in diameter. The Toad tadpole is similar in appearance to that of the Frog but it is darker on the dorsal surface, being black or blackish brown compared with the dark-brown Frog tadpole. When the young leave the pond in midsummer, they are blacker than their parents, their skin is smoother, and the warts are less well developed. It takes four years for a Toad to become sexually mature and it may live for many years after that. Winter is passed in hibernation, either singly or in a large group.

The genus *Bufo*, with more than 100 species, has representatives in most parts of the world except Madagascar, Australasia, and the Pacific islands.

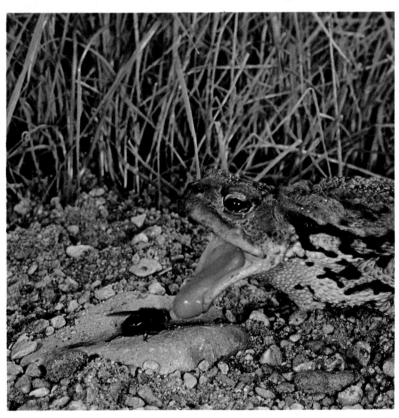

1

2

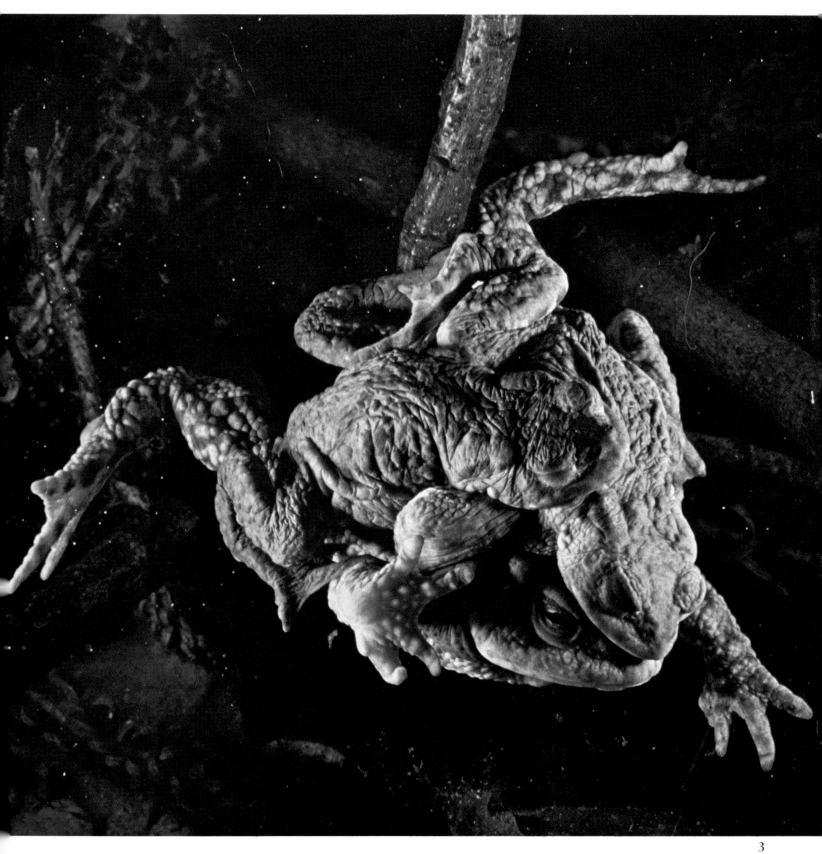

Turtles, snakes, alligators
REPTILIA

The reptiles are cold-blooded vertebrates that breathe by means of lungs and have a dry, scaly skin. The skin is composed of several layers of cells which are impregnated with a protein called keratin that is impervious to water. As a result, the loss of water through the skin of a reptile is insignificant compared with the loss through the skin of an amphibian. Reptiles also conserve water by excreting uric acid which is almost insoluble. Thus, they are able to live quite independently of water although many species are aquatic and some spend much or most of their lives in freshwater ponds.

Most reptiles lay shelled eggs which they usually bury in damp, warm earth or among rotting vegetation. Some snakes and lizards are ovoviviparous, that is, the eggs hatch inside the mother's body and the young are born alive. The reptile egg is large because it contains a lot of food and the chalky or leathery shell prevents loss of water. The abundance of food enables the embryo to grow to an advanced stage so that it hatches as a miniature copy of the adult. Therefore, there is no need for the metamorphosis that amphibians must undergo, and the young reptile can immediately adopt the same way of life as its parents.

Reptiles use the sun's heat to raise their body temperature and, in the mornings and evenings, they bask, presenting the largest possible area of their bodies' surface to the sun's rays. In the heat of the day the animals avoid overheating by seeking shade or immersing themselves in water. It is not surprising that most reptiles are found in the tropics and that there are fewer in temperate regions.

The three groups of reptiles found in ponds are the turtles, Chelonia, the snakes, Squamata, and the crocodiles and alligators, Crocodylia.

Tortoises, terrapins, sea turtles
CHELONIA

The 300 or so species in this group possess a bony shell that encloses the body and is covered by horny plates or, less commonly, by a tough skin. In Britain tortoise is the term used for the strictly terrestrial species, terrapin, for the semiaquatic ones, and turtle for the marine species. In the United States the word turtle includes the terrapins. The only group to be found in ponds is the terrapins but there are none in Britain and only two species in Europe. About eighty species occur in the warmer parts of the world, excluding Australia, Madagascar, and most of Africa.

TESTUDINIDAE

The Red-bellied Turtle, *Chrysemys rubriventris*, is one of more than fifty species of terrapin found in North America. It is a reptile of ponds and lakes as well as of rivers, and it is mainly vegetarian. Unlike some terrapins, it spends much time basking in the sun on logs or rocks. It grows to a length of 25 to 40 centimetres (10 to 16 inches). The photograph (1) shows two very young individuals.

The Alligator Snapping Turtle, *Macroclemys temmincki* (2), is one of the largest freshwater reptiles in the world, reaching a weight in excess of 100 kilograms (222 pounds). The head is huge with strongly hooked beaks. The terrapin lies at the bottom of the pond with its mouth wide open to reveal a pink lure which resembles a worm and which is wriggled when a fish comes near. Any fish that enters the reptile's mouth to investigate the lure is caught.

The Alligator Snapping Turtle is found from Canada to South America. Unlike most terrapins, Snappers rarely bask. Underwater, they pose no threat to humans because they pull in the head when disturbed or stepped on – which can easily happen because the animal may bury itself in mud with only the eyes showing. Out of water a Snapper strikes repeatedly with great ferocity.

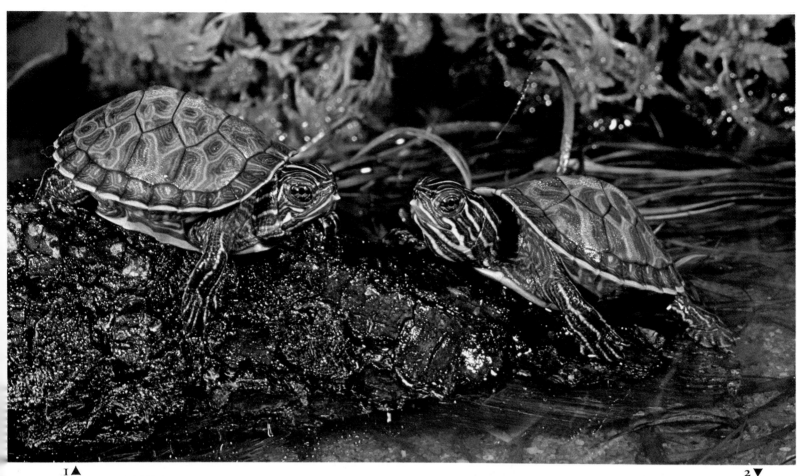

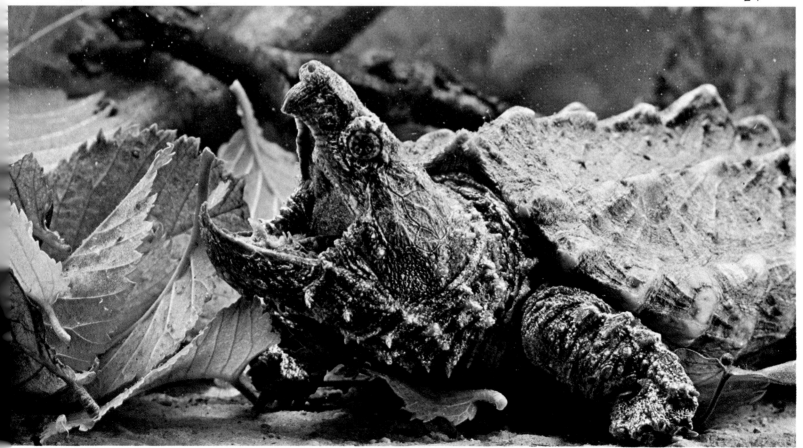

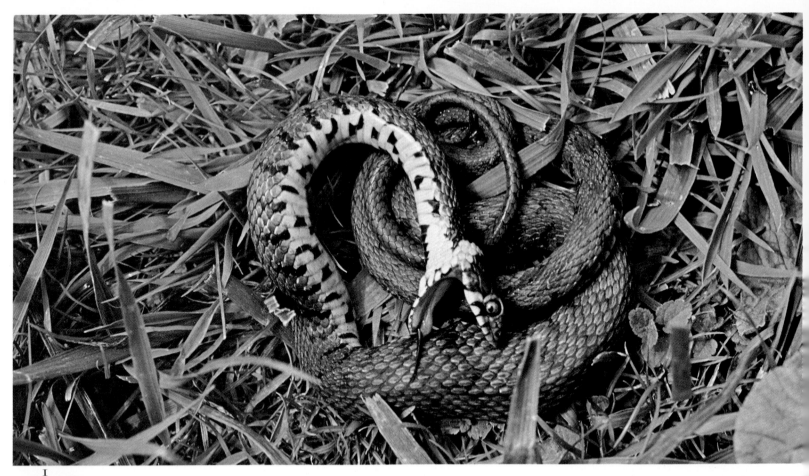

1

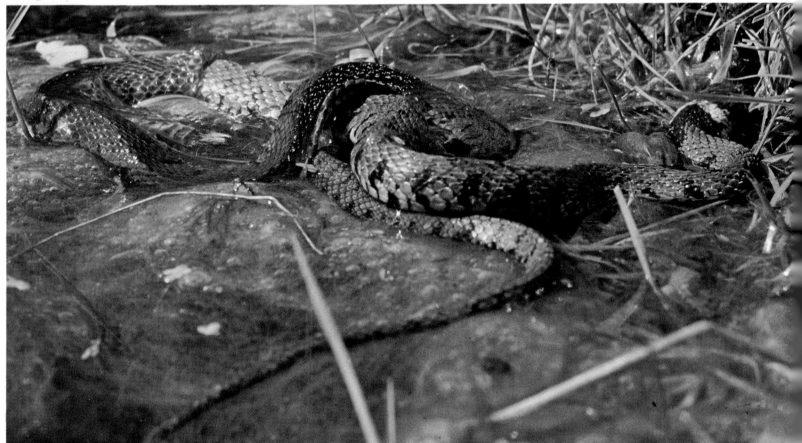

2

Snakes
SQUAMATA

COLUBRIDAE

The genus *Natrix* comprises harmless, semiaquatic snakes often found near freshwater ponds, particularly among marsh vegetation. They are sometimes seen basking on logs or branches from which they can drop into the water at the slightest alarm. They are adept at swimming and diving and obtain much of their food in or near the water.

The Grass Snake, *Natrix natrix*, of England and Wales extends across Europe into western Asia and is also found in North Africa. It can reach a length of 2 metres (6·6 feet). Frogs are the main diet but newts, fishes, and tadpoles are also taken. Some individuals will eat toads but most refuse them. Lizards and Slow-worms, *Anguis fragilis*, are sometimes eaten as well as young birds, mice, voles, and shrews.

When it is picked up, the snake often discharges an evil-smelling fluid from the anal glands but, if it is handled gently and often, a Grass Snake is usually quickly tamed. If it is disturbed, the snake may hiss and strike with a closed mouth, but only rarely does it bite. Occasionally, it feigns death, lying limp with mouth open and the tongue hanging out (1).

The Grass Snake mates in April and May and the thirty to forty eggs are laid in June and July in places where warmth is generated, such as in manure heaps, hayricks, or among decaying vegetation. The eggs hatch in six to ten weeks according to temperature. The baby snake has a well-developed egg tooth with which it tears a rent in the shell to permit escape; soon afterwards the tooth falls off. The young are said to eat slugs and worms, but they remain hidden and are rarely seen because at 16 to 19 centimetres (6·3 to 7·5 inches) in length they themselves may be mistaken for large worms by predators. The adult snakes are eaten by Hedgehogs and Badgers and by large birds of prey.

At intervals snakes moult. The photograph (2) shows a Grass Snake in the process of moulting while lying in shallow water at the edge of a pond. Before the moult, the snake becomes dull in colour and loses its appetite and, even a tame individual is likely to exhibit ill temper.

The American species in the genus *Natrix*, of which there are many, usually spend more time in the water than the Grass Snake does and are more deserving of the description water snake.

Aligators
CROCODYLIA

ALLIGATORIDAE

Most crocodilians are too large to be found in ponds, but the Spectacled Caiman, *Caiman crocodilus* (3), growing up to 2·6 metres (6·5 feet) in length, is an exception. The photograph is of a very young Caiman less than 30 centimetres (12 inches) long which was in a small pond in Venezuela.

The ground colour varies from greenish, yellowish, or brownish grey with dark-brown cross-bands. The best way to identify the reptile is to look for a curved bony ridge on top of the head in front of the eyes.

Spectacled Caimans are found from southern Mexico to northern Argentina but they are becoming rare as a result of being caught for sale in pet shops. This explains why the reptile is sometimes found in the wild in eastern and central North America, well outside its natural range. These specimens have either escaped or have been released.

3

Birds
AVES

Birds are warm-blooded vertebrates with a body covering of feathers. The fore limbs are modified into wings for flight although some birds, such as the Ostrich, *Struthio camelus*, and Emu, *Dromaius novaehollandiae*, have since abandoned flight, or the wings may serve as swimming paddles as in the case of penguins, Spheniscidae. To be able to fly, birds need to be compact and strong, and, above all, light in weight. Hollow bones reduce the weight of the skeleton and internal bony struts provide additional strength where necessary. Certain bones are fused together to reduce the weight of the supporting muscles and ligaments. The bones of the skull are reduced, teeth have disappeared, and the jaw has been greatly lightened. The weight of the body is located as closely as possible to the centre of gravity and this has been achieved by a shortening of the backbone.

A fast-moving animal needs to have very good vision, and the eyes of birds are large in proportion to their body size.

Ponds play an important part in the lives of many birds. Nearly all birds must visit freshwater regularly to drink and bathe. Some, either as herbivores or predators, obtain most of their food from ponds. Others depend on ponds for nesting sites. Reedbeds provide support for the delicate cup nests of some warblers and buntings while Coots and Moorhens build floating nests away from the pond margin to obtain protection from terrestrial predators.

Because birds are very mobile, they are thought to be important agents of distribution of both plant and animal life from one pond to another or from an established pond to a new body of freshwater. Mud adhering to the webbed feet of ducks or partially webbed feet of waders can carry seeds and fragments of vegetation, as well as microscopic animals, protozoan cysts, overwintering sponge gemmules, and the statoblasts of moss animals.

Ducks, geese, swans ANATIDAE

The Mute Swan, *Cygnus olor*, (1) is a large, pure-white bird with a long, slender neck that is carried in a graceful s-shaped curve when the swan is swimming, or stretched straight out in flight. The bird is about 1·5 metres (5 feet) long. The bill is yellow with a basal black knob that is larger in the male than in the female. Swans spend most of their time on water and feed on many kinds of aquatic vegetation which they reach by dipping the head and neck under water or by 'up-ending' like a duck. They also eat some animals including small frogs and toads, tadpoles, worms, insects and their larvae, molluscs, and, occasionally, small fishes.

Both sexes build the large nest; the male brings reeds and other vegetable matter to the female which arranges it to form a depression for the five to seven greenish-tinted eggs. The female incubates the eggs except when the male takes over so that she can feed. The eggs hatch after thirty-four to thirty-eight days and the juveniles are a dingy brown with grey bills. Pairs of semitame swans often breed on small ponds in city parks.

The natural range of the Mute Swan is Europe and Asia but it has been introduced into parks and gardens throughout the world including North America and Australia.

Rails and crakes RALLIDAE

The Moorhen, *Gallinula chloropus chloropus*, is characteristic of ponds, including small ones. Its only requirement is that there should be plenty of emergent vegetation for food and cover. The Moorhen is easily recognized by the brownish-black plumage with oblique white stripes on the flank, red frontal shield, red bill with yellow tip, and white under the tail (2). It is about 33 centimetres (13 inches) long. As it swims the head is pumped backwards and forwards in a comic manner. When it is nervous or excited the Moorhen flirts its cocked tail in a characteristic

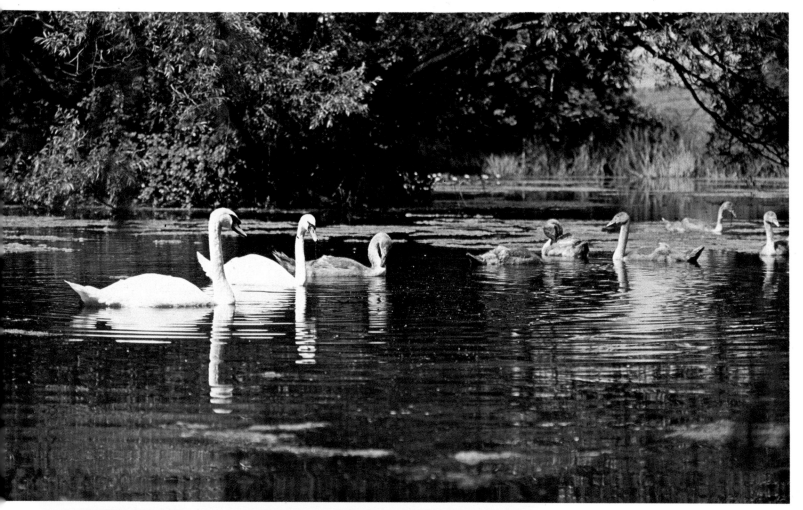

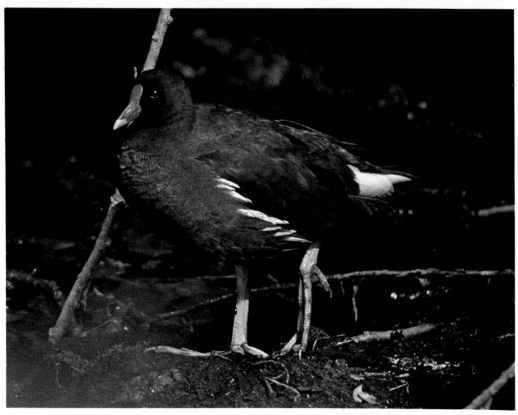

manner although this perky and busy bird is less shy and is easier to watch than related species. In town parks the Moorhen soon becomes indifferent to humans.

About three-quarters of the Moorhen's food is vegetable, the remainder consisting of various aquatic and terrestrial insects, worms, and aquatic snails.

The nest is a shallow saucer of reeds, flags, or sedge, which is semifloating or anchored to aquatic plants or to a fallen tree branch. The eggs, buff with brown spots, number from five to eleven and were once eaten by country people. Incubation lasts from nineteen to twenty-two days and the young remain in the nest for two or three days if they are not disturbed.

The Moorhen is an almost worldwide species, ranging across Europe and Asia to China and Japan, North and South America, and parts of Africa. It is replaced by allied species in tropical and southern Africa and by the Dusky Moorhen, *G. tenebrosa*, in Indonesia, New Guinea, and Australia.

The Coot, *Fulica atra atra* (**1**), is a larger, more thick-set bird than the Moorhen, with black plumage relieved only by a white frontal shield and bill. The Coot is about 38 centimetres (15 inches) long. It frequents large ponds and lakes, often in groups, and frequently in association with ducks from which the Coot may be distinguished by the rounded contour of the back. The bird feeds on the grassy edge beside the water but it is less at home on land than the Moorhen and keeps near its natural element. Coots are quarrelsome and aggressive and make a lot of noise.

When swimming the head is pumped forwards and backwards as it is by the Moorhen but it is less marked. The Coot feeds by diving to bring up waterweed which is eaten on the surface. About 85 per cent of the food is grass and waterweeds; the rest consists of fishes, molluscs, worms, insects, and, when available, the eggs of other birds such as the Great Crested Grebe, *Podiceps cristatus.* The nest is built of dead leaves to a height of 25 centimetres (10 inches) among reeds or other vegetation and contains six to nine eggs. The nest illustrated (**2**) is surrounded by Water Horsetail. The young leave the nest when they are three or four days old and are fed by the parents on the water. At night they return to the nest to be brooded. The young begin to dive and seek their own food after thirty days and are independent at about eight weeks.

The Coot is a Palaearctic, oriental, and Australian species. In southern Africa there is *F. cristata*, in North America, *F. americana*, and, in the West Indies and Venezuela, *F. caribaea*.

The Purple Gallinule, *Porphyrula martinica*, (**3**) is closely related to the Moorhen and Coot; it is a bird of large ponds and swamps and is very striking in appearance. It is about 48 centimetres (19 inches) long. Without doubt, it is one of the most beautiful of all waterbirds. The head and underparts are deep purple, the back is bronzy green, the massive bill is brilliant red tipped with yellow, the frontal shield on the forehead is pale blue, and the legs are yellow. The under tail coverts are white and show clearly when the bird flies with trailing legs. The Purple Gallinule swims less than the Moorhen and Coot; most of the time it walks about on water plants and climbs into shrubs. Its food consists of the leaves, flowers, and seeds of water plants with some insects, tadpoles, and molluscs. With the exception of a protective roof over the nest, the breeding behaviour closely resembles that of the Coot.

Porphyrula martinica occurs in the southern part of the United States, through Central America and the Caribbean, into most of South America to northern Chile, Argentina, and Uruguay. It also occurs in South Africa although a related species, *P. porphyrio* is more common. The latter is also found in southern Eurasia and in Australasia where *P. martinica* is absent.

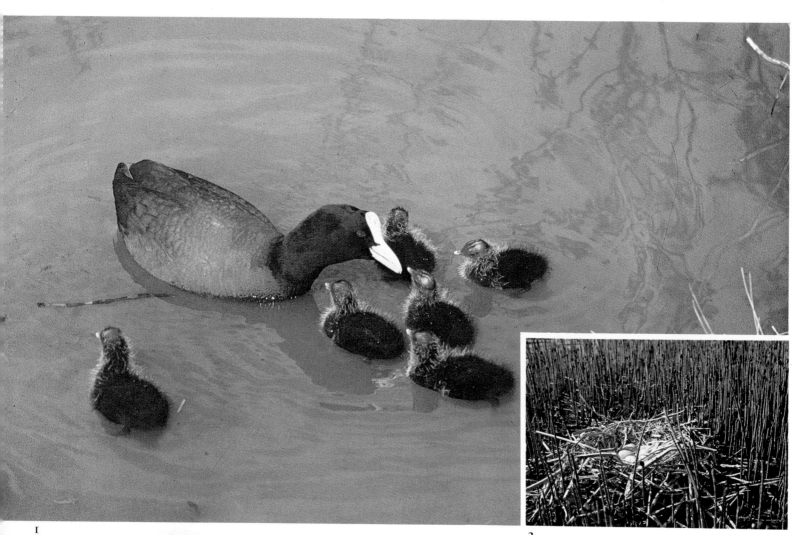

1

2

3

225

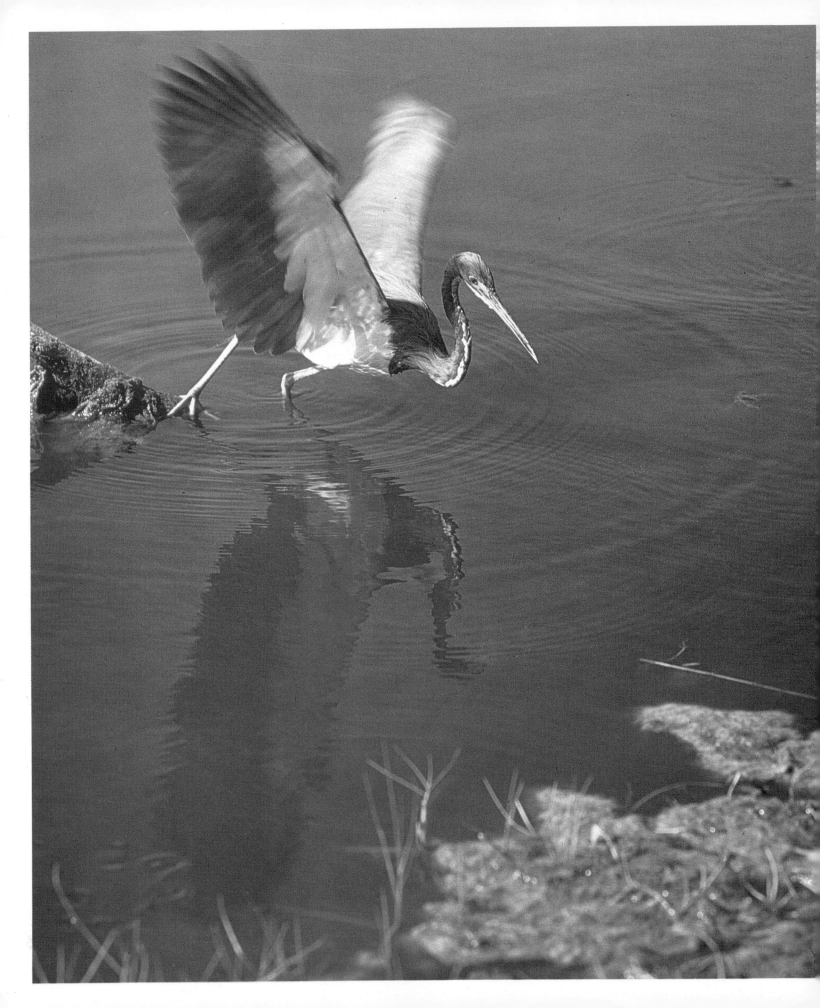

Herons etc ARDEIDAE

The Louisiana Heron, *Hydranassa tricolor ruficollis*, is an example of the heron family of which there are about 100 species in the world. It is a large bird at about 65 centimetres (26 inches) long. Most species use their long bills to stab at passing fishes, frogs, tadpoles, newts, crustaceans, molluscs, and insects. The heron does most of its fishing in the early morning and evening; it either walks slowly and noiselessly in shallow water in a semicrouching posture with the long neck coiled back ready to strike at prey, or it stands motionless waiting for a fish to pass within reach. Many a garden pond has been emptied of Goldfishes by a marauding heron in the early hours of a summer morning while the owners slept. In Britain, the Common Heron, *Ardea cinerea*, would be the guilty party; in Australia, the Pied Heron, *A. picata*, would be the likely culprit. Herons nest communally in trees that may be several kilometres from the nearest fishing ground.

Kingfishers ALCEDINIDAE

The kingfishers form a homogeneous group of about eighty species. They have in common a large head and eyes, rather stumpy body, short tail, short legs, and a large, sword-like bill. Kingfishers display a wide variety of dazzling plumages and, among the most brilliant, is the Common Kingfisher, *Alcedo atthis ispida*, of Europe which occurs throughout the Palaearctic region. It is 16·2 centimetres (6·4 inches) long. Many kingfishers eat insects and do not frequent water, but the genus *Alcedo*, which includes nine species of similar coloration, are fish eaters and catch their food by plunging into the water from an overhanging vantage point. Sometimes, the Kingfisher hovers above the surface before diving in to catch a small fish. The bird in the photograph has captured a male Three-spined Stickleback.

The flight of the Kingfisher is as characteristic as its plumage; the bird skims the water surface at high speed with rapidly whirring wings and has gone before it can be seen properly. Out of the breeding season, the Kingfisher is a solitary bird and, although rivers are the usual haunt, it may be seen at large ponds.

The existence of suitable nesting sites is critical for this species. The six or seven round white eggs are laid in a chamber excavated at the end of a horizontal tunnel made in a steep bank, usually bordering a slow-running river. Occasionally, in the absence of a preferred site, a sandpit or bank at some distance from water will be used.

In North America the Belted Kingfisher, *Ceryle alcyon*, is widespread and behaves like *Alcedo* spp. In Australia most kingfishers live in dry forests and feed on insects but some, like the Azure Kingfisher, *Alcyone azurea*, haunt streams and ponds, and fish by plunge-diving.

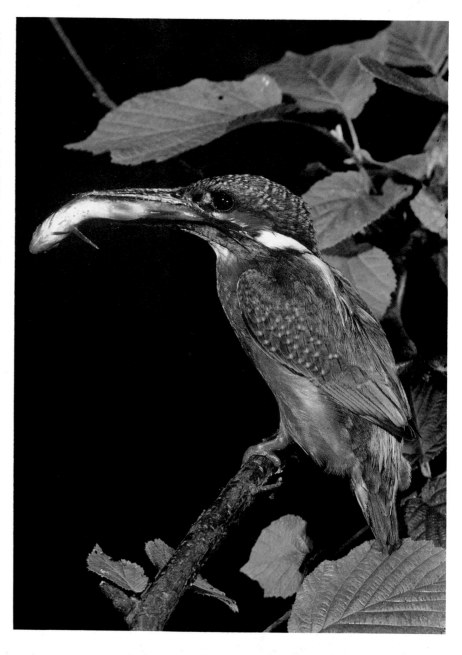

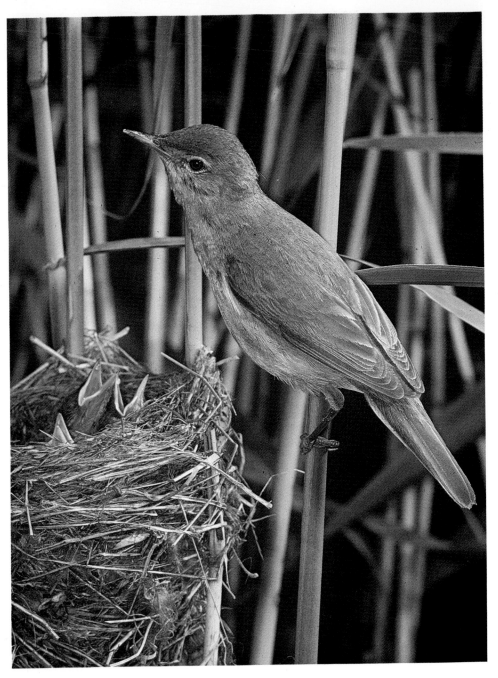

Warblers SILVIIDAE

Birds of the order Passeriformes are adapted for perching by having three toes in front and one at the rear. The order contains over half of all known birds. There are sixty-nine families altogether of which the warblers are second in size to the finches, buntings, and sparrows. Many passerines visit ponds regularly to drink but the Reed Warbler, *Acrocephalus scirpaceus scirpaceus*, is among the few that take up permanent residence and nest at ponds during the breeding season.

The cup-shaped nest is usually built among reeds. The young are fed on insects, many belonging to aquatic groups mentioned in this book (craneflies, midges, mosquitoes, reed beetles, dragonflies, damselflies, and so on). Terrestrial insects and their larvae are also eaten and all food is crushed into a pulp before it is fed to the young. The adults are also reported to eat slugs, snails, and worms. It is a small bird, only 12·5 centimetres (5 inches) long.

Although the warblers are mainly northern hemisphere birds of the Old World, a few species occur in Australia and the Clamourous Reed Warbler, *A. stentoreus australis*, fills a similar ecological niche to its northern cousin.

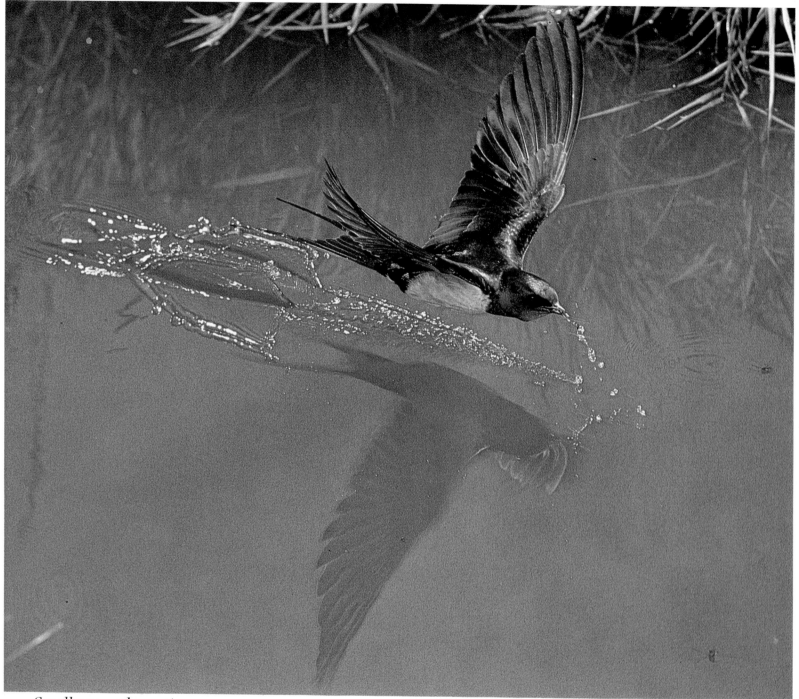

Swallows and martins HIRUNDINIDAE

The flight of the Swallow, *Hirundo rustica*, is noted for its lightness and grace. Swerving and banking while capturing insects on the wing, skimming across a pond picking up insects from the surface, wheeling at great heights in the warmth of summer, the Swallow is an outstanding aerial acrobat. Although the Swallow will drink while settled, it usually does so on the wing, dipping its lower beak briefly into the water while flying with great precision. This high-speed photograph was taken as the bird began to gain height. The bird is about 18 centimetres (7 inches) long.

The Common Swallow breeds in the northern hemisphere from North America across Europe to Japan. Winter is passed in tropical and southern Africa, India, South America and, occasionally, in Australia. Except in the coldest northern regions and in Antarctica species of swallow occur throughout the world.

Mammals
MAMMALIA

The mammals are warm-blooded vertebrates with a glandular skin which is typically hairy. The mother feeds her young with milk secreted by mammary glands. Mammals keep their body temperatures fairly constant and, to do this, they are aided by sweat glands in the skin. As the temperature rises, the glands exude moisture which evaporates to help cool the body. The amount of heat lost from the surface is also controlled by regulating the flow of blood because, when all the blood capillaries are filled, the skin becomes flushed and loses much heat. Heat can also be lost from the surface of the lungs and from the external ears. Because they can control their body temperature, mammals can be active at night or in winter.

In general, mammals are very active animals and their anatomy shows various features that increase efficiency. The diaphragm separating the abdomen and chest cavities make breathing more efficient. The heart is divided into two halves by a partition which prevents the mixing of venous and arterial blood. High activity is based on a high food intake and this requires an efficient digestive system and the development of specialized teeth. A false palate enables a mammal to breathe at the same time as it eats. Mammalian sense organs are also well developed: eyesight is acute and most mammals can see at very low light levels; hearing and the sense of smell are excellent. The brain reaches its highest development in mammals and they can learn, particularly when young, so that their behaviour is less automatic and more adaptable.

Very few mammals can be regarded as pond animals although some visit ponds to drink and they may play a part in the distribution of aquatic plants and animals.

Shrews SORICIDAE

The Water Shrew, *Neomys fodiens*, (**1**) is an unusual insectivore in being aquatic although it may on occasion be found far from water and can then show a disinclination to enter its natural element. A fringe of hairs round the edges of the feet and toes and another fringe forming a keel along the underside of the tail are special adaptations to an aquatic life. The velvety fur is the same as that of terrestrial shrews but, nevertheless, it traps countless bubbles of air when the animal submerges so that the Water Shrew appears to be sheathed in silver. When it emerges from the water, the Shrew's coat is completely dry. As with other shrews, the food consists of assorted invertebrates up to any size that can be overpowered. Underwater, the Shrew relies on its sense of smell because it has poor eyesight and the ears are closed by flaps. Hunting for food takes place by day and by night. The animal's body length is about 10 centimetres (4 inches) long.

The Water Shrew inhabits the whole of continental Europe and extends into Asia. In North America the Northern Water Shrew, *Sorex palustris*, and the Pacific Water Shrew, *S. bendirei*, are aided in swimming by the stiff hairs along the sides of the hind feet.

Raccoons PROCYONIDAE

The Raccoon, *Procyon lotor*, (**2**) is a medium-sized carnivore, about 71 centimetres (28 inches) long, found throughout the United States and extending into the southern parts of Canada. It is chiefly active at night but it is sometimes seen during the day. The Raccoon frequents the shores of ponds and lakes to feed on frogs, insects, and a variety of other animals as well as on vegetable matter. The animal often dunks its food in water before eating it. In the northern part of its range, the Raccoon passes spells of extreme winter cold in hollow logs or trees but it does not hibernate. Europe has no equivalent to the Raccoon.

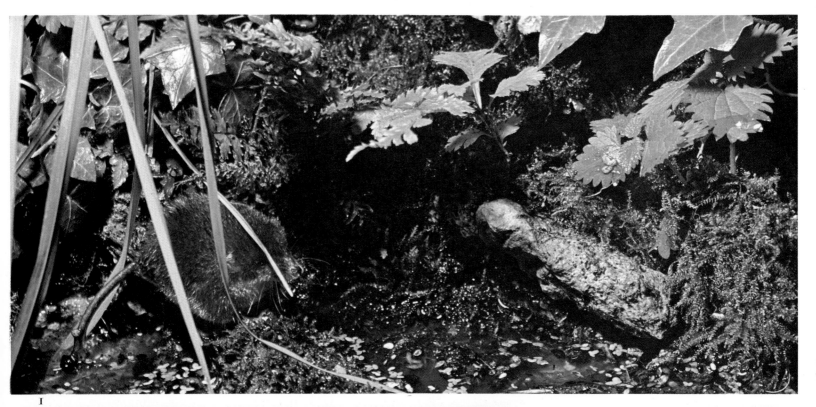

1

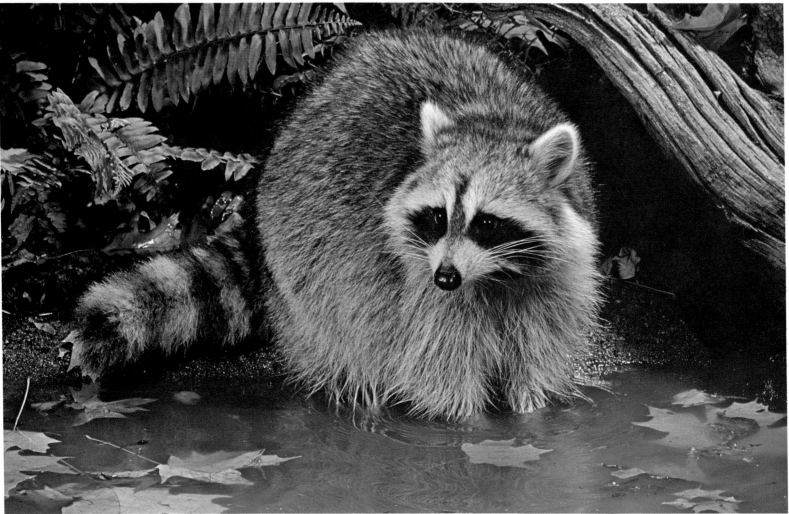

2

Weasels, mink, etc MUSTELIDAE

Carnivores belonging to the family Mustelidae include the minks, weasels, stoats, badgers, and otters. Otters are well adapted for life in water but they frequent rivers and lakes and are unlikely to be encountered in ponds. Minks are less well adapted to water because the toes are only partly webbed. Nevertheless, the mink is an excellent swimmer and often hunts in water like otters. Minks are active at night and are rarely seen but their droppings, footprints, and the remains of prey are evidence of their presence. Minks feed mainly on small mammals, birds, eggs, frogs, crayfishes, and fishes. Out of the breeding season, the animal is solitary and lives in a den near water. It is about 43 centimetres (17 inches) long.

There are two species, the American Mink, *Mustela vison*, (1) and the European Mink, *M. lutreola*. Both are valuable fur bearers but the pelt of the European species is inferior. The American Mink is found in most parts of North America, from the Arctic Circle south to Mexico. The European Mink is much rarer than it was but still occurs in Russia through to Siberia as well as in Finland and a few other places.

American Mink have been bred commercially since 1866 and, in Britain, the first farm was established in 1929. By the middle 1950s escaped American Mink were found breeding in Devon and, since then, they have been found elsewhere in England as well as in Wales and Scotland spreading along the river systems. The American Mink is a major threat to certain pond life and already there have been reports of Moorhens and Water Voles, *Arvicola terrestris*, being exterminated.

Beavers CASTORIDAE

The American Beaver, *Castor canadensis*, (2) is famed for its feats of engineering; it is the second largest rodent, exceeded only in size by the Capybara of South America which reaches 55 kilograms (122 pounds) in weight. Beavers weigh between 14 and 34 kilograms (30 to 75 pounds). The front feet are strongly clawed and are used for digging, carrying, and manipulating the food whereas the hind feet are webbed for swimming. When a beaver submerges, its nostrils and ears are closed by valves. The broad, scaly tail is used for steering and forms a tripod with the hind legs when the beaver stands up to gnaw trees. Beavers live in lodges in a pond which they create by damming a river until it overflows. A lodge is built of sticks and mud with underwater entrances and a central chamber which is above the water level. Provision is made for ventilation. Secondary dams are built upstream and one is usually made downstream of the main dam. Young trees are felled with the teeth and are cut into sections before being transported to the site. If necessary, feeder canals are dug to float logs to the pond. Beavers feed mainly on bark, especially that of aspen, willow, poplar, birch, maple, and alder.

The European Beaver, *Castor fiber* and its American counterpart, *C. canadensis*, were both in danger of extinction in the nineteenth century as a result of being indiscriminately killed for their fur. As a result of rigorous protection, *C. canadensis* is surviving over a reduced area in Canada and the northern United States while *C. fiber* is present in small numbers in Scandinavia and Russia.

Voles and mice MURIDAE

The presence of the Water Vole, *Arvicola terrestris*, is usually betrayed by a plop as it dives into the water. It is a common animal of ponds and slow-moving rivers and is the largest British vole with a body length up to 22 centimetres (8·6 inches) and a tail of 11 centimetres (4·3 inches). There seem to be no special adaptations for an aquatic life and, indeed, the Water Vole is not an outstanding swimmer, but it is a skilful diver and disappears readily beneath the surface to reappear some distance away. The direction of travel is revealed by a trail of bubbles.

1

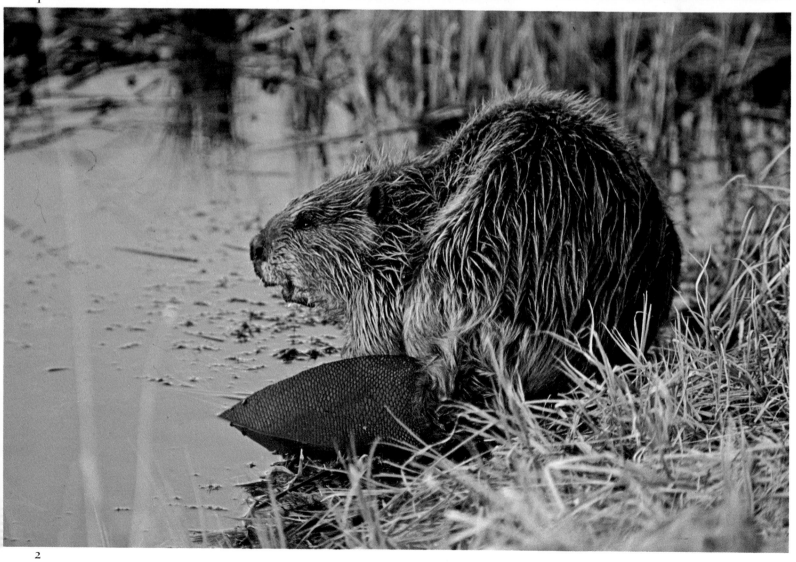

2

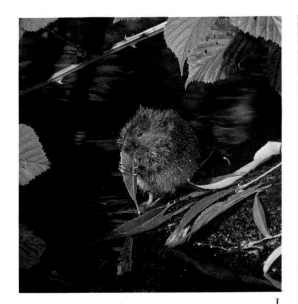

1

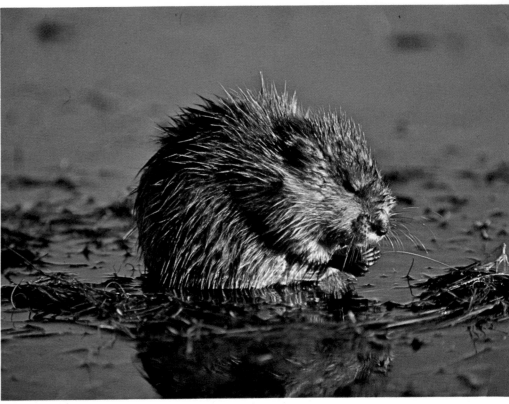

2

The vole lives in burrows excavated in banks beside water, and canals and dykes sometimes suffer minor damage. There is always an underwater entrance as well as at least one above ground. The tunnel system consists of winding passages leading to sleeping chambers lined with grass and other chambers for storing food. The Water Vole is mostly vegetarian and feeds on reeds, sedges, flags, and other waterside plants (1). Acorns and beech mast are stored against a scarcity of food in winter because the animal does not hibernate.

There may be three or four litters a year of five young each on average. Water Voles succumb to various predators – herons, otters, owls, weasels, stoats, pike, large eels, and trout, and certainly the Mink when present.

The Water Vole is widely distributed over most of Europe, parts of Russia and Siberia, Asia Minor, and Iran. In North America the Muskrat occupies much the same ecological niche.

The Muskrat, *Ondatra zibethica* (2), has a body up to 36 centimetres (14 inches) long and an equally long tail. It is widely distributed in North America from Alaska to South Carolina. The Muskrat has been introduced into Europe more than once in an effort to keep waterways open, because, like the Water Vole of which it is a larger edition, it feeds mainly on aquatic vegetation. It also resembles *Arvicola* in tunnelling into banks but, because of the larger size, it does proportionately more damage.

Muskrats have escaped from ranches in Europe where they were being bred for their valuable fur, the musquash of commerce. In Britain, Muskrats became established in the wild in several areas and were only exterminated with great difficulty. The Muskrat is better adapted for swimming than the Water Vole; the tail functions as a rudder and is laterally flattened with a fringe of stiff hairs on the upper and lower keels. The hind feet are partly webbed and are fringed with stiff hairs.

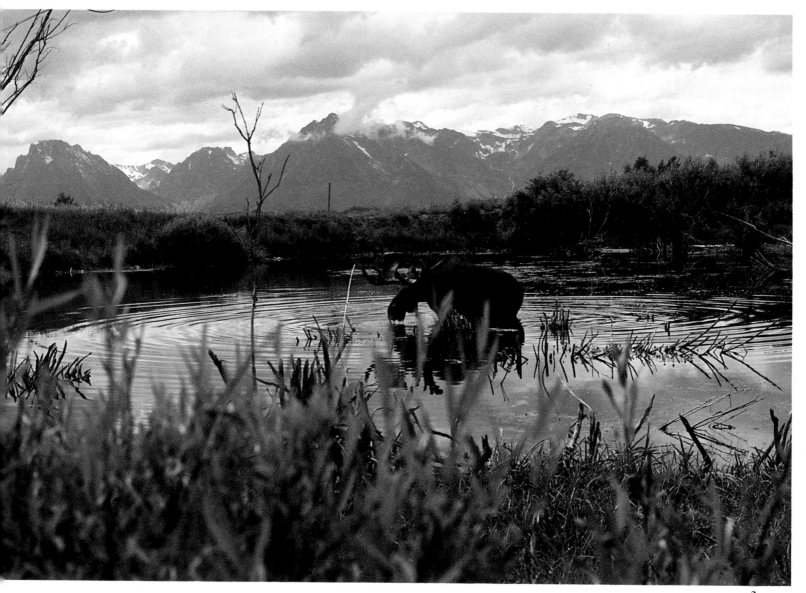

Deer CERVIDAE

The Moose or Elk, *Alces alces* (3), is the largest living deer, up to 3 metres (10 feet) long and weighing up to 530 kilograms (11 hundredweight). The palmate antlers are worn only by the male and span up to 2 metres (6·5 feet).

In summer, Moose spend much of their time standing in water, including ponds, feeding on water-lilies and other aquatic vegetation. They will submerge completely to get at the roots and stems of water plants. Immersion in water also provides some relief from the hordes of mosquitoes and other biting flies that are rife in summer. In winter Moose feed on twigs, bark, and saplings. The bulls shed their antlers in December and new ones begin to develop in the following April or May and are full grown by August, at which time the velvet, which is the skin that nourishes the antler, is shed and rubbed off.

The breeding season occupies September and October and is marked by fierce fighting between bulls. During the rut bull Moose should be avoided because they can be dangerous to man. They have been known to attack and virtually destroy cars by striking down with their large hoofs on the bodywork. Moose are polygamous, a mature bull mating with several cows. The Moose lives in wooded areas of Alaska and Canada and in the vicinity of the Rocky Mountains in the north-west United States. In the Old World the Moose is known as the Elk. It lives in parts of Norway and Sweden and is found eastwards through European Russia and Siberia to Mongolia and Manchuria in northern China.

Studying pond life

A pond is a clearly defined habitat available to most students and the study of pond life has become a popular part of the biology syllabus for schools and colleges in many countries. In Britain, where the number of ponds has diminished rapidly this century, while the teaching of environmental and field studies has expanded enormously, some pond animals have been overcollected and even threatened with extinction, and the pond environment may have been seriously disturbed. There is still much to be discovered about the life histories and interrelationships of the plants and animals found in ponds, but it would be wrong to endanger the habitat while pursuing this knowledge so that the following rules should be observed:

1 Approach the pond cautiously and use a net carefully so as not to disturb the muddy bottom.

2 Place water plants on a sheet of plastic and sort out the animals by hand. Replace the plants in the pond immediately.

3 Do not collect more specimens than necessary.

4 If the weather is sunny, either place the containers in shade or keep them cool by covering them because small quantities of water can soon reach a lethal temperature.

5 If logs or stones are turned over they should be replaced as they were.

6 Do not take specimens away if they can be examined and recorded on the spot and returned at once to the pond. This applies particularly to the larger animals.

7 Avoid trampling down the marginal plants.

8 Leave no litter.

9 Return all specimens to the pond after they have been studied.

10 Keep herbivores and carnivores separately, otherwise the plant eaters may be eaten before you get them home. Carnivores are best kept individually in containers otherwise they may kill one another.

11 Aquatic animals, such as water beetles, backswimmers, water scorpions, and water spiders, that breathe atmospheric air are best transported in damp weed, not in water.

12 Surface-living animals, such as pond skaters, will drown if they are transported in water and they should be carried in damp weed.

The bare necessities for collecting pond life are few and there is really no need for expensive sophisticated equipment. The most important item is a long-handled net made of fine-meshed, strong material, such as bolting silk, on a strong frame, preferably brass. The net has to be able to withstand rough treatment because it may encounter submerged branches and man-made refuse. A large white plastic or enamel dish such as is used for developing film is ideal for sorting the catch because most animals will show up well.

Small, hard-bodied animals, such as waterlice, are more easily handled with forceps than with the fingers. A small paint brush is useful for picking up soft-bodied animals and a disposable white plastic spoon will prove to be invaluable. Very small creatures, such as waterfleas, can be transferred to small vials using a medicine dropper. A home-made grapple constructed from a 10 centimetre (4 inch) length of piping terminating in nails or stiff wire can be thrown out at the end of a length of rope to drag in weed that is out of reach.

Plastic bags are excellent for transporting plants, while jam jars and glass or plastic vials are needed for animals. A times-ten hand-lens will reveal many fascinating details of the plants and animals found.

Not everyone can own a microscope but the lucky ones will have their eyes opened to a strange and exciting world of small organisms that is otherwise almost invisible among the larger inhabitants of the pond. If funds are limited avoid the temptation to buy a toy instrument. It is far better to explore the second-hand market in low-power microscopes. Magnifications up to 200 times are

adequate for most purposes. High magnifications, including the use of oil-immersion objectives, add greatly to the cost and are not especially useful.

When collecting pond life, the most common fault is to take more specimens than can be looked after properly, so that animals and plants die and pond habitats are destroyed. It is essential to take the minimum number of specimens for observation and study. If you keep pond life at home under conditions that are as natural as possible, you can watch their behaviour in close up. With correct care and feeding many species will complete their whole life history in captivity. Glass aquarium tanks are ideal, but bowls and wide-mouthed jars of all descriptions can be pressed into service. Do not overcrowd the animals and, where possible, use pond water or rainwater. Mains water usually contains a lot of chlorine, which will evaporate if you leave it for two days before you add the plants and animals. When you are topping up a container, pour the water on to a piece of paper placed on the surface. In this way the bottom mud will not be disturbed. Glass covers over containers, leaving a small space for aeration, will reduce evaporation and will prevent flying insects from escaping. Silt, sand, or mud from the pond should be added to each container and allowed to settle before introducing the animals. Rocks or waterlogged wood can be provided as shelter for those that need it.

Weed is needed to provide shelter, a site for egg laying, or for food, but do not fill more than about half the tank; some spaces are necessary for the free movement of the animals. Root the weeds in the bottom mud and sand. Dragonfly nymphs and caddisfly pupae climb out of the water before emerging as adults so that they need emergent stems. Froglets also need floating leaves or wood to enable them to leave the water when the time comes.

Containers should not be kept in full sunlight. The water temperature should not exceed 21°C (70°F) and light from a north-facing window would be ideal in the northern hemisphere. Too much light may cause excessive growth of algae and turn the water green. If this happens, reduce the light entering the glass container by masking the window side with paper.

The complete breeding behaviour of the stickleback can be observed in a tank no larger than 30 by 20 by 20 centimetres (12 by 8 by 8 inches). A plentiful supply of live food such as mosquito larvae and pupae, bloodworms, and water-fleas will bring the male into breeding condition. The females are kept separate and are also well fed. Finally, a female, ripe with spawn, is introduced to the male's tank after he has built a nest.

If the habitat is suitable, the secret of successful breeding is enough food of the right kind. Small earthworms are excellent food for the adults and larvae of carnivorous water beetles, dragonfly nymphs, newts, and other predators of medium size but it is better to vary the diet and not use one food exclusively. Worms not eaten quickly will drown and decay and containers should be cleaned out when necessary. Waterfleas and bloodworms are staple foods for many small freshwater predators and can be conveniently cultured in the garden water butt.

Cultures of many different forms of microscopic life are easily obtained by having a series of vessels – jamjars will do – each containing a different kind of organic matter in water, such as hay, moss, and cow manure. The smell may become unpleasant eventually but if you examine the contents under the microscope you will find them fascinating and you should be able to observe the succession of one species succeeded by another if you keep the cultures long enough. These cultures can also be used as food for other animals.

Our knowledge about life in ponds is far from complete and it is perfectly possible for a keen observer to contribute to the exploration of this fascinating habitat by keeping an aquarium on a window sill at home.

Glossary

Those terms which are used in the definitions and which are themselves defined in the glossary are printed in SMALL CAPITALS.

achene
small, dry, single-seeded fruit that does not split open to release its seed, eg, Water-crowfoot and other *Ranunculus* spp.

aerenchyma
plant tissue containing many intercellular spaces in which air circulates freely.

angiosperms
the flowering plants; these are the most widespread and familiar of all plants, and are undoubtedly the most highly evolved and successful plants in the world.

anther
part of STAMEN which produces pollen.

antheridium
male sex organ in CRYPTOGAMS.

arista
in some flies, a slender bristle, usually situated dorsally on the last segment of the antenna.

Australasian region
one of the primary faunal regions into which the land surface of the Earth is divided. It includes Australia, Tasmania, New Zealand, New Guinea, and the islands south and east of WALLACE'S LINE.

auxospore
a resting SPORE formed by diatoms after a sexual fusion.

axil
the angle where a leaf or leaf stalk joins the stem.

bract
leaf or scale at the base of a flower.

bryophyte
in non-flowering plants, a member of the phylum Bryophyta, ie, mosses and liverworts.

byssus
a tuft of strong threads secreted by a mollusc for attachment.

capsule
a dry fruit containing one or more seeds and splitting open in various ways. Or, in mosses and liverworts, the chamber that contains the SPORES.

carbohydrate
a compound such as starch or sugar, made from carbon, hydrogen, and oxygen, and used by plants and animals as a source of energy.

carnivore
an animal or plant which feeds on animal matter.

carpel
in flowers, one of the units making up the PISTIL, consisting of the OVARY, STYLE, and STIGMA.

caudal
the region of the tail.

cerci
sensory appendages at the end of the abdomen in some arthropods.

chelicerae
a pair of grasping appendages in front of the mouth in arachnids.

chitin
the material of which the skeleton is made in arthropods and most other INVERTEBRATES.

chloroplast
a dense PROTOPLASMIC inclusion containing chlorophyll, embedded singly or in large numbers in a plant cell.

cilium
a hair-like process used for locomotion or to create a current of water.

clitellum
a swollen glandular region in earthworms and leeches which secretes a slime tube to enclose the eggs.

cloaca
a chamber into which the digestive, urinary, and reproductive systems open.

cnidocyte
a stinging cell containing a NEMATOCYST.

coelom
a secondary body cavity present in molluscs, annelids, arthropods, and in all the chordates.

commensal
an animal or plant living harmlessly with or in another and sharing its food.

corona
a circle of CILIA surrounding the mouth of rotifers and some protozoans.

cryptogam
a plant that reproduces by means of spores and does not produce flowers or seeds eg algae, fungi, mosses, liverworts, and ferns.

cuticle
the outermost covering of the body of arthropods. A complex, non-cellular layer which may become hardened to form distinct plates separated by zones of unchanged soft cuticle. During growth the arthropod moults at intervals by casting off the whole of the cuticle which is replaced in a larger size. In plants, a non-cellular, waxy outer layer secreted by, and covering, the EPIDERMIS in many higher plants.

Dicotyledon
a major group of the ANGIOSPERMS. Plants belonging to this group have seedlings with two seed leaves (cotyledons) and mature leaves which are usually broad, often stalked, and nearly always net veined. The flower parts are usually in multiples of four or five.

ectoplasm
the outer, clear, gelatinous layer of PROTOPLASM which largely determines the rigidity or flexibility of the protozoan body.

endoplasm
the fluid granular internal PROTOPLASM forming the bulk of the body in a protozoan.

enzyme
a specific protein produced by living cells which triggers a particular chemical reaction.

epidermis
the outermost layer of cells of an animal or plant.

epiphyte
a plant which grows upon another plant but is not a PARASITE.

flagellum
in some microscopic organisms, a hair-like process, much longer than a cilium, which undulates from base to tip, or in the reverse direction, and pushes or pulls the organism through the water.

gametophyte
the generation of a plant that produces sex cells, as found in ferns, mosses, and liverworts,

gemmule
overwintering stage of a sponge. A number of cells are enclosed in a highly resistant case and remain dormant until spring.

glochidium
the larval form of a freshwater mussel, having a toothed bivalved shell and a prominent BYSSUS. The early life is passed as a PARASITE attached to a fish.

glume
the dry membranous BRACT found at the base of the flower of a grass or sedge.

haltere
the modified hind wing of a fly (Diptera), consisting of a stalk with a terminal knob. It serves as a kind of balancing organ.

herbivore
an animal which feeds on plants.

Dicotyledon

Bogbean, *Menyanthes trifoliata*
all parts of the flower are arranged in
fives or multiples of five

Dicotyledon leaf (net veined)

Dicotyledon seedling
Broad Bean, *Vicia faba*

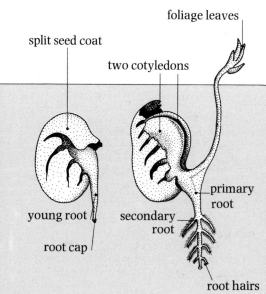

foliage leaves

split seed coat

two cotyledons

young root

secondary root

root cap

primary root

root hairs

Monocotyledon

Water-plantain, *Alisma plantago-aquatica*
all parts of flower are arranged in threes or
multiples of three

Monocotyledon leaf (parallel veined)

Monocotyledon seedling
Maize, *Zea mays*

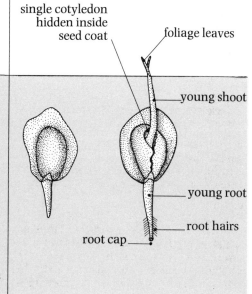

single cotyledon
hidden inside
seed coat

foliage leaves

young shoot

young root

root hairs

root cap

Parts of a plant

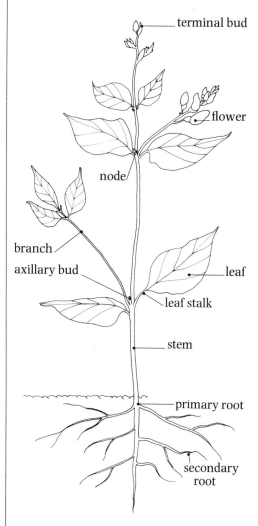

terminal bud

flower

node

branch

axillary bud

leaf

leaf stalk

stem

primary root

secondary root

Parts of a flower

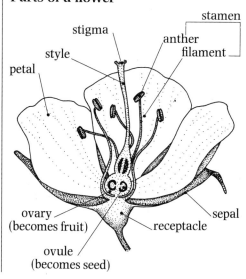

stamen

stigma

style

anther
filament

petal

sepal

ovary
(becomes fruit)

receptacle

ovule
(becomes seed)

239

GLOSSARY

hermaphrodite
having both male and female reproductive organs in one individual.

Holarctic region
one of the primary faunal regions into which the land surface of the Earth is divided. It comprises North America to the edge of the Mexican plateau, Europe, Asia (except Iran, Afghanistan, India south of the Himalayas, and the Malay peninsula), Africa north of the Sahara, and the arctic islands.

humus
the organic matter in soil, derived mainly from the remains of plants that have decomposed beyond the stage at which their original structure can be recognized.

hydrophyte
a plant which needs to live partially or wholly submerged in water.

hypha
one of the simple or branched filaments which make up the MYCELIUM of a fungus.

inflorescence
in flowering plants, the part of the shoot which bears flowers.

instar
from the time it hatches from the egg, the life of an insect is divided by moulting of the cuticle into successive developmental stages, each of which is called an instar. When the insect emerges from its egg it is in the first instar; the final instar is the mature form, or adult, capable of reproduction. Different insect species differ greatly in the number of moults they undergo during their life.

invertebrate
a collective term for animals that have no backbone. About 95 per cent of known species of animals are invertebrates.

labium
the lower lip of an insect's mouthparts.

labrum
the upper lip of an insect's mouthparts.

larva
an immature insect that differs in structure and appearance from the adult and requires a PUPAL INSTAR before reaching maturity (Endopterygota page 134.)

lophophore
a food-catching organ that surrounds the mouth of moss animals. It is a circular or horseshoe-shaped fold of the body bearing numerous CILIATED tentacles. The CILIA create a current of water that drives plankton into the mouth.

mantle
in molluscs, a thin fold of skin covering the body which secretes the shell and protects the internal organs.

mastax
in rotifers, a muscular chamber for grinding up food and in carnivorous species equipped with pincers for seizing prey.

maxilla
in chewing insects, an appendage situated between the mandible and the LABIUM and serving as an accessory jaw for holding food and tearing it apart. In piercing insects, the maxilla is needle-like and the palp atrophied.

Monocotyledon
a major group of the ANGIOSPERMS. Plants belonging to this group have seedlings with only one seed leaf (cotyledon) and the mature leaves are usually narrow and unstalked, often parallel sided, and nearly always parallel veined. The flower parts are usually in multiples of three.

mucilage
slimy substance produced by plants.

mycelium
mass of interwoven HYPHAE which makes up the vegetative body of a fungus.

Nearctic region
a subrealm of the Holarctic region. It includes North America to the edge of the Mexican plateau and Greenland.

nematoblast
a cell which will develop a NEMATOCYST.

nematocyst
a capsule containing poison and a thread-like tube armed with spines. Contained inside a CNIDOCYTE, the structure can be discharged to the outside by fluid pressure. Numerous on the tentacles of *Hydra* spp where they are used to capture food and in defence.

Neotropical region
one of the primary faunal regions into which the land surface of the Earth is divided. It comprises South America, the West Indian islands, and Central America south of the Mexican plateau.

node
the place where a leaf is attached to a stem.

nucleus
controls all activities in a cell and determines the transmission of inheritable characters when the cell divides.

ocellus
in invertebrates, a simple eye.

oogonium
the female sexual organ in algae and fungi.

operculum
in fish, a flap covering the external opening of the gill slits. In some snails, a plate covering the opening to the shell.

Oriental region
one of the primary faunal regions into which the land surface of the Earth is divided. It includes the southern coast of Asia east of the Persian Gulf, India south of the Himalayas, southern China and Malaysia, and the islands of the Malay archipelago north and west of WALLACE'S LINE.

osmosis
the diffusion of a solvent from a weaker solution through a membrane into a more concentrated solution to equalize the concentrations on both sides of the membrane.

ovary
in flowering plants, the swollen base of a CARPEL containing the OVULES which eventually becomes the seed-box or fruit.

ovule
in the OVARY of flowering plants, a female egg cell which develops into a seed after fertilization.

Palaearctic region
a subrealm of the Holarctic region. It includes Europe and northern Asia, together with Africa north of the Sahara.

palp
in insects, a segmented sense organ by the mouth, usually present on the MAXILLA and on the LABIUM.

parasite
an organism which obtains its food from another organism without rendering any service in return.

parthenogenesis
a method of reproduction in which eggs develop without having been fertilized. Sometimes called **virgin birth**.

pedipalps
in spiders, scorpions, mites, and ticks, the first segment behind the mouth bears a pair of appendages which may be tactile or pincer-like.

pellicle
in CILIATE protozoans a thin complex outer covering of the body.

perianth
the petals and SEPALS of a flower considered together.

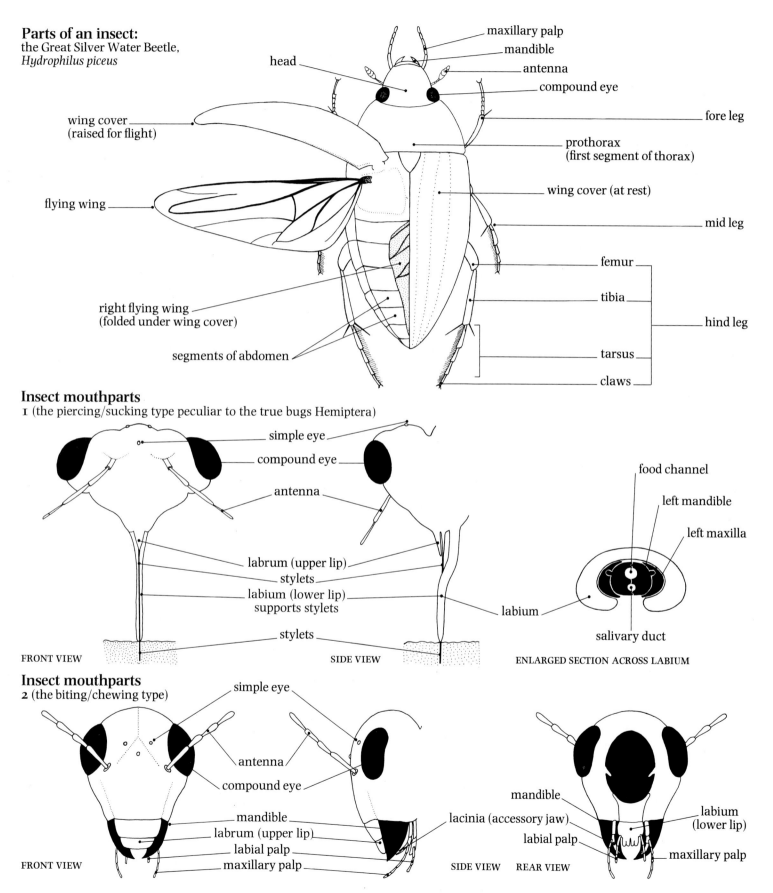

Parts of an insect:
the Great Silver Water Beetle,
Hydrophilus piceus

maxillary palp
mandible
head
antenna
compound eye

wing cover
(raised for flight)

fore leg

prothorax
(first segment of thorax)

wing cover (at rest)

flying wing

mid leg

femur

tibia

right flying wing
(folded under wing cover)

hind leg

tarsus

segments of abdomen

claws

Insect mouthparts
I (the piercing/sucking type peculiar to the true bugs Hemiptera)

simple eye

compound eye

antenna

food channel

left mandible

left maxilla

labrum (upper lip)
stylets
labium (lower lip)
supports stylets

labium

stylets

salivary duct

FRONT VIEW

SIDE VIEW

ENLARGED SECTION ACROSS LABIUM

Insect mouthparts
2 (the biting/chewing type)

simple eye

antenna

compound eye

mandible
labrum (upper lip)
labial palp
maxillary palp

lacinia (accessory jaw)

mandible

labium
(lower lip)

labial palp

maxillary palp

FRONT VIEW

SIDE VIEW REAR VIEW

241

perianth segments
the separate parts of which the perianth is composed, especially when petals and SEPALS look alike and cannot be distinguished.

peristome
in CILIATE protozoans, a specialized food-collecting area, frequently funnel shaped, surrounding the cell-mouth.

pharynx
in INVERTEBRATES, a muscular part of the gut next to the mouth.

pinnate
in a compound leaf, the arrangement of leaflets in opposite pairs on either side of the midrib, like a feather.

pistil
in plants, the female reproductive organ comprising one or more CARPELS.

plankton
small plants and animals floating near the surface of water at the mercy of winds and currents.

plastron
in certain aquatic insects, a thin film of air held by water-repelling hairs or scales that can function as a permanent physical gill provided there is enough oxygen dissolved in the water.

prothallus
in ferns and horsetails and other PTERIDOPHYTES, the small vegetative THALLUS which is the GAMETOPHYTE plant.

protoplasm
the basis of life, found in all living cells. A greyish semitransparent, semifluid substance of complex chemical composition, within which chemical, physical, and electrical changes are constantly taking place.

pseudopodia
in Sarcodina protozoans, a temporary extrusion of PROTOPLASM for movement or food capture.

pteridophyte
in non-flowering plants, a member of the phylum Pteridophyta, eg, ferns and horsetails.

pupa
an inactive stage in the life history of an endopterygote insect during which it does not feed and the larval body is reorganized into that of the adult.

puparium
in some flies the last larval skin forms a protective covering around the PUPA.

pyrenoid
a small, round protein granule which stores starch, found in the CHLOROPLASTS of many algae and BRYOPHYTES.

radula
in snails, a strap-like structure in the mouth bearing numerous chitinous teeth, used for scraping away pieces of food, mainly plant material.

rectal
referring to the rectum, the last portion of the gut before the anus.

rhizoid
in liverworts, mosses, and stoneworts, a short, hair-like structure, functioning like a root.

rhizome
in certain plants, a stout underground stem of one or more years' growth usually lying horizontally and bearing scale leaves and one or more buds.

saprophyte
a plant which feeds on dead or decaying plants or animals.

sepal
one of several leaf-like structures lying outside the petals of a flower.

spermatophore
a package of sperm.

spiracle
in insects, one of the external openings of the respiratory system.

sporangium
the chamber or case in which spores are formed.

spore
a small asexual reproductive body produced by non-flowering plants.

sporophyte
an individual of the spore-bearing generation of plants like ferns, mosses, and liverworts.

stamen
the male reproductive organ of a flower, consisting of a stalk, the filament, bearing at its tip an ANTHER which produces the pollen.

statoblast
in moss animals, a group of cells enclosed in a tough resistant coat which can survive low temperatures in winter and give rise to a new colony in spring.

stigma
in a flower, the terminal portion of a CARPEL, usually at the tip of a STYLE, which receives the pollen.

stolon
in plants, a horizontal creeping stem or runner, which forms a new plant at its tip.

stoma
the small opening in the surface of a leaf or stem which permits the entry and exit of gases and water vapour.

style
the stalk arising from the ovary of a flower, bearing the STIGMA at its tip.

symbiosis
a close relationship between two species in which at least one of the species is dependent upon the other.

thallus
a simple plant body which is not differentiated into roots, shoots, and leaves.

trachea
in insects, an air tube of the respiratory system.

trichocyst
in some CILIATE protozoans, an explosive shaft ending in a barb which can be discharged from the PELLICLE. Used for capturing food, defence, or for anchoring the animal.

tuber
the swollen portion of an underground stem or root, containing stored food and functioning as an organ of vegetative reproduction. A tuber does not last for more than one year.

tubercle
a rounded protuberance.

tun
in water bears, the stage in which extreme drying up is withstood by the animal losing water and contracting and apparently dying. The living processes continue at a very low rate and, when water becomes available, the animal swells and resumes normal activity within a few hours.

vacuole
a fluid-filled space within the PROTOPLASM of a cell.

Wallace's line
an imaginary line passing through the Malay archipelago and dividing the Oriental faunal region from the Australasian region.

zygospore
in algae and fungi, a thick-walled resting SPORE formed after the union of two reproductive cells.

zygote
the product of the union of two reproductive cells.

Classification of pond plants illustrated

Phylum (Subphylum)	Class (Subclass)	Order (Suborder)	Family	Genus & Species	Common Name
CYANOPHYTA	CYANOPHYCEAE	CHROOCOCCALES	CHROOCOCCACEAE	Chroococcus sp	a blue-green alga
		NOSTOCINALES	NOSTOCACEAE	Anabaena oscillarioides	a filamentous blue-green alga
CHRYSOPHYTA	XANTHOPHYCEAE	VAUCHERIALES OR HETEROSIPHONALES	VAUCHERIACEAE	Vaucheria sp	a siphon alga
	BACILLARIOPHYCEAE	CENTRALES	COSCINODISCACEAE	unknown	a circular diatom
			MELOSIRACEAE	Melosira sp	a chain diatom
		PENNALES	FRAGILARIACEAE	Fragilaria sp	a chain diatom
			NAVICULACEAE	Navicula sp	an elongated diatom
				Pinnularia sp	an elongated diatom
				Diploneis sp	an elongated diatom
				Pleurosigma sp	an elongated diatom
CHLOROPHYTA	CHLOROPHYCEAE	VOLVOCALES	CHLAMYDOMONADACEAE	Chlamydomonas sp	a single-celled motile green alga
			VOLVOCACEAE	Pandorina sp	a colonial motile green alga
				Volvox sp	a colonial motile green alga
	CONJUGATOPHYCEAE	DESMIDIALES	DESMIDIACEAE	Closterium sp	a desmid
				Pleurotaenium sp	a desmid
				Euastrum sp	a desmid
		ZYGNEMATALES	ZYGNEMATACEAE	Spirogyra sp	a filamentous green alga
RHODOPHYTA	RHODOPHYCEAE	NEMALIONALES	BATRACHOSPERMACEAE	Batrachospermum sp	a red alga (frogspawn alga)
CHAROPHYTA	CHAROPHYCEAE	CHARALES	CHARACEAE	Chara fragilis	a stonewort
FUNGI	PHYCOMYCETES	SAPROLEGNIALES	unknown	unknown	a water mould
BRYOPHYTA	HEPATICAE	MARCHANTIALES	RICCIACEAE	Riccia fluitans	Floating Crystalwort
	MUSCI	ISOBRYALES	FONTINALACEAE	Fontinalis antipyretica	Willow Moss
PTERIDOPHYTA	SPHENOPSIDA	EQUISETALES	EQUISETACEAE	Equisetum fluviatile	Water Horsetail
				E. palustre	Marsh Horsetail
	FILICOPSIDA	SALVINIALES	AZOLLACEAE	Azolla filiculoides	Fairy Moss (water fern)
			SALVINIACEAE	Salvinia natans	Water Velvet (water fern)
SPERMATOPHYTA					
(ANGIOSPERMAE)	DICOTYLEDONES	RANALES	RANUNCULACEAE	Caltha palustris	Marsh-marigold or Kingcup
				Ranunculus sceleratus	Celery-leaved Buttercup
				R. peltatus	Water-crowfoot
			NYMPHAEACEAE	Nymphaea alba	White Water-lily

ALGAE

Phylum	Class	Order	Family	Genus & Species	Common Name
SPERMATOPHYTA					
(ANGIOSPERMAE)	DICOTYLEDONES	*RANALES*	NYMPHAEACEAE	*Nuphar lutea*	Yellow Water-lily
			CERATOPHYLLACEAE	*Ceratophyllum demersum*	Rigid Hornwort
		CISTIFLORAE	HYPERICACEAE	*Hypericum elodes*	Marsh St John's-wort
		MYRTALES	LYTHRACEAE	*Lythrum salicaria*	Purple Loosestrife
			ONAGRACEAE	*Epilobium hirsutum*	Great Willow Herb
			HALORAGACEAE	*Myriophyllum spicatum*	Spiked Water-milfoil
				M. verticillatum	Whorled Water-milfoil
			HIPPURIDACEAE	*Hippuris vulgaris*	Mare's-tail
			CALLITRICHACEAE	*Callitriche stagnalis*	Common Water-starwort
		POLYGONALES	POLYGONACEAE	*Polygonum amphibium*	Amphibious Bistort
				P. persicaria	Persicaria or Redshank
				Rumex hydrolapathum	Water Dock
		PRIMULALES	PRIMULACEAE	*Hottonia palustris*	Water-violet
		CONTORTAE	MENYANTHACEAE	*Menyanthes trifoliata*	Bogbean
				Nymphoides peltata	Fringed Water-lily
		TUBIFLORAE	SCROPHULARIACEAE	*Veronica beccabunga*	Brooklime
			LENTIBULARIACEAE	*Utricularia vulgaris*	Greater Bladderwort
			LABIATAE	*Mentha aquatica*	Water Mint
	MONOCOTYLEDONES	*ALISMATALES*	ALISMATACEAE	*Alisma plantago-aquatica*	Water-plantain
				Sagittaria sagittifolia	Arrowhead
			BUTOMACEAE	*Butomus umbellatus*	Flowering-rush
			HYDROCHARITACEAE	*Hydrocharis morsus-ranae*	Frogbit
				Stratiotes aloides	Water-soldier
				Elodea canadensis	Canadian Waterweed
		NAJADALES	POTAMOGETONACEAE	*Potamogeton natans*	Broad-leaved Pondweed
		LILIIFLORAE	JUNCACEAE	*Juncus inflexus*	Hard Rush
				J. conglomeratus	Conglomerate Rush
			PONTEDERIACEAE	*Eichornia crassipes*	Water Hyacinth
			IRIDACEAE	*Iris pseudacorus*	Yellow Flag
		ARALES	ARACEAE	*Calla palustris*	Bog Arum
				Pistia stratiotes	Water Lettuce
			LEMNACEAE	*Lemna minor*	Common Duckweed
				L. polyrrhiza	Greater Duckweed
				L. trisulca	Ivy-leaved Duckweed

Phylum	Class	Order	Family	Genus & Species	Common Name
SPERMATOPHYTA					
				Wolffia arrhiza	Rootless Duckweed
(ANGIOSPERMAE)	MONOCOTYLEDONES	*TYPHALES*	SPARGANIACEAE	*Sparganium erectum*	Branched Bur-reed
			TYPHACEAE	*Typha latifolia*	Bulrush
		CYPERALES	CYPERACEAE	*Scirpus lacustris*	Common Club-rush
				Carex riparia	Great Pond Sedge
		GLUMIFLORAE	GRAMINEAE	*Phragmites australis*	Common Reed
				Glyceria maxima	Reed Sweet-grass

Classification of pond animals illustrated

Size range is given for some groups and species. A = adult; N = nymph; L = larva.

Phylum (Subphylum)	Class (Subclass)	Order (Suborder)	Family	Genus & Species	Common Name
PROTOZOA	MASTIGOPHORA	*EUGLENIDA*	EUGLENIDAE 0·0025 to 0·05 mm	*Euglena spirogyra*	a flagellate
	SARCODINA	*AMOEBIDA*	AMOEBIDAE 0·0025 to 0·05 mm	*Amoeba* sp	an amoeba
			DIFFLUGIIDAE up to 0·007 mm	*Diffugia* sp	a testate amoeba
			ARCELLIDAE 0·003 to 0·025 mm	*Arcella* sp	a testate amoeba
			ACTINOPHRYIDAE 0·0015 to 0·003 mm	*Actinophrys* sp	a sun animal
	CILIOPHORA	*HYMENOSTOMATIDA*	PARAMECIIDAE 0·006 to 0·03 mm	*Paramecium* sp	a ciliate; one of the slipper animals
		HETEROTRICHIDA	STENTORIDAE	*Stentor polymorpha*	a trumpet animal
				Stentor sp	
		SESSILIA	VORTICELLIDAE 0·0035 to 0·035 mm	*Vorticella* sp	a bell animal
				Campanella sp	a colonial bell animal
		GYMNOSTOMATIDA	HOLOPHRYIDAE	*Ichthyophthirius multifiliis*	Ick 0·1 mm
PORIFERA	DEMOSPONGIAE		SPONGILLIDAE	*Ephydatia fluviatilis*	Freshwater Sponge usually 20 to 40 mm
COELENTERATA	HYDROZOA	*HYDROIDA*	HYDRIDAE	*Hydra oligactis*	Brown Hydra column up to 20 mm
				Chlorohydra viridissima	Green Hydra column usually less than 15 mm
PLATYHELMINTHES	TURBELLARIA	*TRICLADIDA*	DENDROCOELIDAE 5 to 30 mm	*Dendrocoelum lacteum*	a planarian flatworm 25 mm

Phylum	Class	Order	Family	Genus & Species	Common Name
PLATYHELMINTHES		*MICROTURBELLARIA* usually less than 2 mm		unknown	
	CESTODA		PSEUDOPHYLLIDAE	*Schistocephalus gasterostei*	a tapeworm subadult 10 mm
NEMATODA			most aquatic spp about 2 mm	unknown	a roundworm
NEMATOMORPHA	GORDIOIDEA 10 to 70 mm		GORDIIDAE	unknown	a freshwater hairworm
ROTIFERA 0·4 to 2·5 mm	DIGONONTA	*BDELLOIDEA*	PHILODINIDAE	*Rotaria* sp	a wheel animal
	MONOGONONTA	*FLOSCULARIACEA*	FLOSCULARIIDAE	*Lacinularia* sp	a wheel animal
GASTROTRICHA 0·1 to 0·6 mm		*CHAETONOTOIDEA*	CHAETONOTIDAE	*Chaetonotus* sp	a hairy-back
ECTOPROCTA	PHYLACTOLAEMATA		PLUMATELLIDAE	*Plumatella* sp	a moss animal variable; usually 10 to 20 mm across
MOLLUSCA	GASTROPODA	*BASOMMATOPHORA*	PLANORBIDAE	*Planorbis spirorbis*	Round-spired Trumpet Snail to 12 mm
				Planorbarius corneus	Great Ram's Horn Snail to 27 mm
			LYMNAEIDAE	*Lymnaea stagnalis*	Great Pond Snail to 55 mm
				Lymnaea peregra	Wandering Snail about 18 mm
			ANCYLIDAE	*Acroluxus lacustris*	a freshwater limpet 5 to 6 mm
	BIVALVIA	*UNIONIDA*	UNIONIDAE	*Anodonta cygnaea*	Swan Mussel to 150 mm
		VANEROIDA	SPHAERIIDAE 4 to 27 mm	*Sphaerium* sp	an orb-shell cockle
TARDIGRADA 0·05 to 1·2 mm			SCUTECHINISCIDAE	unknown	a water bear
ANNELIDA	OLIGOCHAETA	*LUMBRICULIDA*	LUMBRICULIDAE	*Lumbriculus variegatus*	to 80 mm
		HAPLOTAXIDA	TUBIFICIDAE	*Tubifex* sp	a river worm to 60 mm
			NAIDIDAE	*Chaetogaster limnaei*	a nymph worm usually 2 to 5 mm
	HIRUDINEA 5 to 450 mm	*RHYNCHOBDELLIDA*	PISCICOLIDAE	*Piscicola geometra*	Fish Leech 25 mm
			GLOSSIPHONIIDAE	*Theromyzon tessulatum*	a snail leech 25 mm
		PHARYNGOBDELLIDA	ERPOBDELLIDAE	*Erpobdella octoculata*	a worm leech 40 mm
		GNATHOBDELLIDA	HIRUDIDAE	*Haemopsis sanguisuga*	Horse Leech 15 cm extended

Phylum	Class	Order	Family	Genus & Species	Common Name
ARTHROPODA					
(CHELICERATA)	ARACHNIDA	*ARANEAE*	PISAURIDAE	*Dolomedes* sp	a fisher spider usually about 25 mm
			LYCOSIDAE	*Pirata* sp	a wolf spider 4 to 10 mm
			AGELINIDAE	*Argyroneta aquatica*	Water Spider 9 to 13 mm
		ACARI	HYDRACHNIDAE 1 to 8 mm	*Hydrachna* sp	a water mite
			HYGROBATIDAE	*Pentatax bonzi*	a water mite
(MANDIBULATA)	CRUSTACEA				
	(BRANCHIURA)		ARGULIDAE 5 to 25 mm	*Argulus foliaceus*	Fish Louse 8 mm
	(BRANCHIOPODA)	*DIPLOSTACA*	DAPHNIIDAE 0·2 to 3 mm	*Daphnia magna*	a waterflea
	(OSTRACODA)	*PODOCOPA*	CYPRIDAE to 1·0 mm	unknown	a seed shrimp
	(COPEPODA)	*EUCOPEPODA*	CYCLOPIDAE to 2·0 mm	*Cyclops* sp	a copepod
	(MALACOSTRACA)	*ISOPODA*	ASELLIDAE 5 to 20 mm	*Asellus* sp	a water louse
		AMPHIPODA	GAMMARIDAE 5 to 20 mm	*Gammarus pulex*	Freshwater Shrimp
	INSECTA	COLLEMBOLA	PODURIDAE 1·0 to 1·5 mm	*Podura aquatica*	a water springtail
			SMYNTHURIDAE 0·5 to 1·0 mm	*Smithurides aquaticus*	a springtail
		ODONATA			
		(ZYGOPTERA) 15 to 34 mm (N)	COENAGRIIDAE	*Enallagma cyathigerum*	a damselfly 20 to 26 mm (N)
		(ANISOPTERA) 15 to 56 mm (N)	AESHNIDAE	*Aeshna cyanea*	Southern Aeshna; a hawker dragonfly 38 to 48 mm (N)
			LIBELLULIDAE	*Libellula depressa*	Broad-bodied Libellula; a darter dragonfly 22 to 25 mm (N)
		EPHEMEROPTERA nymphs 3 to 28 mm excluding tails	BAETIDAE	*Cloëon* sp	a mayfly 10 mm (N)
			EPHEMERIDAE	*Ephemera danica*	Mayfly 28 mm (N)
		HEMIPTERA	HYDROMETRIDAE	*Hydrometra stagnorum*	a water measurer 8 to 11 mm
			GERRIDAE 8 to 15 mm	*Gerris* sp	a pond skater

Phylum	Class	Order	Family	Genus & Species	Common Name
MANDIBULATA	INSECTA	*HEMIPTERA*	NAUCORIDAE 5 to 16 mm	*Ilyocoris cimicoides*	a saucer bug 15 mm
			BELOSTOMATIDAE 20 to 110 mm	*Diplonychus eques*	a giant water bug
			NEPIDAE 17 to 40 mm excluding syphon	*Nepa cinerea*	a water scorpion 18 to 22 mm
				Ranatra linearis	a needle bug 30 to 35 mm
			NOTONECTIDAE 8 to 17 mm	*Notonecta* sp	a backswimmer
			CORIXIDAE to 12 mm	unknown	a water boatman
		NEUROPTERA	SIALIDAE	*Sialis lutaria*	an alderfly 14 to 26 mm (L)
			SISYRIDAE	*Sisyra* sp	a spongefly 4 to 6 mm (L)
		COLEOPTERA	DYTISCIDAE 1 to 40 mm (A)	*Dytiscus marginalis*	Great Diving Beetle 35 mm (A); 50 mm (L)
				Acilius sulcatus	16 mm (A)
				Colymbetes fuscus	15 to 17 mm (A)
				Hyphydrus ovatus	
			HYDROPHILIDAE 1 to 45 mm (A)	*Hydrophilus piceus*	Great Silver Beetle 45 mm (A); 70 mm (L)
			GYRINIDAE 5 to 11 mm (A); 10 to 30 mm (L)	*Gyrinus* sp	a whirligig beetle
			CHRYSOMELIDAE	*Donacia* sp	a reed beetle 6 to 13 mm (A); 8 to 16 mm (L)
				Galerucella grisescens	a leaf beetle 4 to 6 mm (A); 5 to 7 mm (L)
		DIPTERA	TIPULIDAE 10 to 50 mm (L)	unknown	a cranefly
			PTYCHOPTERIDAE 20 to 60 mm (L)	*Ptychoptera* sp	a phantom cranefly
			DIXIDAE 4 to 8 mm (L)	unknown	a dixa midge
			CULICIDAE 3 to 15 mm (L)	*Culex pipiens*	(a culicine) the common midge or house mosquito
				Anopheles stephensi	an anopheline mosquito
			CHAOBORIDAE	*Chaoborus crystallinus*	a phantom or glass larva 13 to 15 mm (L)
			CHIRONOMIDAE 2 to 30 mm L)	*Chironomus* sp	a bloodworm larva

Phylum	Class	Order	Family	Genus & Species	Common Name
MANDIBULATA	INSECTA	*DIPTERA*	TABANIDAE 15 to 40 mm (L)	*Tabanus* sp	a horsefly larva
				Chrysops sp	a deerfly adult
			SYRPHIDAE	*Eristalinus sepulcralis*	a rat-tailed maggot (larva) of hoverfly 15 mm (L) excluding telescopic tail
		LEPIDOPTERA	PYRALIDAE	*Nymphula nymphaeata*	Brown China-mark Moth caterpillar 20 mm (L)
			NOCTUIDAE	*Nonagria typhae*	Bulrush Moth 45 mm (L)
		TRICHOPTERA	LIMNEPHILIDAE	*Limnephilus lunatus*	a caddis larva 20 mm
			LEPTOCERIDAE	unknown	a caddis larva 7 mm
CHORDATA					
(VERTEBRATA)	PISCES	*GASTEROSTEIFORMES*	GASTEROSTEIDAE	*Gasterosteus aculeatus*	Three-spined Stickleback to 75 mm
				Pungitius pungitius	Ten-spined Stickleback to 37 mm
		PERCIFORMES	PERCIDAE	*Perca fluviatilis*	Perch to 2·7 kg
		CLUPEIFORMES	ESOCIDAE	*Esox lucius*	Pike to 20 kg +
		CYPRINIFORMES	CYPRINIDAE	*Cyprinus carpio*	Carp to 20 kg
	AMPHIBIA	*URODELA*	SALAMANDRIDAE	*Ambystoma maculatum*	Spotted Salamander
				Triturus cristatus	Great Crested Newt 175 mm
		ANURA	RANIDAE	*Rana temporaria*	Common Frog 100 mm
				Rana castesbiana	Bull Frog 200 mm
			HYLIDAE	*Hyla arborea*	Tree Frog 50 mm
			BUFONIDAE	*Bufo bufo*	Common Toad 150 mm
	REPTILIA	*CHELONIA*	TESTUDINIDAE	*Chrysemys rubriventris*	Red-bellied Turtle to 400 mm
				Macroclemys temmincki	Alligator Snapping Turtle to 650 mm
		SQUAMATA	COLUBRIDAE	*Natrix natrix*	Grass or Ringed Snake to 2 m

Phylum	Class	Order	Family	Genus & Species	Common Name
VERTEBRATA		CROCODYLIA	ALLIGATORIDAE	*Caiman crocodilus*	Spectacled Caiman to 2·64 m
	AVES	ANSERIFORMES	ANATIDAE	*Cygnus olor*	Mute Swan 1·5 m
		GRUIFORMES	RALLIDAE	*Gallinula chloropus*	Moorhen 330 mm
				Fulica atra	Coot 380 mm
				Porphyrula martinica	Purple Gallinule 480 mm
		CICONIIFORMES	ARDEIDAE	*Hydranassa tricolor ruficollis*	Louisiana Heron 650 mm
		CORACIIFORMES	ALCEDINIDAE	*Alcedo atthis*	Kingfisher 162 mm
		PASSERIFORMES	SILVIIDAE	*Acrocephalus scirpaceus*	Reed Warbler 125 mm
			HIRUNDINIDAE	*Hirundo rustica*	Swallow 180 mm
	MAMMALIA	INSECTIVORA	SORICIDAE	*Neomys fodiens*	Water Shrew body 100 mm
		CARNIVORA	PROCYONIDAE	*Procyon lotor*	Raccoon body 710 mm
			MUSTELIDAE	*Mustela vison*	American Mink body 430 mm
		RODENTIA	CASTORIDAE	*Castor canadensis*	Beaver body 760 mm
			MURIDAE	*Arvicola terrestris*	Water Vole body 220 mm
				Ondatra zibethica	Muskrat body 360 mm
		ARTIODACTYLA	CERVIDAE	*Alces alces*	Moose or Elk male to 531 kg; female to 360 kg

Index

Page numbers in **bold** type indicate main subject references. Those in *italics* refer to illustrations.

251

Further reading

There is a very large number of books available which deal with freshwater life. The following list is a personal selection of works which we have found useful while we were writing *The Pond*.

Amos, William H. 1967. *The Life of the Pond*. McGraw-Hill, London.

Arber, Agnes. 1920. *Water Plants: a study of aquatic angiosperms*. Cambridge University Press, Cambridge. Reprinted 1963 as Vol. 23 in *Historiae Naturalis Classica*. Introduction by W T Stearn. Cramer, Weinheim.

Aston, Helen I. 1977. *Aquatic Plants of Australia*. Melbourne University Press, Melbourne.

Bold, H C & Wynne, M J. 1978. *Introduction to the Algae*. Prentice-Hall, New Jersey.

Bursche, Eva M. 1971. *A Handbook of Water Plants*. Frederick Warne, London.

Burton, R. 1977. *Ponds: their wildlife and upkeep*. David & Charles, Newton Abbot.

Chapman, V J & Chapman D J. 1973. *The Algae* (2nd edition). Macmillan, Basingstoke.

Clapham, A R, Tutin, T G, & Warburg E F. 1962. *Flora of the British Isles* (2nd edition). Cambridge University Press, Cambridge.

Clapham, A R, Tutin, T G, & Warburg E F. 1981. *Excursion Flora of the British Isles* (3rd edition). Cambridge University Press, Cambridge.

Clegg, J. 1974. *Freshwater Life* (revised edition). Frederick Warne, London.

Clegg, J. 1980. *The Observer's Book of Pond Life* (3rd edition). Frederick Warne, London.

Cook, C D. 1974 *Water Plants of the World*. Dr W Junk bv, The Hague.

Dory, J G, Perring, F, & Rob, C M. 1974. *English Names of Wild Flowers*. Butterworth, Sevenoaks.

Engelhardt, W & Merxmüller, H. 1964. *The Young Specialist Looks at Pond Life*. Burke, London.

Maitland, P S. 1977. *A Coded Checklist of Animals Occurring in Fresh Water in the British Isles*. Institute of Terrestrial Ecology, Natural Environment Research Council, Edinburgh.

Mellanby, Helen. 1963. *Animal Life in Fresh Water* (6th edition). Methuen, London.

Pennak, Robert W. 1978. *Freshwater Invertebrates of the United States* (2nd edition). John Wiley & Sons, New York.

Sculthorpe, C D. 1967. *The Biology of Aquatic Vascular Plants*. Edward Arnold, London.

Williams, W D. 1980. *Australian Freshwater Life*, Macmillan, Melbourne.

Photographic acknowledgements

Jill Bailey 50(1). **George Bernard** 8(4), 37(3), 38(1), 39(1,2), 40(1), 41(2), 43(1,2), 44(1,3), 45(1), 46(1,2), 47(1,2), 49(1), 51(2,3), 52(2,3), 53(1,2), 55(1,3), 56(2,3,4), 57(2), 58(1), 59(1), 61(1,2), 62(1), 63(1,2), 65(2,4), 66(2,3,4,5), 69(1,2), 75(4), 76, 84–5, 92(3), 93(4), 94(1,2,4), 95(1,2), 96(1), 97(3), 98(1,2), 105(3), 107(1,2), 108(1,2,3,4), 109(1,2), 110(1,2), 111, 115(1,2,4), 117(1,2) 118(1,2,3), 119, 123(1,2), 125(1,2,3), 130(1), 133(1,2), 135(1,2), 136, 137(1), 138(1,2,3), 139(2), 140(1,2,4), 141(1,2,3,4), 143(2,3), 145–7 inclusive, 148, 149(2), 150, 152, 154, 155, 156, 157, 159(1,2),162(1,2), 163, 164(1,3), 165(1,2), 166(1,2,3,4,5), 167, 168(1,2,3), 169(5), 170(3), 171, 172(1,2,3), 173(4,5,6), 174, 175(2,3,4),176(1,2), 177(3,4,5), 178(1,2), 182–3 inclusive, 184, 185(2,3,4), 186, 187(2,3,4,5), 188(1,2), 189(3,4,5,6,7,8), 190(1,2), 191(1,2,3), 193(1,2,3,4,5), 195(2,3,4,5,6), 196(1,2,3), 197(4,5,6,7,8), 199(2,3), 202(1,2), 203, 204(2), 205, 207(2), 208(1,2,3), 210(2), 211, 212–13 inclusive, 215, 216(1,2), 217, 220(1,2), 221, 223(1), 225(2). **R P Coldrey** (Oxford Scientific Films) 40(2). **John Cooke** 55(2), 57(1), 66(1), 75(1), 78–9, 95(3,4), 101, 121, 124, 131, 137(3), 151, 153, 160(2), 169(4), 180, 181(2,3,4), 195(1), 219(2). **Katherine Cooke** (Oxford Scientific Films) 9(5). **Stephen Dalton** 56(1), 59(2), 62(2), 140(3), 142, 144, 164(2), 170(2), 209, 210(1), 225(1), 226, 227, 228, 229, 234(1). **Harry Engels** (Animals Animals) 233(2), 234(2). **M P L Fogden** (Oxford Scientific Films) 52(1). **Sally Foy** (Oxford Scientific Films) 9(6). **M Gray** (Animals Animals) 235. **Breck P Kent** (Animals Animals) 65(3), 214. **G Kinns** (Biofotos) 233(1). **Zig Leszczynski** (Animals Animals) 207(1), 219(1), 231(2). **G A Maclean** (Oxford Scientific Films) 36, 38(2), 40(3), 41(1), 49(2), 223(2). **R W Mitchell** (Animals Animals) 68(1). **John Paling** 24–5, 32–3, 204(1). **Peter Parks** 63(3), 68(2,3), 71(1,2,3,4,5,6,7), 72(1,2,3), 73(1,2,3), 74(1,2,3), 75(2,3), 77, 87(1,2), 88(1,2,3,4), 89(5, 6,7), 90(1,2), 91(3,4,5), 92(1,2), 93(1,2,3), 94(3), 97(4,5), 99(1,2), 103(1,2,3), 104, 105(2,4), 112(1,2), 115(3), 126, 127, 129(1,2,3,4,5), 130(2), 139(1). **Leonard Lee Rue III** (Animals Animals) 225(3). **David Shale** 42(3). **Philip Sharpe** 231(1). **David Thompson** 7(1), 37(1), 199(1,4), 200(1,2), 201(3,4,5,6,7). **Gerald Thompson** 3(1,2,3,4,5), 7(2), 8(3), 37(2), 42(1,2,4), 44(2), 45(2), 50(2), 51(1), 58(2), 64, 65(1), 67, 96(2), 149(3,4,5,6,7), 160(1), 170(1).

Adult and Nymphs of insects

Springtail
Surface of water. Body chunky with jumping organ. Antennae long. No wings. p 135.

Springtail
Small, black, on surface in large numbers. Body segments obvious. Jumps when disturbed. Short antennae. No wings. p 134.

Damselfly nymph
Mask folded under head. Slender body ending in three leaf-like gills. Colour yellowish, green, or brown. Legs slender. Often found among weed. p 138.

Darter dragonfly nymph
Mask folded under head. General colour brown. Hairy, chunky body is well camouflaged on bottom of pond. There are no external gills. Three flaps control entry of water to rectum which contains six rectal gills. p 139.

Hawker dragonfly nymph
Mask folded under head. Colour brown or grey. More elongate than darter nymph and not hairy. Usually found on bottom of pond. p 142.

Mayfly nymph
Elongate shape. Seven pairs of simple, leaf-like gills on abdomen. Body ends in three tail filaments. Swims actively among water plants. p 148.

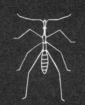

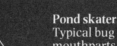

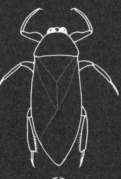

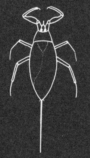

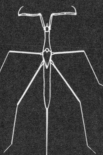

Water measurer
Typical bug mouthparts. Slender rod-like insect with long head and antennae. Legs thin and stilt-like. Crawls slowly over surface of stagnant water. Feeds on dead insects. p 150.

Pond skater
Typical bug mouthparts. Slender body, long legs and antennae. Wings vary from small pads to fully developed. Skates over pond surface and feeds on dead or trapped insects. p 151.

Giant water bug
Strong curved beak. Hind legs flattened and fringed with hairs for swimming. Fore legs strongly raptorial. Antennae concealed beneath head. Often flies readily and comes to light. Among the largest insects. None occurs in Britain. p 152.

Saucer bug
Typical bug mouthparts. Flattened oval shape. Raptorial fore legs. Swimming hind legs. p 152.

Water scorpion
Typical bug mouthparts. Fore legs strongly raptorial. Other legs used for walking. Head small. Long respiratory tube at end of abdomen. Movements sluggish. Feigns death when handled. p 154.

Needlebug
A long slender water scorpion with a very long abdominal respiratory tube. Fore legs raptorial. Head small. Typical bug mouthparts. Hangs head downwards to seize prey. p 155.

Backswimmer
Streamlined shape. Swims on back which is boatshaped. Strong mouthparts of typical bug type can give painful puncture. Long oar-like hind legs. p 156.

Water boatman
Typical bug mouthparts. Depressed body and streamlined shape. Swims right way up. Fore legs short; hind legs large and fringed. p 157.

Great Diving Beetle
Streamlined shape widest near hind end. 11 segmented antennae. Hind legs fringed for efficient swimming. Male back smooth, female ridged. Male fore legs with sucker for grasping female. p 161.

Great Silver Water Beetl
Less adapted for life in water than *Dytiscus* spp Body less streamlined. Hind legs less fringed. Long maxillary palps function as antennae. Hairy antennae proper used to conduct air to dorsal reservoir. Sharp spine pointing backwards on ventral surface. Front legs of male end in triangular plates. Feeds on algae. p 169.

Whirligig beetle
Surface swimmer. Ovoid flattened steely blue colour. Eye in two parts. Mid and hind legs modified as paddles. p 171.